Saint Jan
in History,

Saint James the Greater in History, Art and Culture

WILLIAM FARINA

McFarland & Company, Inc., Publishers
Jefferson, North Carolina

LIBRARY OF CONGRESS CATALOGUING-IN-PUBLICATION DATA

Names: Farina, William, 1955– author.
Title: Saint James the Greater in history, art and culture / William
 Farina.
Description: Jefferson, North Carolina : McFarland & Company, Inc.,
 Publishers, 2018. | Includes bibliographical references and index.
Identifiers: LCCN 2018005121 | ISBN 9781476669175 (softcover : acid free
 paper) ∞
Subjects: LCSH: James, the Greater, Saint—Art.
Classification: LCC NX652.J34 F37 2018 | DDC 226/.092—dc23
LC record available at https://lccn.loc.gov/2018005121

BRITISH LIBRARY CATALOGUING DATA ARE AVAILABLE

ISBN (print) 978-1-4766-6917-5
ISBN (ebook) 978-1-4766-3281-0

Front cover: statue of Saint James the Greater by Gil de Siloe
(The Metropolitan Museum of Art, The Cloisters Collection);
Pilgram Shell photograph © 2018 PFMphotostock/iStock

Printed in the United States of America

McFarland & Company, Inc., Publishers
 Box 611, Jefferson, North Carolina 28640
 www.mcfarlandpub.com

To the memory of
recently deceased friends
and loved ones

Acknowledgments

Thanks to my life companion Marion Buckley for patiently listening to "book thoughts" randomly spoken aloud—you are still my most valuable audience. Thanks to my brother Joseph Farina for contributing his considerable storehouse of knowledge on the visual arts. Repeated thanks to Philip and Kathleen Farina for always being enthusiastically engaged; thanks to Greg Jorjorian and Marlys Conrad for introducing me to the epic heritage of Armenian Christianity.

Thanks to Mimi Herrington and James Warshall for offering a librarian's perspective, helpful observations on C.S. Lewis, and lending me their dining room table. Thanks to Dr. Robert Orsi and Dr. Christine Helmer for being good role models, and to Steven and Ethel Rosenberg for their non-stop flow of wit combined with common sense. And thanks again to the libraries at Northwestern University and the University of Chicago, as well as their patiently supportive staff.

Last but far from least, special thanks to my friend, the late Rev. Dr. Robert Cotton Fite (1938–2017), for his boundless encouragement and good cheer in times most needed.

Table of Contents

Introduction

Of these holy romances, that of the apostle St. James can alone, by its single extravagance, deserve to be mentioned. From a peaceful fisherman of the lake of Gennesareth, he was transformed into a valorous knight, who charged at the head of the Spanish chivalry in their battles against the Moors. —Edward Gibbon[1]

Some years past while flying from Paris to Chicago one beautiful morning, I looked out of the passenger window to gaze upon some of the most spectacular landscape ever beheld during my travels. It was the "Green Spain" of Asturias, the northern Iberian coastline facing the Bay of Biscay. Previously, my mental image of Spain had been strictly one of arid, dry countryside dotted by patches of vineyards, olive groves, and a few scattered, dense urban oases.[2] The only thing dense about Green Spain, however, was the impenetrable forest canopy shrouding its rugged mountainous terrain. No doubt from the air it mostly looked the same as it did in ancient times, suggestive of its comparatively sparse population: wild, foreboding, and unconquerable, or at the very least, incredibly tough and stubborn. By coincidence, at that time, I was writing about the history of medieval chivalry in France and England.[3] It occurred to me that Spain and the Iberian Peninsula have their own venerable traditions in this regard, some of which appear to have originated in the very same region then being flown across. Moreover, a strong case could be made that these Iberian traditions have contributed towards more tangible, permanent results in terms of worldly affairs, than any of their trans-European counterparts. In any event, the experience has stayed with me, and these pages represent one outcome of that strong first impression.

Historians normally apply the term *Reconquista* to the long period spanning roughly from 711 CE to 1492 in which Christian Spain and Portugal slowly recovered from the Islamic conquest of the early eighth century, gradually reclaiming the Iberian Peninsula while invoking the Roman Catholic

1

faith. Among Anglo-Americans, this tremendous achievement too often represents barely a footnote for the pre–Columbian era in Europe, but to the rest of the world (including countless displaced Muslims and Jews) it was and remains a big deal, the profound significance of which is unlikely to change anytime soon. Near the beginning of the process, however, the famed cult of Saint James the Greater or *Santiago Mayor*, surnamed *Matamoros* ("Moor-slayer"), physically centered at Santiago de Compostela in the Galician province of far northwestern Spain, took momentous hold.[4] The "stupendous metamorphosis" (Edward Gibbon) of Saint James the Greater from obscure Galilean Christian apostle into a symbol of irresistible Roman Catholic militarism helped to inspire medieval Iberian *cavaleiros* in the reclamation of their homeland.[5] Today, Christians and non–Christians alike continue to make arduous pilgrimages on foot or otherwise to Santiago de Compostela, for which they are presented with official certificates of completion from the Vatican.

After 1492, this strident and fanatical militarism took on an entirely new dimension, but continued to use Saint James the Greater as its symbolic figurehead. Within the astonishingly short time frame of five decades, two heavily populated continents had been discovered and largely subjugated—not unlike the manner Umayyad invaders had overrun the Iberian Peninsula within a matter of months during the eighth century. Spanish and Portuguese conquest of the New World, by contrast, involved a much larger geographic area of hitherto unknown territory, with far more global and lasting impact on religion, language, and culture. Admittedly, the permanent Islamic influence on Spain and Portugal had been significant and far-reaching as well; indeed, some of this Islamic influence, particularly via art and architecture, carried over into the New World in the immediate wake of Spanish and Portuguese *conquistadores*.[6] By comparison to the overt legacy of the Santiago cult, however, the subtle sway of Moorish culture on the New World must be viewed as less pronounced.

Today, longstanding traditions of Saint James the Greater continue to spark imaginations for those engaged in less warlike and more spiritual quests of the heart and mind. Military conquest has, for the most part, been supplanted by personal inward journeys.[7] This alternative aspect had in fact been present from the outset. Long before the *Reconquista* concluded, Geoffrey Chaucer, writing in Middle English during the 14th century, informs readers that his eponymous Wife of Bath proudly included Santiago de Compostela among her extensive list of religious pilgrimages (see Chapter 9).[8] The European Renaissance only seemed to heighten this veneration, producing a magnificent body of visual art by many of its greatest masters. Even after the Reformation had blunted the global authority of Roman Catholicism, writers such as Shakespeare, Cervantes, and Montaigne (among many others) all

were making casual literary references to Saint James the Greater as warrior-knight, pilgrim wayfarer, or both. Today, the shrine of Galician Santiago continues to present itself as a physical thread of spiritual continuity over the last 13 centuries, fully justifying its current designation as a UNESCO World Heritage site. It is commonly and accurately observed that the traditional burial site of Saint James the Greater in Spain continues to be the most popular religious destination in Christendom after Rome and the Holy Land.

While the end of the 16th century saw Anglo, French, and Dutch interests effectively block further Spanish-Portuguese expansion into North America, the latter two (by then temporarily combined into a single political entity) had auspiciously begun its close assimilation into Native American societies as well. After this they would only be removed by force and rather infrequently at that. The remaining political question would be to what extent these newly evolved societies would govern themselves autonomously or be ruled remotely by distant powers. The national emergence of the United States during the late 1700s and Latin American national independence movements immediately following in its wake both decisively answered these questions, although political relations within these the two blocs continues to evolve in a complex and unpredictable manner. Curiously, veneration for Saint James the Greater continues to be seen everywhere, even among those whose religious beliefs may be described as marginally Christian at best. One might well argue that, for Latin Americans and their Native American religious converts, a new *Reconquista* has in fact been progressing all along, a process in which this old cultural heritage—one long predating the *Mayflower* landing in New England—is now reasserting itself, not only in terms of language, but also within the spheres of religion, politics, history, art, economics, and most other aspects of American daily life.

Another notable aspect of this widespread veneration is the multifaceted role of Saint James the Greater as a prolific patron saint of places and professions, a benevolent intercessor to whom prayers may be fervently addressed. In addition to being the patron saint of Spain, James is closely identified with numerous Latin American nations, as well as cities and other countries far-flung across the globe, not excluding the United States. In terms of professional occupations, the diversity of worship is even more startling. Historically, as one might expect, Saint James the Greater became the patron saint of soldiers and pilgrims both in the Old and New Worlds. Today, he is the official patron of multifarious occupations: veterinarians, tanners, furriers, hat makers, pharmacists, blacksmiths, porters, menial laborers, and equestrians, to name a few. Those suffering from arthritis and rheumatism are directed by church authorities to pray to this specific saint for intercession as well. The obscure roots of these old customs will not be the focus of this

study, but occasionally referenced to highlight the ongoing popularity of the saintly icon within the context of our growingly uncertain world.

A surprising amount of devotion to Saint James the Greater comes from non–Roman Catholic sources. In addition to Roman Catholics, the Santiago tradition is honored among Protestants not otherwise typically enamored of iconic devotion, including Lutherans, Methodists, and British or African Anglicans, along with their occasionally dissenting Episcopalian counter-parts. Eastern Orthodox churches enthusiastically embrace the tradition as well, particularly among the Coptic, Syrian, and Armenian branches. From older Christian denominations, variations on the cult become even more exotic. American Mormons include Saint James the Greater (along with Saint Peter and James' brother Saint John) among the resurrected divine personages giving express legitimacy to the Church of Latter Day Saints (see Chapter 16). In Haiti, the Santiago cult is sometimes merged into and amalgamated with pre–Columbian and African voodoo religious customs.[9] Given these seemingly endless permutations, it appears that veneration of Saint James the Greater is one of the few things that most Christian denominations can agree upon. It also makes for endless fascination within the realm of visual art, which this study will strive highlight. In fact, the ancient and not-so-ancient traditions of Santiago Mayor would appear to surround us daily, although we may be unaware of these associations. Our goal will be, if nothing else, to heighten reader awareness of these commonplace associations.

All this may seem incredibly far removed from the historical James, Galilean fisherman, son of Zebedee and Salome, early disciple of Jesus, brother of the apostle-evangelist John, and first of the original 12 apostles to be martyred for his faith sometime around the year 44 CE in Jerusalem. And yet there can be little denying that, some two millennia later, the symbolic prestige of Saint James the Greater is surpassed only by that of Saint Peter among the original disciples. While Saint Paul (not one of the original 12) unquestionably influenced the theology and evangelization of the early Chris-tian church far more than any other single personage (that is, after Jesus Himself), Paul has nonetheless been notably superseded by James in terms of popular veneration and iconography. This status becomes even more note-worthy if one considers that the New Testament abounds with textual infor-mation about Paul, not the least of which are his very own attributed epistles. No so with James.[10] Other than some basic facts that even non–Christians have no reason to contest, scripture tells us almost nothing about James. Despite this scarcity of data, we venerate, pray to, and portray him in some our greatest and most inspirational works of art. His name has been invoked in countless military and political endeavors across the globe over the course of 12 centuries, the results of which continue to impact our everyday lives. This important phenomenon—or miracle, some might say—would truly

appear for us all to be a matter worthy of some additional reflection, from the standpoint of the visual arts if nothing else.

Surprisingly, full-length scholarly works focused on Saint James the Greater are practically nonexistent.[11] The reasons for this scarcity are twofold. First, the generally agreed upon historical facts about James can easily be narrowed down to a few sentences from the New Testament and some other extraneous commentary made long after James' martyrdom approximately 14 years after the death of Jesus. Simply put, it is almost impossible to make a conventional book-length study strictly drawn from such scant eyewitness testimony. Second (and perhaps more indicative), to write anything at length about James is really to write about the immeasurable impact of his cult or traditions on external world events. To this latter end, there has been voluminous commentary produced over the last 800 years; however, few (if any) have attempted to take a global perspective or examine visual imagery in detail. For example, we will make no attempt to surpass more recent landmarks such as *The Road to Santiago: Pilgrims of St. James* (1957) by Walter Starkie, an extensive meditation on the cult's history in and around Spanish Galicia. Instead, this study will strive to demonstrate the worldwide impact of the Santiago cult as it emerged in the aftermath of failed European Crusades from the early 12th and late 13th centuries. The legendary and non-scriptural traditions of the cult will be especially embraced, while at the same time reminding readers that these aspects may or may not be historical. Finally, the wide impact of these traditions will be underscored with period artwork, ranging from the earliest medieval iconography to the most modernist of painters (see Chapter 21).

This study is organized somewhat chronologically and divided into two historical segments: the first (Part I) covering the pre–Columbian era in Europe and the second (Part II), post–Columbian global history. As for source materials, with respect to the pre–Columbian traditions of Santiago Mayor in the fine arts, there appear to be relatively few books in English about the *Reconquista* and Medieval Spanish history in general. In fact, as a world-defining event, Iberian history prior to 1492 may represent one of the most underserved yet significant topics on today's library shelves, at least from an Anglo readership perspective. Regarding more contemporary history for Iberia, many volumes focus on the Spanish Civil War of the 1930s or are best categorized as travelogues, the latter containing some very fine entries by the likes of Richard Wright and James Michener. This study, however, will mostly steer away from both genres. Part II will use parallel European events strictly as a backdrop for the far more dynamic international developments taking place in the New World from the moment that Christopher Columbus first set foot on the Caribbean West Indies. This rippling impact beyond western Europe applied not only to Latin America, but also to parts of Asia (such as

the Philippines), as well as the Anglo, French, and Dutch settlements of North America. Artwork selected for examination over the last 500 years oftentimes, not surprisingly, makes visual reference to earlier themes of the more distant past. More surprisingly (at least to this untrained eye), masterworks of the pre-modern era frequently seem contemporary in their portrayal of ideas, moods, and events; hence, chapters covering the post–Columbian era (in Part II) selectively draw upon much older works whenever these are seen as appropriate.

Before proceeding any further on this topic, a word on etymology for the sake of avoiding, or at least minimizing, unnecessary confusion. The name of James is itself a French-Latinized form of Jacob, a very common Hebrew name, originally for the patriarchal grandson of Abraham, and a pivotal figure in the biblical Old Testament from whom the 12 tribes of Israel were descended.[12] In source materials, these two names are often used interchangeably. Within Iberia, any visitor to that corner of Europe to this day quickly discovers a baffling array of regional dialects, and hence a surprising range of derivations for the name of James: Jaime, Jaume, Jacó, Diego, Iago, and so forth. In France, Saint James the Greater is known as Saint-Jacques le Majeur, in Italy, San Giacomo il Maggiore. Compounding these difficulties, Islamic religion also claims lineal and spiritual descent from Abraham, therefore the Arabic name for Jacob or Yaqub is not uncommon as well. During the Iberian Reconquista, it would have not been unusual to find combatants on both sides with names derived from the Jacob of Old Testament fame— in the case of Christians, from one of two apostles named after that same patriarch. The very fact that this name has so many declensions and variations throughout western civilization is a good indicator as to the importance and revered status of both the biblical Jacob and his numerous Christian namesakes.

This confusion does not end with nomenclature. The name of James is found throughout the Christian New Testament, obviously referring to several different individuals, and to specifically two of the original 12 apostles of Jesus, both saints and martyrs in Jerusalem. Besides Saint James the Greater, brother of Saint John the Evangelist (also an apostle) and son of Zebedee, we have Saint James the Lesser (or the Younger), son of Alphaeus and, according to some sources, first cousin to Jesus.[13] This James might be equated with the first Bishop of Jerusalem, aka "James the Just," martyred circa 62 CE nearly two decades after James the Greater was executed around 44 CE by anti–Christian authorities in the same city. To top off this complex history, the physical relics of both Saint James are today claimed and venerated by the Armenian Cathedral of SS. James in Jerusalem (see Chapter 11), somewhat in contradiction to the claims of Santiago de Compostela in Galician Spain. Moving forward in time from the Apostolic Age, dozens of other Christian

saints were subsequently named after one of two original apostle-martyrs by the same name, some of whom became quite famous in their own right, and themselves inspiring a notable amount of visual art. For purposes of this study, however, we shall focus strictly on the visual art legacy of Saint James the Greater, known in the Spanish-speaking world as Santiago Mayor.

To say that the historical accuracy of the Spanish Santiago tradition has been questioned would be tremendous understatement. Indeed, across-the-board silence of prominent Spanish Christian writers on this topic right up until the Middle Ages repeatedly suggests ignorance, indifference, or hostility (see Chapter 1). Arguments in favor of the cult, however, are not unreasonable either. In the ancient Roman Mediterranean world, long-distance travel and transport of the types allegedly undertaken by the apostles were much more feasible (and not necessarily supernatural) than later during the chaotic Dark Ages of the fifth century moving forward; moreover, during this latter period much recorded information was lost or forgotten, while very little was preserved or written anew.[14] Widespread veneration of Christian relics was largely a product of this later, more obscure time, which might explain, for example, the apparent indifference of the Galician-born Roman Emperor Theodosius towards the cult during the fourth century, assuming the tradition did in fact exist at that time. By then, Roman Christianity had been ascendant for less than a century and the western empire was itself in sharp decline. Invading barbarians, such as the Visigoths who soon conquered all of Iberia, would have little or no knowledge of such things, even those embracing various heretical or orthodox variations of the primitive Christian religion. And then there were sharp regional rivalries within the early church, especially after Christianity became the official religion of the Roman Empire. Within Iberia itself, it could hardly be expected for Toledo to readily acknowledge Santiago de Compostela as an apostolic shrine (which it was in fact very slow to do), let alone for Spain to cede any prominence to emerging rival states in Europe boasting their own pilgrimage sites, such as France, Italy, or England. Lastly, ignorance or contradiction among the early church fathers was not uncommon. For example, there is no compelling reason for Saint Paul to have known about the Spanish Santiago tradition when writing his Letter to the Romans, which he apparently did not. All in all, many rational objections to the authenticity of the Spanish tradition are certainly compelling, but still are far from being conclusive or definitive.

On the other hand, the tradition more likely was gradually manufactured out of thin air over the course of several centuries, which in some respects is far more impressive and miraculous than the idea of a Galilean fisherman traveling across the Mediterranean during Roman times and then later being buried at a site far from his place of execution.[15] Ultimately, the entire question boils down to what is probable versus merely possible. In this sense, it is

comparable to the Shakespeare Authorship Question, in which this writer has maintained that it is *possible* that the traditional Shakespeare from Stratford-on-Avon was the true author of canon, but *unlikely* given cumulative weight of circumstantial evidence.[16] In the case of Saint James the Greater, it must, in the final analysis, be considered *unlikely* that he preached and was buried in Spain, but still *possible* nonetheless. More importantly, many of us (this writer included) find ourselves wanting to believe that the Santiago tradition is factually true, regardless of all logical probabilities. Above all, this study will suggest that what we want to personally believe or disbelieve is often assisted by great works of art, and in the case of Saint James the Greater, many fabulous works of visual art spanning the centuries. During the Renaissance era alone—the same period seeing completion of the Iberian *Reconquista*—talented artists created visual images that continue to capture the modern imagination, images that have replaced reality, even for those of us educated enough to distinguish between reality and art.[17] Once again, Shakespeare comes to mind in comparison, for it is now well known the author of Shakespeare's tremendous history plays created a kind of alternative reality that most of us think of as actual English history—even if we know better— no small accomplishment on the part of the playwright, to be sure.

This book owes a special debt to the established work of British scholar Sir Thomas Downing Kendrick (1895–1979), a combat veteran of the World War I trenches and former director of the British Museum in London, whose concise and balanced study on the cult of Saint James the Greater (published in 1960) remains a benchmark for this topic.[18] There is no need for us to delve into the centuries of fraud and deception surrounding the Santiago cult, because Kendrick did it so well for us, usually with great sensitivity, perception, and a small dose of levity.[19] Nevertheless, in his own introduction, Kendrick observed: "No one can prove that St. James did not visit Spain; no one can prove that the miracle of the pillar did not happen; no one can prove that the apostle's body was not transported, miraculously or otherwise, to Galicia; no one can prove St. James did not come down from heaven to assist a Spanish army in action."[20] At the end of the day, as Kendrick observed, religious faith prevails over all rational objections, and perhaps rightly so. There is no proverbial smoking gun to prove any argument one way or another, nor will there ever be; moreover, even if there were such arguments, it would probably not make much of a difference. Saint James the Greater, along with all his rich, ancient, and multifaceted traditions, bolstered by some of the most striking visual works of art ever created, is here with us to stay, and we are all surely better off for it, at least for those who can remember the past and pay some degree of attention to the grave lessons of western history.

Brilliant visual images attached to the Santiago tradition from its very inception. Among the most renowned is also one of the earliest to have

survived down to the present day. The Salamanca *Codex Calixtinus* illuminated manuscript, produced by an anonymous artist in Santiago de Compostela sometime during the early 14th century, depicts Santiago Matamoros with all his essential accoutrements and a twist added.[21] Portrayed as an Iberian light cavalryman *à la jinete* (see Chapter 11), the warrior-apostle is seen mounted on a white battle steed, brandishing a sword and holding a Christian banner. In addition to these standard features, the saint's emblematic scallop shell symbolizing religious pilgrimage is to be seen everywhere as well—in the sky substituting as stars, on the saddle harness of the battle steed, and on the war banner itself.[22] Multiple aspects of the Santiago cult were thus closely intertwined from the very outset.[23] Readers or viewers are not allowed to think of him strictly as a warrior without being reminded that he was also a pilgrim-evangelist, and vice versa. The Salamanca illuminated manuscript was produced during an era in which the Reconquista seemed poised for ultimate success, but in fact was about to be stalled by various external disasters and self-inflicted setbacks (see Chapter 9). These medieval illuminated manuscripts played a crucial role in promoting the cult from its inception (at least among the educated), including valuable source documents such as the *Codex Calixtinus* and other related books, which it influenced or was influenced by, such as the earlier *Commentary on the Apocalypse* by Beatus of Liébana (see Chapter 3). It also behooves us to remember that these manuscripts predated the 15th century invention of movable type, yet not only managed to survive the ravages of time, but made a deep impression on anyone looking at them as well, literate or otherwise, and continue to do so.

This book is not about relics; rather, is about art and about faith, roughly in that order. For those seeking a more in-depth analysis of the Santiago tradition and its breathtakingly complex history, as well as its alleged truth or falsity, I refer them to the bibliography herein, or better yet, to the multilingual bibliography presented over half a century ago by T.D. Kendrick. Anyone who peruses this complicated topic for more than a few minutes will discover how controversial it can quickly become, even among designated experts devoting their entire careers to it. As for this modest study, it makes absolutely no pretense at comprehensiveness, even with respect to visual art.[24] It merely scratches the surface, based mainly upon subjective personal preferences. Hopefully, it will encourage more interest or, if nothing else, cause patient readers to possess a more heightened awareness of these images and symbols surrounding their everyday lives. As for the factual origins of the tradition, surely the best place to begin is with the early Christian writers, including those of the New Testament. From these sources come a handful of basic facts specifically about this legendary apostolic figure, few of which are ever contested, even by non-believers, since few of these asserted events (as they pertain to the saint) are overtly miraculous or supernatural in any

respect. From these meager beginnings, however, eventually sprung one of the most powerful traditions in all of Christendom, especially in terms of visual art. Its remnants are still all around us to be seen. Most importantly, its moral and spiritual lessons remain continuously applicable to the contemporary world in which we all live.

1

First in Apostolic Martyrdom
(27–410)

And so he [Jesus] appointed the Twelve, Simon to whom he gave the name Peter, James the son of Zebedee and John the brother of James, to whom he gave the name Boanerges or 'Sons of Thunder'... —Mark 3:17[1]

Frequently overlooked by the vast commentary on Saint James the Greater is the stark biblical fact, which no one has ever questioned, that he was first among the original 12 apostles to die for his Christian faith. More typically, James' manner of death is perfunctorily recounted in the strict chronological sense, but then immediately forgotten. Little if any connection is made between his martyrdom and the inspirational cult attaching to his name over the subsequent millennia. Nevertheless, any serious study examining the process must begin with the life and death of this obscure historical personage, or at least what very little we know about him as gathered from accepted scripture or reliable ancient sources. Only then can we hope to fathom how and why such a transformation took place, the "extravagance" of which apparently so annoyed the eminent British historian and proto–Enlightenment critic Edward Gibbon (see Introduction). Human religious faith, for worse and for better, often tends to strengthen itself around basic, incontrovertible data, then embellishing and glossing over this data according to personal needs for both interpretation and understanding. The singular example of James the Greater thus offers excellent opportunity to explore this phenomenon, not to demean, discount or dismiss, but rather to closely examine its strengths and weaknesses, as well as to imbue our own consciousness with a healthy dose of intellectual humility and restraint, qualities desperately needed in today's overly presumptuous and dangerously self-righteous world.

A convenient though perhaps less obvious place to summarize more

certain knowledge of James the Greater is with the New Testament. Matthew (4:21–22), Mark (1:19–20), and Luke (5:10) all affirm that James and John, the sibling fisherman sons of Zebedee, were the third and fourth individuals (after Peter and Andrew) called by Jesus to Christian discipleship. Tradition holds that James was the elder brother, although scripture is silent on this point. Matthew and Mark, with possibly unintentional humor, elaborate that the two were in a boat with their father mending nets when Jesus called them, and at once left to follow him. Mark (3:17) adds the valuable detail that Jesus nicknamed the brothers "Sons of Thunder" (see header quote), likely denoting their fiery temperaments, as demonstrated several times throughout the narrative, beginning with them impulsively walking away from their father's business.[2] Later, they suggest to Jesus that a Samaritan village should be consumed by fire after it refuses to receive them, a sentiment for which they are sternly rebuked (Luke 9:54). Later still, they are among the apostles showing keen interest in Jesus' prediction that the city of Jerusalem will be leveled (Mark 13:3–4). These reported incidents stand in marked contrast to Gibbon's somewhat condescending characterization of James as a "peaceful fisherman" later transformed by medieval romancers into a supernatural man-of-arms. Even doubters of the later embellishments usually concede that the sons of Zebedee were probably hot tempered, well in keeping with the apocalyptic and often exasperated tone of Johannine scripture, although (rather interestingly) the biblical writings attributed to John and his circle make no mention of John's brother James, unlike the synoptic gospels of Matthew, Mark, and Luke, all of which provide somewhat more information.[3]

Further perusal of the gospels reveals additional evidence of James' prominent place within the apostolic hierarchy, in tandem with his brother, the Evangelist John. Both James and John are present when Jesus heals the mother of Peter and Andrew (Mark 1:29–31); more dramatically, both (along with Peter) accompany Jesus when he raises the daughter of Jairus from the dead (Mark 5:37). In Matthew (17:1), both witness (again, along with Peter) the Transfiguration, and are overwhelmed by it. Peter and the Sons of Thunder attend Jesus during his agony in the Garden of Gethsemane, but cannot stay awake (Mark 14:33). Perhaps the most unlikely incident in the New Testament involving James and John, recounted by Matthew (20:20) and Mark (10:35), occurs when Jesus is approached by their mother, requesting that her two sons be allowed to sit at the respective right and left hands of Jesus after coming into his glory. The subtle exchanges and not-so-subtle reactions which follow between Jesus and his disciples are telling. Included is a prediction of James' future martyrdom for his faith, which is not comprehended as such until long after the fact. More on this later (see Summary). As for *The Letter of James*, this great masterpiece of the New Testament is nowadays generally associated by biblical scholars with James the Just, kinsman of Jesus

and first Bishop of Jerusalem, rather than James the Greater. Nevertheless, the fiery, indignant tone of *James* is still well in keeping with what little we know about James the Greater. Given that much of the bible is today generally viewed as having a long and complex compositional process, we see no reason why *James* cannot be doubly affiliated with the elder son of Zebedee as well as the first Bishop of Jerusalem.

The most memorable event in the New Testament with respect to James, however, is unquestionably his martyrdom in Jerusalem, personally ordered by King Agrippa I (of Judea and Samaria), as perfunctorily recounted by the Evangelist Luke in *Acts of the Apostles* (12:2).[4] The incident is presented by Luke as prelude to the miraculous escape of Simon Peter from a similar fate soon afterwards. No other details are provided regarding James' death. Given that Agrippa himself is described by Luke as dying a painful, lingering death from divine punishment shortly thereafter during the Passover feast, historians normally assign dating to James' martyrdom as circa 44 CE (before Passover), approximately 14 years after the crucifixion of Jesus, 17 years after James had been called to discipleship, and sometime shortly before the first missionary journey of Saint Paul, during the reign of the Roman Emperor Claudius.[5] That is pretty much it for biblical information. Otherwise, for purposes of scripture, James is simply another one of the 12 apostles. Nevertheless, on the biblical authority of the Luke, James holds special place among the twelve as being the very first to publicly die for his faith, a martyrdom perhaps second only in overall importance to the earlier death of protomartyr Saint Stephen not long after the crucifixion (circa 30 CE?), as recorded at length by Luke (Acts 7:55–60).[6] Moreover, James' apostolic martyrdom is the only one of its kind specifically mentioned in the New Testament.

While one searches hard, long, and ultimately in vain for ancient references to the Santiago tradition in Spain, glaring and troubling omissions are easy to find, beginning with scripture itself. By some scholarly estimates, Luke's *Acts* were written at least 16 years after James' martyrdom, but makes no mention of James having traveled anywhere, let alone to Iberia. In fairness, Luke was a writer of Hellenist background and Hellenist emphasis, mainly concerned with highlighting the missionary activities of Paul, and does not mention any other missionaries besides Paul and his attendants venturing beyond Judea and Samaria.[7] For Luke, Paul was the true apostle of the gentiles to the west, although Paul was not one of the 12 apostles himself. The only hint provided by Luke that Jewish Christians were well capable of evangelizing beyond their native land comes during the Pentecost (of which James was a part), in which the Holy Spirit descends on the fledgling Christian community, thus allowing them to converse in foreign languages. Even for this miraculous event, however, Luke catalogues foreign place names confined to the Eastern Roman Empire, with the exception of Rome itself (Acts 2:1–13). To

repeat, this is not surprising coming from a Hellenist author, one primarily concerned with recounting the words and deeds of Saint Paul.

The extensive biblical writings attributed to Paul add nothing to shed any further light on this. Famously, in the epilogue to his *Romans* epistle—probably written before Luke's *Acts* but long after James' martyrdom—Paul repeatedly states his intention of traveling to Spain, prefacing the remark with "...it has been my rule to preach the gospel only where the name of Christ has not already been heard for I do not build on another's foundations..." (*Romans* 15:20).[8] Thus Luke's assigned apostle to the gentiles of the Latin-speaking West, by Paul's own admission, seems to have no knowledge of Christianity being preached in Spain before the time of the Emperor Nero. On the other hand, there is no reason to insist that Paul was all-knowing or infallible in such matters. For example, it is well established that the Christian gospel message had reached Rome long before SS. Peter and Paul did so in person. Furthermore, even determined apologists for James' Spanish mission concede that he was not conspicuously successful in terms of generating multitudes of followers. If the tradition is true, James may have considered himself a failure in this regard and not proclaimed it very loudly after returning home to Judea. Given the spectacular success of others, he may have even been somewhat embarrassed. In any event, the worst that can said is that by the time the New Testament began reaching its accepted modern form sometime during the second century, there was absolutely nothing within it that could be claimed by the Iberian Santiago tradition for purposes of authentication.

Unfortunately, beyond scripture, the same problem of written omission for a Spanish Santiago tradition continues to inconveniently accumulate over the next 500 years or more. Compounding difficulties, these omissions persist long after Christianity became the favored religion of the late Roman Empire. After the "Great Persecution" of 303–310 was unleashed by the Emperor Diocletian, followed by a period of civil war lasting until 313, Constantine the Great emerged as victor and new Emperor. Almost immediately he issued his Edict of Milan, proclaiming religious freedom throughout the empire. More importantly, Constantine formally declared himself to be a Christian, owing all his worldly advancement to the Christian faith, and extended imperial favor to anyone else doing the same. As a result—and not too surprisingly—the fourth century saw the previously slow spread of Christianity grow by leaps and bounds throughout the Mediterranean world. At this point in history, early church fathers began, really for the first time, to write proudly and extensively of their faith, and were sometimes subsidized by the Roman government for doing so. One would expect the Santiago cult to now clearly emerge from the shadows; instead, one must wait patiently for yet another three centuries before seeing the name of Saint James the Greater mentioned

in any connection whatsoever with the Iberian Peninsula, and even then only as being one place that he once had preached (see Chapter 2).

During the early fourth century, immediately following Christianity's dramatic political ascendency, Eusebius, Bishop of Caesarea Maritima (in modern day Israel), wrote his benchmark *Ecclesiastical History*, still considered a semi-reliable source of information on the early church. Citing a lost work by Clement of Alexandria from the early third century, Eusebius recounts the heroic martyrdom of Saint James the Greater, adding many new details but making no mention of Spain.[9] In particular, Eusebius introduces the attractive and durable tradition (one not found in Luke) that James' accuser, the scribe Josias, was so impressed by the apostle's courage, dignity, and miracles performed that he too was converted, condemned, and executed at the same time.[10] Regarding the lack of reference to Spain, one might argue that Eusebius, despite his trustworthiness, was (like Luke) a Greek-speaking easterner whose writings generally tended to downplay the importance of the Latin-speaking west.[11] It is worth recalling that by 324, the Emperor Constantine was in full process of redeveloping the former Greek city of Byzantium into a newly rechristened Constantinople as capital of the Eastern Roman Empire and de facto capital of the entire Roman world. The power center of the empire had by then, thanks to Constantine, shifted eastwards away from Rome, and the Western Empire would gradually decline over the next 150 years. It would be fair to say that most early church fathers from this period followed suit by glorifying the eastern history of the church at the expense of the west, which included Iberia.

Meanwhile, another significant inconvenience for the Spanish Santiago cult had appeared in the Holy Land. Several years before Christianization of the Roman Empire was initiated by Constantine, King Tiridates III of Armenia had, in the year 301, thanks to the evangelical efforts of Saint Gregory the Illuminator, controversially proclaimed Christianity to be the national religion of his country.[12] Accordingly (and with little or no dissent from historians), Armenia holds the signal honor of being the first country on earth to do so. Sometime soon thereafter, Armenian Christian monks began migrating to Jerusalem, where they established the still-intact Armenian Quarter of the city.[13] Some eight centuries later, the Armenian Orthodox Church would claim the site within the Armenian Quarter on which, according to another old tradition, Saint James the Greater had been executed by order of Herod Agrippa I in 44 CE. On this very same locale today stands the Armenian Cathedral of Saint James (see Chapter 6), allegedly housing the venerated relics of both Saints James the Greater and James the Just, kinsman of Jesus and first Bishop of Jerusalem. Although the Armenians claim only to possess the skull of James the Greater, this is obviously in direct contradiction to existing Roman Catholic shrines at both Santiago de Compostela and

Pistoia, Italy (see Chapter 7). More on this later. For now, let it simply be noted that these competing claims represent a major bone of contention between the Catholic and Armenian Orthodox faiths, if we may be permitted to use that turn of phrase.

Sometime after Armenian monks began arriving in Jerusalem during the fourth century, the prolific Roman-Hispanic poet Prudentius wrote in praise of Spanish Christian martyrs, saints, and shrines in his verses titled *Peristephanon* ("Crowns of Martyrdom"). Among others, Prudentius showed keen interest in martyrs associated with the eastern Iberian city of Caesaraugusta or Zaragoza, which some believe may have been the poet's home town, as well as a place name later closely associated with the first Marian vision of Saint James (see Chapter 2). It would be hard to imagine a better time and spokesperson to celebrate the Spanish Santiago tradition, if in fact one existed at that point in history. Instead (and rather strikingly), Prudentius makes no mention whatsoever of Saint James the Greater. Regarding this frustrating omission, the modern British critic T.D. Kendrick tartly observed that "The inescapable conclusion is that when Prudentius wrote the *Peristephanon*, he had not the slightest idea that an apostle-martyr was reputed to be buried in Galicia."[14] The silence of the poet on this matter becomes even more troubling when one considers that it came at a time when the Iberian cult was presumably being ignored or contradicted by reputable Christian sources in the east.

One of these reputable sources, in fact arguably the most preeminent, was Saint Jerome (c.347–420), a Doctor of the Church who personally spent significant amounts of time living in both the eastern and western sides of the late Roman Empire. Among Jerome's voluminous surviving works, his *De Viris Illustribus* ("On Illustrious Men"), written during the late fourth or early fifth century, presents an extensive collection of biographical sketches on early Christian authors, some biblical, some not, and even some heretical as well. James the Greater is not included among these since Jerome did not consider James to be a writer; however, James is briefly mentioned in Jerome's account of Saint John the Evangelist, in which the martyrdom of John's brother James' is duly mentioned, but little more than that and nothing at all about Spain. Elsewhere in his writings, Jerome suggests that one of the apostles had been to Spain and that each of the apostles were interred in the lands in which they had preached, but then very oddly stops short of linking James the Greater to Iberia.[15] It was if Jerome had heard something but declined to endorse it. His silence on James' alleged overseas journeys is also surprising coming from a prolific writer who had himself traversed the Mediterranean world from Gaul, Italy, and Greece, to Asia Minor, Egypt, and the Holy Land. His presumed view of James as a non-literary holy man (in contrast to his brother John) is further interesting in that much later James would routinely be portrayed in medieval and Renaissance art as an honorary pseudo-doctor

of the church (comparable to Jerome himself), heavy bible in hand as part his necessary pilgrim's gear, sometimes too engrossed in the good book to be bothered with any other distractions (see Chapter 14).

In contrast to these speculations, it is well documented that in the year 385, the Galician-born Priscillian, Bishop of Ávila, was declared a heretic by a Roman court of law and executed (along with his followers) by order of the Emperor Magnus Maximus, a fellow Spaniard by birth.[16] It appears to have been the first documented instance of a high church official being condemned and put to death by civil authorities on religious grounds after the empire had become predominantly Christian.[17] It was certainly not the first time that professed Christians had turned on each other in violent fashion; however, it may have in fact been the first time in which this was done under the guise of legal due process. The capital punishment inflicted on Priscillian by Maximus was publicly opposed by the sitting Pope (Siricius), as well as by the contemporary likes of Saint Martin of Tours and Saint Ambrose of Milan, but to no avail. About three years after this lamentable affair (in 388), and after the military defeat and execution of Maximus by the new Emperor Theodosius (another native of Galicia), the remains or relics of Priscillian were brought back to his native Galicia and there interred.[18] His memory was afterwards honored in northwestern Spain for centuries, long after the Western Empire had fallen, and well into the subsequent Visigoth era, although the precise location of his shrine was forgotten. To this we shall later return as well (see Chapter 4).

After death of Theodosius in 395, and after the execution of Theodosius' leading General, Flavius Stilicho in 408 (at the hands of Theodosius' inept son and successor, the Emperor Honorius), the Western Roman Empire began its final phase of precipitous decline and collapse. Restless Germanic tribes once again erupted across the Rhine frontier in 406, but this time there was nothing to stand in their way. After overrunning Gaul, by 409 they had invaded the Iberian Peninsula, and following years of famine, pestilence, and political chaos, the conquerors gradually assimilated with their new Spanish subjects. Galicia became part of a new Suebian Kingdom while the Visigoths ruled most of the remaining peninsula. In 410 a Visigoth army under its intrepid chieftain Alaric—another one of Theodosius' former generals— sacked the city of Rome itself, the first event of its kind in over 800 years. Coming hard on the heels of a devastating raid into Italy by Attila in 452, an even more destructive sack of Rome by the Germanic Vandals in 455 soon followed. Rome was no longer able to offer resistance against its enemies. In 476 the last western emperor was summarily deposed by a Germanic warlord, and the Western Roman Empire was no more. Although many of the invaders identified as Christians, most subscribed to Arianism, a flat-out heresy in the eyes of both Rome and Constantinople, and a far more dangerous one

than that which killed Priscillian a century earlier, in that Arianism often led to violent political disturbances.[19] More importantly, by the fall of the Western Empire during the late fifth century, some 432 years after James the Greater had been martyred in Jerusalem, there was still no surviving indication that anyone, Catholic, Arian, or pagan, associated his memory with Spain. This surprising silence on the part of church fathers would continue for yet another century and well beyond.

Returning to the death of Saint James as a historical fact, the event has been regularly portrayed in the visual arts for nearly a thousand years. Many of these depictions are quite remarkable, but insofar as this untrained eye can tell, most add extensive details not found in the bible, understandable since the bible itself does not have many details to offer. Much of this extraneous content is drawn from later, non-canonical sources, and a good deal of it appears to come directly from artistic imagination, occasionally to gripping effect. For example, the ancient but non-biblical tradition (as recorded by Eusebius) of James' accuser led to the execution block after being converted by the condemned apostle has inspired more than one great artist. Far more unusual, however, have been works attempting to strictly follow Luke's *Acts*, or at least to minimize the embellishments. One artist able to accomplish this difficult task in spectacular fashion was the highly-regarded painter Francisco de Zurbarán (1598–1664), sometimes called the Spanish Caravaggio, near contemporary of Diego Velázquez, and active during the reign of King Philip IV.[20] Zurbarán needs little introduction to art lovers, but suffice it within these pages to say that he lived and worked during a time in which the Spanish Empire was beginning its long decline as a political and military power, but certainly not its cultural sophistication. Indeed, this extended period has been rightfully dubbed by some historians as the Spanish Golden Age for its impressive output in literature and visual arts.

The Martyrdom of Saint James by Zurbarán dates from a mature, prolific phase in which the master seemed to be at the height of his powers. Eventually acquired by the Museo del Prado in Madrid, the 19th century provenance of the work is uncertain, but the enormous size of the painting, combined with what little is known, indicate that it was produced for a church somewhere in in Zurbarán's home region of Spanish Extremadura, circa 1640.[21] Whatever the exact circumstances, he certainly put his best effort into it. The depiction is plaintive and restrained, with some very subtle non-biblical details added, but nothing to contradict Luke's account from *Acts*. The apostle kneels at the execution block as if in prayer. Herod Agrippa and his approving Jewish advisors—one looking suspiciously like a Spanish Inquisition official—watch closely as a swordsman prepares to strike while holding the martyr's long hair aside. An angel overhead holds a floral crown in one hand and a symbolic martyr's palm in the other, as royal guardsmen stand in the background, one

of them clutching a distinctively Spanish spiked axe.[22] A marble column in the immediate background symbolizes James as a pillar of the church, or perhaps the Zaragoza pillar on which he was later alleged to have seen his Marian vision. The most interesting detail, however, is the canine head of a saluki to the direct right of the kneeling martyr at eye level, looking on impassively, expectantly.[23] Nature itself is witness to the deed. Likely completed during the ugly apex of the Thirty Years War, Zurbarán's tremendous masterpiece conveys its powerful message with absolute clarity despite minimal reliance on extraneous ornament.[24]

The Martyrdom of Saint James is doubly interesting in that it was produced during an era in which nearly all Zurbarán's contemporaries were painting the apostle as a lone pilgrim or penitent (see Chapter 14).[25] Taken within this historical context, the work comes across as a refreshing exception to then current fashion. Viewers are presented with an episode having nothing to do with the later Spanish Santiago tradition—and yet one that somehow lays at the very heart of it—a biblically-recorded occurrence undisputed even by non–Christians. James' martyrdom dated nearly 16 centuries before Zurbarán's memorable rendering, a time in which the Roman Empire was at its seemingly invincible height while Christianity itself little more than a regional cult within that large empire. Nevertheless, less than four centuries later Iberia would have new de facto rulers, many of whom called themselves Christians, but with a heretical barbarian twist. The Dark Ages had officially begun, and the task of bringing the Visigoths into the fold of the orthodox Roman Catholic faith would fall to those living within their own society. Curiously, it would also be this highly obscure period that saw the first faint signs of Saint James the Greater being personally associated with Iberia by its new masters.

2

Visigoth Iberia
(410–711)

St. Isidore seems to have foreseen that unity of religion and a comprehensive educational system would weld together the heterogeneous elements which threatened to disintegrate his country, and it was mainly thanks to him that Spain was a centre of culture when the rest of Europe seemed to be lapsing into barbarism.—Butler's Lives of the Saints[1]

Modern-day Madrid offers, among countless cultural attractions, an enormous city block-sized complex containing Spain's national library (Biblioteca Nacional de España) and archeological museum (Museo Arqueológico Nacional). Flanking the public entrances to these temples of Iberian learning and ancient heritage are six larger than life, 19th century statues of various Spanish artists, sages, and visionaries, including (among others) Cervantes, Velázquez, and King Alfonso "The Wise" (see Chapter 8). Pride of place, however, is given to Saint Isidore of Seville (560–636), situated at the outside entrance base of the library's grand staircase.[2] The highly visible placement of this particular personage is rather appropriate.[3] Though not a household name outside of Spain, arguably fewer historical figures had more to do with carving out Spain's national identity than Saint Isidore.[4] As noted by the modern editors of *Butler's Lives*, "It was said of St. Isidore by his disciple and friend St. Braulio that he appeared to have been specially raised up by God to stem the current of barbarism and ferocity which everywhere followed the arms of the Goths who had settled in Spain."[5] Appearing at a time and place in which western civilization itself seemed threatened with extinction, a good case can be made that Isidore was its most persistently civilizing influence. Beginning with Isidore, Spain would gradually become a center for learning and later a conduit of learning for the rest of Europe. He is also the first identifiable individual on record, and a rather distinguished one at that, credited

with making a written specific link between Saint James the Greater and the Iberian Peninsula.[6]

Little is known of Isidore's personal background, except that he appears to have hailed from a family of high-ranking Spanish clergy which seemed to move comfortably between the normally opposing spheres of the old Roman nobility and more recent Visigoth conquerors.[7] By age 40, he had succeeded his older brother as Bishop of Seville, a post held for the remainder of his long life. By the end of that life, he had become widely recognized as the greatest educator in all of Iberia. His Latin writings were extensive, and many still survive. Theologically, Isidore is given undisputed credit for leading the ongoing conversion of Visigoth monarchs from Arianism to Catholicism, and hence most of their subjects as well. This was no small accomplishment, given that Rome and Constantinople had failed to make any similar headway with the Gothic Kingdoms during previous centuries. As observed in *Butler's Lives* (see header quote), Isidore achieved this in no small part by expediently advocating religious conformity as a strong unifying factor for an unstable barbarian kingdom showing signs of political disintegration at a relatively early stage. Combined with his respected personal integrity and great learning, all during an era in which both qualities were in very short supply, Isidore's efforts probably helped to preserve the Spanish Visigoth Kingdom much longer than it otherwise would have lasted, and for that matter, longer than many other European monarchies during the Dark Ages. His example also set an interesting precedent on how exactly this might be accomplished, and his positive influence continues to be felt in contemporary 21st century Spanish society.

Isidore's relatively overlooked Latin treatise *De Ortu et Obitu Patrum* ("Birth and Death of the Fathers"), probably composed near the end of his life circa 630, conveniently provides short biographies for leading figures of the early church. These include two brief mentions of Saint James the Greater, both expressly made in connection with his supposed evangelization of Spain. The idea of James having physically been in Iberia fell squarely within an already established tradition of the 12 apostles being each assigned a geographic field of activity after the Pentecost (see Chapter 1). Isidore, however, was the first church authority to expressly acknowledge it; more importantly, his was considered a highly respectable and reliable source of learning. His opinions carried great weight both within and without the institutional church, and it was highly fortunate for the Iberian Santiago cult that it received his early endorsement. Part of the reason that the teachings of the Bishop of Seville were (and remain) so esteemed is that he was known typically not to just make things up, and indeed his repeated reference to "Iacobus Spaniam" was likely drawn from an existing, but far less authoritative source.[8] The best earlier candidate for this tradition was the anonymous *Breviarium*

Apostolorum, dating from perhaps a century earlier and itself tapping into older, less specific Greco-Byzantine sources. Isidore also incorporated from the *Breviarium* the highly ambiguous phrase *acha marmarica* to identify James' burial place, without necessarily insisting this location was in Spain (or anywhere else specifically).[9] The important thing is that by the late sixth or early seventh century, the most prestigious living Doctor of the Roman Catholic faith was publicly associating, however tentatively, the life and acts of Saint James the Greater with the Iberian Peninsula.

This was far from the first instance in which an important historical personage was connected to Spain, or Roman Hispania, as it was known during ancient times. Hispania, though rich in its own prehistoric artifacts, entered the stage of European (and world) affairs during the epic Punic Wars of the third and second centuries BC when it became a regular Carthaginian staging ground for military operations against Rome. The most notable example occurred when the Spanish-trained Carthaginian general Hannibal launched his initially-successful invasion of Italy from Spain via Gaul in 218 BC, which included a numerous contingent of Spanish infantry loyal to Carthage.[10] Later, after the defeat of Carthage and Hispania had been annexed by Rome, its most serious insurrections often came from that same province, particularly the one led by Quintus Sertorius in 80–72 BC. Not long after this in 62 BC, a young and still untested Julius Caesar was given his first major military command in Spain; 17 years later (in 45 BC), Caesar fought his final, victorious battle of the Roman Civil War at Munda in Spain. Later still, during the imperial era, Spain produced some of Rome's most powerful and dominating emperors, including Hadrian, Trajan, and the Galician-born Theodosius. The latter was in fact the last Roman emperor to wield any kind of meaningful authority on a continental scale, before his death in 395 triggered a final period of decline. Overall, it might well be said that Hispania, as the westernmost edge of the Roman Empire, was a constant political-military protagonist and instigator of sweeping change throughout the history of Western Europe. This dynamic role would carry over into the Middle Ages and well beyond. In this sense, Isidore's direct linkage of Hispania with the apostolic tradition represented only one chapter in a very long story.

The Visigoth era in Hispania, though lasting over 300 years, for purposes of this study may be briefly summarized in a few sentences. After an initial period of truce, the Iberian Visigoths gradually gained ascendency over their rival Germanic tribesmen (the Suebi and the Vandals), and by the late sixth century controlled most of the peninsula, except for narrow portions of the Mediterranean coast still held by the Byzantine Empire. By the early seventh century, the Visigoths dominated all of Iberia and most of Gaul as well. Toulouse, France, and Toledo, Spain, became twin Visigoth capital cities located on opposite sides of the Pyrenees. In 589, King Riccared, with encour-

agement from Isidore's older brother, Bishop (and Saint) Leander, became the first Visigoth monarch to publicly renounce Arianism in favor of Catholicism at the Third Council of Toledo. After Isidore succeeded his brother as head of the Spanish church at the turn of the century, he presided over the Fourth Council of Toledo in 633, in which it was established that public education—such as it existed during that time—would be administered by designated cathedral schools, based on the model of Seville, the same institution that had so successfully educated the young Isidore. With Iberian religious and political hegemony, however, soon came severe military decline and internal division, both eventually proving fatal to the Visigoth realm.

At the time of Isidore's death around 636 (three years after the Fourth Council of Toledo), the Iberian Visigoth Kingdom had less than 75 years of survival remaining. Curiously enough, the last great Spanish churchman of the seventh century following Isidore appears to have contradicted him in the matter of Saint James the Greater, at least in terms of James as the assigned evangelist of Hispania. Saint Julian of Toledo (642–690) was the first designated Archbishop of Toledo and, like Isidore before him, a learned and accomplished writer. In Julian's polemical *De Comprobatione Aetatis Sextae* ("Concerning the Sixth Age"), he recites the biblical facts surrounding James the Greater but willfully ignores any aspect of the Spanish connection.[11] The omission is striking. To suggest that Julian was unaware of the newer tradition at this point in history is a highly unlikely scenario, given Isidore's previous authoritative testimony and ongoing circulation of the *Breviarium Apostolorum*.[12] Far more likely (if not certain) is that Julian knew of the Santiago tradition quite well and simply rejected it, or at best, did not feel comfortable endorsing it. There were also likely strong political and religious motivations behind his views. Even by this early stage, Julian's home seat of Toledo—future stronghold of the Spanish Inquisition—had become a dual bastion for both the Roman Catholic faith and Visigoth monarchy. Any religious viewpoints coming from outside of Toledo, good or bad, especially any related to an apostolic figure the stature of James, would have been reflexively viewed as a threat to its civic authority.[13] On top of this, it was probably well known that Julian himself came from a family of Christianized Jews. As such, he would have been constantly compelled to stick to a more conservative line of doctrine, one less tainted by anything perceived as external novelties. This would especially include unnecessary reminders that Christianity was originally an offshoot of Jewish religion, even though that is precisely what it was.[14] Pointedly, however, a mere 21 years after Julian's death, the Visigoths would need all the nationalist zeal they could muster for mere survival (see Chapter 3).

Notwithstanding Julian's silent reticence, it was clear by the turn of the eighth century that the popular notion of Saint James preaching in Spain had

gained a strong foothold, even beyond Spain itself. Far to the north in Saxon-dominated Great Britain, Saint Aldhelm (639–709), Abbot of Malmesbury and later Bishop of Sherborne, fully embraced the tradition, praising James as the first bishop of Spain who evangelized that country, without making any mention of his alleged burial there.[15] Aldhelm, like Isidore before him, was not the type of person to simply regurgitate anything that he had heard. Having been a student of some of the finest Latin scholars then active in the British Isles, the young Aldhelm was steadily promoted within church ranks. By the time he was in his mid–30s, as a newly-appointed abbot, he became the very first in England to adopt the Benedictine Rule, which later during the High Middle Ages would extend its sway across Western Europe with crucial impact on the Santiago pilgrimage customs of Spain (see Chapter 6). Thus, as evidenced by the reliable testimony of Aldhelm, Saint James the Greater seems to have been accepted by church authorities in Great Britain as the original evangelist of Spain, centuries before even the more historically recent King Arthur had become adopted as symbolic hero of England.[16]

Meanwhile, far beyond the Atlantic Ocean to the West, within a New World long yet to be discovered by Europeans, other civilizations were tentatively taking shape. Around the Four Corners Region of the modern day United States, the Ancient Pueblo Peoples, also called the Anasazi (or "Ancient Ones") by their traditional enemies and territorial rivals, the Navajo, were entering the final phase of what later was dubbed by archeologists as the Late Basketweaver Period (c.500–c.750). During this same era, the previously nomadic Pueblos were now beginning to settle down, with far less reliance on hunting and more on agriculture, arts and crafts, tentative building activities, and stationary communal living in general. This was not unlike the manner western civilization had first developed in prehistoric Mesopotamia long before. Unbeknownst to the Pueblo (or the Navajo for that matter), within less than a thousand years from this time the images of Saint James the Greater and Santiago Matamoros would be stamped upon their religious shrines by Spanish conquerors of the Americas. At the turn of the eighth century, however, the Iberian Peninsula was not even Spain; rather, it was a decaying Visigoth Kingdom on the verge of itself being overrun by foreign invaders from other continents. These invaders fervently adhered to an alien religious creed, and in many respects represented a more advanced civilization than the one they were about to dominate. Once cannot help but to be struck by certain ironies. Perhaps the Spanish had to be conquered themselves before conquering others.[17] On the other hand, this transformative process, if in fact there was one, would take another eight centuries to complete its cycle.

Accepting at face value Isidore's matter-of-fact assertion that James had evangelized Spain, without necessarily conceding the saint's final interment

there, one is led directly to one of the more attractive and durable legends attaching to the Santiago cult. According to this beloved tradition, around the year 40 CE, as a tired and discouraged James, accompanied by a meager handful of followers, paused near the Roman city of Caesaraugusta (Zaragoza) along the River Ebro, a vision of the Virgin Mary appeared at the top of stone column to offer encouragement, assuring James that a great Christian nation would one day there arise, and furthermore instructing him to build a chapel upon that exact location. Therefore, according to this legend, James the Greater is credited with the signal honor of receiving the first Marian vision in recorded church history, notwithstanding that Mary was, according to most non-biblical sources, still alive at that point in time. As for documented literary sources for the Marian Pillar of Zaragoza, these reach a dead end before the 12th century (see Chapter 6). On the other hand, while today's magnificent *Catedral-Basílica de Nuestra Señora del Pilar* in Zaragoza dates from the 17th century, evidence shows that this had been a church site since at least the days of Constantine the Great, which in turn suggests it had been a church long before that era as well. It is certainly possible (and impossible to prove otherwise) that Isidore drew cumulative support for the Spanish Santiago mission journey postulated in the *Breviarium Apostolorum* from an extant Marian Pillar tradition at Zaragoza.[18] While the event itself is alleged to have occurred on January 2, the designated church feast day is October 12, the same day that Christopher Columbus later first spotted landfall in the New World from his flagship *Santa María* in 1492, and later still formally becoming the national holiday of Spain (see Chapter 11).

One of the most intriguing sidebars to the history of James the Greater is a minority of modern scholarly opinion, though a fairly respectable one, holding that James and his brother John were biological first cousins to Jesus on their mother's side; hence, under this theory, the Virgin Mary would have been James' maternal aunt.[19] This writer sees nothing in this idea to contradict orthodox Christian teaching; therefore, it might be an interesting possibility to keep in mind, especially given the apparent close rapport between Mary and James in longstanding traditions such as that found in Zaragoza, particularly within the framework of western art history. On the other hand, it might be argued that James was granted the honor of the first Marian vision (as well as that of building the first Marian church) for the same reasons that he eventually became the patron saint for all of Spain, namely, that he was the first of the original 12 apostles to be martyred for his faith. In either event, Our Lady of the Pillar provides yet another convenient and plausible link between James and Spain—one which seems likely to have existed during the Visigoth era—but again, not necessarily allowing Spain as his final place of interment. Although this latter item may well have been in circulation by that time as well, it would take yet another century of dramatic events and

changes on the Iberian Peninsula for the idea to really take hold and receive wider circulation in the popular European consciousness (see Chapter 3).

As one might expect, the *Nuestra Senora Del Pilar* theme has inspired many a memorable work of art over the last millennia and surviving down to the present day. Among Spanish-born painters, arguable the most distinguished to tackle this ethereal subject matter was Francisco de Goya (1746–1828), whose two youthful but splendid works deserve brief mention, although bearing little resemblance to the artist's later, more famous, and far more darker style. Goya's father had reputedly worked as an artisan at the Zaragoza Cathedral during its rebuilding, and his famous son Francisco was later commissioned to paint spectacular frescoes for the dome vaults. Apart from these larger scale works, however, the 23-year-old Goya had produced the first of his two Santiago paintings in 1768–1769, the *Aparición de la Virgen del Pilar a Santiago y a sus discípulos zaragozanosa*, a magnificent exercise in the Rococo style, possibly while in Rome or travelling to Rome. A few years later, after Goya had established himself in Madrid, he returned to the same theme, but with a noticeably different take. His *El apóstol Santiago y sus discípulos adorando a la Virgen del Pilar* (1775–1780) puts far more emphasis on the person of Saint James by enlarging his figure to the forefront while, in contrast, placing a definitely more statuesque, iconic Virgin (and Christ child) on a distant pedestal.[20] It is possible, or at least we would conjecture, that Goya had taken some flak from the church establishment for earlier daring to portray the Virgin in a highly classical, humanist manner, and then wanted to rectify this perceived problem with a more strictly conservative approach.

A full century earlier than Goya, however, another prominent painter having no qualms about utilizing a classicist manner for religious themes, but reportedly paying dearly for it with a lack of church commissions, was the influential French-born artist Nicolas Poussin (1594–1665). Poussin was a near exact contemporary of Francisco de Zurbarán (see Chapter 1), but worked in a completely different environment. By the time he was in his mid–30s, Poussin resided in Rome, where he would remain, except for an unhappy two-year return to France in 1640–1642, as a base of operations for a very long and productive career. Circa 1628–1630, he painted his *Virgin of the Pillar Appearing to St. James the Greater*, today the property of the Louvre Museum in Paris. The work is a tour de force of Baroque mastery, executed during the culmination of the Counter-Reformation era and early stages of the Thirty Years War in Europe. It also represents a culmination of sorts for Poussin's early period as a painter, a period in which he at one point fell seriously ill, recovered, and met his future wife-to-be in the process. In the immediate wake of his grisly *Martyrdom of St. Erasmus* (1628), Poussin probably realized that official church commissions would be scarce in coming thereafter, and earned his living mainly through the distinguished private patron-

age of Cardinal Francesco Barberini, along with Barberini's sophisticated and discerning secretary, Cassiano dal Pozzo. For the Barberini circle in Rome, Poussin produced a dazzling series of works delving into both sacred and secular subject matter, oftentimes blurring the lines between these supposedly separate categories, all exhibiting his bracing style and highly accomplished manner.[21]

This kind of sacred-secular boundary crossing had in fact been a notable feature of western art since at least the Renaissance era, and early 17th century artists like Poussin could occasionally take it to new, almost ecstatic extremes. His *Virgin of the Pillar* provides one such example. Poussin, despite his Catholicism, and like many of the artists and writers surrounding the circle of Cardinal Barberini, was also steeped in the sensual, sometimes profane, pagan world of Ovid's *Metamorphoses*. His reposed Virgin, cradling the infant Jesus, appears much like one of Poussin's classical goddesses, complete with supporting cherubim, while James could be easily mistaken for one of his rustic shepherds or smitten lovers of ancient times.[22] The missionary saint is surrounded by a small but intrepid band of followers, all overwhelmed to varying degrees by the vision beheld. A serene Mary directs James to continue his efforts and to build her a church, with outstretched hand and pointing gesture reminiscent of Michelangelo's God creating Adam on the ceiling of the Sistine Chapel. James, overcome with emotion, hand on heart, intimately contemplates the Virgin and child Jesus almost at point blank range. A cowering disciple at James' feet recalls Raphael's earlier depiction of James himself during Christ's Transfiguration.[23] A feeling of swirling transformation or metamorphosis predominates. The young Francisco Goya, also journeying to Rome over a century later, may well have taken his inspiration from Poussin for his very first assay into the same subject matter. In any event, all subsequent depictions of the Marian pillar vision after Poussin appear stilted and tame by comparison.

Returning to the seventh century, by the time of Isidore's death in 636, another notable passing had occurred not long before in the year 632, located thousands of miles away in the Arabian city of Medina. There, the Prophet Mohammad left behind a religious and cultural legacy that would soon enough leave its indelible stamp on civilization, including the Iberian Peninsula. With the death of King Recceswinth in 672, the last of the strong Visigoth monarchs had passed, and the rest of the century would be marked by civil strife, discord, and decline. Meanwhile, irresistible Islamic armies of the Umayyad Caliphate swept aside most of the decaying Byzantine Empire in the Middle East, North Africa, and beyond. To the shock of all Christendom, Jerusalem fell in 638. Not long after this in 674–678, a prolonged, all-out siege of Constantinople by the Umayyads was lifted only by the recent Greek invention and intensive, horrific use of naval flame throwers. It seemed a

terrible and rather artificial way to preserve what little was left of the old Eastern Roman establishment. Otherwise, Islam was triumphant everywhere it opted to plant its standards. In hindsight, it was easy to see what was about to transpire, as Umayyad forces launched probing raids into southern Iberia from North Africa opposite Gibraltar during the latter part of the century. As Visigoth nobility quarreled amongst themselves for petty power and prestige, European history was about to undergo a major turning point. Nevertheless, with this unexpected shift would also come countless other unexpected results, setting the stage for even greater changes in the following centuries and beyond.

3

Asturian Uprising
(711–813)

And now I saw heaven open, and a white horse appear; its rider was called Trustworthy and True; in uprightness he judges and makes war. His eyes were flames of fire, and he was crowned with many coronets; the name written on him was known only to himself, his cloak was soaked in blood. He is known by the name, The Word of God. Behind him, dressed in linen of dazzling white, rode the armies of heaven on white horses. From his mouth came a sharp sword with which to strike the unbelievers; he is the one who will rule them with an iron scepter, and tread out the wine of Almighty God's fierce retribution. On his cloak and on his thigh a name was written: King of kings and Lord of lords.— Revelation 19:11–16[1]

In 711 world history reached a major turning point, although for precise reasons that admittedly escape this observer, these events tend to be given far less than adequate coverage by English-speaking historians or (for that matter) by most anyone outside of Spain. One notable exception was that oft-quoted sage of the British Enlightenment, Edward Gibbon, who acknowledging the enormity of this period, devoted several pages of eloquent commentary to it.[2] For purposes of this modest study, however, let it suffice to say that the Islamic occupation of Iberia, excepting a few short pauses, represented no fewer than 781 years of relentless, non-stop peninsula warfare, usually driven by religious fanaticism, and all taking place within the narrow confines of Europe's very own back yard. By stark comparison, the Crusader Kingdom of Jerusalem continues to be highly popular subject matter that is well chronicled, though it only existed temporally on another distant continent (Asia), concurrent with the approximate middle point of the epic Iberian struggle. The doomed Crusader Kingdom lasted a mere 88 years, not including

another 83 years of subsequent and futile European attempts at recovery after its sudden and decisive demise in the year 1187. While both the Crusades and Spanish *Reconquista* permanently impacted all aspects of European culture and thought, the shear longevity, complexity, and scope of the latter, not to mention the countless ripple effects on world history which followed—and are still being felt today—would seemingly justify far more coverage than what is otherwise customary, if nothing else here within the limited topicality of western European art.

For those requiring a brief overview, after decades of probing military excursions, in 711 a highly trained Umayyad expeditionary force from North Africa under the intrepid, determined leadership of Berber general Tāriq ibn Ziyad, crossed over the Straits of Gibraltar into European Spain.[3] The very name of Gibraltar is indeed derived from a Spanish bowdlerization of the Arabic *Jabal Tārik* ("Mountain of Tāriq").[4] Shortly thereafter a furious battle was fought near Cádiz along the Río Guadalete, in which an overconfident Visigoth host under its unpopular monarch Roderic were catastrophically defeated by the invaders. The king, many of the nobility, and a large portion of the Visigoth army were slain. Prepared for expected success as usual, the Umayyads then overran most of the Iberian Peninsula within a matter a months, including the capital city of Toledo. Sephardic Jews, harshly persecuted by Christians for centuries, tended to favor the new Islamic rule because of much greater tolerance shown towards them. To their further surprise, Christians were allowed religious freedom within boundaries, and to keep much of their property, so long as they paid taxes. Given the widespread unpopularity of recent Visigoth kings, most acquiesced to the new regime with shocking readiness.[5] Those who did not acquiesce fled into the northern mountains to live as outlaws in poverty and isolation. The once mighty Visigoth kingdom, which two centuries before had helped to bring down the Western Roman Empire, was extinguished virtually overnight. It all happened so quickly that many Iberian natives remained psychologically traumatized for decades to come. Christian North Africa had experienced a similar disaster during the previous century, but unlike North Africa, Iberia would soon exhibit staunch resistance to its new overlords.

Among specialized historians of that particular time and place, there is disagreement as to exactly when this organized resistance began; however, all agree that it started in the remote north central region of Asturias sometime during the early eighth century. According to ninth century Latin Christian sources, perhaps as early as 718–719 (only 7–8 years after the Muslim conquest), Islamic efforts to put down an isolated revolt in Asturias met with their first major setback at an obscure place known as Covadonga (northeast of León). There a rebel force led by the Visigoth nobleman Pelagius (685?–737) won an important victory against the attempted police action, killing

the Umayyad leader and capturing a bishop sent to persuade his fellow Christians to surrender.[6] Subsequently, Pelagius was proclaimed king of Asturias, and thereafter was known as Pelayo, founder of a long line of Spanish monarchs running unbroken into modern times.[7] Islamic sources are less complimentary. The great Moroccan-born historian, Ahmed Mohammed al-Maqqari (1578?–1632), quoting earlier Arabic chronicles, referred to Pelayo's stubborn band as "30 wild donkeys" who were in fact defeated but not properly pursued afterwards.[8] Covadonga is not mentioned; al-Maqqari's sources portray the episode merely as an Umayyad failure to thoroughly mop up opposition. All sources, however, agree on some fundamental facts, namely, that Pelayo's group was ultimately successful in their resistance to Islamic authority, he was afterwards proclaimed king, the resistance quickly grew in numbers, and for the occupiers it represented the beginning of what later became a serious, irreversible, and fatal problem.

It is also true that by the 720s, the Umayyad Caliphate had their sights set on, and mainly devoted their resources to, much bigger objectives. Temporarily ignoring the Asturian brushfire now smoldering to the northwest, Islamic armies began in earnest by 720 to cross over the Pyrenees into Gaul. The Visigoths of Gaul had long been supplanted by a yet new wave of Germanic invaders, the Franks, who firmly held modern day France with a very loose but militant federation of independent kingdoms. After some initial skirmishing, all of southwestern Gaul collapsed to the Islamic invaders, and north central Gaul became the new front line of operations. By then the Umayyads consisted of a large veteran host led by one of their very best field commanders, Abdul Rahman al-Ghafiqi. Surviving Franks rallied around Charles, titled Mayor of the Palace and later surnamed Martel ("Hammer"), who though not a king himself, had by far their most successful track record for military leadership.[9] In 732, one of the most famous land battles in world history was fought in the French plains between Tours and Poitiers.[10] After a week of maneuvering and skirmishing, the invading Umayyad force was utterly defeated and Abdul Rahman killed in action. The dramatic Christian victory had nothing to do with Saint James the Greater, but rather the venerated Saint Martin of Tours, whose nearby shrine was being protected, along with the peerless generalship of Charles and the disciplined valor of his infantry. Though southern France would remain a scene of action between Christian and Islamic armies for some time to come, the Umayyads were gradually forced to retreat back across the Pyrenees. They had never previously known defeat in a fully pitched land battle, and their all-out invasion of Western Europe was permanently repulsed. Tours also marked the beginning of a very long and very complicated relationship between the French and the Spanish, one continuing through the medieval period and well beyond.

The next hundred years or more would be characterized by nearly non-

stop warfare along the Spanish border between the victorious Franks of the
Carolingian dynasty and the Umayyad Caliphate of Córdoba.[11] This early
period marked the first historical phase of the *Reconquista*, and it proved to
be a highly fortunate thing both for the fledgling rebel Kingdom of Asturias
and the Santiago cult then barely in its embryonic stage. During the mid–
8th century, after Pelayo's modest and isolated victory at Covadonga, the
Asturians would be little more than a loose association of defiant Visigoth
noblemen, constantly feuding amongst themselves after having somehow
managed thus far, against all odds, to avoid Islamic authority. They could
have easily been snuffed out by a focused, concerted effort, had the Umayyads
not been heavily preoccupied at the time with the Franks. The concentrated
efforts of Martel (c.686–741), his son King Pepin (c.714–768), and grandson
Charlemagne (c.742–814) to throw the Umayyads into a permanent defensive
posture behind the Pyrenees allowed two critical things to happen, thus
allowing the Santiago tradition as we know it today to fully take shape.[12] First,
it allowed the young Kingdom of Asturias to mature and eventually coalesce
around the strong leadership of an outstanding monarch. Secondly, as we
shall see below, it also ensured safe haven within Asturias for the most impor-
tant Spanish churchman of the century, one who, in the estimation of some
scholars, would do more than any other to perpetuate Spain's association
with Saint James the Greater.

Surely the most far-reaching incident of this complicated period in
Spanish-Franco history occurred in 778 along the Roncevaux Pass in the
Pyrenees Mountains east of Pamplona. Here the rearguard of Charlemagne's
army, returning to France from one of its many Spanish expeditions, was
ambushed and annihilated. It was the only military defeat ever suffered by
Charlemagne during a long career of military campaigning, one extending
over half a century and across most of Western Europe. Among the French
slain were a number of noblemen, including one Hruodland, better known
in later times as Orlando or Roland. This incident was later romanticized in
12th century French literature as *Le Chanson de Roland* ("The Song of
Roland"), during the same golden age in which King Arthur, El Cid, and San-
tiago Matamoros were all becoming the stuff of medieval legend (see Chapter
6). French romancers had the heroic Roland treacherously surprised and
killed by Muslim occupiers of Iberia. The problem with this inspirational
tale is that it went directly against well-documented historical fact. Charle-
magne's rearguard was in fact ambushed and wiped out by Basque moun-
taineers, apparently angered at the manner in which the French army had
recently behaved at nearby Pamplona, but also generally hostile towards any
outside invasion force not originating from Basque country. To this day, a
lively argument continues between the Basques and the French as to whether
the historical Roland was a hero or a rapist.[13] It should also be re-emphasized

that during this early stage of the *Reconquista*, the Santiago cult had yet to fully take shape, although by then it was widely believed that the apostle had indeed once preached in Spain. Moreover, the Roncevaux incident underscores that, notwithstanding the recent Islamic conquest or Charlemagne's growing continental authority, the independent Iberians of that period were far from ceding sovereignty to any foreign power, whether that power be Christian or non–Christian.

Around the same period that Umayyad armies began suffering serious and repeated reversals in France, a young Christian monk was coming of age in the isolated, mountainous regions of Asturias. Almost nothing is known of the life of (Saint) Beatus of Liébana (730?–800?), except that by the 770s he had become personal confessor to Queen Adosinda of Asturias, wife of King Silo, and granddaughter of King Pelayo. Beatus appears to have been that rarest of combinations, a genuine country rustic but also possessing a deep scholarly and intellectual bent. Around 776 he authored the lengthy work for which he will always be remembered, the *Commentary on the Apocalypse*, one of the most famous illuminated manuscripts produced during the Dark Ages. Utilizing the biblical *Revelation* of John as a starting point, Beatus proceeds to sternly criticize—not the Islamic invaders to whom he makes only passing references—but rather Christian heretics and hypocrites appearing to collaborate with the foreign occupiers.[14] This was not too surprising a message emanating from independent Asturias. What did surprise is that the rebukes of Beatus were clearly aimed at the official Spanish Roman Catholic church then headquartered in Islamic-occupied Toledo. The earnest vehemence expressed by Beatus against church officials was the first overt sign that Christian political power in Spain was shifting at least temporarily to the north. On the surface, Beatus condemned what later became known as the Adoptionist heresy then prevalent in Toledo, the theological aspects of which are well beyond the scope of this study; however, the deeper implications of the literate holy man from the north were quite clear as well. For Beatus, traditional Christian teachings and ideals were being compromised, and these compromises might well represent a precursor to the biblical Doomsday of *Revelation*. Among many other things, Beatus strongly advocated Spanish Catholic nationalism and staunchly endorsed the tradition of Saint James the Greater as having once preached in Spain, thus presenting himself as a follower of the venerated Saint Isidore of Seville (see Chapter 2).[15] Eminent modern Spanish scholars such as Claudio Sánchez-Albornoz y Menduiña have gone so far as to suggest that the Santiago cult really began in earnest with the eighth century *Commentary* of Beatus.[16]

In the immediate aftermath of Beatus' fiery admonitions came a talented Asturian monarch possessing a shrewd sense of international affairs, although like Beatus, there is a frustrating scarcity of available information about his

life and reign. King Alfonso II *El Casto* ("the Chaste") assumed the precarious throne of Asturias in 791 after his predecessor, Bermudo I, hastily abdicated in wake of alarming military defeat against Umayyad forces at the Battle of Río Burbia in Galicia that same year. Alfonso the Chaste (760?–842) was the great grandson of King Pelayo, the grandson of King Alfonso I *el Católico* ("the Catholic"), the son of King Fruela I *el Cruel* ("the Cruel"), and the nephew of Beatus' patroness, Queen Adosinda.[17] Upon reaching majority age in 781, he was proclaimed king by the ministers of Adosinda but then immediately rejected by the incessantly feuding nobility of Asturias, forcing him into early retirement. Ten years later, terrified by recent Islamic successes in the field, the same nobility invited him back. Alfonso proceeded to reign ably for the next 51 years. His nickname came from his reputation for being faithful to his wife, an unusual male trait of that era. After securing the Asturian kingdom against pressing external and internal threats, Alfonso's most spectacular achievements transpired during the latter part of his reign, particularly with reference to Saint James the Greater (see Chapter 4). Realizing that the Kingdom of Asturias owed its continuing existence to the Carolingian Franks of Gaul, Alfonso made every overture possible to secure an alliance. His goals were realized in 796–798 when both Charlemagne and Pope Leo III officially recognized Asturias as a legitimate, independent monarchy.[18] The Umayyad Caliphate of Córdoba now had a serious situation on their hands, less than 80 years after its lightening conquest of Iberia, and one from which it would never fully recover.

As the eventful eighth century drew to a close, manuscripts of the Beatus *Commentary* began circulating through Iberia and probably beyond as well. Of those which have survived, some 26 are illuminated, and these rare documents taken as a whole constitute one of the greatest treasure troves of medieval art still in existence. Today the Beatus illuminated manuscripts are housed and curated by some of the world's finest libraries and museums. Though neither the oldest nor most extensive of these, the so-called Silos Apocalypse is as famous as any because of its spectacular illuminations, and is currently owned by the British Library in London. Nicknamed after its reputed place of origin, the monastery of Santo Domingo de Silos near Burgos in north central Spain, the Silos Apocalypse is dated with unusual precision to the years 1091–1109, over three centuries after the dating of the original text by Beatus in 776. This late 11th and early 12th century period roughly coincided with the time of El Cid and the First Crusade (see Chapter 6), an era in which the idea of an Iberian *Reconquista* was gaining considerable headway in the popular imagination.[19] As such, it gives useful insight into the psychology of Christian Europe from that epoch via the visual arts.

Among surviving copies of the Beatus *Commentary*, the Silos Apocalypse is unusual in other respects as well. In addition to precise dating (April

18, 1091, through July 1, 1109), we know the names of the individual monks who copied and illustrated the manuscript (Munnio and Dominico). Among its spectacular, beautiful illuminations are included the earliest pseudo-maps of the world, at least as these were understood by the medieval mind. Lastly, the more modern history of the Silos is fascinating in and of itself. The British Library acquired the treasure by purchase in 1840 from the self-styled Count Survilliers, i.e., Joseph Bonaparte (1768–1844), older brother of Napoleon, then living in safe and relative obscurity wherever he could find sanctuary.[20] By this point in time, Joseph Bonaparte had long been deposed as the highly unpopular and short-lived monarch of French-occupied Spain, but he also appears to have looted some valuable Spanish literary heritage while escaping from the country circa 1813.[21] In effect, early 19th century Spain had one of its greatest artistic and cultural legacies purchased by a former ally (England) from a former enemy (Joseph Bonaparte), the latter possibly selling low under heavy duress. The good news is that the Silos Apocalypse currently now appears to be in very capable and competent hands.

One could easily write an entire volume on the prodigious wealth of illuminated art found within extant Beatus *Commentary* manuscripts. Within these pages we will confine ourselves to only a few of these, including a series found in the Silo Apocalypse. Stylistically, the Beatus illuminations are often characterized as Mozarabic (or Arabized Christian), but the text was in fact originally inspired as an admonition directed against the perceived heresies and compromises of Arabized Christians centered in Toledo and other parts of Islamic-controlled Iberia. More precisely, the text and illustrations criticize Mozarabic theologies while adopting Mozarabic artistic styles. Equestrian images throughout the manuscripts are particularly striking, given Iberia's characteristic reliance upon horsemanship both in times of war and peace. Nor is this unexpected since much of that horsemanship, along with the horses, were imported from the Middle East where, centuries before, the *Revelation* of John had been written and itself made generous use of equestrian images in its literary text.[22] Above all, it is striking that images of these holy (or not so holy) warriors on horseback appear to long predate any depictions or textual mention of Saint James the Greater on horseback fighting in the cause of the Spanish *Reconquista* (see Chapter 6). Some of the surviving illuminations of the Beatus *Commentary* date from as early as the 10th century; therefore, it is reasonable to suppose that there may have been older ones that have not survived.

Depicting a *Revelation* in which heavenly warriors are unleashed against the forces of earthly evil (see header quote), the Silos Apocalypse includes one of the more unusual illuminated images of its kind. A heavenly White Rider ("Trustworthy and True"), often interpreted as a militantly resurrected Christ figure, is pictured in six sequential frames on the same page. The repetitive

effect is almost cinematic, worthy of a 20th century Andy Warhol silk-screen print, even though this was a thousand years before the 1960s or the invention of film. These repetitive images might also represent the "armies of heaven" following in the irresistible wake of the White Rider—it is hard to be certain. More certain is that the illumination may easily be viewed as a harbinger (or offshoot?) of the Santiago Matamoros tradition in which a resurrected Saint James leads Spanish Christians into battle astride a supernatural white mount. One may also see striking similarities to later images of Santiago Matamoros. For example, the depiction of a mounted Santiago from the Codex Calixtinus of Salamanca (c. 1325) shows the saint galloping into battle with sword and banner held high (see Introduction), but otherwise bearing notable similarities to the White Rider of the Silos Apocalypse.[23] His posture is erect and countenance serene. Body armor is minimal. The saint wears a halo rather than crown, and a starry sky is replaced by his emblematic scallop shells. There are no corpses at his feet. Whether the artist of the Salamanca Codex had seen the earlier Silo Apocalypse is unknown; however, similarities are notable despite separation in time.

Among the Beatus Apocalypses, however, none is more renowned than the Girona Beatus, named after the Girona Cathedral in Catalonia, its current custodian. Completion of the manuscript is precisely dated at July 6, 975, making it one of the earliest surviving illuminations of its type. More unusual still is that the artists of this generously illustrated work signed their names, "Ende, woman painter and servant of God and Emeterius, monk and presbyter." Ende, of whom nothing is known except for the spectacular visual evidence in the manuscript, is one of the few female artists from the Middle Ages whose name has come down to us. The Girona Beatus was likely produced at the now-ruined monastery of Tábara, southeast of Galicia and northeast of Portugal. During the late 10th century, as many believed that a millennial Doomsday was rapidly approaching, Tábara would have been viewed as a frontier town, or possibly a contested no man's land. Its mostly Christian inhabitants would have lived a precarious existence, likely counting each day of life given as a blessing. One of many illuminations unique to this manuscript is a two-page portrait of 12 standing apostles, most of whom are specifically designated by their name coupled with the geographic region (of then known civilization) where they were alleged to have preached. Fourth from the left is "Iacobus" (James), under which is written "Spania." Thus the Girona Beatus presents striking visual evidence that, by the end of the first millennium, Saint James the Greater had become, for all practical purposes, the patron saint and protector of Spain. Moreover, this development had clearly begun in earnest sometime during the aftermath of the Islamic conquest, and Beatus of Liébana was likely its greatest exponent.

Certainly the most unusual image from the Girona Beatus, one presum-

ably created by the illuminator Ende, is generally known as the Islamic Rider, found near the front of the manuscript near quotations from *Revelation*, but with no obvious connections to the text. The large color illustration depicts a light cavalryman, unmistakably Islamic in attire and mount, in the style of *à la jinete* ("hit and run") tactics which dominated Iberian warfare for both sides in the conflict (see Chapter 6). The Rider appears to slay a monstrous serpent with his outreaching spear. Scholarly interpretation of this surprising image, as one might expect, has been highly divided and far from definitive.[24] We will venture one possibility herein. Since Beatus was primarily concerned with the evils of Christian heresy, as opposed to those of infidel invasion, the Islamic Rider may well symbolize an allowed chastisement of heretical Christians (the serpent) then centered in Toledo and to the south, in contrast to the true believers of Asturias and the free north. Obviously, this is not an illustration of Santiago Matamoros, nor are any such to be found within the pages of surviving Apocalypses; however, the Islamic Rider of Girona may well represent an interesting counterpoint, one in which divine will or retribution is administered by one of the ubiquitous mounted warriors (like Santiago Matamoros) so dominant during that time and place in history.

As the eventful eighth century came to a close, an uncertain ninth century began. The Iberian Peninsula appeared to be poised on the cusp of some great change, as indeed subsequent events proved it to be. A century after the old Visigoth kingdom had been obliterated—seemingly within the blink of an eye—its Umayyad conquerors still controlled an impressive majority of its former territories and peoples, and would continue to do so for centuries to come. To the northwest, however, a new upstart kingdom had suddenly arisen, to be led for the first 42 years of the new century by a talented, creative monarch, Alfonso II, one seemingly unfettered by old conventions and free to reinvent all things anew. Moreover, his subjects had a brand new identity; they no longer called themselves Visigoths, but rather Asturians, Galicians, and Leónese. They were a people formidable in the arts of mountain warfare and stubborn defense of their own borders, now firmly aligned with the most powerful Christian nation in the western world, the Holy Roman Empire of the Charlemagne and the Carolingian Franks. In many respects, this tremendous sea change had been embodied by Beatus of Liébana, whose theological, political, and literary legacies left their impressive mark on the young king and many of his subjects. The next phase of this long developmental period, quite logical in hindsight, would be creation of a Christian symbol, a rallying focal point conveniently serving to further unite a fledgling realm constantly threatened both by internal divisions and a neighboring, more civilized external power. By the early 800s, the moment had finally arrived for Saint James the Greater to take front and center stage.

4

Beginnings of a New Cult
(813–935)

They then made the sign of the cross over the bulls, which suddenly became gentle and submitted to the yoke. Next they put Saint James' body, with the rock upon which they had laid it, on the wagon. The oxen, with no one guiding them, hauled the body into the middle of Lupa's palace. This was enough for the queen. Recovering from her astonishment, she believed and became a Christian, granted everything the disciples asked for, gave her palace to be a church dedicated to Saint James, endowed it magnificently, and spent the rest of her life doing good works.—Jacobus de Voragine[1]

With the death of the Holy Roman Emperor Charlemagne in January of 814, western civilization seemed on the verge of yet another shift. Although the military prowess of the Carolingian Franks had preserved Europe from foreign invasion in the eighth century, something novel was by then clearly developing in remote northwest Iberia. Against all odds, the tiny Kingdom of Asturias had become a viable political entity, recognized by the rest of Europe as a bastion of hope for Christendom among all former outposts far beyond Rome and Constantinople, outposts otherwise swept away by recent Islamic ascendency. In the eyes of religious fanatics such as Beatus of Liébana, Asturias had succeeded where the rest of Iberia, North Africa, and the Holy Land had failed: it remained stubbornly independent of infidel rule. Curiously, the Umayyad Caliphate of Córdoba was by then largely independent as well, having been ousted from Damascus the previous century by the insurgent Abbasids. While foes with their Christian neighbors to the north, the Umayyads were now free to forge their own uniquely Iberian identity, one that would strongly influence Spanish culture straight into the modern era. While this was happening, however, a stunning transformation was taking place within Asturias, although the origins of this metamorphosis had in fact

been percolating since at least before the time of Saint Isidore (see Chapter 2).

According to later surviving sources (the 12th century *Historia Compostelana*), sometime around the years 813–814, the burial site and relics of Saint James the Greater were discovered in Ira Flavia (modern day Padrón), along the Atlantic coastal region of Galicia.[2] This revelation was reportedly inspired by the visions of a local monk fortuitously named Pelayo, not to be confused with the Asturian king successfully rebelling against the Umayyad Caliphate about a hundred years earlier (see Chapter 3). Word of the momentous find spread like wildfire, first to the Galician bishop Theodomor, then to King Alfonso II, and finally to a no doubt startled but apparently pleased Pope Leo III. Its legitimacy was quickly ratified by all authorities. The discovery centered around an ancient Christian burial site concealed in a wood and long forgotten after the barbarian invasions of Iberia 400 years previous. The site itself came to be known by the name of Compostela. One suggested (and quite plausible) origin of the place name derived from the Latin *Campus Stellae*, or field of stars.[3] Soon afterwards, the newly-identified relics were relocated to a more accessible site, around which a great shrine proceeded to gradually develop. The nickname of Compostela, however, appropriately stuck. According to longstanding tradition of which there is no good reason to doubt, King Alfonso the Chaste was the first personage to make a religious pilgrimage to Santiago de Compostela from the Asturian coastal capital of Oviedo, along a daunting, mountainous route later dubbed the Camino Primitivo.[4]

Alfonso the Chaste had no biological heirs, but he had produced perhaps the greatest political brainchild in the history of Western Europe. By officially endorsing Galicia as the final resting place for one of the 12 original apostles—one of the four greatest apostles, for that matter—he instantly put Galician Iberia on the map among the world's most important religious shrines. In this, as in so many other things, Alfonso showed shrewd judgment and foresight. After having saved the young Asturian monarchy during the precarious early stages of his reign, he effectively created a potent unifying symbol for all of Christendom west of the Pyrenees and beyond. It represented a logical extension and dramatic culmination for everything that Beatus of Liébana had been advocating in Asturias only a generation earlier.[5] By the mid–ninth century, distant French writers such as Florus of Lyon and Usuard of Saint-Germain-des-Près were both making excited references to the relics of Saint James the Greater discovered at Iria Flavia. This was still an age in which writing and literacy were unusual. Public imagination had obviously been captured. Other budding nation-states in Europe took careful note of the enthusiasm. In 828, only 14 years after the monk Pelayo had his starry vision at Compostela, the Venetian Republic claimed to have stolen or rescued

the relics of Saint Mark the Evangelist from Alexandria in Islamic-controlled Egypt and brought these back to Venice for permanent safekeeping, becoming the very symbol of the city-state itself. Between Venice and Santiago, Catholic Rome now boasted powerful twin pillars of holy shrines located along the eastern and western frontiers of its authority.[6] By this time, other great kingdoms, even those within Christian Europe, no doubt looked on in amazement, as well as considerable envy.

Back in Galicia, King Alfonso had a modest chapel built over the newly-consecrated shrine, and then a few years later (around 829), the first church proper constructed on the same location.[7] Thus inaugurated was the ongoing and ever evolving industry of tourist pilgrimage to the destination now world famous as Santiago de Compostela. After making considerable allowances, however, for imprecisions in early ninth century archeology, there were still a number of vexing questions attached to the sensational news coming out of Iria Flavia.[8] One of these, perhaps the most troubling of all, was that absolutely no one before the humble monk Pelayo, not even the formidable Beatus, had expressly claimed that James the Greater had been buried in Spain, or at least had not done so in writing. Many others maintained that James preached in Spain and originally founded the Spanish church, but the idea that his relics had been transported there from Palestine appears to have been a somewhat more recent innovation, or perhaps an idea gradually gaining popular currency after the saint's physical presence in Spain became more widely accepted.[9] In any event, easily overcoming scholarly hesitation was powerful incentive that Asturians were now fanatically defending their young kingdom against infidel invaders.

Yet another question of doubt, one gaining some acceptance in modern times, is that the Christian relics discovered at Iria Flavia were in fact those of someone else. By far the most infamous among these alternative candidates was the accused, condemned and executed heretic bishop, Priscillian, whose remains are well documented to have been returned to his native Galicia during the late fourth century, albeit to an indeterminate location (see Chapter 1). As more than one mischievous commentator has noted, the ancient Christian remains discovered by Pelayo and possibly today resting at Santiago de Compostela may in fact be those of Priscillian rather than Saint James the Greater. For purposes of popular veneration, however, none of these doubts mattered. By the early ninth century, the once locally venerated memory of Priscillian was long forgotten. Waves of Germanic and Islamic invasions had partially seen to that, as had the fall of Western Roman Empire. What now mattered most was that a very big idea's time had firmly arrived in Christian Iberia, thanks in no small part to the creative political genius of Alfonso. People believed what they wanted to believe and ran with it. If subsequent chronicles are to be half believed, this religious faith yielded tangible and

nearly instantaneous social, economic, and military results, the repercussions of which would be felt for centuries to come across several oceans and continents.

While the relics of Saint James uncovered at Compostela may or may not have been authentic, the first major outgrowth of the discovery, as recorded centuries later, was most certainly a mythical one. According to the notoriously forged 12th century Diploma of Ramiro I (see Chapter 6), in the year of 834 Christian armies under that same Asturian monarch allegedly won a tremendous long shot victory over Islamic forces at the so-called battle of Clavijo in far northeastern Spain. More importantly, at the moment in which Christian defeat seemed certain, it was reported that an overwhelming apparition of Saint James the Greater on white horseback appeared, like something out of the biblical *Revelation*, to rally and lead the Asturian army back to the offensive and ultimate triumph. Thus was born the irresistible, and by definition, bloodthirsty image of *Santiago Matamoros*, or Saint James the Moor-slayer. As previously noted, however, these events did not in fact occur, or at least not as originally written down. Even religiously devout Spanish scholars otherwise accepting that Saint James preached in Spain, was buried in Spain, and possibly later appeared posthumously at the head of Spanish armies, are usually quick to concede this. Multiple problems begin with dating. In 834, Ramiro I was not the king of Asturias but rather Alfonso II, who was still very much alive and would continue to rule until his death in 842. Moreover, there is no record of Alfonso or anyone else ever fighting such a battle at such a place. At first, this discrepancy was simply corrected by moving the date forward to 844, by which time Ramiro had indeed become the king of Asturias. Then, however, a second major problem comes into play, namely, that there is still absolutely no contemporary or near contemporary record, Christian, Islamic or otherwise, of Ramiro or any other leader ever having fought at Clavijo, let alone reporting the supernatural elements attaching to much later accounts. It also appears that in 844, Ramiro was busy fending off Viking invaders at the other end of the Iberian Peninsula. In short, the Battle of Clavijo must be viewed purely as a legend by the standard disciplines of historical methodology.[10]

The good news for Spanish nationalism is that a fairly well documented battle with numerous similarities to Clavijo did occur a few decades later in 859, when the Asturians under King Ordoño I, along with their Basque allies, dealt a crushing defeat to an Islamic army under the command of Musa ibn Musa, until then the most successful warlord of that era, at the Battle of Monte Laturce in Aragón. Following recent successes against marauding Franks, Musa ordered the geographic high point of the region (Monte Laturce) to be fortified, only to find his construction project then daringly besieged by Asturian and Basque mobile forces.[11] Attempting to raise the

siege, Musa suddenly found himself counterattacked and routed by the Iberian Christians. By any measure it was a great victory and prestige builder for the Asturians, which seemed to shift military momentum in northern Iberia for the remainder of the ninth century.[12] Although there was no mention of Santiago Matamoros in surviving accounts, notable elements of Monte Laturce were later incorporated into the fictional Battle of Clavijo, as well summarized by the imminent 20th century Spanish historian Claudio Sánchez-Albornoz.[13] There can be no denying that a military surge by Iberian Christians took place around this time. Then in 866, Alfonso III (848–910), nicknamed *El Grande* ("The Great"), assumed the throne of Asturias. Within the space of five years, much of northern Portugal was reclaimed by the Asturians, setting off alarms both for the Caliphate of Córdoba and for Christian Portuguese nationalists, the latter group even at this early stage beginning to form their own separate identity.[14] For that matter, it might well be argued that the late ninth century saw the birth of the notorious Conquistador mentality, although the New World would have to wait yet another five centuries to be discovered.[15]

Immediate Islamic response to the new Christian offensive was fitful but consequential. Among these aftershocks, perhaps the most significant occurred sometime during the late ninth century when Muhammad I of Córdoba (823–886) ordered that a prominent site along the banks of the Manzanares River, about 70 kilometers north of Toledo, be fortified as a defensive buffer and staging area against the Christian threat now posed from both Asturias and Portugal. Although the location had been a human settlement since prehistoric times, it was the Umayyads who first put it officially on the map, and their place name for it ("Magerit") appears to have been a bowdlerization of more indigenous references. The new fortress eventually became known to Iberian Christians as Madrid. It was destined to become the third largest capital city in Western Europe. As for Toledo, stronger efforts from Córdoba to protect it only seemed to feed internal rebellion against Córdoba. Chaotic records and chronicles from the period suggest that Muhammad I spent just as much time suppressing insurrections from his own Islamic vassals in Toledo as he did trying to contain Christian gains to the north and west. Although he succeeded in doing this, the groundwork had been effectively laid for the gradual loss of central Spain to the Reconquista over the next two centuries, as well as a perceptible shift away from Córdoba as the center of Islamic political power.[16] Accordingly, the first immediate impact of the newborn Santiago shrine was to throw the Umayyad Caliphate into a divided and defensive posture.

The second immediate impact of the Santiago shrine was to generate a wave of prosperity for Asturias, which also bred their own internal division and strife. After having achieved territorial gains unimaginable to his

Asturian predecessors, Alfonso the Great gave thanks for his good fortune by building an enlarged church edifice over the Compostela shrine towards the end of the ninth century.[17] This church, however, was destined to exist less than a century before it would be erased by a furious Islamic raid into Galicia (see Chapter 5). More immediate than this setback, however, was that by the end of his long reign in 910, Alfonso lived to see all three of his living sons rise in unified rebellion against him, forcing the aging monarch to divide his extensive realm into three separate kingdoms: Asturias, Galicia, and León. On paper, these now separate political entities would provide mutual military support to each other whenever threatened, but in reality, an overt sign of weakness had been openly presented to the Caliphate of Córdoba, which would in turn proceed to make the remainder of the 10th century a living nightmare for Christians in northern Iberia.

This prolonged rough patch for the Reconquista began with the reign of Abd-ar-Rahman III (891–961), nicknamed "Defender of God's Faith," effectively assuming power at Córdoba in 912. His near half century rule would be remembered as an era in which Christian aggression in Iberia was firmly halted and to some extent reversed. Abd-ar-Rahman's ascension also inaugurated what later became known as the Golden Age of Spanish Jews, a prolonged period in which Jewish cultural and political influence within Al-Andalus reached unprecedented heights. Architecture and the arts flourished. While the new monarch showed unusual tolerance and respect for non–Muslims within his realm, he was vigilant and ruthless in putting down insurrections led by Iberian Muslims. Abd-ar-Rahman's most visible achievement, however, occurred in the year 920 when he confronted a sizeable Christian host in the Basque country led by King Ordoño II of León and King Sancho I of Pamplona. Ordoño, the ambitious second son of Alfonso the Great, had responded to an appeal for aid from Sancho, and by doing so sought to shield all of Spanish Navarre from future Islamic incursions. This time, however, Santiago Matamoros did not come to their aid. Instead, they were roundly defeated at an obscure place later known as Valdejunquera. Two Christian bishops expecting to consecrate a triumph were instead taken hostage by the Caliphate. Immediately afterwards, the city of Pamplona was brutally sacked by the victors, just as it had been by Charlemagne's Franks back in 778.[18] Ordoño and Sancho managed to physically escape the disaster, but never recovered their former prestige. As for Abd-ar-Rahman, had it not been for untimely rebellions breaking out within his own realm, he may well have overrun all of Asturias and Galicia in the aftermath of this stunning success.

In hindsight it might well be argued that Saint James was in fact looking after the best interests of the Reconquista, even while refusing to grant Christians victory at Valdejunquera. Traumatized by this unexpected reversal, the northern kingdoms temporarily reunited after the death of Ordoño in 924

and prepared for the inevitable onslaught which, fortunately for them, was very late in coming, thus giving ample time for preparation. By the time Abd-ar-Rahman had put down multiple insurrections, declared his independence from other caliphates of North Africa and the Middle East, and raised a new expeditionary force, some 19 years had passed. Finally in 939, at the head of a massive but somewhat less than enthusiastic army, he marched north and was met at Simancas in the Duero River Valley (near Valladolid) by an allied Christian force under the joint leadership of King Ramiro II of León and King García I of Pamplona. This time the Asturians were fighting on their own frontier, and the stakes were for nothing less than political independence. Following a total eclipse of the sun, Christian forces first broke the ranks of the invaders, then sent them running for their lives. Santiago Matamoros was reported to have been seen again fighting for the Christians.[19] Abd-ar-Rahman was so shaken by the defeat that he never again personally led his troops into battle. Although future invasions by the Caliphate of Córdoba would have far more success pushing northwards (see Chapter 5), the Battle of Simancas seemed to psychologically establish the Duero Valley as a temporary buffer zone between Iberian Christians and Iberian Muslims, at least for the remainder of the first millennium. Nevertheless, this defensive posture for the Christians seemed a far cry from only two decades previous, when the Asturians appeared on the verge of reclaiming all of Al-Andalus. The mid–10th century also marked the end of another era—in a sense, the second phase of the Reconquista—one in which the public declaration of a major religious shrine at Santiago de Compostela provided Christian armies with a valuable but temporary aura of invincibility in the field.

All of this naturally raised the question as to exactly how the body of Saint James the Greater was brought to Iberia in the first place, following his martyrdom in Judea circa 44 CE (see Chapter 1). On this point, the historical record is silent until the 12th century Codex Calixtinus provided pseudo-historical data for the Santiago shrine, much of which had in all likelihood existed in older oral traditions or lost written sources (see Chapter 6).[20] On a more popular level, however, *The Golden Legend* by Jacobus de Voragine of the 13th century has supplied the modern English-speaking world with its best-known backdrop for these distant events. According to the *Codex* and *Golden Legend*, James' disciples (Athanasius and Theodore, traditionally by name) transported his relics by sea to Iberia, the alleged earlier scene of James' evangelical efforts, where they asked permission for interment from the local reigning monarch or noblewoman, one Queen Lupa.[21] At first, Lupa maliciously imposed various obstacles to thwart their efforts, but after these barriers were miraculously overcome, then had a complete change of heart. The climactic moment occurred when two wild bulls became docile at the sign of the cross and peacefully hauled the body of the apostle, along with a

stone burial slab and cart, directly into Lupa's palace, to the amazement of all onlookers (see header quote). Not only did Lupa grant permission for burial, she also became a baptized Christian, converted the palace into a church, and devoted her remaining life to good works. Notwithstanding many fantastical details thrown into the tale designed to impress gullible minds, the tale of James' Spanish burial and Queen Lupa's conversion conveys an undeniable sense of poignancy and pathos. Malice and deceit are repeatedly frustrated, and eventually confounded, by simple acts of religious faith. Evil is directly confronted by Good, and is ultimately defeated.

There is nothing to prove or disprove this legend. Galician Spain of the first century had been firmly under Roman control since the time of Christ, and continued to be so during the reign of the Emperor Claudius, although local rulers were frequently given considerable autonomy as part of standard Roman foreign policy. For example, as far as we know, James in Judea, unlike Jesus, was tried, condemned, and executed solely on the authority of King Herod Agrippa I with no outside input from Roman authorities. The name Lupa may itself represent a medieval nod to the she-wolf symbol of Rome, as well as to Galician society's comparatively matriarchal traditions.[22] One early artistic depiction of the legend, which strikingly contrasts the authoritative attitudes of Herod and Lupa towards the relics of James, may still be viewed today at the Prado Museum. This striking diptych by the Gothic Renaissance master of Zaragoza, Martín Bernat (1450?–1505?), dates from the late Reconquista period of the 1480s. Respectively titled *The Embarkation of James the Greater's Body at Jaffa* and *The Translation of the Body of Saint James the Greater at the Palace of Queen Lupa*, the dual works depict each monarch along with James' two loyal disciples Athanasius and Theodore as they transport the saint's relics. Agrippa is portrayed as a placid, self-satisfied despot unmoved by the pious devotion of James' disciples; Lupa is shown reacting to the tamed wild bulls—the very moment of her conversion—astonished and disarmed, regally aloof but totally helpless in the face of divine intervention.

Still more dramatic are the spectacular series of frescoes in Padua titled *Stories of St. James*, by the northern Italian painter, Altichiero da Zevio (c.1330–c.1390), particularly Episode Number Seven, *Miracle of the Wild Bulls and Arrival of St. James' Body to the Realm of Queen Lupa* (1372–1379). Altichiero created his highly visible masterwork for the San Giacomo Chapel situated within the world-renowned Pontifical Basilica of Saint Anthony of Padua, itself housing the relics of its venerated namesake. Very little beyond conjecture is known of Altichiero's life, but his groundbreaking visual style speaks for itself. At the time of Altichiero's work, Spain, Italy and the rest of Europe, were still reeling from the Black Death and other catastrophes (see Chapter 9).[23] The Santiago legends seem to have provided an easy rallying

point for surviving believers. The large set piece depicts dozens of human or saintly figures representing every segment of society and the full gambit of emotional response, beginning with shocked surprise from Queen Lupa and her attending ladies, all occupying a balcony in the upper center right side of the scene. Other figures at street level are amazed, frightened, skeptical, dismissive, uncertain, oblivious, excited, or piously devotional. Heavenly saints situated in the mountains above the palace serenely contemplate the miracle and its effect upon the local populace. Even more impressive is the composition, which somehow makes the diversity all fit and flow together seamlessly. Compared to the late medieval illuminations from only a century before, the latter appear almost childish by comparison. Although many historians date the Renaissance as beginning approximately during the 15th century, Altichiero's late 14th century commission at the San Giacomo Chapel is a prime example of proto–Renaissance sensibility, not unlike that of his great predecessor in Padua, Giotto de Bondone.[24]

The latter half of the 10th century saw a Portuguese rebellion in Coimbra break out, not against the Caliphate of Córdoba, but against their own Christian overlords from Asturias. It represented a clear harbinger of a separate Portuguese national identity; nevertheless, by 981 the uprising had been ruthlessly suppressed by King Ramiro III of León (961–985). It seemed a rather pitiful way to enforce Christian unification, but far worse was yet to come. With the death of Ramiro in 985, he was succeeded by his far less impressive son, King Bermudo II, who proved more adept at persecuting fellow Christians than guarding the borders of his vulnerable realm. Some churchmen later added in hindsight, not without some plausibility, that subsequent misfortunes represented divine punishment for Bermudo's earlier mistreatment of his own Christian subjects. Add to these internal problems widespread fears in Iberia and throughout Europe that the end of the first millennium marked the end of the world or beginning of Doomsday. Some of these anxieties were fueled by the very same apocalyptic visions promoted by Beatus of Liébana two centuries previous. All Reconquista efforts now appeared to be paralyzed. Then, at the worst possible moment for Iberian Christians, Córdoba produced its greatest military genius, one who proceeded to wreak sustained havoc against the independent kingdoms of the north.

5

Ferdinand *El Magno*
(985–1064)

In Arab eyes, Santiago was a Christian Mecca.—Jan van Her-
waarden[1]

As the end of the first millennium approached in Europe, a growing
sense of paralysis and inertia seemed to seize the Christian West. This malaise
did not exclude northern Iberia. During the late 900s, Christian Spain had
become a splintered confederacy of competing petty monarchs, despite all
authoritative efforts to maintain a unified front against the Umayyad
Caliphate of Córdoba. The old Kingdom of Asturias had been absorbed into
the expanding Kingdom of León back in 924, although within the latter, Gali-
cia always maintained its own identity while coastal Portugal was beginning
to form its own as well. Taking the reigns of the Leónese kingdom in 985 was
one of its least impressive monarchs, Bermudo II (953–999), nicknamed *El
Gotoso* ("The Gouty"), who would continue to rule for the remainder of the
century, notwithstanding all the disasters about to unfold within his realm.
To the east and south, Castile, Pamplona, Navarre, Aragón, and Catalonia all
maintained separate sovereignties. In effect, earlier territorial gains under
Alfonso the Great had only produced serious internal divisions, reminiscent
of the disunities which had earlier brought down the Visigoth kingdom. After
victory at Simancas in 939 (see Chapter 4), Spanish Christian armies, par-
ticularly those of the northwest, were perhaps convinced that their appointed
protector Santiago Matamoros and designated shrine at Santiago de Com-
postela would shield them from all external threats. They were soon to
receive, however, a lesson in harsh reality, along with the pitfalls of overcon-
fidence.

It was at this precise moment in history that Iberian Islam produced its
most brilliant military genius. Muhammad ibn Abi Aamir (938–1002) began
life in relative provincial obscurity before arriving Córdoba as a young law

student, where his extraordinary abilities were soon recognized and he was hired as an estate manager by the caliph's family. By age 40 he achieved the official rank of *hajib* or prime minister, a title he chose to never discard. Like his earlier Frankish counterpart Charles Martel (see Chapter 3), he realized that wielding absolute power did not always require royal blood or regal titles. Then like Julius Caesar of old, the new hajib of Córdoba proceeded to demonstrate that field experience was not a prerequisite for military aptitude. By 981, he had defeated his last Islamic rival for power (his own father in law), and assumed the humble appellation *al-Mansur bi-llah* ("Victorious by the Grace of God"). Christians knew him simply as Almanzor. Bringing in fresh hordes of Berber mercenaries from North Africa, Almanzor then turned his undivided attention to the defiant free kingdoms of the north. In 985, without warning, his forces sacked Barcelona, a city under Christian rule since the time of Charlemagne. The raid was akin to a calling card that displayed all of Almanzor's trademark characteristics as a military strategist—audaciousness, speed, and unpredictability. For the next 15 years he waged almost nonstop warfare aimed at dismantling the Reconquista, culminating in the year 1000 with a bloody victory over combined Christian forces at the Battle of Cervera in Castile near Burgos.

Almanzor's most famous (and notorious) achievement, however, occurred three years earlier in 997 when he accomplished what no Islamic leader had before or since, namely, to raid and pillage Santiago de Compostela in Galicia, along with its venerated shrine of Saint James the Greater. Outraged Asturian annuls of the time record that Christian mercenaries from the south figured among Almanzor's invaders, strongly suggesting that not all Iberian Christians were as enamored of the Santiago cult, even at this relatively advanced stage in medieval history. Although Santiago de Compostela had been previously occupied in 968–970 by Norman freebooters, this was the first and only instance in which a non–Christian led army had taken the city.[2] After yet another brilliant campaign, Almanzor entered a deserted Santiago unopposed on August 10, the Feast Day of Saint Laurence, where his troops proceeded to methodically raise the city to the ground, including the church over the Santiago shrine built by Alfonso the Great a century earlier.[3] Then, according to all available sources, something unusual happened. Discovering that the physical grave site of Saint James was being guarded by a lone, elderly and unarmed monk, Almanzor ordered that both the tomb and the monk be spared, even placing guards around the shrine for protection.[4]

Almanzor was well aware of the importance attached to the Santiago cult (see header quote), and at first glance his extraordinary behavior might seem difficult to believe; yet upon further reflection, appears quite plausible. Islamic military occupations had traditionally been much more lenient than those of their Christian counterparts, which was always a factor in their

ability to make massive territorial conquests. Perhaps he deduced that the cult had by then become so powerful in the popular imagination that if the old tomb were to be desecrated, a new and even more miraculous one would simply be concocted; or possibly, he may have been thinking about appropriating the cult for his own purposes. Saint James, it must be recalled, was a pre–Islamic figure, a martyred disciple of a holy figure (Jesus) venerated by Islam as a prophet, though not divine. As such, James and Jesus belonged to the Quranic People of the Book (Jews and Christians). Almanzor did take trouble, however, to confiscate the famed bells of the Santiago church built by Alfonso, bringing these back to Córdoba as trophies, then melting them down for re-consecrated, symbolic use in the Great Mosque.[5]

At this historical low ebb tide for the Reconquista, several things are noteworthy. The first is that the indomitable Almanzor, despite 15 years of unbroken successes in the field, could not succeed in destroying or subduing the Christian Iberian kingdoms. In effect, by the end of the first millennium these had become too strong to conquer merely by winning battles or pillaging cities. Despite all their divisions, the Christian kingdoms of the 10th century were not like the dysfunctional Visigoth kingdom during the early eighth century (see Chapter 3), nor was the Umayyad Caliphate of Córdoba the same dominating overlord that it had been two centuries earlier. Christians, despite all their deadly rivalries and internal disputes, were now united in a way that their Visigoth ancestors had never been. Secondly, the climactic Battle of Cervera had proved to be the most costly and unnerving of Almanzor's victories, dissuading the ever prudent commander of the faithful from further pressing his advantage into hostile territories. Reportedly at Cervera, Christian knights had sworn oaths not to retreat or leave the field under any circumstances, dead or alive, and many proved good on their word. Thirdly and perhaps most important, the previously separatist Christian kingdoms had somehow become closely allied and firmly strengthened through adversity, even as the Umayyad Caliphate of Córdoba, notwithstanding the repeated victories of Almanzor, became imperceptibly more divided and weaker than ever.[6] All in all, it might well be argued that Saint James the Greater was still looking out for the best interests of the Christian cause even in the midst of military defeat and economic desolation.

Almanzor died at age 64, although it is unclear whether the immediate cause of death was the Reconquista or the endless cares and fatigues of his office. In the year 1002, while leading yet another raid into the heart of Castile, his forces were ambushed and defeated near Calatañazor. Vague, contradictory sources all agree that he survived the disaster, retreated, and died soon afterwards, either from wounds or a broken heart or both. His track record as a military leader places him among the most successful in European history; like Hannibal of Carthage, he was not personally beaten in the field

until his final campaign, despite waging non-stop warfare for several decades in one of the world's toughest military theaters. Upon his death, however, the Umayyad Caliphate immediately went into a tailspin. The precedent set by Almanzor of caliphate advisors assuming true power over the caliphs continued, but with no one of his abilities emerging as a successor. Less than 30 years later in 1031, the Umayyad Caliphate of Córdoba, whose line of authority stretched back four centuries, crumbled into a patchwork of *taifas* or Arabic city-states stretching across Al-Andalus. Islamic Iberia then found itself in a divided political and military situation similar to the northern Christian kingdoms only half a century before, still generally united against its common enemies but acting independently and with no central authority to enforce alliances.

Given that Islamic Spain remained independent for another four centuries, it appears impressive in hindsight that these city-states managed to hold on for as long as they did. In many respects, the taifas still represented a far more cultured and superior civilization than their northern counterparts with whom they cohabitated the Iberian Peninsula. Moreover, by the second millennium most of these city-states had achieved their own unique blend of Arabic and European cultural influences, giving them a separate identity from both the Christians and their North African counterparts across the straits of Gibraltar. In a similar manner, the Christian kingdoms were beginning to absorb Islamic cultural influences, just as their Mozarabic brethren to the south had done previously. For western civilization this cross-fertilization would prove to be a highly positive development, although both sides would probably have been slow to admit anything of the kind. These perceived advantages, however, would soon be undermined by fresh waves of Islamic fundamentalist invasions arriving from North Africa. Then again, these fanatical jihadists about to land on Iberian soil would be doing most of the fighting to preserve Islam in Spain and Portugal over the next few centuries against the re-energized ambitions of the Christian Reconquista.

As the second millennium began in the Old World, a tragically unaware New World carried about its business, some of which included its own wars and catastrophes, but on a much less epic scale. In modern day southwestern United States, the Ancient Pueblo Peoples by then were engaging in construction activities recognizable in scope to their early European counterparts. In what later became the state of New Mexico, the Taos Pueblo began emerging on its present location, and today claims the distinction of being the longest continuously habited dwelling structure in North America.[7] More impressively, within the Chaco Canyon area of New Mexico, the densest concentration of pueblo dwellings ever known to exist, including the remains of the Pueblo Bonito or "Great House" were all probably taking shape by this point in time.[8] All of these developments were roughly concurrent with the

founding and expansion of Santiago de Compostela in Galician Spain, although the latter remains one of the world's most active sites of religious pilgrimage, while the former is comprised mostly of ruins abandoned by their original inhabitants long before the arrival of Spanish conquistadors during the 16th century. At the dawn of the 11th century, however, the main focus of Iberian Christians was how to most quickly recover all that had been lost, especially now that the Umayyad Caliphate was in its final stage of decline following the death of Almanzor.

As previously noted, the havoc wreaked on northern Iberia by Almanzor seemed to have long-term positive effects for the Reconquista. Because Basque country held relatively firm during the crisis, its influence now began to spread. Not long after the death of Almanzor, the young Sancho III of Pamplona (c.990–1025) came to power while still a teenager. After reaching adulthood and consolidating a firm hold on his own kingdom, Sancho began looking west. In 1027–1029, he scored a diplomatic triumph when the rightful Count of Castile was unexpectedly assassinated by malcontents. Sancho promptly designated his youngest son, Prince Ferdinand (1015–1065) as the new Count of Castile, a convenient way to assume control of Castile since Sancho's queen (Ferdinand's mother) was also the sister of the assassinated count.[9] By 1034, Sancho had incorporated León into his kingdom as well; northern Spain was once again reunited under a strong ruler. Thanks to this aggressive unification process, and thanks to Sancho's inherited political ties with neighboring France, east-to-west pilgrimage traffic along the Camino de Santiago rebounded and rapidly expanded to new unprecedented proportions. The popularity of this pilgrimage route grew despite the physical shrine of Santiago having itself been mostly demolished during the Almanzor raid of 997. Upon Sancho's death in 1035, his son Prince Ferdinand nominally remained Count of Castile while his elder brother García Sánchez III ruled Pamplona, his half-brother Ramiro I ruled Aragón, and his brother-in-law Bermudo III ruled León. This divided arrangement, however, would not last long.

Similar to Almanzor before him, King Ferdinand I *El Magno* ("The Great") spent the first phase of his long rise to power by subduing rivals close to home, which often included his own relatives. Between 1037 and 1056 he respectively defeated and killed his brother-in-law and older brother in battles that not only resolved longstanding territorial disputes, but consolidating those rival kingdoms, for all practical purposes, into a single unified entity. By 1056, Ferdinand was styling himself Emperor of Spain, although his over-awed half-brother, Ramiro I of Aragón, had begun addressing him by that title as early as 1036. Then borrowing a page from the Almanzor military playbook, Ferdinand began launching large-scale lightning raids or *razzia* aimed at disrupting the Islamic taifas. Unlike Almanzor, however, Ferdinand

did not have to bring in outside mercenaries. Between 1057 and 1065, Portugal, Zaragoza, Toledo, Seville, and Valencia all bore the brunt his unpredictable and irresistible assaults. During all his wars, Ferdinand was never personally defeated in battle, and voluntarily withdrew from Valencia only when his health began to fail. Predating the First Crusade by several decades (see Chapter 6), these campaigns represented the first prolonged contact between Europeans, more specifically, the Reconquista Christians of northern Iberia, with Muslim civilians (along with their Christian Mozarabic subjects) in Muslim-held southern Iberia. As such, there must have been a significant degree of culture shock, especially for the invading Christians. It was one thing to confront a more advanced civilization within its own habitat; it must have been quite another to find Mozarabic Christians benefiting as subjects living within that more tolerant civilization.

In 1064, as Portuguese Coimbra was being retaken by Ferdinand's raiding armies to the west, the far northeastern side Iberia witnessed the city of Barbastro in Aragón brutally sacked and its Muslim population mercilessly slaughtered by Christian forces comprised largely of Frankish and Norman mercenaries from the other side of the Pyrenees Mountains. This ugly event was sadly reminiscent of nearby Pamplona's fate at the hands of Charlemagne's marauding army in back in 778 (see Chapter 3), as well as presaging the French-led First Crusade that would be unleashed against the Holy Land before the end of the 11th century (see Chapter 7). The Reconquista had now assumed an entirely new level of aggression and bloodlust as Iberian Christians correctly sensed that centralized Islamic resistance no longer stood in their way; as a consequence, there was easy loot was to be had, and lots of it. This was a far cry from more recent previous centuries in which Santiago Matamoros appeared supernaturally to preserve outnumbered, underdog Christian kingdoms against powerful infidel invaders. Now the tables had turned, and Muslim southern Iberia may well have totally collapsed had it not been for the sudden illness and death of Ferdinand in 1065, along with the arrival of fierce Almoravid reinforcements from North Africa shortly thereafter.[10]

When King Sancho II of Castile and León inherited his father's impressively expanded realm in 1065, Sancho's royal standard-bearer was a 25-year-old Castilian knight by the name of Rodrigo Díaz de Vivar, dubbed *El Campeador* ("Great Warrior").[11] Later, however, he was to become far more renowned by his Latinized Arabic nickname *El Cid* ("Master").[12] Díaz had come of age participating in the lightning campaigns of Ferdinand the Great into southern Iberia, during which he appears to have mastered, if not invented, an entirely new style of fighting and recruiting. This style often blended similar (and dissimilar) tactics of Christian and Islamic chivalry into a unified, unorthodox, and highly effective brand of frontier warfare. According

to tradition, a good part of his military apprenticeship had been spent in and around the theater of Ferdinand's Zaragoza invasions. Here, the Cid found himself in the novel position of commanding and fighting alongside local Muslim allies agreeing to be Ferdinand's vassals, either fearing the formidable reputation of *El Magno* or preferring him over other invaders, particularly the French or their Spanish French allies.[13] Much was learned quickly by everyone involved. As a result, the Cid's movements would dominate the Iberian Reconquista for the remainder of the 11th century (see Chapter 6). Meanwhile, as Christian domains in southern Iberia expanded, Santiago de Compostela continued to rebound as a pilgrimage destination from the destruction experienced during the terrifying invasion of Almanzor less than a century previous.

Ferdinand's audacious raids into southern Iberia had other consequences besides intimidation and conquest. The militant cult of Santiago Matamoros now found itself with a more pious competitor, the Virgin Mary, so prevalent with Mozarabic Christians and one never relegated to any secondary tier of veneration.[14] While the territorial unifying efforts of Sancho, Ferdinand and their immediate successors during the mid–11th century did much to increase pilgrimage traffic along the Camino de Santiago, Christian southern Iberia, under the relatively tolerant rule of its Muslim overlords, had always clung to its traditional and longstanding customs. One of these, perhaps the greatest, was formal worship of the Madonna and Christ child. Moreover, this direct confrontation of the Santiago cult with its Marian counterpart represented perhaps only the most conspicuous clash of a profound cultural divide between northern and southern Iberia. Religious, political, and social differences had always existed, and still do, for that matter. Most of these regional variances are well beyond the scope of this study; however, a sampling may be gleaned merely by comparing longstanding traditions of depicting the Virgin in religious artwork. Their contrasting tone and emphases with those emerging simultaneously from the north for Santiago Matamoros are often notable. For example, because southern Iberian society tended to be more multicultural, its artwork also frequently displayed more diverse influences in terms of race, religion, and style.[15] It is also well worth recalling that Saint James the Greater had his own close Marian associations, both as the possible nephew of the Virgin (according to some), and for having been, based on another very old tradition, the first Christian to experience a Marian vision during his own lifetime (as well as hers), occurring conveniently enough, near the southern Iberian city of Zaragoza (see Chapter 2).

Although earliest surviving artwork from Iberia was mostly created during the pre–Renaissance and Gothic periods, the aforementioned tendency in southern Spain to de-emphasize the Santiago tradition appears to have been noticeably manifest by that time period. Though dating several hundred

years after the milieu of Ferdinand the Great, an excellent example of this sensibility can be found in the distinctive work of Pere Serra, a Catalan painter active during the latter half of the 14th century. Much like his Italian contemporary Altichiero da Zevio (see Chapter 4), Pere Serra's striking religious portrayals anticipated the early Renaissance with their sophistication, attention to detail, and expressive intimacy. Virtually nothing is known of Serra's life, except that he came from a family of artists and specialized in decorative altarpieces. By this point in the history of the Reconquista, all of Catalonia and surrounding environs firmly belonged to Christian Spain, although during the reign of Ferdinand, neighboring Zaragoza and Valencia were active theaters of conflict while Barcelona itself had within recent memory been sacked by Almanzor's mercenaries. Serra also painted (again, like Altichiero) during an era in which most of Europe was still recovering from the ravages of the Black Death, as well as reeling from schismatic divisions within the Roman Catholic Church (see Chapter 9). Unlike Altichiero, however, Serra turned to a different rallying point for Christendom, namely, the Virgin Mary. This was particularly appropriate in Catalonia where non-stop invasions and upheavals had been unpleasant features of everyday life since the ancient Punic Wars between Rome and Carthage.

During the mid–1380s Serra produced one of his most impressive works, an altarpiece for the Tortosa Cathedral, located approximately midway between the cities of Barcelona, Zaragoza, and Valencia, at the mouth of the famed Ebro River.[16] Serra's *Lady of the Angels* altarpiece, complete with flanking panels of eight saints and apostles (including Saint James the Greater) are today seen in the Museu Nacional d'Arte de Catalunya of Barcelona. The centerpiece and focal point of attention are a beautiful Virgin and Child surrounded by six musician angels, predominated by peaceful dove imagery— the Christ Child holds a symbolic dove—as opposed to the grisly conquistador-like Matamoros or violent sacrifices of Christian martyrdom. The Catalonians were a people deeply appreciating the blessings of peace, having themselves previously known little else but war and upheaval. In a separate panel to the right of the Virgin are SS. John the Baptist, Mary Magdalene, James the Lesser, and Paul; in another panel to the left, SS. Peter, Claire, James the Greater, and John the Evangelist. James the Greater is portrayed second from the left next to his brother John, as a humble pilgrim with staff, codex, hat, and cockle shell badge, one of many saints paying homage to the Virgin. Thus James assumes a much more modest position within a much bigger religious hierarchy, one including James the Lesser, as if to make a special point that there were two apostles bearing that name. Interestingly, however, James the Greater is the only figure on all three panels depicted as glancing directly at the viewer. All other reverent eye contacts in the holy assembly are on the Madonna, the Christ Child, Heaven above, or meekly to the ground

below. This is not the James of Santiago Matamoros or Son of Thunder courageously dying for his faith in the face of persecution; rather, he seems to be personally inviting everyone in the congregation to come and join him on a great religious pilgrimage, presumably to his own shrine on the opposite side of the Iberian Peninsula in faraway Santiago de Compostela.

With the passing of Ferdinand the Great in 1065, European history seemed to enter yet another new phase of shifting allegiances and power realignments. In 1066, Duke William of Normandy decisively conquered Saxon England, personally riding into the Battle of Hastings on a Spanish steed given to him by a knight making a previous pilgrimage to Santiago de Compostela.[17] In doing so it appears that William the Conqueror had, figuratively speaking, covered all bases for his bold endeavor across the English Channel. Meanwhile in Iberia, Ferdinand's tremendous reversal of fortunes in favor of the Christian Reconquista had caused considerable political instability and unrest within the Islamic city-states to the south. That same year (1066), in the city of Granada, Islam's greatest Iberian stronghold for another four centuries to come, a spontaneous massacre of its most prominent Jewish citizens was carried out by Islamic fundamentalists under the helpless or complicit watch of Muslim authorities. For over three centuries previous, Iberian Jews had been close allies of the Umayyad regime and its taifa satellites. Now all of that seemed to be changing, or at least far less enthusiastically embraced as a convenient political alliance between local rulers and a Jewish minority once severely oppressed by its former overlords.[18] Consequently, Jewish influence within Iberian Muslim courts, one so definitive since the time of Abd-ar Rahman III of Córdoba (see Chapter 4), now began to perceptibly wane. The shift represented a startling contrast with the beginning of the 11th century, when Almanzor terrorized all of Iberia with both Christian and Jewish vassals in his enthusiastic train of followers. Within the mere span of a generation, the tables had truly turned. The next hundred years would witness a significant consolidation of Reconquista Iberian power, with a major assist from the French, including a French-led military push into the very heart of the Middle East.

6

Mythologized Traditions
(1064–1150)

The Book of St. James was intended by the propagandists of Cluny to be an account of the great pilgrimage written at the height of its fame, and they created by personality of Archbishop Turpin, the faithful prelate of Charlemagne in Cluny, with the object of giving wider significance to the cult of the Apostle and of reviving the mystical heroism of Charlemagne and Roland.—Walter Starkie[1]

The Age of El Cid, Ferdinand, and his immediate successor sons, Sancho II and Alfonso VI, represent the first triumphal peak of the Reconquista. It was during this era that Christian Iberia, previously a loose confederation of northern kingdoms simply trying to preserve their independence, now found themselves imposing their will on southern city-states, sometimes with surprising cooperation from local Muslim rulers and citizens. Part of this willingness to pay tribute was due to a realization that their greatest immediate danger was posed not by the Christians, but rather Islamic fundamentalist movements from North Africa. Soon enough, successive waves of Berber jihadists would engulf southern Iberia, blindsiding the Christians and temporarily putting them back on their heels. Another reason for local cooperation was that Iberian Muslims also feared that, with the recent demise of the Umayyad Caliphate, there was now nothing left to enforce Islamic unity. Consequently, the city-states were no longer strong enough to withstand armed assaults from the likes of El Cid or allied Christian invaders. In effect, the city-states wanted to maintain a unique Iberian identity while preserving self-rule and religious freedom. Sadly, however, by the time the Reconquista finally ended some four centuries later, these desirable goals would be completely lost.

In 1072, the same year that Sancho II was assassinated and succeeded

by Alfonso VI as King of León and Castile, another strange development was taking place far away in the Holy Land. In Jerusalem, under the distracted watch of rival Islamic rulers (the Fatimid Egyptians and Seljukian Turks), the Georgian Orthodox Church began building a new place of worship on the site of an ancient shrine located within the confined Christian Quarter of Jerusalem. As early as 444 CE, a church or shrine dedicated to the obscure Saint Menas, a fourth century Egyptian military saint and martyr, was reported at this site.[2] This same structure was destroyed during the Persian Sasanian conquest of Jerusalem in 614, but rebuilt after the Byzantines under Heraclius regained the city by 630.[3] Although very little can be historically verified about either Saint Menas or his primitive Jerusalem shrine, by the 10th century it appears that a substantial cult had developed around his legend.[4] Interestingly, the earliest written sources on the Saint Menas tradition reflect a number of similarities with that of Saint James the Greater.[5] By the late 11th century, Georgian Christians were presumably living and worshipping side by side with Armenian Christians, also their immediate neighbors from a common Caucasian homeland. It is likely that the relationship between the two sects was uneasy.[6] Even before the Roman Empire, the Armenians had been the first nation on earth to officially declare itself Christian (see Chapter 1), and their early presence in Jerusalem as a religious-oriented community was as distinguished as any. By the year 1078, however, a new Georgian Orthodox Church in Jerusalem was reportedly completed.[7]

With the cataclysmic arrival of the First Crusade in Jerusalem on June 7, 1099, the status of the Armenian Christian community in Jerusalem underwent a significant transformation. Having been expelled from the city along with all other Christians by the Fatimid governor prior to the siege, the Armenians were spared the carnage and mayhem ensuing over the next two months. After local Muslims and Jews had been massacred by the Crusaders, a newfangled Latin Kingdom of Jerusalem was established by the victors. It proved to be an environment in which Armenians were not only welcomed, but singled out for special favor. Part of the reason for this favoritism was that Armenian Christians had provided valuable aid and support to the Crusaders during their perilous march through modern-day Turkey in route to the Holy Land. As circumstances played out, the very first independent Crusader state was officially established at Edessa in 1098, where Baldwin of Boulogne, after taking an Armenian wife, set himself up as monarch with strong support from local Armenian Christians.[8] Two years later (in late 1100), Baldwin was invited to become the second king of Jerusalem when its first elected king, Godfrey of Bouillon, died prematurely after less than a year of rule. Consequently, within two years after arriving in the Holy Land, the First Crusade had resulted in an Armenian Christian queen at Jerusalem. As one might expect, the Armenian community in Jerusalem would continue

to wield great influence within the Latin Kingdom of Jerusalem during its short period of existence.

The most durable and visible legacy of this influence was construction of the spectacular, still-standing Armenian Cathedral of Saint James some-time during the mid–1100s over the same site of the Georgian Orthodox Church erected during the previous century, partially incorporating the old structure into the new design.[9] Later in 1165, the visiting German pilgrim John of Würzburg recorded that included among numerous relics housed by the new Armenian Cathedral was the skull of Saint James the Greater, in addition to claiming the entire bodily remains of Saint James the Just, first Bishop of Jerusalem, and (for good measure), the arm of Saint Stephen, proto-martyr from *Acts of the Apostles* (see Chapter 1).[10] Possession of James' skull has been consistently maintained by the Armenian Orthodox Church ever since, and obviously stands in contradiction to the longstanding tradition of Santiago de Compostela. To this sensitive subject we shall return while recounting the rapid demise of the Crusader Kingdom of Jerusalem only two decades later (see Chapter 7). The First Crusade itself seemed to have little or no veneration for Santiago Matamoros, a surprising attitude given the mil-itary success of this cult in Iberia. Instead, this group of mostly Frankish and Norman conquerors apparently preferred paying homage to Saint George, which included several recorded visions of the warrior saint during their own battles.[11] Local Armenians, on the other hand, felt a need to venerate Saint James the Greater with a new edifice and shrine. Whatever the precise motives, suffice it to say that by the mid–12th century, Christian pilgrims seeking out the relics of Saint James the Greater had at least two choices, each with respective backing from major religious institutions and located on far opposite sides of Christendom (Santiago and Jerusalem) as it then stood in world geography.

While the Armenians of Jerusalem were busy reinventing their monas-tery and cathedral as a pilgrim destination, the Galicians of Santiago de Com-postela were doing them one better. In addition to constructing a new edifice, Santiago was developing a written tradition, one that would find wide circu-lation throughout Europe and beyond. Around the year 1075, during the early reign of King Alfonso VI *El Bravo* ("The Brave"), construction began on the world-famed Cathedral of Santiago de Compostela, centered around the Gali-cian shrine of Saint James the Greater, whose pilgrimage traffic by that era was more robust than ever. The monumental project would be ongoing for the next half century. By the time the exterior edifice was completed circa 1122, the political and military situation in Iberia for the Reconquista was considerably more challenging; Santiago's symbolic importance to effort was needed more than ever. Shortly after the last interior stone was laid, perhaps as early as 1140, an even more remarkable thing happened: the illuminated

manuscript titled *Codex Calixtinus* or *Liber Santi Jacobi* ("Book of Saint James") emerged from France and was presented to the new Santiago cathedral, which today still houses the oldest surviving copy of the work. In its own way, the *Codex* was more audacious than the cathedral itself. If the Armenians had successfully created an alliance with Crusader Kingdom of Jerusalem to promote pilgrimage tourism in the Holy Land, then the Spanish, and particularly the Galicians, had joined forces with their traditional allies the French to manufacture something even more astonishing—a thriving pilgrimage tourism industry centered around the most remote region of western Europe, one continuing strong into the present day.

Construction of the Santiago de Compostela Cathedral, like other similar large-scale projects throughout Western Europe, helped to usher in the High Middle Ages, announcing to the rest of the world that this was not the same Europe of the Dark Ages in which Carolingian Franks had once defended so tenaciously against outside invasion (see Chapter 3). Western Europe of the 11th century had an expansionist mentality, not a defensive one. Crusading and Reconquista were watchwords of the day. Moreover, although the first phase of the Santiago development physically resembled any number of Romanesque religious monuments springing up across the continent, the great shrine arising in Compostela had something noticeably different to offer.[12] Besides boasting the relics of a Christian Apostle (like Rome), Santiago was now firmly established as the western terminus of European pilgrimage traffic, hence the focal point of a major commercial corridor extending across Iberia, France, and beyond. In many respects it symbolized an economically prosperous Europe, as opposed to the impoverished wreckage of the former Roman Empire. Less obvious, but nonetheless real, was Compostela's unique architectural style, a regionally distinctive take on the Romanesque tradition with subtle Moorish and Islamic details. It seems that Iberian Christian shrines could not help but to acknowledge a certain admiration for their Islamic adversaries, even if unconsciously.[13] Last (and most importantly) the Santiago project and all along the Camino Frances ("French Road") openly displayed its close alliance with French interests on the other side of the Pyrenees, most notably with the Benedictine monastics of Cluny in eastern France. Clues of this ecclesiastic and economic cooperation begin with the French names of the architects, Bernard the Elder and his assistant Robertus Galperinus. It can be easily inferred that much of the specialized labor required for such a sophisticated undertaking were imported from France as well.

Another clue was that a very similar project was developing almost simultaneously on the opposite site of the Pyrenees in the old French Visigoth capital of Toulouse. There taking shape was another magnificent Romanesque structure, the Basilica of Saint-Sernin (or Saturninus), named after the third

century Christian martyr and first Bishop of Toulouse whose venerated relics may very well be interred at that location.[14] Conveniently, the Toulouse Basilica became a popular launching pad for religious pilgrims headed west over the mountains towards Santiago de Compostela. Like the Santiago Cathedral, the Toulouse Basilica is today a designated UNESCO World Heritage Site. The prestige of the Toulouse location as a depository for saintly relics had been established long before construction of the Basilica itself; according to tradition, Charlemagne himself had donated a number of items during the late eight century, in addition to those already possessed by the then-extant church, probably providing incentive for its later expansion. As for the ever-increasing pilgrimage traffic along the Iberian Camino routes, particularly along Camino Frances (into which Toulouse directly fed, south of Pamplona), French Cluniac connections with Spain had existed since at least the time of Ferdinand the Great, and usage now appeared to be reaching unprecedented volume. Concurrent developments of monumental religious shrines in Santiago and Toulouse not only sought to take advantage of this trend, but also helped to bolster it even further.

This latest phase of extraordinary expansion unfolding around Santiago de Compostela was given a tremendous boost by the tireless efforts of Bishop Diego ("James") Gelmírez (1069?–1040) the most influential Spanish churchman since Beatus of Liébana (see Chapter 3). Though a man of the cloth, Gelmírez probably did more than anyone at the time to help forge a new Spanish national identity. Coming of age in the ambitious court of Alfonso El Bravo and during the celebrated military exploits of the Cid, the Galician-born Gelmírez learned early in life to make no little plans. By 1095, the Bishopric seat of Galicia had been transferred from Iria Flavia to Santiago de Compostela. By 1100, Compostela was transformed into an episcopal see by none other than Pope Urban II, the same pontiff who five years earlier incited and sanctioned the First Crusade. In 1120, as the new cathedral edifice reached for the sky, Gelmírez was personally appointed by Pope Callixtus II as first Archbishop of Santiago de Compostela, essentially making him the top religious leader in Spain. All during this time, Gelmírez continued to relentlessly promote the cult of Saint James the Greater. In 1122, the topped-out but still uncompleted Cathedral of Santiago de Compostela officially opened for worship, as well as for long distance pilgrimage devotion. It represented the crowning achievement of the Galician Archbishop's ambitious career. Then in 1140, sometime shortly after the death of Gelmírez, compilation of the anonymous *Historia Compostelana* was completed, recounting in laudatory, but at best semi-reliable manner, his notable tenure.

The aggressive and highly promotional style of Gelmírez won him many enemies and jealous rivals, but there can be no denying the numerous literary works commissioned by his long regime provided much of the primary doc-

umentation, however untrustworthy, of the Santiago tradition as remembered today. Most prominent among these are the five illuminated books collectively known as the *Codex Calixtinus* (i.e. *Liber Sancti Jacobi*), probably first compiled near the end of Gelmírez's life and career during the late 1130s. Multiple prefaces in the grand work are fictitiously attributed to Pope Callixtus II, who had earlier elevated Gelmírez to the status of papal legate but whose death in 1124 seems to rule him out as the true author. The manuscript states that it was presented to the Santiago Cathedral sometime before 1143 by Pope Innocent II, although this date has been questioned as well. Modern scholars generally agree that the *Codex* was in large part written by the French Cluniac monk Aymeric Picaud as part of a coordinated Franco-Spanish effort to promote tourism along the Camino Frances. A significant portion of the *Codex* is devoted to liturgy, miracles, and music. In addition to the first preserved reference to Santiago de Compostela as the final resting place of Saint James the Greater, the *Codex* includes a detailed tourist guide for pilgrims, the latter the very first of its kind in western literature.

Interestingly, Book IV (purportedly written by Archbishop Turpin of Reims) recounts the eighth century adventures of Charlemagne and Roland while campaigning in northern Iberia (see Chapter 3). The effect is not only to glorify France within the context of the Santiago cult, but also (perhaps unwittingly), to underscore the international importance being then achieved by the Santiago tradition during the early and mid 12th century (see header quote). Also traced to this same period are several other documents of interest, including the notoriously forged and so-called Diploma of King Ramiro I, purportedly giving thanks for Spanish victory at the Battle of Clavijo (which never occurred) and, more to the point, reserving a perpetual right of the Spanish monarchy to tax the whole of Spain for the exclusive benefit of the Santiago shrine at Compostela. The Diploma of Ramiro I is in fact the earliest surviving account for the Battle of Clavijo, nearly four centuries after the supposed event, and written in truth not by Ramiro I but by one Pedro Marcio of Santiago de Compostela, or a perhaps a group of authors working under Pedro's direction.[15] In either event, it can be safely said that this was a prolific era of robust literary activity. To repeat, over the long term these multiple works would do more to enshrine the traditions of Santiago than any physical monument constructed for the same purpose, although the edifice is indeed magnificent.

Expansion of the Santiago shrine and corresponding production of its companion literature was undeniably being driven at the time by a sense of urgency and anxiety. After Alfonso the Brave had conquered the cities of Madrid and Toledo in 1085 and appointed Toledo's first Christian governor, the Mozarab Sisnando Davides, panicked Iberian Muslims took drastic measures by appealing to the fanatical Berber Almoravids of North Africa.[16] This

eventually proved to be more than they had bargained for. The fundamentalist Almoravids had not long before established their capital city at Marrakesh in modern day Morocco, after having conquered most of the Magreb with a combination of fierce military prowess and uncompromising religiosity. In 1086, only one year after Toledo had fallen, an Almoravid invasion force under Yusuf ibn Tashfin utterly defeated a Castilian host led by Alfonso at the Battle of Sagrajas near Badajoz along the Portuguese frontier. Although Alfonso and most of his knights managed to survive the day, overall losses were heavy, while the king retired seriously wounded and lame for life. More significantly, the hitherto relentless Christian advance into southern Iberia had finally been halted and would remain stymied for years to come.[17] It was in this general atmosphere of setback and adversity that Santiago Compostela made its big push to completion under the direction of Bishop (and later Archbishop) Gelmírez.

While the Castilians suffered reversals in the field, however, other parts of Christian Iberia were faring better in the face of this new menace. To the east, the Christian Kingdom of Aragón, until then (at best) a secondary rival to the Castilians, saw a considerable rise in their fortunes under King Alfonso I (1074?–1134) *El Batallator* ("the Battler"), not to be confused with the much earlier Alfonso I *El Católico* ("the Catholic") of Asturias from the eighth century. The highlight of Alfonso the Battler's reign was his decisive conquest of Zaragoza and surrounding environs in 1118. Although Alfonso died shortly after fighting the last of his many engagements in 1134, the Battler was succeeded by his protégé García Ramírez of Navarre (1112?–1150), called *El Restaurador* ("the Restorer"), whose subsequent reign witnessed the long contested County of Barcelona voluntarily merge itself with Aragón for protection against the emerging Almoravid threat. One agreeable byproduct of this Reconquista extension into southeastern Iberia appears to have been the earliest preserved written source, circa 1150, for the beloved Marian Pillar tradition of Zaragoza (see Chapter 2), by Pedro de Librana. Although the miraculous vision had occurred over a thousand years before this document materialized, the tradition had obviously existed long before that time as well; moreover, it did not assert or contradict that Saint James the Greater was buried in Iberia, only that the apostle once had preached there long ago.

At the other far end of the peninsula, the Portuguese were also impressively effective in defense of their homeland, although this success also came at the expense of their would-be Castilian overlords. In 1139, rather dramatically on the Feast Day of Saint James (July 25), the Almoravids suffered their first big defeat at the hands of an outnumbered Portuguese force at the Battle of Ourique in southern Portugal. The Portuguese were led by the Franco-Portuguese Infante, Prince Dom Afonso Henriques, later becoming King Afonso I (1109–1185) nicknamed *O Fundador* ("the Founder") of Portugal.

Notably, as in their earlier 10th century victory at Simancas (see Chapter 4), Christian forces were later said to be inspired at Ourique by Santiago Mata-moros, on whose feast day they fought. Closer inspection of these subsequent traditions, however, reveal that the vision of Prince Afonso was of Jesus Christ on the Cross, rather than of Santiago. Just as the Christians of southeastern Iberia still venerated the Virgin Mary above any of the apostles (see Chapter 5), the Portuguese, obviously for their own political reasons, were not willing to fully embrace Saint James the Greater as their exclusive benefactor.[18] More indisputable is that Portuguese independence was formally recognized soon afterwards in 1143 by the Castilians under the Treaty of Zamora, although relations between Portugal and Spain would always remain difficult. Then in 1147, Lisbon fell to Afonso's energized Portuguese nationalists, with an assist from English allies, who have remained friends of the Portuguese more or less ever since. Meanwhile, with Almoravid defeat and decline came yet another Islamic power from Moroccan North Africa, the Berber Almohads, who after the fall of Lisbon became the latest formidable adversaries of the Reconquista.

As Christian Iberia reeled from successive waves of new Islamic inva-sions during the late 11th century, a great military hero arose among them, one still celebrated across the Spanish-speaking world and well beyond. While the Almoravids were rolling back Christian gains in the south, the aforemen-tioned Castilian warlord Rodrigo Díaz de Vivar metamorphosed into his Arabic moniker *El Cid*, while establishing an indomitable reputation as a military adventurer and troubleshooter, sometimes employed by the Muslims of Zaragoza to defend against both Christian and Islamic external threats. Then in 1094, to the surprise of almost everyone it would appear, the Cid suddenly pushed all the way to the southern coastline and the city of Valencia, which he seized and held against all challengers for the four remaining years of his life.[19] More remarkably, especially for a man who spent his entire adult life on the battlefield, the Cid proved himself a popular and tolerant local ruler among both Muslims and Christians, a template for rule that certainly went against the grain of those intolerant times. Like Almanzor before him, the Cid did not come from the high nobility, was considered by the common people to be one of their own, and excelled in forming unlikely alliances; moreover, he tended to respect his adversaries, even while beating them in the field.[20] His fighting career also predated the First Crusade, and seemed consistently unencumbered by any perceived restraints of pious convention or religious dogma.[21] The Cid's heroic exploits would later be immortalized anonymously in the 12th century by the Castilian epic poem *El Cantar de Mio Cid*, and in the English speaking world primarily through the benchmark 1961 film *El Cid*, directed by Anthony Mann. The narrative of the poem (unlike the film) includes obligatory Christian appeals to Saint James for

assistance, although in real life the Cid looks to have been far more intrigued by the advanced Moorish culture of southern Iberia, rather than the Galician cult of Santiago de Compostela.

The Age of El Cid, however, did influence modern perceptions of Saint James indirectly. Much if not most of the artwork which later appeared on this same theme portrayed Santiago Matamoros as a light cavalryman with little or no armor, carrying only a simple lance as weaponry. This image of course tied in with surviving literary accounts that began to appear during the early 12th century. Its supernatural aspects were in all likelihood related to the apocalyptic symbolism of mounted warriors prevailing in Iberia since at least the time of Beatus (see Chapter 3). One might attribute this minimalism in armament to a religious faith in the power of Matamoros, but by the time of the Reconquista wars with the Almoravids and Almohades there was some basis in fact as well. Artistic portrayals of Santiago Matamoros as unarmored light cavalry often bore striking resemblance to the Christian *à la jinete* ("hit and run") light cavalry of the era, originally based on ancient North African tactics, first developed in Granada, then adopted by their Christian opponents soon afterwards.[22] Both sides in the conflict well understood the power of the image; moreover, by the era of Bishop Gelmírez, the idea of a total Iberian Reconquista was itself beginning to gain wide currency.[23] It has also been observed that raiding armies living off the land and outright cattle rustling now became regular features for this style of warfare.[24] Thus in a very real sense, central Iberia became a kind of Wild West long before there was an American Wild West. The idea of associating Saint James the Greater with foraging and cattle rustling may at first seem incongruous, but further reflection suggests that visually presenting Santiago Matamoros as a mounted warrior of lightning speed and infinite versatility was really a stroke of genius on the part of Christian propagandists.

Leaving aside for now the more militant persona imposed onto Santiago by the Reconquista, it behooves us to return to the more peaceful Santiago who lived and died a martyr in Jerusalem over a thousand years before the time of the Crusades. Many of the extra-biblical written details of the saint's life in fact derive from the 12th century *Codex Calixtinus*, as neatly condensed within the popular 13th century hagiography, *The Golden Legend* by Jacobus de Voragine, along with its important edition in the English language printed much later by William Caxton in 1483.[25] One of the most enduring of these stories, perhaps partially or wholly apocryphal, is the incident purportedly setting off a rapid sequence of events which led to James' martyrdom shortly after his return to Jerusalem from Spain (see Chapter 1). This elaborate tale involved the magician Hermogenes and his disciple Philetus being directed by malicious Pharisees to falsely accuse and entrap James, but instead being themselves ultimately freed by James from their evil bondage and happily

converted to Christianity. The very moment of Hermogenes' conversion was beautifully depicted during the late 1420s by the Florentine master Fra Angelico (1400?–1455), aka Fra Giovanni da Fiesola, a Dominican monk and painter whose civilian name was Guido di Piero. This vivid and poignant work is today possessed by the distinguished Kimbell Museum of Fort Worth, Texas.

The Apostle Saint James the Greater Freeing the Magician Hermogenes is one of five panels including the Virgin Mary and other saints originally commissioned for an altarpiece, not unlike the ensemble created by Pere Serra in Tortosa a few decades earlier (see Chapter 5). Set in ancient Jerusalem (the site of James' martyrdom) as reimagined by the early Renaissance mind and where the Armenians had by then their own well established shrine drawing pilgrimage traffic, Fra Angelico's snapshot storytelling is a tour de force of exotic variety, bright colors and vivid contrasts. The thematic focus is on the miraculous powers of Saint James the Greater, something not appearing in the bible but achieving central importance in the 12th century *Codex Calixtinus*. A chained Hermogenes is miraculously set free by his recently Christianized disciple Philetus, as a haloed James looks on while touching the headdress of Philetus with his staff, as if it were a magic wand. No fewer than six grotesque demons huddle together on the left side of the grouping, daring not to interfere with the holy proceedings. Behind James stand two figures, possibly a Pharisee and his scribe, skeptically beholding the scene and conversing amongst themselves as to how they will soon bring the saint to execution, even after having instigated and witnessed the miracle they now refuse to acknowledge. The message is straightforward: the miraculous powers of Santiago touch all of us, but we all react in different ways to these events, for better or for worse.

Reconquista historian David Nicolle perceptively wrote that "After 1148 the Iberian kingdoms got virtually no help from the rest of Europe, Crusading energies being channeled to the East. The Spaniards were left alone to cope with the problems of their own success."[26] Problems of their own success indeed. After centuries of close military, religious, and economic collaboration between Spanish and French, the latter found themselves preoccupied with recent setbacks in the Middle East, along with formidable European competitors such as the English, the Germans, and the Papacy. Pilgrimage infrastructure had been established between Toulouse and Santiago de Compostela (as well as in Armenian Jerusalem), extending throughout France and Spain. The financial and spiritual benefits of this foundation would benefit both countries, to varying degrees, for the next nine centuries. Military cooperation between Spain and the rest of Europe, however, was by the mid– 12th century a thing of the past. Most of Christian Europe focused exclusively on the Holy Land. What seemed to have been won in 1099 now threatened

to be lost, and would in fact be irretrievably lost by 1187. As for the Iberian Reconquista, over three more centuries of bitter fighting lay ahead. In between the ongoing bloodshed, destruction and waste, however, a minority of Iberians would begin asking questions about tolerance and coexistence. Such questions had also no doubt occurred to the Cid during the late 11th century as he forced his way south deep into lands previously occupied and held by advanced Islamic culture since the year 711.

7

Waning of the Crusades
(1150–1270)

Here it is important to recall the importance of relics in the piety of Western laymen. They were a physical contact with heaven and a source of valuable power. Holiness was still locally conceived and bound up with the physical and tangible, rather than a spiritual and pious state of soul. A good Christian king was not expected to have Solomon's proverbial wisdom and religious insight, but he was expected to build beautiful churches to enshrine relics.—Karen Armstrong[1]

As the second half of the 12th century began, European religious fervor and military energies had clearly shifted away from the Iberian Peninsula and more towards the Holy Land with its recently established (and precarious) Latin Crusader Kingdom of Jerusalem. Spain and Portugal were by then more or less on their own in terms of completing the Reconquista or, more immediately, defending themselves against the latest Islamic onslaught coming from the North African Almohads. As for the Middle East, the inaugural Crusader state of Edessa had abruptly fallen to the Seljuk Turks in 1144 after less than half a century of existence. This setback in turn prompted the Second Crusade immediately afterwards which, to the consternation of western Christendom, was rounded defeated by the Turks in 1148–1149, although a faraway Portuguese victory led by Afonso I at Lisbon in 1147 was unconvincingly spun by the Papacy as a "Crusader" success (see Chapter 6). Placing these events into a larger historical context, one is struck by the tremendous disparities in chronological time spans. The European Crusades into the Middle East, from total start to finish, lasted less than two centuries. By contrast, the Iberian Reconquista stretched from 711 to 1492—no less than 781 years of relentless Christian-Muslim conflict within a relatively confined geographic area. Yet it is the Crusades that have far more captured the popular imagi-

nation of subsequent generations, perhaps because of their failure and futility (for Christians at least), perhaps because of widespread anti–Spanish bias, or perhaps because the sheer chronological length of the Reconquista boggles human comprehension.

Even as the Crusader kingdoms lurched towards their imminent demise, however, a more durable legacy of the Armenian Orthodox Church began reaching prominence in Crusader-occupied Jerusalem. In 1165, the German pilgrim John of Würtzburg announced in writing that the newly completed Armenian Cathedral of Saint James claimed among its numerous holy relics the skull of Saint James the Greater.[2] There is no prior documented evidence for this claim, and this is not the proper place to delve into the infinite difficulties of sorting out fragmentary references to this ancient Christian site since the early fifth century (see Chapter 6). A generation earlier, before the arrival of the Crusades, the very same location had been occupied by a rival Georgian Orthodox Church, part of which was incorporated into the subsequent Armenian structure.[3] Various scholarly theories, some dazzlingly elaborate, as to how the Jerusalem shrine eventually came to be associated with Saint James the Greater have been recently well summarized by Jan van Herwaarden in his exhaustive study on the subject.[4] Suffice it within these pages to say that numerous similarities between the legends of the Spanish Santiago and the obscure Egyptian martyr Saint Menas, along with considerable name-confusion between Saint James the Greater and Saint James the Just (both martyred in Jerusalem during the mid–first century), further exacerbated by formidable barriers of east-west language translation, may have contributed to the creation of Jamesian traditions in both Spain and Jerusalem. Some of these theories have attempted to reconcile or at least plausibly explain how both came into simultaneous existence. More significant is that less than 25 years after John of Würtzburg's excited testimony regarding the Armenian Cathedral, Jerusalem would once again be under Islamic rule, albeit with a far more tolerant attitude towards Christian pilgrims.

The abysmal failure of the Second Crusade, combined with the growing strength of rival Christian kingdoms such as Portugal and Aragón, contributed to a growing sense of insecurity in north-central Iberia. In 1171, the Military Order of Santiago was formally established with Pedro Fernández de Castro (1115–1184) as its first Grand Master, thereby institutionalizing the same cult so tirelessly promoted by the late Bishop Gelmírez.[5] The biggest source of anxiety, however, was the clandestine arrival of the Almohad Caliphate in southern Iberia during mid-century, methodically displacing their Almoravid predecessors with a more durable, efficient and formidable center of Islamic resistance. After shifting their Iberian base of operations from Córdoba to the more strategically located Seville (where they built another impressive Great Mosque), in 1172 the Almohads recaptured the city

of Murcia just southwest of Valencia. For a while it looked as if the latest gains of the Reconquista might be rolled back, but in 1184 the Almohads were roundly defeated at the Battle of Santarém in southern Portugal by an allied Christian force under the intrepid leadership of Afonso I (see Chapter 6) with a major assist from his son-in-law, King Ferdinand II of León. Santarém proved that the Almohads were no more invincible than the Almoravids. At this point in time both sides in the prolonged conflict seemed to regroup and consolidate their resources for a new round of hostilities playing out over the next several decades.

In contrast to this latest Iberian stalemate, things were going very badly for Christian Crusaders in the Middle East. On July 4, 1187, the flower of the combined military orders serving the Latin Kingdom of Jerusalem were wiped out at the Battle of Hattin in modern day Israel. Doing the damage was a dynamic new Islamic coalition led by the Egyptian Sultan Salah ad-Din Yusuf, better known as Saladin, the premiere hero of his generation both in war and peace. Shortly after this disaster, Jerusalem itself surrendered to Saladin, who won himself additional lasting fame by allowing Christian defenders to peacefully evacuate, in stark contrast to the merciless slaughter of Jerusalem's civilian population by Christian Crusaders back in 1099. Long story short: all subsequent European Crusades failed to regain Holy Land, excepting an ephemeral negotiated truce between 1229 and 1239, and the coastal city of Acre, which was permitted to exist as a fortified trading post until 1291, when its Latin remnants were mercilessly extinguished by the Egyptian Mamluks. Christian pilgrimage access to Jerusalem (though not Jerusalem itself) had been temporarily secured by military and diplomatic efforts of the Third Crusade in 1192, but the Fourth Crusade of 1204 resulted only in the sack and weakening of Constantinople by a formidable alliance of French and Venetian Christian forces.[6] It mainly proved to be a signal harbinger of Venetian international trade ambitions over the next several centuries.

Crusader setbacks during the late 1180s and early 1190s then seemed to carry over back to Iberia, where in 1195 the Almohads under Caliph Moulay Yacoub decisively defeated an overconfident Castilian host under the personal leadership of King Alfonso VIII (1155–1214) *El Noble* ("the Noble") at the Battle of Alarcos near Toledo. Present that day as an advisor in the victorious ranks of the Almohads was Pedro Fernández de Castro (1160–1214), son and namesake of the original Grand Master of the Santiago Order. During previous decades, Castro the Younger had managed to fall afoul of both Alfonso and the Castilian nobility, after which he accordingly switched allegiances.[7] Christian casualties were enormous and most of the Santiago knights were killed in action. King Alfonso managed to escape the field and lived to fight another day. Fortunately for Iberian Christians, however, the Battle of Alarcos proved costly for the Almohads as well, who were forced afterwards to move

deliberately rather than fully exploit their temporary advantage, not unlike Almanzor's bloody triumph at the earlier Battle of Cervera (see Chapter 5). Nonetheless, Alarcos proved to be the high water mark of Almohad power on the southern Iberian Peninsula.

Amidst this atmosphere of political and military uncertainty, pilgrimage traffic along the Camino de Santiago continued to thrive, even as wars were waged and epic-scaled battles fought to the immediate south. On the literary front, sometime during the early 13th century, the anonymous epic poem *El Cantar de mio Cid*, written in Castilian, reached the final form by which it is generally known today.[8] Just as Santiago de Compostela had become a sacred destination closely tied to the Reconquista effort, "The Song of My Cid" became its secular literary counterpart, occasionally invoking the aid of Saint James within the text. In 1211, the fully completed (at least in its original design) Cathedral of Santiago de Compostela was formally dedicated by King Alfonso IX of León, son of Ferdinand II (who had triumphed at Santarém) and cousin to King Alfonso VIII of Castile (recently defeated at Alarcos). The great ceremony marked the latest royal designation of Santiago de Compostela as a landmark shrine representing Christian military and political fortunes in the Iberian Peninsula, a long process begun four centuries earlier at a time in which the tiny Kingdom of Asturias was fighting for its very existence (see Chapter 4). Since then, Christian Iberian kings had won many battles and lost more than a few; most importantly, however, they had provided Spain with a magnificent physical monument housing important religious relics which could be venerated by all (see header quote). As if to ratify its holy status, Santiago de Compostela was visited in 1214 by the venerable future saint, Francis of Assisi, traveling in the guise of a Camino pilgrim.[9] By the early 1200s, Santiago had also become a highly visible symbol for all of Iberian Christianity's tremendous resiliency, conquering spirit, and staying power in the face of all adversity.

As if right on cue, one year after the official dedication of the Santiago Cathedral, arguably the most important battle in the long history of the Reconquista was fought on July 16, 1212, at Las Navas de Tolosa in south central Iberia, not too far from the scene of Castilian disaster at Alarcos 17 years earlier. This time around, an unusually united coalition of Iberian Christians under the nominal leadership of the now 57-year-old Castilian King Alfonso VIII, with supporting contingents led by the kings of Portugal, Aragón, and Navarre, took by surprise a larger encamped Almohad force under Caliph Muhammad al-Nasir and dealt them a catastrophic defeat. The Christian campaign had been blessed as a holy war by Pope Innocent III, and the Archbishop of Toledo, Rodrigo Jiménez de Rada, who personally accompanied the army into battle. As a sign of their unified purpose, the Christians flew banners displaying images of the Virgin Mary and Christ child.[10] The great

victory at Las Navas de Tolosa redeemed the reputation of Alfonso VIII as a Christian warrior king and correspondingly destroyed that of the Caliph, who fled from the field and died soon afterwards in Morocco. Consequently, the fleeting Almohad hold on southern Iberia was forever broken.

Repercussions of the battle were almost immediate. With the death of the Caliph in 1213, the Almohad dynasty plunged into disputed chaos for the next four decades, unable to mount any meaningful, organized resistance during that period. Meanwhile in 1217, Ferdinand III (1200?–1252), later canonized a saint by the Roman Catholic church, ascended the Spanish throne and quickly reunited, this time in permanent fashion, the previously competing crowns of Castile, León, and Galicia. After this administrative triumph, the Christians proceeded to make massive territorial gains in Andalusia, including conquests of Córdoba (1236) and Seville (1248), both former proud capitals of Iberian caliphates. Granada remained the only independent Islamic kingdom, but paid heavy tribute to Castile in return for its freedom. Earlier in 1229, the appropriately named Jaume I (James I) *El Conquistador* of Aragón, in a surprisingly bold and well-organized naval action, conquered the Balearic Islands (southeast of Barcelona), thereby instantly enriching his kingdom with massive trade revenues.[11] In nearby Portugal, Alfonso III conquered Faro in the southern Algarve region, thereby completing the Portuguese phase of the Reconquista by 1249. Thus by mid-century, with the exception of a now tributary Islamic Kingdom of Granada, all that had been lost four centuries earlier by Christian Iberia was by then regained. This time around, however, the Peninsula was ruled by a confederacy of strong rival kingdoms, as opposed to the monolithic and unpopular Visigoth monarchy of old.

Islamic influence in Iberia, however, was far from being over. Devout Muslims from across Christian-occupied southern Spain and Portugal now flocked to the geographically compact Kingdom of Granada and transformed it into a very defensible, though not impregnable, fortress-state, not unlike what Constantinople had become to Christians in Eastern Europe. In 1232 began the reign of Mohammad I ibn Nasr (1191–1273), founder of the Granada-based Nasrid dynasty, which would last for the next 260 years, until 1492 (see Chapter 10). Ibn Nasir was wise and strong enough to keep the peace with the Reconquista alliance as he strengthened the last remaining stronghold of Iberian Islam, including construction of the famed Alhambra Palace in Granada. Helping Granada in this effort, though somewhat unwittingly, was the rise of yet another Berber power in Morocco, the Marinid dynasty, who by 1259 had replaced the Almohads as rulers of the North African Maghreb. Repeated Marinid intervention into Iberia affairs over the next several decades, though having little or no permanent impact, created confusion and shifting alliances between Granada and rival Christian states such as Castile, Aragón, and Portugal. This continued political and military

uncertainty provided Islamic Granada with a valuable, much needed respite from a freshly aggressive and re-energized Christian Reconquista effort.

Meanwhile, things continued to go very badly for the last of the European Crusaders. After brooding for nearly 20 years over his defeat in Egypt during the Seventh Crusade, King Louis IX of France (1226–1270), later beatified as Saint Louis, led a mostly French army into Tunisian North Africa, inspired by baseless rumors that the Caliph of Tunis was interested in converting to Christianity. In the terse expression of British historian Edward Gibbon, "Instead of a proselyte he [Louis] found a siege."[12] After a significant part of his army died rapidly from disease and Louis himself succumbed, the survivors of the Eighth Crusade quickly packed up and returned home to France. The Crusade had been highly unpopular among the masses, and after the death of Saint Louis, European interest in Crusader military interventions considerably waned. Rulers and nobility continued to affect enthusiasm for centuries afterwards, but their subjects would have none of it, by that time having witnessed several generations destroyed by pointless and futile foreign excursions.[13] There were also other distractions. Europe was beginning to become wealthier; there was a lot of money to made and spoils to be divided much closer to home than the Holy Land. Saint Louis himself was a good example of this, despite his passion for Crusading, being a perpetually rich monarch even after having paid literally a king's ransom for his own release from Egyptian captivity, in addition to easily financing (near single handedly) two Crusades. All of this seemed far removed from the simple militarist piety and practical homeland defense that had originally inspired the still-thriving cult of Santiago de Compostela.

In addition to foreign military adventures and ransom money, Louis IX also financed some of the most magnificent medieval religious structures ever constructed. For example, in 1248, shortly before his defeat and Egyptian captivity during the Seventh Crusade, Louis dedicated completion of the astonishing Sainte-Chapelle ("Holy Chapel") in Paris, a short walking distance north of Notre Dame Cathedral. Among Sainte-Chapelle's many amazing features are well over a thousand beautiful stained glass windows, all recently restored through modern laser technology.[14] As an art form, stained glass had been utilized by many cultures long prior to the High Middle Ages; however, it was during the 12th century in France, perhaps in Burgundy, where it began to be manufactured and incorporated wholesale into the new Gothic cathedrals then rising all across Europe, including faraway Santiago de Compostela. Thanks to northern Iberia's longstanding close ties with France, via the Camino Frances, the new technology would easily be imported, then eventually replicated. Nine centuries later, stained glass is still nearly synonymous with religious art. Much later, in 19th century England, pre-Raphaelite artisans such as William Morris and Edward Burne-Jones would

take it to even greater heights of sophistication. Arguably their most spectacular achievement in this medium is Trinity Church of Sloane Square, completed circa 1890 and still miraculously standing after the London Blitz of World War II. Trinity's centerpiece is the enormous east window by Morris and Burne-Jones depicting no fewer than 48 religious figures, including Saint James the Greater, assuming his familiar third place of standing within the hierarchy of the 12 apostles.

In terms of Jamesian stained glass iconography, however, nothing can compare with that dedicated by Louis IX at Chartres Cathedral in 1260, a decade before his death as a Crusader on the shores of Tunisia. Located southwest of Paris along the main French pilgrimage route to Spain, Chartres may well represent the apotheosis of all medieval gothic cathedrals. In terms of beauty, scale, and proportion, it certainly belongs to a very select class of architecture. Like Santiago de Compostela and Saint-Sernin Basilica in Toulouse, Chartres Cathedral today is, quite deservedly, a designated UNESCO World Heritage Site. Although the true original design and building process of Chartres is clouded in uncertainty and scholarly debate, there is no disagreement on the result, still there for all to see. Begun sometime during the mid–1100s, the stunning development was delayed or stalled several times due to various mishaps and interruptions before King Louis IX himself, assisted by his tremendous wealth, apparently pushed the project to completion a century later. Long before the cathedral, however, Chartres had been a pilgrimage shrine commemorating local martyrs and, like Sainte-Chapelle in Paris, became a repository for an ever-growing collection of holy relics. For purposes of this study, the obvious focal points of Chartres are the enormous stained glass panels, particularly those depicting the life of Saint James the Greater in no fewer than 30 interlocking scenes, prominently situated among the lower windows along the easternmost chevet and adjacent ambulatory. Its magnificence beggars all description, especially when one considers that it was the product of an age innocent of mass production or modern technology as we understand those terms today.

Among the series of stained glass scenes at Chartres covering the life of Saint James the Greater, limited space permits only passing commentary, despite a treasure trove of detail.[15] Interestingly, at the base of the window are two corresponding plates portraying the medieval professions of furrier and draper, both of whom claimed Saint James as their patron, as surely both profited from pilgrimage traffic along the Camino Frances between Paris and Santiago de Compostela. It is safe to deduce that the furrier and draper guilds of Chartres financed this window, and may have indeed been compelled by authorities to do so. From examples such as this, it is easy to see how and why Louis IX of France was such a wealthy monarch throughout his long reign.[16] In tandem with resources from royalty and nobility, these traders and

tradesmen would help to patronize anonymous artisans, whose talented work would in turn find ultimate expression in the imposing cathedral masterpieces such as the one dedicated at Chartres. Selecting a single window pane in this series for discussion is nearly impossible, but at least one deserves mention. Near the upper central portion, James is depicted being led off to execution, along with the scribe Josias, the latter being converted to Christianity by James after having publicly accused the saint of being a Christian. Both have ropes around their necks as they are led by a club-wielding officer, followed by a swordsman—presumably their executioner. The facial expressions are passive and resigned; a sense of sympathy for the condemned is strongly conveyed. This scene, like most of the surrounding ones in the overall window, are drawn from Jacobus (James) de Voragine's highly popular *The Golden Legend*.[17] The story of the repentant scribe Josias is traceable back to Eusebius who did not, however, name the accuser (see Chapter 1). Curiously, the Chartres window makes no allusions or references to James having been buried in Spain or later appearing as an apparition at the head of Spanish armies. Instead, almost all focus is on the interaction between James and his Jerusalem contemporaries. By this point, French authorities were apparently not interested in over-emphasizing Spain's growing nationalistic power and territorial ambitions.

For ultimate visual expression of the theme on Josias, the repentant whistle-blower, however, one must turn to later masters of the Renaissance and beyond. The destroyed fresco on this subject matter by Andrea Mantegna is discussed separately (see Chapter 19). In terms of sheer visceral impact, however, it is doubtful that anyone has ever surpassed *Martyrdom of St. James* (1722) by the Venetian master Giovanni Battista Piazzetta (1682–1754), an older contemporary of Tiepolo (see Chapter 15). The work is still on display in the Venetian Church of San Stae (Saint Eustachius) as part of a cycle on *Lives of the Apostles*, in which various artists, including Piazzetta and Tiepolo, competed with one another to produce memorable images. Piazzetta's *St. James* depicts and aged but sturdy saint literally being roped-bound by a determined and brutish-appearing Josias. James appears barely aware of his captor, moving forward while carrying an oversized codex and his emblematic pilgrim's staff. Informed viewers, as those at the church would have likely been, immediately realize that the unrestrained ferocity of Josias will soon be transformed into repentant remorse. In the end, both will become martyrs, each in their own way, but neither lacking in powerful physicality. Once again, there is no hint of Spanish Santiago in this drama, only James' singlemindedness in spreading the gospel, which he succeeds in doing even with respect to his captor Josias. Overall, the painting has a similar effect to a station of the cross (with its subject an apostle rather than Jesus), conveniently serving to inspire or edify, depending on the occasion and the audience. At the time,

Piazzettia would have been about 40 years old and at the height of his abilities. A younger Tiepolo would have been in his mid–20s and famous in his own right, yet surely impressed by what his older colleague and competitor had just produced.[18] Tiepolo's work would continue to bear the stamp of Piazzetta's influence afterwards.

Before leaving this fascinating topic, it would be remiss not to mention a relatively unknown work today on display in the Musée National du Moyen Âge (formerly the Musée de Cluny) in Paris.[19] Here can be seen a series of four stained glass panels portraying SS. Peter, Paul, John and James, dating from the late 13th century and of somewhat uncertain provenance, possibly taken from the chapel of the famous Chateau du Rouen where Joan of Arc would be imprisoned two centuries later.[20] Saint James is depicted as a humble Camino pilgrim holding a staff and travel purse, surrounded by his emblematic cockle shells. The cult of Santiago Matamoros is nowhere to be seen. Aside from its inherent beauty, this Burgundian image underscores how Saint James had by then been considerably pacified, if not outright commercialized. The French nobility of Rouen, capital of the same Normandy province which had not so long previous produced a warrior class terrorizing all of Europe (including Iberia), appeared to be no longer interested in crusading or Reconquista efforts, especially following the death of Saint Louis. Now they were mainly interested in commerce, and with good reason considering the potential profits to be realized. For a brief moment it looked as if Christian coexistence with Islam might become a desirable alternative to never-ending conflict and strife.

8

Experiment in Tolerance
(1270–1300)

So it is with everything: it is difficulty which makes us prize things. The people of the Marches of Ancona more readily go to Saint James of Compostela to make their vows: those of Galicia, to Our Lady of Loreto.—Montaigne[1]

As Crusader pretensions in the Holy Land began to forever unravel during the late 13th century, a remarkable contrast in cultural coexistence briefly appeared at the far opposite end of Christendom on the Iberian Peninsula. Not long after the last standing Crusader kingdom at the city-fortress of Acre had been erased from the map by Egyptian Mamluks in 1290, the Iberian coastal citadel of Tarifa near Cádiz held firm against a Marinid assault from nearby Morocco in 1296. The Tarifa garrison was commanded by a Christianized Muslim (Guzmán "the Good"), while the besieging Marinid force included the Christian rebel John of Castile, alienated brother to King Sancho IV. Local defenders against the Marinids no doubt included Muslims, since Tarifa had belonged to the Islamic Kingdom of Granada only five years before. Meanwhile, adjacent Granada offered no help whatsoever to the invading Marinids, who were eventually forced to withdraw by a surprising show of unified resistance. The close collaboration between Christians and Muslims on both sides of the Reconquista at Tarifa represented nothing unusual by Iberian standards. By this point, the two cultures had been living geographically side by side, or in some cases intermingled, for nearly five centuries. Ever since the time of the Cid (see Chapter 6), it was standard practice for Christians and Muslims to forge temporary military alliances. Nevertheless, by the late 1200s, an even bolder spirit of cooperation between the two camps seemed to briefly assert itself (and then to recede) under the creative leadership of an extraordinary Spanish monarch.

Alfonso X *El Sabio* ("the Wise") of Castile (1221–1284) ascended the

Castilian throne in 1252, following the death of his father, the (later) canonized Saint Ferdinand III. Whereas the rule of Ferdinand was characterized by irresistible expansion of Iberian Christian rule, that of his son would be marked by policies nearly unprecedented in medieval Europe, namely, legal and cultural coexistence between Christians, Muslims, and Jews. Thus Alfonso played King Solomon to his father Ferdinand's King David. Whereas Ferdinand had been a conqueror, his son Alfonso was a consolidator and bridge builder. Although the new policy of peaceful coexistence would not last long and ultimately fail, it was not forgotten by any means, and during modern times has found considerable resonance for those who pay any attention to history. Today, flattering effigies of Alfonso the Wise grace both the entrance to the National Library of Spain (see Chapter 2), as well as the interior of the U.S. Capitol Building in Washington, D.C., although it is likely that most of the American legislators who work there have no actual clue who the historical Alfonso was, quite unlike modern Spaniards who admirably view him as a nearly iconic secular monarch.[2]

Concurrent with this experiment in tolerance was a burst of royally patronized literary activity that more or less finalized Castilian as the dominant Spanish dialect of Iberia, a dialect eventually spreading across the globe over the course of the next three centuries. Arguably the cornerstone of this intellectual foment was Alfonso's *Siete Partidas* ("Code in Seven Parts") of 1265, extensive medieval legislation that codified the egalitarian principles of social justice, so ahead of its time and not widely accepted at first (especially by the privileged of that society), but then having a lasting influence throughout Iberia and well beyond into the New World. In tandem with his activities as a lawgiver, Alfonso systematized academic activities in Toledo that had been revolutionizing European learning for over the last century.[3] Assembling an elite team of Christian, Muslim, and Jewish translators in Toledo, these experts proceeded to make accessible for the rest of Europe previously lost literary works from the ancient Greek and Roman worlds at an even faster pace than before. These would help lay the groundwork for an intellectual Renaissance that would begin to take shape in the following century, even as Europe itself reeled under various unforeseen disasters (see Chapter 9). In addition, Alfonso was actively involved with compilation of the *Estoria de España*, the first Castilian language chronicle of the Iberian Peninsula.[4] Whether promoting new laws or historical memory, the literary legacy of Iberia represented a novel, unified, and multicultural vision of society which the Wise King saw as the only feasible and desirable way of moving forward for his country. To do otherwise would involve bloodshed, acrimony, and lack of credibility over the long term, as subsequent Spanish history over the next three centuries would prove all too well. In most respects, this unfulfilled vision of Alfonso X proved to be more influential and appealing to the popular

imagination than those of Saint James the Greater appearing on horseback to lead victorious Spanish military ventures.

In spite of these achievements, after a brilliant reign of over three decades, Alfonso's long rule ended in rebellion, exile, and apparent mental derangement.[5] Problems began when his vassal, the Caliph of Granada, cut off paying tribute, possibly feeling his authority undercut by Alfonso's growing popularity among Muslim subjects living on both sides of the divide. The difficult situation with Granada was exacerbated by Alfonso's repeatedly thwarted ambition to become Holy Roman Emperor, which also proved an unwelcome distraction. On top of this, there were marital estrangements with his wife Queen Violante, daughter of the formidable King James *El Conquistador* of Aragón. The hardest blow came in 1275 when Crown Prince and heir apparent Ferdinand de la Cerda of Castile was killed in the Battle of Écija near Granada. This cleared the way for the ambitions of Alfonso's second son, the future King Sancho IV, who openly rebelled against his father in 1282 when Alfonso formed an alliance with the Islamic Marinids of Morocco against the continually defiant rulers of Granada and dissident Castilian nobility.[6] The Christian-Islamic alliance was particularly startling to conservative Castilian nobility who had not long previously been defeated by the Marinid navy near Gibraltar, thereby forcing the Castilians to abandon their siege of Algeciras in 1278–1279. Despite these serious blows, however, Alfonso's legal and moral authority continued to exert itself until his natural death in 1284, repeatedly supported by the devotion of his diverse common subjects and a handful of similar-minded and progressive-thinking aristocratic followers. Even as his life came to an unhappy close, there seems to have been a general realization that he represented something quite out of the ordinary in the course of human affairs.

Interestingly enough, Alfonso's domestic opponents included the military Order of Santiago, who were among those taking sides with Prince Sancho during his rebellion.[7] They may have felt long slighted because Alfonso never bothered traveling to Santiago de Compostela and never showed much personal interest in the jingoistic cult of Santiago Matamoros, although Alfonso had once sent his elder son Prince Ferdinand there in 1270, before the Infante died fighting at Écija five years later.[8] As noted by Jan van Herwaarden, "It would seem most probable that Alfonso the Wise tried to play down the significance of the shrine in Compostela."[9] Instead, Alfonso proved himself a lifelong devotee of the Virgin Mary. This was not unusual for the times, for as also observed by Herwaarden, the Marian cult tended to overshadow that of Santiago from the 12th century onwards, and even more so after the watershed Reconquista victory at Las Navas de Tolosas in 1212, which involved a very broad Christian coalition (see Chapter 7).[10] Alfonso, for his part, associated some of the greatest literary and musical works of his reign

with devotion to the Virgin, including the *Cantigas de Santa María* ("Songs of Holy Mary"), excerpts of which were buried alongside of Alfonso at his final resting place, per directions from his own last will and testament.[11] Although Alfonso's will also makes an obligatory appeal to Saint James ("our lord, defender, and father"), this same appeal is made in conjunction with that of other saints (SS. Clement and Alfonso) to intercede on his behalf with the Virgin Mary and divine son.[12]

While the cult of Santiago would continue to play an important role in the development and worldwide spread of Spanish-speaking culture, after the time of Alfonso the Wise it would become far more nuanced and subdued, with more of an emphasis on individual pilgrimage (over territorial conquest) and subservience to the unifying power of the Marian cult. There were a number of good reasons for this. Worship of the Virgin Mary was, by geographic definition, far more multicultural and diverse than that of Saint James the Greater.[13] Add to this the Marian cult being far less gender specific than Santiago Matamoros and, for that matter, less brutally militant. By the time of Alfonso, the Reconquista had spread itself across a wide geographic area no longer united by language or custom. There were even some converts (with varying degrees of sincerity) coming into Christianity from Islam and Judaism, for whom the traditions of Saint James meant little or nothing or at least nothing positive. Something extra was therefore needed in terms of popular iconography and worship. Alfonso was born in Toledo, the traditional rival of Santiago de Compostela both in theology and politics, while his mother, Elisabeth (Yolanda) of Swabia, was a Hohenstaufen princess descended from a German international dynasty of Holy Roman emperors. Accordingly, his cultural outlook and frame of reference extended far beyond Iberia, often to own his political and military disadvantage.[14] One aspect of this internationalist viewpoint was Alfonso's veneration of the Marian cult. For example, in the influential *Cantigas*, which he either sponsored or wrote himself, the superiority of the Virgin Mary as a healer and miracle worker over Saint James is repeatedly asserted.[15]

By the late 1200s, this closely related but strictly hierarchal relationship between SS. James and Mary was further reinforced by the initial appearance and enormous success of *The Golden Legend* by Jacobus de Voragine, Italian Bishop of Genoa. Voragine was by training a member of the Dominican order that attached special devotion to the Marian cult, and this priority is clearly evident both in *The Golden Legend* and his other surviving literary works. Drawing upon biblical text, upon the *Codex Calixtinus* (see Chapter 6), and expressly upon respected authorities such as the Venerable Bede and John Beleth, Voragine compactly summarizes in Chapter 99 of the *Legend* the Jamesian tradition as it is best remembered today, thanks in no small part to the first English version being later printed by William Caxton in 1483.

Voragine also conveniently provides his readers with a chronology, specifying that Saint James the Greater was martyred on March 25, his body brought to the environs of Santiago de Compostela on July 25 (the saint's official feast day), and buried there on December 30, the date on which his tomb was completed. March 25, the date of James' martyrdom, is of special interest, being also the Feast of the Annunciation, one of the most important holy days of the Lenten season and obviously of central importance to the Marian cult as well. Lastly, it should be noted that March 25 is also a date traditionally (though not universally) assigned to the crucifixion, thereby forever inter-twining the martyrdom of Saint James the Greater with both the Virgin Mary and the Passion of Christ.[16]

The Marian cult focus of prominent personages such as Bishop Voragine and Alfonso the Wise was well within in the spirit of the times. Pinpointing when, where, and how this trend began is difficult; however, a good case can be made that it received its first big boost from the life and work of Saint Dominic of Caleruega (1170–1221). Santo Domingo, as he is known is Spanish, was a Castilian-born and educated churchman first achieving prominence at the court of Alfonso VIII, the future Reconquista hero of Las Navas de Tolosa (see Chapter 7). Dominic was a rough contemporary of Saint Francis, and like Francis, traveled extensively, spending his final years in France and Italy. Unlike Francis, Dominic was an establishment insider throughout his career, and often worked on behalf of powerful political interests. He was canonized by Rome in 1234, only 13 years after his death. Rightly or wrongly, his name is often associated with early prototypes of the Spanish Inquisition, usually in connection with his unsuccessful attempts at dealing with the Catharism heresy then prevalent in southwestern France. Dominic learned early that a good way to bring Christians together was through devotion to the Virgin Mary, and this became a hallmark of his preaching. Some credit him with beginning or promoting use of the Marian Rosary. Whether by coincidence or by design, after the time of Dominic a totally different image of Saint James the Greater seems to predominate, one almost the opposite of Santiago Mata-moros, the latter possibly derived from Beatus' White Rider of the Apocalypse or the famed *à la jinete* light cavalryman dominating the Iberian Peninsula for centuries (see Chapter 3). From then on the new Santiago would, with a few notable exceptions, instead typically be represented as a peaceful pilgrim, one strictly subservient to the Virgin and Christ child.

The Dominican de-emphasis upon the Galician-centered Santiago cult in favor of a more widespread Marian devotion had political consequences for the likes of King Alfonso the Wise, as well as finding frequent visual expression in medieval and Renaissance art. No better example of this can be demonstrated than in the somewhat underrated and comparatively unknown work of Venetian-born painter Lorenzo Lotto (1480?–1556), whose

distinctive oeuvre included a unique depiction of Saint James the Greater, completed at the very height of Spanish triumphalism during the early 16th century (see Chapter 11). Lotto was a journeyman artist who struggled to earn a living over a long and prolific career. He was a contemporary of Titian, and there is some visual evidence that they influenced each other's output. Today his surviving canvases may be viewed in the world's best known museums. Early on, Lotto produced notable masterworks as he traveled through the region known as the Marches of Ancona, located along the Adriatic coast of northeastern Italy, and anchored by the famous Marian shrine within the Basilica della Santa Casa of Loreto. The site had been a popular pilgrimage destination since at least the 13th century and the time of Alfonso the Wise. By the late 16th century, the French humanist Montaigne was making dry remarks about religious pilgrims choosing far-flung destinations based on difficult distances from home (see header quote). Tellingly, Loreto from its very beginnings was a major bastion of the Dominican order, and Lotto himself became a Dominican lay brother at Loreto late in life, having understandably grown weary of his precarious existence as a freelance painter for hire, though he appears to have continued painting until the very end. Upon his death, Lotto requested that he be buried in a Dominican habit, in keeping with his lifelong devotion to the church and gratitude towards the religious order which employed and allowed him to have some dignity in his final years.

During his initial wandering period through the Marches of Ancona, circa 1512 (when he was probably in his early 30s), Lotto did a standard rendition of *San Giacomo Maggiore* as a religious pilgrim on the road, not unlike the journeyman artist himself, one would suspect. Some three and a half decades later, still before Lotto would take his vows as a Dominican lay brother, came his *Madonna and Four Saints* (1546), in which Saint James the Greater figures among those paying appropriate homage to the Virgin, standing opposite fellow apostolic martyr Saint Andrew. Perhaps the most telling, however, is Lotto's haunting self-portrait from the 1540s, today on public view in Madrid's Thyssen-Bornemisza Museum. Here we come face to face a 60-something year old painter who was obviously a deeply driven artist, and one whose personal intensity causes him to appear as a kind of Renaissance-era Vincent Van Gogh. By the end of the decade, Lotto had found sanctuary at the shrine of Loredo among the Dominicans, who in turn used Lotto's tremendous talent to adorn their sanctuaries. The shrine itself, according to legend, had been wondrously brought back to Italy after final collapse of the last Crusader states along coastal Palestine during the late 1200s. These Holy Land artifacts are said to have been the house of the Virgin Mary herself, a small enclosure simply constructed of stone and Lebanon cedar. Its traditions and attributed miracles, like those of Santiago de Compostela, are too vast to enumerate within these pages.

Returning to an earlier stage in the long career of Lorenzo Lotto, surely his most striking depiction of Saint James the Greater occurred around 1529, during one of several brief returns to his home town of Venice, but several years after having first visited the Marches of Ancona. His beautiful canvas, *Madonna and St. Catherine of Alexandria, St. James the Greater, and an Angel*, today on view at the Kunsthistorische Museum in Vienna, must rank as one of the more personalized interpretations of the Santiago tradition in Renaissance art. In this sense, the work is a forerunner of numerous other semi-autobiographical images of Saint James that would dominate the 17th century (see Chapter 14). In Lotto's masterpiece, viewers encounter the Christ child at the center of the painting, being presented like an offering by a youthful Mary to a kneeling James. A hovering blond angel holds a laurel wreath over the head of the Virgin, who is seated at the base of what appears to be a Lebanon cedar, perhaps symbolic of the Loreto shrine. The most unusual feature of the work (though not unprecedented) is the presence of Saint Catherine of Alexandria, kneeling between James and the Christ child, the latter turning the pages of the bible she holds as Catherine dispassionately observes James, as if assessing his devotional sincerity. She wears a rosary, a device nearly synonymous with the Dominican order. The fact that Catherine's own legend as virgin Christian martyr has almost always been viewed as ahistorical, raises implied questions about the perceived historical status of the Santiago tradition, at least to a modern viewer.[17] As for James, his pilgrim's staff is the only accessory identifying him. His complexion is dark and ruddy, perhaps denoting Spain or perhaps the artist himself, a solitary Venetian traveler.

This type of devotional depiction is quite different than, say the one of Saint James shown by Nicolas Poussin a century later in connection with the Marian Pillar of Zaragoza (see Chapter 2). In Lotto, or at least in this specific painting, the figure of James is relegated to the far right side of the canvas, only about three quarters delineated, literally a peripheral figure. The center of attention is the Madonna and Christ child. Saint Catherine of Alexandria receives precedence over Santiago in every respect as well. There is none of the family intimacy between James and the Virgin (possibly as a nephew-aunt relationship) suggested by Poussin, nor is there any hint of the ancient pagan world that Poussin was so attracted to. The iconic Pillar of Zaragoza, Spain, is prominently replaced by a cedar of Lebanon. No longer is James carrying a bible, as he did in Lotto's own earlier version, or in many other archetypal depictions of James. In effect, the pilgrim Saint James here travels to the Marian shrine at Loreto, Italy, and not to his namesake, Santiago de Compostela in Galicia. As Lotto painted, the Reconquista was a thing of the past and the conquest of the New World was proceeding apace (see Chapter 11). Never had the role of Saint James the Greater been reduced to a more

humble status—now he was just another religious pilgrim paying simple homage to the Holy Family at a decent and respectfully removed distance, standing in line behind other semi-legendary saints, it should be added.

The 13th century closed in Iberia with the 1297 Treaty of Alcanizes between Castile and Portugal, in which territorial borders between the two neighboring and long feuding states were peaceably established, more or less in permanent fashion. This acknowledged separatism was quite a contrast from a few decades earlier when Alfonso the Wise aspired to a tolerant form of Christian European unity in his thwarted ambition to become Holy Roman Emperor. By the year 1300 there was instead a renewed mood of Reconquista aspirations, especially since the Crusades had officially ended in abysmal failure. Everything seemed poised for the imminent, final fall of Iberian Islam; yet, as often happens in human affairs, conventional wisdom in Europe was about to be blindsided by a series of unforeseen catastrophes. These terrible setbacks, as if sent by Heaven itself in rebuking disapproval, including worldwide pandemic and a fractured pontificate, would delay completion of the Reconquista for yet another two centuries. Meanwhile, the Italian city-state of Venice, which one day would produce a bumper crop of artistic geniuses such as Lorenzo Lotto, was about to once again forcefully enter the stage of world affairs. Around the turn of the 14th century, a popular Venetian manuscript later known as *The Travels of Marco Polo* began to widely circulate throughout Europe. Interest in Eurasian trade routes began to intensify more than ever, along with the staggering potential profits to be made through these routes. Further fueling this interest was the inconvenient fact that, in the aftermath of Crusades, Ottoman Turkish resistance to European traders had understandably intensified as well. With motives of financial fortune dressed up in the guise of Christian evangelization, Europeans now began, perhaps for truly the first time since the fall of Rome, to think outside of the box in terms of geography and trading routes.

9

Black Death
and Western Schism
(1300s)

She'd journeyed to Jerusalem three times.
Strange rivers she had crossed in foreign climes.
She'd been to Rome and also to Boulogne,
To Galicia for Saint James and to Cologne,
And she knew much of wandering by the way.
She had the lover's gap teeth, I must say.
 —Geoffrey Chaucer[1]

As the 14th century began it seemed to be conventional wisdom that the Spanish Reconquista was on the verge of imminent completion while the days of Islamic Iberia were severely numbered. The brief flirtation with cultural coexistence introduced by Alfonso the Wise had ended with rebellions on both ends of the extreme political spectrum—one by his supposed Islamic vassal in Granada, and the other, far more devastating, by his own son and aristocratic allies who only saw in coexistence their own worldly privileges and prerogatives being threatened. Now, by the year 1301, Alfonso's grandson, Ferdinand IV (1285–1312) *El Emplazado* ("The Summoned") occupied the throne of Castile and thoughts of reconciliation with Muslims and Jews could not have been further from the Christian mentality of that era. Then, contrary to expectations on all sides, the world itself seemed to convulse and depopulate, sending severe, multiple disruptions and political disorders across the whole of Europe, including Iberia. Although the fragile and vulnerable Kingdom of Granada would not be completely immune from these disasters, it somehow appeared to weather them better than most, giving it a new lease on life for over another century to come. What emerged from this century-long reprieve was a city-state of legendary beauty and refinement that still captures the popular imagination and, for many, even among Christians,

causes them to grieve for its eventual and irretrievable loss in the year 1492.

Despite showing considerable promise and determination, Ferdinand IV died in 1312 at age 26 under mysterious circumstances, according to some in divine retribution for a capital miscarriage of justice against some of his own knights.[2] His 23-year-old Queen, Constance of Portugal, joined him in death shortly thereafter in 1313. In hindsight, these setbacks appeared like an ominous harbinger of events for the rest of the century, especially with respect to the Christian Reconquista effort. Nevertheless, the overall mood of the era in Christendom was still optimistic, as reflected in Dante Alighieri's poem *Paradiso*, in which the pilgrim narrator and his guide Beatrice, encounter and receive encouragement from SS. James, John, and Peter (see Chapter 21).[3] Ferdinand and Constance left a one-year-old son behind them, the future King Alfonso XI (1311–1350) *El Lusteçero* ("The Avenger"), while adult rival claimants to the Castilian throne all perished during an attempted but failed invasion of Granada in 1319. After Alfonso later came of age, he led the Castilians to victory in 1330 at the Battle of Teba near Málaga. Among the Christian casualties during that successful engagement was a prominent Scottish nobleman, Sir James Douglas; by this point in history, outside Europeans were fulfilling Crusader vows by joining the Spanish Reconquista rather than traveling to Middle East to die far away from home in vain. Then in 1340, an attempted Islamic invasion of Iberia from Marinid North Africa to relieve the pressure was thrown back by combined Castilian and Portuguese forces under Alfonso at the Battle of Río Salada near Cádiz. Back on the offensive by 1344, Alfonso conquered Algeciras, and after that, began planning a siege of Gibraltar, which now stood alone with the city of Granada as the sole remaining outposts of Iberian Islam.[4] For Spanish Christians, total victory was now clearly in sight, as Granada braced itself for what appeared to be the final, inevitable onslaught. Then came the unexpected.

The origins of the Black Death in Europe have been widely studied with much speculation and hypothesis, but it is not within our purpose herein to recap the various competing theories. It is generally agreed, however, that the pandemic first began somewhere in central Asia, perhaps India, then rapidly spread in all directions with an impact never witnessed before by recorded civilization, hitting particularly hard in the urban centers of Eurasia and North Africa. No one knows exactly how many people died, but some fairly reliable estimates believe it was roughly one out of every three persons. The plague reached Europe by boat in 1348, no doubt accelerated by the expanding globalized economy and booming east-west trade along the Silk Road in wake of Marco Polo and other world travelers from the Italian city-states.[5] There is also some evidence that by the mid–14th century, the civilized world had become overpopulated in terms of man-made infrastructure

systems being unable to support its growing number of dependents. Many prospered and multiplied, but far more lived in poverty and squalor. It was perhaps Nature's unforgiving way of making a correction in human folly. Whichever the causes, the mortality rate was so overwhelming that survivors at first denied what was happening all around them, or joked about it while trying to cope, then finally mourned and lamented, being helpless to do much of anything until the devastation had run its course. Very slowly, very gradually, limited preventive measures were identified and implemented, but the process took several generations and ultimately proved more useful in blunting or containing the effects of future outbreaks, provided those outbreaks were similar in cause.

The Iberian Peninsula was no different than the rest of Europe in this regard. The Black Death swept away Christian, Muslim, and Jew, regardless of economic class, political allegiance or religious sect. Its most prominent victim, however, was King Alfonso XI of Castile, who at age 39, expired in March of 1350 while laying siege to Gibraltar, having remarked shortly before that while he feared no man, he very much feared the plague, which indeed proved to be the cause of his sudden demise.[6] After Alfonso's death, everyone looked to their own safety, and the Castilian threat to Gibraltar and Granada receded as speedily as the Black Death continued to advance forward. Everything, for that matter, seemed to stop in its tracks. Then the most talented Italian poets, at least those still left alive, such as Boccaccio and Petrarch, began to write about the catastrophe, either directly or by inference, trying their best to articulate the widespread sense of grief and loss.[7] Curiously, although no precise numbers are available, the impact of the pandemic on the city of Granada, while terrible, also appears to have been somewhat less severe than on the Christian dominions then closing in around it, possibly because at that unique point in history, Granada probably had the best sanitation, the best medicine, and the highest living standards (read: civic support systems) in all of Europe. Meanwhile in northern Iberia, it is difficult to surmise whether pilgrimage traffic to Santiago de Compostela along the Camino Frances was more reduced due to higher overall death rates or in fact more increased by those fleeing from perceived certain death in the cities.

Even before the Black Death began to reconfigure world demographics, however, Europe managed to self-inflict itself another major wound with the Hundred Years War between France and England, breaking out in 1337.[8] The Reconquista and Saint James the Greater had nothing to do with this conflict. Instead, two of western civilization's most wealthy and powerful emerging nation-states, neither interested any longer in Middle Eastern crusading, began to relentlessly hammer away at each other over territorial rights on opposite sides of what later became known as the English Channel. Unlike the Reconquista, which ground to a halt during the pandemic, the Hundred

Years War dragged on remorselessly year after year. Even as the ranks of contending French and Anglo armies were thinned out mid-century by the bubonic plague, it only seemed to increase determination on both sides never to capitulate. Somehow surviving all this mayhem was the greatest English writer of the Middle Ages, Geoffrey Chaucer (1343–1400), whose Middle English masterpiece *The Canterbury Tales* was written during the last decades of the poet's life. It seems likely that pilgrimage life on the road as portrayed by Chaucer was not unlike that simultaneously transpiring in northern Iberia along the Caminos to Santiago de Compostela. The primary difference between the two was that Canterbury pilgrimage traffic was more localized.

Canterbury Tales also forever provides readers with a lively portrait of society from that time and place, set within the context of English pilgrimage whose characters are, for the most part, fleeing the ravages of plague under the guise of religious tourism. Chaucer's unforgettable Wife of Bath is introduced in the Prologue, along with other main characters. She openly boasts of her many other pilgrimages, including to Santiago de Compostela (see header quote). Chaucer was himself documented to have been a savvy continental traveler—which likely saved his life from random death in the cities—including a possible trip to Santiago conjectured by some biographers, although this is unproven. What is in fact firmly documented is that Chaucer, in addition to being a great writer, was a successful civil servant and retainer under at least two British monarchs, Edward III and Richard II, as well brother-in-law to John of Gaunt, father to King Henry IV.[9] Another societal aspect vividly revealed by *The Canterbury Tales* and Chaucer's later writings in general is that public faith in religious institutions and religious leaders had been understandably shaken and undermined after the multiple calamities of the 14th century.[10]

By way of contrast, the journeys and pilgrimages of Chaucer and his semi-fictional (or semi-autobiographical) characters were short local excursions compared to those of the Berber world traveler Muhammad Ibn Battuta (1304–1369?), whose astonishing Arabic-language memoir *Rihla* ("Journey") was dictated after his return to Morocco in 1354 and began to circulate about the same time that Chaucer was producing his greatest works in Middle English. Ibn Battuta began traveling around the year 1325 as an obligatory religious pilgrim to Mecca, but in the process discovered that he had a taste and knack for living on the road. Over the next three decades, he would traverse most of the civilized world across Eurasia and Africa, dwarfing even the earlier long travels of Marco Polo by comparison. In 1350, following a sudden impulse, Ibn Battuta rushed across the straits to Iberia to fight as a jihadist in what appeared to be Granada's last stand against the Christian Reconquista. By the time that he arrived at Gibraltar from Tangiers (his home town), King Alfonso XI was dead and the immediate crisis over, although

Battuta dodged death a second time as the regiment he sought to join was ambushed and killed or captured shortly thereafter.

Reaching Granada, Battuta was amazed at the Islamic kingdom's beauty, prosperity, and refinement (see Chapter 10).[11] There he met Ibn Juzayy, an Iberian scholar whose father had been killed 10 years earlier at the Battle of Río Salada, and who happily took on the not inconsiderable task of writing Battuta's dictated travel memoirs. In effect, Juzayy played the important role of Rustichello da Pisa to Battuta's Marco Polo.[12] Understandably, the dead Alfonso is characterized by Battuta and Juzayy as a "tyrant" punished by God for his arrogance and presumption.[13] Then the world traveler turned back to his forte, descriptive prose. When not being dazzled by the agricultural bounty of Al-Andalus (especially during an era in which worldwide hunger was common), Battuta speaks of Gibraltar, named after the eighth century conqueror of Iberia (see Chapter 3), in the reverential tone of a religious pilgrim.[14] To Juzayy and Battuta, the shrine-like Gibraltar is a "Mountain of Victory" and "stronghold of Islam, a choking obstruction in the throats of the worshippers of idols."[15] In Battuta's memoir, Gibraltar becomes an interesting symbolic counterpart to its approximate Christian equivalent, Santiago de Compostela. Many centuries later, fate would play one of its many ironic tricks on both Spain and Morocco by transforming Gibraltar (along with its iconic rock) into a tiny nation-state of its own, after having been the flashpoint of numerous military contests between various world powers throughout history.[16]

As for Spanish Christendom, its misfortunes were far from being over. By 1367, the Kingdom of Castile and León had turned upon itself by erupting into civil war, resulting in the overthrow of Alfonso's anointed successor, King Pedro I (1350–1369) el Cruel ("The Cruel"), who during his unproductive reign mainly busied himself with making unnecessary war on neighboring Aragón. Then in 1385, Castile made the big mistake of picking a fight with its old rival Portugal and was badly defeated by them at the Battle of Aljubarrota. For this memorable engagement, the Portuguese had enlisted its useful English allies and loudly invoked the protection of Saint George while prevailing over the Castilians, as well as their traditional protector, Saint James the Greater. Shortly thereafter, in 1387, this effective Portuguese-English alliance was formalized by marriage between King João (John) I with Philippa of Lancaster, daughter to John of Gaunt, a woman likely known to Gaunt's brother-in-law and contemporary, Geoffrey Chaucer. In any event, this maiden era of ongoing Portuguese-Anglo cooperation may well have marked the beginning of long-term distrust and hostility between England and Spain, animosity that would find full violent expression during the 16th century and continuing somewhat into the present day (see Chapter 13).

Returning to the 1300s, Castile's military setbacks had indeed been severe

and in rapid order. Within the mere space of 35 years it had gone from the cusp of dominating all of Iberia to being thrown into an unaccustomed defensive posture by its surrounding neighbors Granada, Aragón, Portugal, and England. This political descent was in turn aggravated by one of the more sordid periods in the history of the Roman Catholic Church, an institution from which Castile and Toledo derived much of its presumed authority. Beginning in 1378, two popes claimed simultaneous legitimacy, one based in Rome and the other in Avignon, France.[17] This embarrassing situation would continue for the rest of the century and beyond. Avignon and the southern Rhone Valley had in fact been a summer residence for the popes since the early 1300s, during which time the papacy itself became a political football between Italian and French Cardinals. After the break, Castile and Aragón sided with Avignon while, not too surprisingly, Portugal and England allied themselves with Rome. Because of this divided ecclesiastic authority and prestige, it became almost impossible to do anything unanimously in the name of the Christian religion. Even a humble pilgrim traveling on foot to Santiago de Compostela might be hard pressed to answer which earthly Pontificate the cult of Saint James the Greater served. Technically, it would be Avignon since Castile had given formal recognition. The reality, however, was that many Spanish Catholics stayed loyal to Rome or could never accept any religious authority originating from France. It is worth recalling that by the late 1300s, the old alliances between Spain and France—never strong to begin with—had long since vanished, now replaced by the escalating rivalries of emerging European nation-states, with France and England occasionally using a still divided Christian Iberia as their pawn in these wider struggles.

And yet some vestiges of solidarity remained. If along the Camino Frances images of Santiago still inspired the devout, so did those of Saint Martin of Tours (especially in France), whose shrine had been so vigorously defended by the Franks back in 732 as a prelude to the Reconquista (see Chapter 3). Moreover, Martin is traditionally venerated as patron saint of the same poor and impoverished who so surely swelled the ranks of Camino pilgrims during the late Middle Ages. The historical Bishop Martin also had odd roundabout connections with the Santiago cult, via the Priscillian controversy of the fourth century (see Chapter 1), and much later the shrines of the saints became intertwined along the same Franco-Spanish thoroughfares crossing over the Pyrenees Mountains.[18] In Paris itself to this day along the Rue St. Jacques, travelers may contemplate a bas relief depiction of Saint Martin severing his cloak for the benefit of a homeless beggar at the entrance to the Saint-Séverin Church in the Latin Quarter section of the city along the Left Bank.[19] Named after either a shadowy fifth century Parisian hermit or a shadowy fifth century Parisian abbot, the current structure dates from the mid–15th century when the church was rebuilt after damage from the ongoing

Hundred Years War.[20] Certain Gothic or Romanesque elements of the design hark back to those of earlier-built religious shrines along the Camino, including those in Toulouse (named after Saint Sernin, not Saint Séverin) and Santiago de Compostela.[21] The site remains a popular tourist and pilgrim destination, having survived 15 centuries worth of upheavals caused by war, revolution, plague, schism, and time itself.

Adjacent to Saint-Séverin in Paris is the famed Musée National du Moyen Âge, originally the Hôtel de Cluny and dating from the early 14th century (see Chapter 7). Even before Europe and Spain were blindsided by the Black Death, the booming medieval industry of hospitality along the Camino Frances reached new and greater proportions. Vestiges of this industry still exist, some continuing to serve tourists who may or may not be traveling in route to faraway Santiago de Compostela. Food and lodging naturally play a big role in this apparatus, occasionally appearing in the most unlikely places and forms. In the ubiquitous outdoor markets of Paris near the vicinity of the Rue St. Jacques it is not difficult to find "St. Jacques scallops" for sale, named not after the street but for the emblematic scallop shell of Saint James the Greater. By the time one finally reaches Spain anywhere along the Camino, it is easy to enjoy delicacies such as Galician "Santiago" almond cake ("Torto de Santiago"), a local signature (gluten-free) desert, typically decorated with the Cross of the Order of Santiago, and having its culinary origins during the Middle Ages. On a more bizarre level, it is also not difficult to find restaurants worldwide named after the patron saint of all Christian pilgrims. These range from the touristy Restaurante St. James in Madrid's posh Barrio de Salamanca, to the American small town vibe of the St. James Restaurant located in Spanish-named Avilla, Indiana.[22] This digressively broad topic obviously could generate a book by itself, but a few random examples such as these demonstrate how the Santiago cult eventually became a global phenomenon via tourist pilgrimage beginning in the Middle Ages, whether it be to Canterbury, England, or Santiago de Compostela in Spanish Galicia.

Choosing artwork that captures the disoriented spirit of 14th century Iberia is no easy task, but perhaps we would not be totally remiss in looking beyond that specific era, after the shocks had long passed but near enough in memory to have been thoroughly internalized by European society. In this respect, the late 16th century work of Doménikos Theotokópoulos (1541–1614), better known as El Greco ("The Greek"), is appropriately representative of a much older time and place, yet instantly recognizable by its unmistakable style and mood. This is not surprising since the life and career of El Greco were also one of a kind. Born on the Venetian-ruled Greek island of Crete, he had migrated west to Spain and Toledo (via Venice, Rome, and Madrid) by age 36, yet his painting never seemed to lose its original Byzantine iconic flavor. Like his Venetian predecessor Lorenzo Lotto (see Chapter 8), El Greco

was a journeyman artist in the truest sense of the phrase, but on a much broader geographic and cultural landscape. Fleeing the impoverished and militarily contested environment of Crete, El Greco landed at ultra-Roman Catholic Toledo in response to a demand for outside artists when the dominant Italians and French saw no attraction in exchanging their native lands for the growing tyranny of Hapsburg Spain (see Chapter 13). El Greco spent the last 37 years of his life in Toledo, where he produced some of the greatest masterpieces of the early Spanish Golden Age. Most of these have devout Christian religious themes, including multiple depictions of Saint James the Greater, with the majority of these portraying an unstable earthly existence in which all human endeavors have been blasted by various setbacks seemingly beyond anyone's control.

The first overt indication that El Greco was a tremendous genius (as opposed to merely a good painter) came during the late 1580s when he was commissioned by his own parish church in Toledo, the Iglesia de Santo Tomé (Church of Saint Thomas) to create a huge canvass depicting the miraculous *Burial of the Count of Orgaz* (1586–1588). Orgaz, aka Don Gonzalo Ruíz, was historically minor but highly popular local knight and jurist in Toledo interred at Santo Tomé who had previously donated a large sum of money for its beautification. His death in the year 1312 (the same year that the young King Ferdinand IV had died) harked back to a much earlier period in Spanish history in which such losses seemed to presage an entire century filled with premature loss. According to the legend, attendees of the public funeral for Orgaz were dazzled by an apparition of SS. Stephen and Augustine appearing to personally lay the body of the deceased to rest. El Greco's grandiose, heroic treatment of the legend won him instant fame and recognition. Many of the themes and motifs in the work are parallel to those of the Santiago legend: famous saints supernaturally appearing and actively participating in current affairs, the living being inspired by these divine interventions, an unapologetic overlap between politics and religion, etc. Curiously, however, King Philip II of Spain was not a fan of El Greco's style, and the artist's livelihood remained firmly rooted in Toledo throughout his long career.[23] Nevertheless, after 1588, important paintings were typically expected from El Greco, and he frequently did not disappoint in this regard.

Not surprisingly, El Greco's interpretations of Spain's patron saint began to appear shortly thereafter. One prototype, perhaps dating from the 1590s and now displayed in the Museo de Santa Cruz of Toledo, shows Santiago as a full figure pilgrim with his standard paraphernalia—a staff, a codex, and a hat (on shoulder) sporting a scallop shell emblem.[24] The execution is competent, straightforward, and a bit pedestrian—not displaying the high level of genius that we today have come to expect from this outstanding master. By way of contrast, not long after this, or around the same time (1597–1599),

El Greco created one of his most celebrated canvasses, that of *Saint Martin and the Beggar*, with a larger version found at the National Gallery of Art in Washington, D.C., and a smaller version of the same image at the Art Institute of Chicago. The work dramatically depicts the most famous scene from Martin's life, one in which as a young cavalryman he divides his cloak with a sword and gives half to a freezing, naked beggar along the roadside. The beggar may as well have been a pilgrim along one of the Caminos during the miserable mid–14th century. Martin is astride a magnificent Arabian white mount, not as a military avenger like Santiago Matamoros, but rather as a benefactor to the poor, the weak, and the disenfranchised. Martin's bright green cloak unfolds across nearly the entire length of the scene, as if to emphasize that there was plenty to go around for everyone. Whereas El Greco's earlier Santiago portrait had seemed a bit uninspired by comparison, his *Saint Martin and the Beggar* must rank as one his most inspired (and inspirational) creations.

The old master, however, was not finished with Saint James the Greater. During the last decade of the artist's life (1604–1614), another prototype appears for Santiago. This time, Saint James is not viewed as a fully-equipped, confident traveler along the Camino, and certainly not as any sort of military conqueror. By the 17th century, the Reconquista was long over, not completely unlike the mid–14th century in which the Black Death seemingly brought all human aspirations to a complete standstill. Now Saint James is imagined by the artist as a rather dirty, unshaven, and unkempt highway beggar, rustic staff in hand, the other hand ambiguously outstretched either to invite us along for the journey or (more likely) asking us for alms. This version of Saint James as an impoverished and homeless pilgrim was of a type not often seen on canvass, and the effect is both unsettling and unforgettable.[25] Is it a portrait of the artist as a young man? Closer inspection reveals a bright green cloak betraying the look of a luxurious hand-me-down. Then we, as the viewers, realize that it appears to be the very same green cloak given to the beggar by Saint Martin in El Greco's earlier work. Saint Martin's beggar is thus transformed into Saint James the Greater as a Camino pilgrim in want. The overall message is not one of Reconquista, patriotism, pilgrimage, or tourism, but rather of moral and social commentary. El Greco's brilliant and unique contribution to a soon-to-be overworked genre of the 17th century (see Chapter 14) may today be viewed at the El Greco Museum in Toledo, along with his slightly less vivid versions of the same later prototype at the Museum of Fine Arts Asturias in Oviedo, Spain, and at Oxford University in Great Britain.[26]

As the wretched 14th century in Europe drew to a merciful close, all participants in the ongoing Iberian drama seemed to draw a collective breath. Santiago and Spanish Christians may have been down, but they were far from being out. The new century to come would be no less violent or tragic than

its predecessor, but there would be far more geo-political change, ending with what later historians would dub "The Encounter," as a Genoese mariner turned Spanish explorer for hire would venture into unknown territory and, more importantly, make it widely known to others thereafter. In the meantime, as Europe reeled from depopulation, newly emerging nation-state rivalries, and a fractured papacy, Islamic Iberia was perhaps lured into a false sense of security as Grenada enjoyed the height of its prosperity and prestige. All of this was about to be permanently disrupted. The papacy would reconsolidate far more quickly than it had taken to break apart. Castile would recover its lost prestige. Major military and political shock waves would be felt from the far east, sending ripple effects to the opposite side of the European continent. At almost the same instant in time, one of the most outstanding political figures in world history would be born in Castile, though it would be decades before many people realized it. Then suddenly, with little warning, Santiago Matamoros would reappear on the Iberian scene with a vengeance.

10

Isabella I
(1400–1492)

*From there I went to the city of Ghanāta [Granada], the cap-
ital of al-Andalus and the bride of its cities. Its surroundings
are unequaled in any country in the world.... Ibn Juzayy
remarks: 'If I were not afraid of being charged with excessive
local patriotism I would try to describe Granada, since I have
the opportunity. However, such is its fame that there is no
sense in speaking at length about it.*—Ibn Battuta[1]

From the viewpoint of the Spanish Reconquista, the beginning of the
15th century appeared to represent little more than a continuation of the pre-
vious, highly disruptive 1300s. Castile and León, the traditional bulwark King-
dom of central Iberia, was in shambles thanks to ongoing internal strife and
antagonistic relations with all its neighboring states, both Christian and
Islamic alike. Moreover, no help whatsoever was forthcoming from the out-
side, the rest of Europe being preoccupied with its own miseries and political
divisions. In truth, as late as 1481, a casual outside observer might assert that,
in pure military terms, Europe and Spain were weaker and more vulnerable
than ever to outside threats.[2] The entire state of dysfunctional affairs was
typified in 1409 by a botched attempt at reconciliation between the two papal
factions in Pisa, Italy. Roman Catholic Cardinals, finally realizing that the
ongoing Western Schism, with two popes claiming simultaneous legitimacy,
was an unsustainable state of affairs, tried to jettison the competing claimants
by electing a third, Pope Alexander V. Instead, neither of the still living popes
would step down, even after their former partisans informed them that their
services were no longer needed.[3] Now, Western Europe witnessed the farce
of three popes simultaneously claiming supremacy, each making pronounce-
ments and fulminating excommunications against their opposition. At this
unsettling stage of events, it would not have at all been unreasonable for any

Spanish Christian to ask the simple question, for what and for whom exactly are we fighting for?

And yet somehow, against all odds, amidst the atmosphere of dissension and uncertainty, arose an outstanding Iberian leader, as had happened on more than one previous occasion. In 1410, only one year after the papacy had split into three factions, the 30-year-old Prince Ferdinand of Aragón (1380–1416) out of the blue led a daring expedition which conquered the city of Antequera near Málaga in the Kingdom of Granada.⁴ It was a bold and unexpected move, but proving that the old enterprising spirit of Reconquista was still alive and well. By birth Ferdinand was a Castilian, younger son of the inept King John I of Castile, but his mother was from Aragón, and rather than play an insignificant role in Castilian affairs he chose to become a regent in Aragón, where he won a reputation for evenhandedness and square dealing. In 1412, two years after his stunning success at Antequera, Ferdinand was elected to the throne of Aragón as Ferdinand I, surnamed *El Justo* ("the Just"), after most of his competitors had died naturally or proved themselves to be completely incompetent. During the four short years remaining in Ferdinand's life, he then proceeded, not to lead more military adventures, but rather to play the role of royal diplomat in the ongoing Western Schism. By surprisingly agreeing to pull his support for the Spanish antipope in Avignon (Benedict XIII), Ferdinand shamed his contemporaries by setting a good example, making possible the final resolution of the schism one year after his death in 1417, with the near unanimous election of a single Pope (Martin V) at the Council of Constance (Konstanz) in neutral Alpine Germany. After his death at age 36, Ferdinand left behind him a sterling reputation in both war and peace, and for the first time in a long time, a few things had managed to go right for Iberian Christians.⁵

Much bigger problems, however, were still on the immediate horizon for European Christendom. Foremost among these were the Ottoman Turks, whose resurgence in Asia Minor during the 15th century revived fears of continental invasion not felt since over 700 years previous when the Saracens rampaged their way through Spain and France. Although in hindsight the crisis clearly could be seen approaching, the big shock came in 1453 with Byzantine Constantinople falling to the Ottoman juggernaut, led by their ambitious 22-year-old sultan, Mehmed II (1432–1481), surnamed "the Conqueror," appearing as a direct challenge to the seemingly dormant Spanish Reconquista. The last Byzantine Emperor, Constantine XI, was slain while defending the city and Christian survivors were either sold into slavery or ransomed. In the aftermath of conquest, local Orthodox Christianity was nominally allowed to continue in accordance with Islamic custom, albeit segregated from the mainstream. The Eastern Roman Empire, on the other hand, which had stood firm since the early fourth century (excepting the Venetian-

led sack of Constantinople in 1204), was promptly terminated. Within a matter of days, Constantinople was itself renamed Istanbul, while the famed Hagia Sophia church built by the Emperor Justinian was stripped of its Christian iconography and converted into a Grand Mosque.

The psychological shock wave of this event was felt throughout all of Christendom, and continued to be felt as the Ottomans pressed their advantage. Two months after the fall of Constantinople, the Hundred Years War between England and France effectively came to an end when the English were thoroughly beaten at the Battle of Castillon. The French had been inspired by the late Joan of Arc, burned at the stake for witchcraft by the English in 1431 but posthumously cleared of wrongdoing by a French ecclesiastic court in 1456. The final partition of France and England into separate geographic realms represented yet another paradigm shift which plunged England into its own civil war (the War of the Roses), but at least France was now free to focus on defending its own borders—just as it had back in the year 732 from Saracen invaders. Such talk was not considered outlandish at the time given the rapid progress of the Turks. After obliterating the remnants of the Byzantine Empire, the Ottomans and Mehmed began expanding westward, and nothing appeared capable of stopping them. British historian Edward Gibbon, quoting the eyewitness Aeneas Sylvius (the future Pope Pius II), concluded that Europe during mid-century was incapable of any kind of unified military action, even under the banner of religion.[6] The political landscape was too fractured. No person, or country, for that matter, was strong enough to lead an effective resistance. Leaders spoke boldly of crusading, but the Crusades were in fact long over and never coming back. When an Ottoman invasion force easily overran the Italian city of Otranto (located on bootheel of the peninsula) in 1480, there was serious talk in Rome of evacuation. The papacy, which during the previous generation had tenaciously won back its right from Avignon to be in the Roman Vatican, now spoke of northern flight across the Alps for the sake of survival. Then, as the Kingdom of Naples braced to become the next victim of Islamic conquest, Mehmed died unexpectedly in Istanbul under suspicious circumstances. The Turks peaceably evacuated Italy and the crisis seemed to pass as almost suddenly as it had precipitated.[7]

The loss of Constantinople as a supposed inviolable bastion of the Christian faith had consequences more symbolic than strategic for Europe; however, this symbolism was so strong as to hardly be equaled before or since during the annuls of western civilization. The city had stood firm against infidels for over a thousand years, and many believed it to be more untouchable than Rome itself. Obviously, this proved not to be the case. Although relations between the Roman Catholic and Eastern Orthodox churches had always been problematic, particularly since the great East-West Schism of

1054 (and even more so after the Franco-Venetian conquest of 1204), religious solidarity tended to override differences in language and culture in the face of serious outside threats. This had certainly transpired within Iberia over the last 700 years since the Islamic conquest of 711. As for the eastern Christian churches now under Islamic rule, these were allowed to exist, but not allowed to have any say in political or military decisions, perhaps all for the better. Regarding the Armenian Apostolic Church, it had long since parted company with the Greek Orthodox Church over theology, and by the mid–1400s was grudgingly accustomed to living under its Ottoman overlords.[8] The Armenian shrine of Saint James the Greater in Jerusalem no doubt continued as if little had happened. Meanwhile in central Europe circa 1454, only one year after the fall of Constantinople, Johannes Gutenberg printed a complete Bible in Latin using the newly invented technology of movable type. The innovation would have multiple, far reaching effects.[9] One of these would be the West's ability to mass produce and quickly disseminate information for the literate, including propaganda for the tremendous military initiatives that were about to unfold, first within Iberia, then westward into a New World (see Chapter 11).

Almost right on cue, at this highly pivotal moment in European history, two of its most extraordinary and influential future monarchs, destined to be a power couple in the truest sense of the phrase, were born in the respective kingdoms of Aragón and Castile. Fernando or Ferdinand II of Aragón (1452–1516), *el Católico* ("the Catholic") had an excellent pedigree, being the son of a king (John II of Aragón) and the grandson of Ferdinand the Just, but more importantly, possessed a steady temperament, as well as a knack for avoiding big mistakes—the latter being an especially rare quality for that time and place. Far more interesting, however, was his second cousin and slightly older wife to be, Isabel or Isabella I of Castile (1451–1504), *la Católica*, also descended from royal lineage but born with no particular expectation of becoming queen, initially having other male family relations in line ahead of her.[10] Isabella's namesake mother, Isabella of Portugal, who became Queen of Castile and León through marriage, was also the granddaughter of Portuguese King John I, the same monarch who during the late 14th century had successfully defended Portugal against both overreaching Castilian ambitions and attempted Islamic incursions (see Chapter 9). The younger Isabella, practically from childhood, exhibited traits of both religious fanaticism and fighting spirit, both of which seemed to run in her bloodline. She was destined to almost single handedly resurrect the dormant cult of Saint James the Greater to even greater heights of prominence than previously seen. Both she and Ferdinand came of age in the aftermath of Constantinople's subjugation by the Ottoman Turks; moreover, it is nearly impossible to believe that they were not both deeply affected by the unhappy legacy of that event, especially the fiery and religiously inclined Isabella.

The teenage Isabella also steadfastly insisted on choosing her own husband, another very unusual thing for those times. For most of the eligible female nobility of that era, the typical options were to wonder who more powerful or wise elders would choose for them, to imagine who their lovers might be after marriage, or to choose the cloister if they preferred a higher education. How a young woman such as Isabella managed to pull this off, living in one of the most autocratic and chauvinistic societies of Europe, remains one of the great underappreciated stories in history, but unfortunately lies beyond the scope of this study. One true story, however, is worth repeating. At one point, Isabella's older half-brother, the weak Castilian King Henry IV, tried to use Isabella as a negotiating tool by promising her to a very wealthy and powerful but dissolute and rebellious knight, the Master of the Order of Calatrava. According to tradition, the 15-year-old Isabella prayed fervently that she would not be forced into this marriage, and the groom promptly died under mysterious circumstances while traveling on his way to meet her. After this incident, everyone, including King Henry, seems to have taken Isabella a bit more seriously. She capitalized on this newly gained credibility by promising her uncle to be dutiful, so long as she maintained a right of consent to whatever marriage might be proposed for her.[11] Though mostly forgotten today, this agreement would prove to be one of the more momentous contracts in world history. For our part, we would speculate that in her prayers the young Castilian princess vowed that if sparred a bad marriage, she would devote her life to the extension of Christendom, which she in fact later did with unprecedented aplomb.

Another likely impressionable event from the childhood of Isabella and Ferdinand was the surprise conquest of Gibraltar by the Castilians in 1462, only nine years after the fall of Constantinople. Gibraltar had continuously changed hands during the last two centuries of the Reconquista, but this time the Christians managed to hold on, mainly through an odd set of circumstances. While it was often unclear during the siege whether the Castilians were fighting Muslims defenders or amongst themselves, the ultimate success of the operation proved that Castile was still a military power to be reckoned with, provided they were not engaged in civil war. Prominent among the infighting victors was the local Guzmán clan, descendants of the same Guzmán "the Good" who back in the late 13th century had apparently converted to Christianity, then helped Castilians to defend against Marinid incursions from North Africa (see Chapter 8). As events would play out, after 1462 the next 30 years would see the Reconquista noose gradually tighten around the Kingdom of Granada.[12] Gibraltar had been held or retaken by Islamic rulers since the year 711 when its namesake conqueror had subdued Visigoth Iberia (see Chapter 3). Granada no doubt tried to console itself with the thought that Gibraltar would yet again be retaken, and that the infighting

Christians, especially those within Castile, would not put up an effective defense. The truth was that Granada struggled hard with its own internal wrangles while Castile and Aragón were on the cusp of unprecedented unification. As for Christian Iberia, there was a new sense that anything once again seemed possible. Such was the public mood during the late 1460s as Ferdinand and Isabella approached adulthood.

Ferdinand and Isabella had been betrothed as children as a half-hearted gesture of friendship between neighboring monarchs, but no one seems to have really pushed the idea until the 17-year-old Isabella was named heir apparent to the Castilian crown by a failing Henry IV after the premature death of her brother Alfonso in 1468.[13] Gradually, the dim-witted nobility surrounding them began to grasp the enormous advantages of the proposed union, while others opposed seemed to panic at the thought of a united Spain threatening their petty fiefdoms. The pope did his part, however, by granting a special dispensation so that the second cousins could legitimately wed. After the prerogatives of each royal spouse were carefully spelled out in a meticulously drafted prenuptial agreement, the controversial couple met clandestinely in Valladolid to secretly wed on October 19, 1469. For five years there was calm, as King John of Aragón and King Henry of Castile were still alive. Neither Ferdinand nor Isabella immediately inherited their thrones, but upon King Henry's death in 1474, civil war broke out yet again in Castile.[14] Those who feared the recently consolidated power of Castile and Aragón rallied behind Isabella's half-sister Joanna, and attempted to bring in the Portuguese as would-be Castilian overlords. The war on the ground proved to be another bloody stalemate, but the two young monarchs clearly demonstrated their superior political skills during the conflict, culminating with Isabella giving birth to a male heir to the Castilian throne in 1478. That same year (1478), Ferdinand and Isabella were given papal permission to formally establish the Spanish Inquisition to root out religious minorities perceived as rebellious (specifically, *conversos* or Jews pretending to be Christians), as well as to solidify support from wavering church factions. By 1479, the five-year internal struggle had finally ended, and the Kingdoms of Castile and Aragón were firmly united by marriage, both more powerful and aggressive than ever before.

With the unexpectedly rapid retreat of the Ottoman threat to Western Europe in 1581, Aragón-Castile under Ferdinand and Isabella were suddenly presented with a unique opportunity to renew Reconquista efforts with singular, undistracted zeal. That same year (1481), news arrived that the now isolated Kingdom of Granada had dared to attack the Christian mountain border town of Zahara in retaliation for Christian raiding parties having made it their staging ground. After nearly eight centuries of non-stop conflict, it had become pointless to argue about who began hostilities. The time to

end it once and for all had finally arrived for Christian Iberia; moreover, it was payback time for Constantinople. Just as the Ottoman Turks had ventured into Europe and appropriated one Europe's most treasured cities, Spain would now expel Islam from Western Europe and confiscate perhaps its most fabled urban center (see header quote). Ferdinand and Isabella initiated the final Granada War in 1482 by sacking the peaceful Andalusian town of Alhama, located only about 30 miles from Granada itself. Here the Spaniards introduced semi-modern artillery pieces, not unlike the kind that the Ottomans had used with such devastating effect against Constantinople less than three decades previous. Santiago Matamoros had now taken the form of gunpowder and munitions, and there was no debate on whether or not it was real. Also quite real was the granting of an audience by Ferdinand and Isabella in 1486 to an fanatical Genoese mariner by the name of Cristoforo Colombo (Christopher Columbus), presenting them with a seemingly far-fetched scheme to reach Asian trade routes by sailing west through unknown waters of the Atlantic Ocean (see Chapter 11). The royal couple tabled the proposal of Columbus until the Granada War was concluded, but in the meantime granted him an allowance in order to prevent him from leaving Spain.

Things then began to move quickly. Granada, finally waking up to its danger, was still badly hindered by internal conflicts, and no reinforcements from North Africa were forthcoming. In 1487, after a lengthy siege, the Castilians conquered the important Andalusian port city of Málagra, thereby reducing the Kingdom of Granada to the size of an inland city-state. After making careful preparations and the failure of half-hearted diplomacy, the Castilian all-out siege of Granada began on November 25, 1491. By January 2, 1492, it was over. Correctly sensing that the Christians would not offer any quarter (as had the Ottomans at Constantinople), the last Nasrid ruler of Granada, Mohammad XII (aka King Boabdil) formally surrendered the city to Ferdinand and Isabella. Victorious Spanish troops marched into Granada shouting "Santiago! Santiago!" and waving banners bearing the image of the saint.[15] Muslims for the time being were allowed religious freedom, but Jews were given an ultimatum: they had four months to convert to Christianity, clear out of Spain, or die. On March 31, 1492, the infamous Alhambra Decree was issued by Ferdinand and Isabella, expelling all un–Christianized Jews from Spain, effective July 31. Those who converted immediately became targets of suspicion for the Inquisition, especially those owning valuable property. Only nine years later (in 1501), Iberian Muslims would be given similar harsh options (see Chapter 11). For the first time since the year 711, all of Iberia was under autonomous Christian rule.

Exactly how Isabella I of Castile became a devotee of Saint James the Greater is anyone's guess, but there can be little doubt of her enthusiasm.[16] English-language biographies of her, tending to be underserved in general,

also gloss over such important matters.[17] Herein we will at least venture a surmise. The psychological roots of Isabella's interest in the Santiago cult most likely went back to her childhood and formative years, a time in which no one expected her to be a reigning monarch, let alone of powerfully joined Castile and Aragón, as well as a time of great anxiety and uncertainty for Europe. Most of this childhood and adolescence was spent in the provincial towns of Medina del Campo (her birthplace) and Arévalo, located northwest of Ávila and southwest of Valladolid, along what is today known as the Camino de Levante to Santiago de Compostela.[18] Before marrying Ferdinand, her teenage years were spent in more cosmopolitan Segovia, northwest of the capital along a parallel route to Santiago, the Camino de Madrid.[19] By all accounts, these were mostly unhappy times for the princess, living in comparative poverty and isolation, under the watchful, suspicious eye of King Henry, while witnessing her mother, the widowed Queen Dowager, slowly slip into dementia.[20] Decades later, after the end of the Reconquista, Isabella would commission a magnificent and still extant tomb for her parents at the Miraflores Carthusian monastery near Burgos, designed by the important artist Gil de Siloe and situated along the Camino Frances.[21]

During the same period, the Spanish Reconquista had stalled and degenerated into civil strife, while to the east, the seemingly unstoppable Ottoman Turks had overrun Constantinople and would soon threaten Rome itself. Given these circumstances, an intelligent, pious girl of royal lineage would need something positive to latch onto, especially given her own precarious personal situation. Perhaps Isabella found comfort in the Santiago cult, being situated along the Spanish Camino routes, particularly in Arévalo where local legend held that the saint himself had once preached. In Arévalo she came under the fortunate influence of her designated tutor, Gonzalo Chacón, a professed admirer of Joan of Arc, who no doubt instilled this same admiration into his apt pupil.[22] From Joan of Arc, it would have been a natural transition to fascination with the cult of Santiago, another martyr saint with nationalistic and militaristic associations. By the time she reached marriageable young adulthood, it would be no wonder that Isabella viewed herself as a pilgrim journeying along the uncertain road of life itself, and for the remainder of her life and subsequent legacy, the pilgrim badge of Santiago came to be associated with her own royal personage.

Five hundred years later, the visual tradition of Isabella as Catholic monarch transformed into Camino pilgrim is hard to miss. Much of the statuary paying homage to the first great queen of the Renaissance has her sporting variations of a scallop shell neckless, with the pilgrim badge covering her heart. One visible example of this ("Isabella la Católica") can be found within the very halls of the Palacio Real or Royal Palace of Madrid, even though both the palace and the statue date from a much later period.[23] More typical

from the epoch of Isabella, or at least more in keeping with recent usage of Santiago imagery, is an embroidered Castilian altarpiece tapestry, currently on display as part of a special exhibition at the Art Institute of Chicago. This spectacular work was produced for Pedro de Montoya, Bishop of Osma, some-time between 1454 and 1474, long before Ferdinand and Isabella had consol-idated their political power, or perhaps just as this consolidation process was beginning and the Spanish nobility beginning as well to realize its tremendous possibilities. The focal point of the tapestry is not Santiago, but rather the Virgin and Christ child, well in tune with the Christian iconography of greater Iberia. Saint James the Greater is demoted to the role of worshipping pilgrim at the bottom of the tapestry, along with five other saints. Osma (today El Burgo de Osma-Ciudad de Osma) and the Castilian province of Soria are sit-uated along the eastern frontier of Castile, adjacent to the Kingdom of Aragón and west of Zaragoza, traditional site of the very first alleged Marian vision by Saint James himself (see Chapter 2). The religious hierarchy reflected by the altarpiece tapestry pays respectful homage to Santiago as a Camino pil-grim, but also (more prominently) to the Madonna. As religious artwork goes, this is as politically correct as it gets for that specific period in Spanish history.

One of the best-known images of *la Católica*, however, is today found within the monumental 19th century canvass on display in Madrid's Museo de Prado. *Queen Isabella the Catholic Dictating Her Will* (1864) by Eduardo Rosales Gallinas (1836–1873) was meticulously and painstakingly executed by a 28-year-old artist trying to establish his reputation. In this he succeeded. Painted at a time in which Spain was struggling to achieve a new national identity but long after it had lost control of its Latin American holdings (see Chapter 17), while in the United States the War between the States furiously raged, the mul-tiple symbolic layers of this work are too rich to be fully addressed within these pages. Regarding the deathbed figure of Isabella, however, near the very center point of the canvass is the same pilgrim scallop shell neckless being worn by the dying queen, with which she was closely associated. According to tradi-tion, as she lay dying in 1504, Isabella directed in her will that Native Amer-icans be treated with justice—as opposed to being exploited—a wish that, if it ever came to pass, did so only long afterwards.[24] Whether or not real (and possibly it was in fact real), in the popular imagination Isabella remained a religious pilgrim right to the very end. If as an unmarried teenager she had made a prayerful promise to extend Christendom when given the opportu-nity, the promise was indeed kept. Rosales himself lived a tragically short life, dying of consumption less than a decade after producing the masterwork for which he will always be remembered. Anyone doubting the power and broad appeal of this work need only stroll into the Prado Museum to witness the crowds of casual viewers stopped in their tracks when encountering it.

Perhaps the most iconic example of this same motif can be found in the

famous 19th century painting, *The Capitulation of Granada* (1882), by Francisco Pradilla Ortiz (1848–1921), depicting Isabella's ultimate moment of triumph in early 1492, as Mohammad XII hands over the city to her and Ferdinand, thereby completing the Reconquista. The city of Granada is seen in the middle background, displayed like a trophy. Here we see a very imperious, regal, and romanticized version of Isabella mounted on a white Arabian steed (not unlike Santiago Matamoros himself), but around her neck wearing a pearl-lined pilgrim scallop shell emblem of the saint, embellished by a red cross (or bloody sword) symbolic of the military order. It is perhaps the same neckless worn on her deathbed as earlier depicted by Rosales. Within the context of the scene, the pilgrimage aspect of the cult is almost completely lost, while that of the warrior saint is highlighted. For the artist, Isabella herself has become the incarnation of Matamoros, adorned with a pilgrim badge. Pradilla was a prolific artist specializing in historical scenes, particularly from this period. *The Capitulation of Granada* took him three years to complete after being commissioned by the Spanish government.[25] The painting romanticizes the crowning achievement of Isabella's career, although it would soon be overshadowed by the commission she and Ferdinand were about to give to Christopher Columbus.

With the conclusion of the Reconquista, its ugly side immediately asserted itself with the expulsion of unconverted Jews from Iberia, even though for many families Iberia had been their home long before Christianity arrived. Things were about to get even uglier. Rather than fade into oblivion with the surrender of Granada, the mentality of Santiago Matamoros would soon cross the Atlantic Ocean to unsheathe its sword against Native Americans or anyone else standing between Spain and its perceived manifest destiny in the New World. One unpleasant byproduct of this global shift would be the first modern refugee problem on a global scale, whether it be Sephardic Jews and Muslims leaving Iberia, enslaved Native Americans and African-Americans, or religious dissidents fleeing persecution from the Spanish Inquisition.[26] Tragically, these problems remain relevant to the present day, as the world economy continues to globalize at an accelerating pace. Whether in 1492 or the present, the vision of multicultural coexistence earlier dreamed in Iberia by the likes of Alfonso the Wise or El Cid seems to have faded even more so into the realm of fantasy and illusion. What Isabella's own feelings were is impossible to say. There were probably regrets; on the other hand, a war lasting eight centuries had finally been put to rest, the likes of which history had never witnessed in terms of sheer obstinacy and vicissitudes of fortune. Termination of the conflict had been achieved not through tolerance or compromise, but through brute force and uncompromising persistency. And yet, notwithstanding the immeasurable bloodshed and rank injustice, the old dream of something better for humanity still remained after all was said and done, even perhaps in the final hopes of the great Catholic Queen.

11

Santiago Invades the Americas (1492–1542)

… it was as if Spain wished somehow to atone for her former tolerance, which she now regarded as unchristian.—Karen Armstrong[1]

With the fall of Granada and the conclusion of the Reconquista in 1492, Iberian Christianity seemed to enter another sinister phase of heightened, unprecedented religious intolerance. Muslims were given a short reprieve, which would last less than a decade. Unconverted Jews were expelled outright. The Spanish Inquisition had become nearly all-powerful. Most disturbing of all, however, were Spanish foreign ambitions. Spain had become a permanently militarized society, now secure on the home front, but with an idle war machine in need of employment. Just as the Ottoman Turks of the East had attempted to spread their faith abroad by force of arms, Spain and Portugal would now do the same, but with far more effectiveness. Tellingly in 1492, no sooner had Granada fallen than King Ferdinand and Queen Isabella revived the so-called Diploma of Ramiro, allowing the government to collect taxes from all of its realm for the sake of maintaining its pilgrimage shrine at Santiago de Compostela, even though its originator, King Alfonso VII, had been dead since the year 1157 (see Chapter 6).[2] The Santiago cult should have died a peaceful death from the moment that Granada fell, but instead Matamoros seemed only to gain new life and renewed purpose, seeking new targets or victims to satisfy its ambitions. Meanwhile, pilgrimage traffic along the Caminos flourished. In faraway Paris, the imposing Church of Saint-Jacques-de-la-Boucherie was constructed between 1502 and 1525, serving as a convenient rallying point for Parisian pilgrims preparing to head out for Spain along the Camino Frances.[3]

Over the last five centuries, whether mythologized or denigrated, the inescapable legacy of Christopher Columbus has been consistently distorted

and misinterpreted. At the end of the day, he was a religious fanatic sponsored by another religious fanatic, Isabella of Castile. As observed by Karen Armstrong, Columbus had a Crusader mentality, was possibly of distant Jewish ancestry, and had recurring thoughts of Jerusalem, even as he sailed west dreaming of new Asian trade routes and, more fantastically, conversion of Asian peoples to Catholicism.[4] As a religiously conservative Genoese, he despised the more progressive Venetians for their treaties and compromises with Islamic states for the sake of Eurasian trade, even though recent Ottoman aggression in Eastern Europe had cut severely into Venetian profit margins. The opportunity had now arrived to completely reinvent these trade patterns, and the Spanish, along with their Iberian rivals the Portuguese, were at the forefront of this movement. One can argue endlessly whether the prime motivator was piety or greed, or whether one inevitably led to another. The indisputable facts are as follows: on August 3, 1492, Columbus sailed west from Palos de la Frontera in search of the Asian continent; on October 12, he reached San Salvador in the West Indies, then explored the neighboring islands, including Cuba and Hispaniola; finally, commanding the *Niña* after the shipwreck of his flagship *Santa María* (and mutiny of the *Pinta*), Columbus returned to a hero's welcome at Palos de la Frontera (via Portugal) on the Ides of March (March 15), 1493. World history would now begin to witness the greatest series of demographic and technological changes since humanity first began recording history.[5]

October 12, the date of the Columbian landfall in the New World, is today celebrated as Spanish Columbus Day, the national holiday of that country.[6] October 12, as the fates would have it, is also the Feast Day for the Virgin of the Pillar, an ancient tradition holding that Saint James the Greater was divinely granted the first Marian vision in Zaragoza, Spain, on that date circa 40 CE (see Chapter 2).[7] Therefore, through this circuitous, backdoor connection, one might well say that Christian Europe reached the New World to stay on the very same calendar day that Santiago had received reassurance from the Madonna that his early missionary journey to Spain would not be in vain. Columbus was surely aware of the association, and no doubt found it significant. His maiden trans-Atlantic voyage had a number of Santiago overtones, beginning with the *Santa María* itself, originally built in Galicia, christened *La Gallega* ("The Galician") and likely displaying on its sails, along with the other two ships, the red Spanish cross closely associated with the Santiago tradition. Anyone doubting the ongoing popularity of Columbus Day in Spain need only attend the annual parade in Madrid, as did this author in 2016. In a country still deeply divided by the shadow of civil war from a previous generation (see Chapter 18), Columbus Day serves as a convenient rallying point of national pride for most Spaniards.[8] For better and for worse, the anniversary of the cataclysmic "Encounter" between Europeans and

Native Americans—as often euphemistically dubbed by modern historians—appears to remain well remembered throughout Spain and Spanish-speaking Latin America, notwithstanding a modern age that has difficulty remembering much of anything.

No sooner had Columbus returned to Spain than Pope Alexander VI issued a papal bull in 1493 methodically dividing all newly discovered and conquered lands between Catholic Spain and Catholic Portugal, with details later worked out in the subsequent 1494 Treaty of Tordesillas.[9] Rome's assertiveness at this moment may have prevented immediate war between the two budding superpowers. Meanwhile between 1493 and 1504, Columbus made his second, third, and fourth voyages to the New World, claiming most of Caribbean "West Indies" region for Spain. In 1495, the city of Santiago de los Treinte Caballeros was founded, today the second largest municipality in the Dominican Republic and nicknamed "the first Santiago of the Americas"—a startling development considering that three years prior to this many people still believed the world was flat. In 1504, Queen Isabella died, for many years weighed down by personal tragedies and justified anxiety over ominous trends of Spanish colonialism.[10] A good case can be made than no individual ever did so much to change the world in such a short space of time. As for Columbus, he did not long outlive his great patroness, dying in 1506, possibly still believing that he had reached the East Indies.

The chagrined Portuguese, approached originally by Columbus but rebuffing him, were right behind the Spanish almost from the very beginning, pushing out in every direction with their scrappy, well equipped navy.[11] In 1497, Vasco de Gama rounded the African Cape of Good Hope, thus proving that India and China could be reached by Europe sailing east, as well as west. His achievement only helped to further spur Spanish exploration efforts westward. England, France, and the rest of Europe stood by and watched in amazement, trying to process the fact that half of the world was previously not known to have existed. In 1500, Pedro Álvarez Cabral claimed Brazil in the name of Portugal, forever establishing a Portuguese cultural legacy in the Americas. The very term "America," however, did not come into common usage until after 1504–1505, when the letters of the Florentine explorer and cartographer Amerigo Vespucci were published as *Mundus Novus*.[12] Unlike Columbus, Vespucci unambiguously believed that new continents had been discovered, as opposed to outlying islands of Asia. The obvious quickly gained widespread currency and popular use of Vespucci's Latinized first name (America) became the standard reference to the New World, especially following the 1507 German publication of *Cosmographiae Introductio*, which included Latin translations of Vespucci's letters. Thus, Gutenburg's press, at this point slightly more than half a century in existence, played a key role in the development of nomenclature during the Age of Discovery, since

humankind was trying to label and describe things not previously known or barely even imagined until that era.

Back in Spain and Portugal, what little was left of religious freedom (there had not been much to begin with) was now being completely abolished. By mid–1492, all that was left of Sephardic Jewry in Spain were either *conversos* or those pretending to be; either way, the Spanish Inquisition persecuted both with zeal, especially if there was potential for significant property confiscation. Then, in response to illegal forced conversions of Muslims, rebellions to Spanish rule around Granada at the turn of the 16th century resulted first in violent suppression, then finally an official government policy of intolerance, reversing the peace treaty of 1492. By 1502, Muslims were given the same harsh options as Jews from a decade previous: convert, leave, or die. Like Spanish Jews who could not or would not leave and tried to convert, *Moriscos* ("Moorish Christians") were subjected to same type of persecutions by the Inquisition, with the innocent majority being forced to suffer alongside a guilty minority of pretenders, or simply because they were guilty of being Muslim when Granada fell. These affairs represented a stark contrast to long-time Muslim rule of Iberia in which the Catholic Church was not only allowed to exist (within boundaries), but in some instances to even prosper and grow. As a result, the final years of Queen Isabella's momentous life and reign were tarnished at home by religious persecution and political oppression.

In the Americas, however, things were just getting started. In 1513, the Spanish adventurer Vasco Núñez de Balboa crossed the Isthmus of Panama, becoming the first European to sight the Pacific Ocean before it was known by that name. That same year, Juan Ponce de León, a veteran of Columbus' second voyage and playing an important role in the settlement of Puerto Rico, sailed out searching for the legendary Fountain of Youth and instead discovered Florida, becoming the first conquistador to reach the present day United States. The name of his flagship for this historic voyage was the *Santiago*. Not long thereafter, on July 25, 1515, the Feast Day of Saint James, the city of Santiago de Cuba founded by Spanish conquistador Diego Velázquez de Cuéllar. Today Cuba's second largest city, Santiago quickly became a launching point for subsequent Spanish conquests, including that of Mexico. Amidst this triumphalism, King Ferdinand died in 1516, formally succeeded by his mentally unstable daughter Joanna of Castile (1479–1555) *la Loca* ("The Mad"), but in reality the scepter of power passed to her 16-year-old son Charles V (1500–1558), destined to become Holy Roman Emperor (see Chapter 12) and the first world leader in a true global sense.[13] Then in 1517, just as the scene appeared set for worldwide domination by Castile and Aragón, a German Augustinian monk from Wittenberg by the name of Martin Luther published a list of 95 theses, or objections, to the aggressive papal marketing

of religious indulgences, thereby initiating the Protestant Reformation, although this watershed moment was not realized until much later. In hindsight, the consequences of the event appear almost like a divine retribution against the Roman Catholic Church for Spanish and Portuguese oppression then unfolding across Iberia and throughout the New World.

Not long after American cities began being named after Santiago, the saint also began to personally appear there in battle. The conquest of Mexico and the Aztec Empire by the Spaniards under Hernán Cortés (1485–1547) in 1519–1521 must rank as one of history's more notable military expeditions in terms of small numbers overcoming a great civilization through superior technology and tactics, plus a healthy dose of luck. Cortés himself must also rank as one of the more disturbing figures in western history—not merely a hired killer like most Spanish conquistadors, but appearing to have been a man of some education and culture before going over to the dark side for the sake of wealth and power. Ironically, by the end of his life he felt disappointed in both, although no one, not even his critics, have ever downplayed the magnitude of his exploits. In the aftermath of Cortés subduing Mexico, unprecedented quantities of precious metal wealth began flowing into Spain. Moving forward, Spain would be a world power with only the Protestant Reformation and its own conscience standing in the way. As for Cortés, by the time he arrived in Santiago de Cuba as an impressionable, ambitious teenager to become first the protégé, then the son-in-law, and finally the dedicated enemy of the Spanish governor there, he no doubt quickly came to appreciate the high stakes involved for everyone in the New World. Accordingly, he sought his own place within that world, exhibiting the kind of single-minded zeal once displayed by Queen Isabella, who died the same year (1504) that the 16-year-old Cortés first set out for the Americas.

The key engagement in Cortés' epic campaign against the Aztecs took place on July 7, 1520, at Otumba, located northeast of Tenochtitlán and modern day Mexico City. Here the Spanish, after being harassed out of the capital with mounting casualties, and now outnumbered (by some estimates) twenty-to-one, turned on their pursuers and delivered them a bloody defeat, thereby sealing the fate of Aztec civilization. Much has been written regarding the key advantages of gunpowder and steel enjoyed by Cortés' tiny force, but less about his tremendous advantage in light cavalry. Native Americans had never encountered horses in combat, let alone the kind *à la jinete* style of horsemanship employed by the Spanish with murderous efficiency, its distant origins in the conflicts of ancient North Africa and medieval Iberia (see Chapter 6). An eyewitness later writing a widely-read account of the battle, Bernal Díaz de Castillo, emphasized the role of this cavalry in the stunning Spanish victory, as well as a vision of their patron Santiago, to whom Cortés was in the habit of loudly appealing to during moments of crisis.[14] After the Battle

of Otumba, *Santiago Matamoros* ("Moor-slayer") was thus unapologetically transformed into *Santiago Mataindios* ("Indian-slayer").[15]

Roughly concurrent with Cortés' astounding conquest, but no less astonishing, was the first naval circumnavigation of the globe by an intrepid Spanish expedition under the command of Portuguese-born Ferdinand Magellan (1480?–1521). Setting out west from Spain in 1519, Magellan's fleet initially consisted of five ships, one named *Santiago*, which unfortunately was the first of the group to be scuttled off the east coast of South America in 1520. It proved to be a harbinger of other misfortunes. After swinging around the southern tip of the continent (today known as the Straits of Magellan), and dubbing by name the Pacific Ocean first seen by Balboa, Magellan personally made it as far west as the Philippine Islands, where he was killed in 1521 during an unnecessary skirmish with natives. The survivors, along with their sole remaining ship *Victoria*, then somehow made it back safely to Spanish port in 1522 to tell of their amazing adventures. The debate was now officially closed: the world was in fact round. More importantly, about half of that world seemed ripe for European domination, particularly by the Spanish. Moreover, all previous Asian and non–Christian economic competitors were about to be left far behind in colonial activities. The name and cult of Santiago, however, would soon make it back to the Pacific and the Philippines during the next wave of Spanish exploration (see Chapter 12).

With Mexico and the Caribbean subdued, Spanish conquest now expanded with a fast and furious pace. In 1530–1533, Cortés' second cousin Francisco Pizarro conquered the Inca Empire in Peru with a level of ruthlessness that would incite both foreign approbation and envy. In 1539–1542, Hernando de Soto secured Florida and explored most of the modern southeastern United States, becoming the first known European to encounter the Mississippi River. In 1540–1542, Vázquez de Coronado explored much of the southwestern United States in search of the legendary Seven Cities of Gold (*El Dorado*), while his lieutenant García López de Cárdenas became first European to view the Grand Canyon circa 1540. Pizarro, de Soto, and Coronado were all known to invoke the name and help of Santiago in their conquests.[16] In 1542, Juan Rodríguez Cabrillo explored the California coastline, pushing as far north as the Russian River in Sonoma County. Military victory usually imposed Roman Catholicism on the vanquished, and far more stridently than Iberian Moors had done with Islam during the early eighth century (see Chapter 3).[17] Also in 1542 came the landmark Spanish New Laws proclaimed by Emperor Charles V in response to these rapid American conquests, outlawing all slavery of Native Americans, and the very first emancipation legislation of its kind in history. Charles may have been thinking of his grandmother, Queen Isabella, whose last will and testament expressed a desire to see Native Americans treated with humane justice rather than simply to be exploited for profit.

More cities appeared as well. In 1536, Santiago de Cali was founded in modern day Colombia; in 1538, Santiago de Guayaquil in present day Ecuador; in 1541, Santiago, the capital of Chile. And yet before all these, Santiago's old religious rival had firmly established herself in the New World as well. In 1531, a mere 10 years after Cortés vanquished the Aztecs, the apparition later known as Our Lady of Guadalupe first appeared in suburban Mexico City to a Native American Christian convert rechristened Juan Diego by Franciscan missionaries only seven years earlier in 1524.[18] The incident, or rather series of incidents, occurred around a former Aztec sacred site formerly dedicated to their mother earth goddess, and despite initial reservations by the institutional church, immediately became a popular pilgrim destination and has remained so ever since.[19] Today Our Lady of Guadalupe is said to be the most visited religious shrine in North America, and worldwide for Christians it rivals those of Jerusalem, Rome, and Santiago de Compostela. At this point in our chronicle it is useful as well to remember than Santa María ("Saint Mary") is also one of the most common place names in the New World, beginning with the first permanent European settlement on the mainland (in modern day Colombia), Santa María la Antigua del Darién, founded by Balboa in 1510, only four years after the death of Columbus and before any American city had been named Santiago. This Christian religious precedence of the Virgin over Santiago was of course nothing new. After all, Columbus' own flagship *La Gallega*, built not far from the shrine of Santiago de Compostela and given a name associated with that locale, had been rechristened *Santa María* before its famous last voyage.

The launch of the Spanish-Portuguese American conquest coincided with creation of some of the greatest works of western religious art during the High Renaissance, particularly in Italy. Between 1495 and 1498, Leonardo da Vinci painted his iconic *The Last Supper* in Milan; between 1516 and 1520, Raphael painted *The Transfiguration* in Rome.[20] These are but two selected examples. Both include well-known images of Saint James the Greater, although many (if not most) viewers of these famous works do not even realize they are looking at Saint James among the depicted apostles. In Leonardo da Vinci's *The Last Supper*, James (*Giacomo il maggiore*) is seated at table to the immediate left of Jesus and reacts with gesticulating horror when informed that one of the disciples is a betrayer. In Raphael's *Transfiguration*, somewhat humorously, all that is seen of James is the apostle's posterior as he crouches in terror, along with John and Peter, while a divinely glorified Jesus is attended by the raised prophets Moses and Elijah. At the stylized base of the mountain, representing the rest of humanity, the other apostles and onlookers stand baffled by their inability (through lack of faith) to cure an epileptic. One interesting aspect of large canvasses such as these is that the artistic focus on Jesus is so strongly emphasized that the individual identities of the

apostles—indeed of all humankind—become rather submerged by comparison. As such the cults of the individual saints, with possible exception of the Virgin Mary, were being subtly challenged by the new intellectual possibilities recently offered by the European Renaissance and discovery of the New World. It is worth remembering, for example, that Raphael's intensely divine depiction of Jesus' transformation (in stark comparison to the rest of mankind) was created about the same time that Martin Luther was presenting his 95 objections to a stunned Roman Catholic establishment.[21]

In Germany itself, the newfangled technology of movable print helped to spread an even greater revolution of thought throughout Europe, America, and beyond. Suddenly, mass-produced information, as well as engraved illustrations, were at everyone's fingertips, at least for those who could afford it and who could read. And even those who could not read could still look at the pictures. This demand created tremendous opportunities for talented artists such as the Alsatian-born Martin Schongauer (1440?–1491), who began his professional life as a painter but then quickly came under the spell of Gutenberg's press. Schongauer eventually became one of the most influential engravers in all of Europe, admired by the likes of Michelangelo, and whose works, thanks to the printing press, spread throughout the world, including Spain. As conquistadores rampaged their way through the Americas shouting the name of Santiago as a war cry, artistic images of Santiago Matamoros, or rather a subtly disguised Santiago Mataindios, became to reappear and proliferate, and would continue to do so right through the colonial period (see Chapter 17). These artistic expressions of violence would too often be over-sentimentalized or romanticized. To the great credit of Schongauer, his portrayal of Saint James the Greater in the posthumous role of supernatural religious warrior has been handed down with none of these soft trimmings. In the case of the German printmaker, the harsh brutality is both real and anticipatory, especially given that the artist died immediately before the New World had been discovered or the German Protestant Reformation officially begun.

Produced either by Schongauer or one of his associates during the latter part of the 15th century, the paper engraving titled *The Battle of St. James the Greater at Clavijo*, today the property of the Art Institute of Chicago, depicts Santiago as most of us have never seen him before.[22] Matamoros is presented leading a Reconquista army on horseback *à la jinete*, lightly clad with no armor and waving a sword, otherwise identified only by the scallop shell badge on his pilgrim's hat.[23] Surrounding him on all sides is mayhem and carnage. Men and horses are trampled underfoot. Decapitated bodies and severed limbs are strewn about. The wounded, the dying, the stragglers, and the fleeing are as numerous as those fighting. The barren landscape of the field at Clavijo is devoid of life, except for soldiery. The image would not

make a very good recruiting poster; it merely depicts medieval warfare for what it really involved, nothing more or less.[24] Clavijo was a battle that never occurred (see Chapter 3), and yet Schongauer's realistic view of Iberian warfare might well represent every battle that ever took place, including those yet to take place on undiscovered continents. The image also accurately reflects the European mentality towards Islam in general after the fall of Constantinople and final assault on Granada (see Chapter 10). Within a generation, this same mentality would be transported to the Americas and unleashed upon a populous, though technologically less advanced society.

By the year 1542, conventional wisdom seemed to hold that the entire globe was within the grasp of Spain, Portugal, and the Roman Catholic faith. Spanish viceroys had been established for New Spain (in North and Central America) and Peru (South America) thereby beginning the administrative consolidation of power within those realms. The lion's share of trans-Atlantic and trans-Pacific trade routes not controlled by the Spanish were held by the Portuguese, and there were as of yet few significant challengers.[25] Santiago Matamoros now seemed to be everywhere at once. The European military machine unleashed upon the New World victims of The Encounter, in tandem with the propagandistic power of the printed word, appeared to be unstoppable. Nevertheless, they would be stopped eventually, or at least the Spanish-Portuguese Roman Catholic version of this sweeping tide. In truth, things were happening and changing so rapidly that perceptive people, including their leaders, were given repeated pause. Problems and questions were being raised, most of which had not even occurred to the best European thinkers only a century before. Worse, these same problems and questions appeared to be multiplying faster than solutions and answers, let alone any effective implementation and communication. It seemed incredible that only 61 years before this (in 1481), the Ottoman Turks appeared on the verge of overrunning all Christian Europe. Now, a generation later, the tables had completely turned. Half a globe had been discovered, and Catholic Spain seemed to hold all the cards. The idea of universal Christian empire headquartered in Rome, an idea dead or not taken seriously beyond Europe since the Dark Ages, was now been seriously revived. The downfall of this presumptuous dream, however, would be even more rapid than its recent ascendance.

12

New Holy Roman Empire
(1542–1600)

> *How should I your true-love know*
> *From another one?*
> *By his cockle hat and staff,*
> *And his sandal shoon.*
> —William Shakespeare[1]

Not to be Spanish or Portuguese during the mid–16th century was, almost by definition, to be rightfully fearful of rapidly accumulating Spanish-Portuguese political and military power on a global scale. With much of the New World being appropriated with lightning speed by Iberian conquistadors, the idea of universal dominion by the Roman Catholic church suddenly did not seem like too far-fetched an idea. Along with growing religious hegemony came the proposed authority of law. By the 1540s, the Holy Roman Empire assumed an importance (and to many, a threatening potential) not enjoyed since the coronation of Charlemagne back in the year 800 (see Chapter 3). In 1519, an 18-year-old Charles V, the Hapsburg grandson of King Ferdinand and Queen Isabella of Spain, was elected Holy Roman Emperor. The old ambitious dream of Alfonso the Wise (see Chapter 8)—that of a Castilian-based Catholic emperor—was finally realized three centuries after the fact, even though Charles, strictly speaking, was Dutch by birth and upbringing. The same intolerance that had swept the Iberian Peninsula clear of non–Catholics within a matter of decades during the late 1500s, had now become a serious liability to anyone anywhere not of the Roman Catholic faith. Charles, unlike Alfonso, had succeeded in becoming Holy Roman Emperor; unlike Alfonso, however, Charles showed little toleration towards Jews, Muslims, or Protestants, let alone non-believers. Nevertheless, Charles V was obviously a man of tremendous talent, learning, and energy, fluently speaking most of the languages found within his huge realm, including Castilian. As

a formidable military leader, he was rarely defeated in the field, and as a sophisticated, worldly statesman, he fully appreciated the unprecedented complexity and difficulty of his challenging job. Notwithstanding these many advantages, however, the Roman Catholic dream of imperial unification did not last very long, and within a few short decades, had vanished almost as quickly as it had initially arisen. Winning battles, passing legislation, and punishing offenders, in the final analysis, proved not enough, not nearly enough in fact, to perpetuate or sustain global dominance, at least in the political sense.

At the heart of this unanticipated inherent weakness lay an old dilemma that the ancient Romans had often wrestled with, namely, individual freedom of religion, as opposed to top-down imposed religion from the state. Frequently Roman efforts were incredibly successful thorough an official policy of toleration, but at other times the results could be counterproductive, particularly whenever that policy of tolerance was forgotten or disregarded. Santiago Matamoros had conquered Iberia and the New World through force of arms, but holding, governing, and strengthening those conquests would require other non-military qualities. Within Europe itself, the Protestant Reformation initiated by the likes of Martin Luther and John Calvin found fuller nationalist expression in King Henry VIII's English Supremacy Act of 1534.[2] Henry had dared to divorce, or rather annul, over strenuous papal objection, his longstanding marriage to Catherine of Aragón, the daughter of Ferdinand and Isabella, and the aunt of Charles V. The Holy Roman Empire now faced formidable military resistance over religious matters from the likes of England, Germany, Scandinavia, and the Low Countries. Even as Charles introduced progressive legislation advocating the human rights of oppressed Native Americans, the anti–Spanish Catholic propaganda campaign later known as the Black Legend was in its formative stages—vestiges of which are still with us today—thanks in large part to widespread abuses of the conquistadors and of the Spanish Inquisition.[3] Apart from religion, Spain's empire also faced consistent opposition from European Catholic rivals such as Portugal and France, and sometimes from within the Vatican itself. Taken together, this European fire in the rear presented daunting, and in hindsight, debilitating obstacles to Spain's global ambitions, notwithstanding its massive territorial gains and burgeoning coffers of wealth.

More new Spanish cities in Latin America, however, continued to appear. Among these were Santiago Atitlán in modern day Guatemala, founded in 1547. Another was Santiago del Estero (del Nuevo Maestruzgo) in present day Argentina, founded in 1553. Other new place names prefaced with variations on the name of Santiago proliferated across the New World, including throughout Mexico. Then in 1550, less than 30 years after the conquest of the Aztecs by Cortés, and just as Christian religious conflict began to seriously

escalate in Western Europe, Mexico witnessed the first widespread insurrection by Native Americans against Spanish rule, known as the Chichimeca War.[4] This decades-long conflict was finally resolved only after Spanish troops had been removed from certain provinces, government subsidies granted to petitioners (later dubbed "Peace by Purchase"), and the continuous intervention of Franciscan missionaries, had successfully diffused tensions. The outbreak of these hostilities coincided in 1550–1551 with a timely public debate over the human rights of Native Americans (or lack thereof) held in Valladolid, Spain, between the Dominican missionary-turned-reformer, Bartolomé de las Casas, and the academic pro-slavery-apologist Juan Ginés de Sepúlveda. The official result of the debate was inconclusive, but on the ground opponents of slavery were gradually winning. The New Laws of Charles V issued in 1542 which outlawed enslavement of Native Americans (see Chapter 11) found growing acceptance and enforcement in both the Old and New Worlds, even as the Holy Roman Empire met with its first permanent setbacks at home in Europe against the Protestant states of the Reformation.[5]

The first tangible sign that the Reformation was a permanent phenomenon arguably came in 1556 when Charles V shocked the world by voluntarily abdicating as Holy Roman Emperor, retiring to a Hieronymite monastery for the last two years of his life. Charles was peacefully succeeded as Holy Roman Emperor by his younger brother Ferdinand I, but the Spanish crown passed to Charles' son, Philip II of Spain (1527–1598). Exhaustion, failing health, and personal demoralization, had caused Charles to step back. Historians are still debating his thought processes, although it appears obvious that he was taken aback by the fanaticism of the Protestant resistance, especially in his native Low Countries where he probably expected to be hailed as universal monarch with little opposition. Instead, he there frequently encountered ferocious rebellion only overcome through bloody and expensive Pyrrhic victories.[6] By 1555, German Protestants states had forced outright concessions from him, a tacit admission of Roman Catholic failure, even though the Germans continued to nominally acknowledge Charles as their sovereign until his abdication.[7] The original idea had been to use the tremendous inflow of wealth coming from the Americas to help the Holy Roman Empire achieve global dominance. Instead, other nation-states now wanted a piece of the action and those from whom the wealth was being extracted were in outright defiance.

The biggest disappointment for Charles, however, had to have been England. He and Henry VIII had started out as friends, in-laws, coreligionists, partners and allies. By 1534, all of that was over. Charles' son Philip attempted to mend fences, or rather join fences, with England in 1554 by marrying his father's cousin and the granddaughter of Ferdinand and Isabella, the English

Catholic Queen "Bloody" Mary I (1516–1558), but this royal marriage proved to be a sham and only escalated civil strife within England itself. In 1558, Henry VIII's other daughter, the Protestant Queen Elizabeth I ascended to the throne, and the English Reformation was instantly provided with both a rallying point and stabilizing force to secure its future. Now Spain was faced with its most formidable enemy since the time of the Reconquista, a rival ably led by a talented monarch, and one with comparable naval expertise plus no shortage of ambition for using it.[8] Moreover, on a symbolic level, England had little or no use for the Spanish traditions of Santiago. Although England had hundreds of churches and places named after Saint James the Greater, the legends of Santiago Matamoros carried minimal resonance for the average Englishman or Englishwoman, whether noble-born or commoner. For example, in direct opposition to the popular Spanish cult, Henry VIII had built St. James's Palace in London as a high-profile royal residence, named after the other apostle Saint James (the Lesser), followed by numerous Anglican churches in England dedicated to the same personage.[9] This English disdain or indifference towards the Santiago cult was well in keeping with the Protestant Reformation's generally critical attitude towards religious pilgrimages and their attached commercial infrastructure, financial profits of which mostly flowed into the coffers of Roman Catholic countries opposed to the Reformation or directly to the Vatican itself.[10]

The clearest English literary expression of hostility towards the Santiago tradition, however, though one rarely noticed (let alone dwelled upon), came from none other than Elizabethan playwright William Shakespeare. Leaving aside legitimate questions of true authorship, there can be no doubt whatsoever that the creator of these plays had a highly critical attitude towards the old Spanish cult that was both consistent and reoccurring, either by design (for purposes of propaganda) or from genuine sentiments of English patriotism. Specific examples of this Shakespearean hostility are numerous but limited space within these pages permits only a few of these be briefly summarized. The most famous without a doubt is the Bard's original arch-villain to end all arch-villains, Iago from *Othello*.[11] Iago (or James, Anglicized) is no saint, but he is certainly a Moor-slayer (and far from being sympathetic as a result), not by supernatural force of arms but rather through sustained cunning and deceit, arguably on a superhuman level. Shakespeare's most famous dramatic antagonist was likely, on one level, a parody of the character's fellow Florentine Niccolò Machiavelli, but was also clearly a caricature of Spain's patron protector, at that time presenting a direct threat to the political and religious independence of Protestant England. Moreover, the character of Iago plainly had an earlier prototype from Shakespeare's dramatic canon in *Cymbeline*, where another similarly-named villain, the Italian-born Iachimo (or Jachimo), does his very best and worst to undermine, ultimately without

success, the romantic happiness of the English-born hero and heroine, respectively, Posthumous and Imogen.[12] Given not one but two obvious examples of this kind within Shakespeare's catalogue, it is difficult to believe that the Bard held an overly- favorable opinion of the Spanish quasi-religious cult.

The list of dubious references continues. More subtly, in *Hamlet*, Ophelia during her famous mad scene makes direct reference to Camino pilgrims on their way to Santiago de Compostela while singing a deranged lament (see header quote).[13] Given the disturbing context, audiences are led to naturally associate Camino pilgrimage with madness and falsity, since in the play Hamlet has just unwittingly killed Ophelia's father Polonius, triggering her insanity and ultimate suicide.[14] The allusion is not meant to be flattering, nor is it an isolated example. In the far less well-known but no less astringent play *All's Well That Ends Well*, Shakespeare uses another allegory of religious pilgrimage to even more unsettling effect. The heroine Helena leaves her home in "Rossillion," France, disguised as a Camino pilgrim with true intent to pursue and bring back her wayward husband Bertram from Italy.[15] In the play, she announces her feigned purpose by letter to the Countess with "'I am Saint Jacques' pilgrim, thither gone…'" (III.iv.4). After arriving in Florence, Italy, where Bertram is situated, Helena cleverly tells her hostess (a Florentine widow) that she is in fact traveling in the opposite direction from whence she just came "To Saint Jacques le Grand" (III.v.34). Geography aside, the fact is that alleged Santiago pilgrimage in *All's Well* is repeatedly used as a ruse, and a very effective one at that. Yet another example is the melancholic Jacques (James) from *As You Like It*, this comedy's only cheerless character. Even more sacrilegious, at least from a Spanish Catholic point of view, is the secular use of pilgrimage allegory in the timeless revelry scene from Shakespeare's *Romeo and Juliet*, in which the teenage star-crossed lovers fall for each other at first site (I.v.93–110).[16] Romeo refers to the person of Juliet as "dear saint" (103) and "holy shrine" (94), then to his own lips as "two blushing pilgrims" (95), while Juliet addresses Romeo as "Good pilgrim" (97), urging his advances with "For saints have hands that pilgrims' hands do touch" (99). And so forth. Later in Act V, Juliet's tomb becomes an irresistible shrine for Romeo's desperate return to Verona. For Shakespeare, Camino pilgrimage deliberately takes on every possible worldly meaning except that for which it was originally intended. In these plays, we are not far from profane universe of Boccaccio (see Chapter 9), an acknowledged source material for the English Bard, and another writer possessing a keenly critical eye directed towards the Santiago cult.

While English poet-playwrights such as Shakespeare were challenging foreign Spanish authority with quill and paper, English adventurers were doing the same on land and sea, with similar effective results. By far the most renowned and successful of these adventurers was Francis Drake (1540?–

1596), a common-born privateer who made a long career out of tormenting Spanish trade shipping worldwide, and was rewarded with a knighthood by Queen Elizabeth for his extraordinary efforts. A seasoned veteran of New World piracy or privateering by the time he was in his thirties, Drake's first astounding feat came in 1577–1580 when, imitating Ferdinand Magellan (see Chapter 11), he circumnavigated the globe with his flagship *Golden Hind*, pillaging Latin American trade routes as he went along. Notably, in 1579 he took the trouble to make port in northern California at Point Reyes (i.e., Drake's Bay), formally claiming for England the very same remote territories that Juan Rodríguez Cabrillo had claimed for Spain some 37 years previously. Meanwhile, King Philip II was taking his own high-handed measures to extend unified Spanish Catholic rule. In 1580, the so-called Iberian Union of the Spanish and Portuguese crowns was imposed—much to the dissatisfaction of Portuguese nationalists—thereby creating a single political entity under Philip's growing authority both in Europe and the Americas. The time for a final show down between Spain and England was rapidly approaching. This moment arrived in 1585 when the English sent military aid to the Protestant Low Countries, at the time newly asserting their independence against Spanish rule, and thus sparking an undeclared war between England and Spain that would continue unabated for the rest of the 16th century. Francis Drake wasted no time in entering the fray.[17] That same year (1585), he first raided southern Galicia (Vigo) in Spain, then after that, the Portuguese Cape Verde Islands located off West Africa, making his primary target the heavily populated and symbolically named Santiago Island. From there, Drake crossed the Atlantic Ocean and hit several prosperous locations in the New World, including the city of Saint Augustine in modern day Florida, a settlement founded by Spanish only 20 years earlier in 1565. Though all successful, Drake's trans-Atlantic raids proved to be a mere practice run for what would follow over the course of the next decade.

In 1588, came the unhappy climax of Spanish frustrated ambitions as the ill-fated "Invincible" Spanish Armada of Philip II was first beaten back in the English Channel by a makeshift fleet under Drake's command, then ravaged and reduced by storms. By the time the remains of the Spanish fleet had limped back to Iberia, they were merely happy to still be alive. Protestant England remained free, while King Philip retired in reclusive prayer to ponder why his great enterprise had failed. Drake, however, was far from finished. The following year (in 1589), *El Draque*, as Drake was now known to the Spanish, once again boldly raided Galicia. This time, though, the Galicians were ready for him. After making port and inflicting some damage at A Coruña, the English were repulsed with heavy losses in both men and shipping. This was not far from Santiago de Compostela, perceived as the ultimate target of the English attack. Not since the days of Almanzor (see Chapter 5)

had a non–Catholic military force so severely threatened the revered shrine. According to local legend, Galician women joined Galician men in hand-to hand fighting against Drake's forces, much to the astonishment and dismay of the English.[18] Before the English retreat, however, the relics of Saint James the Greater at Santiago were hidden for safekeeping—so much so these artifacts were subsequently lost for nearly three centuries before being rediscovered in 1879 (see Chapter 17).[19] As for Francis Drake, this setback seems to have curbed his aggressiveness somewhat, and he never enjoyed another major victory afterwards. In 1595, he attempted to repeat his record of successful raids against Latin America but instead suffered a series of embarrassing defeats, culminating in a complete repulse at San Juan, Puerto Rico, late that same year. Now in poor health and presiding over a damaged, demoralized task force, Drake expired from dysentery in early 1596 and was buried secretly at sea off the coast of Panama. In hindsight, one is tempted to conclude that the beginning of the end for this great military commander came only when, at the height of his fame, he apparently aspired to desecrate the religious shrine at Santiago de Compostela.

Some three hundred later, by the late 19th century, after the tables had turned politically and militarily with the British Empire dominating world affairs while Spain had been more or less ejected from Latin America (see Chapter 16), vestiges of national rivalry between the two cultures were still going strong enough to help generate a commercial industry. One vehicle of expression for this was the ever-growing popularity of Shakespeare's plays. Towards this end, the wood engravings of the artist John Gilbert (1817–1897) cannot go without mention. The young British provincial-born Gilbert was a mostly self-taught painter of middling rank at best until he decided to devote his long career with impressive single-mindedness—not unlike Francis Drake before him—to a focused task, namely, the print illustration of Shakespeare's complete dramatic works.[20] By the time he was finished, working in partnership with the Brothers Dalziel (often leaving their signature name on the plates), Gilbert had produced well over 700 engravings of this type. One would be hard-pressed to name other Shakespearean images that have received wider distribution amongst the general reading public over the last 150 years. Indeed, the prolific work of Gilbert in this area has nowadays become nearly synonymous with all Victorian-era Shakespeare production values, sketched out and highlighted in all their unrestrained, sentimental and melodramatic glory.

For *Othello* alone, Gilbert published at least 28 illustrations (circa 1867), 10 of which depict the evil character of Iago in a sinister light hardly equaled before or since. Among these, one can choose according to individual taste, but the one depicting Act III, scene iii, in which a calculating Iago brings a despairing, helpless, and insanely-jealous Othello to his knees, is of special

note. Both men are armed with swords, but arms are irrelevant in this case since human weakness is effectively exploited by whoever truly knows how to exploit them. A Greek column of Cyprus anchors the background behind Othello, as if to emphasize the classical tragedy of the scene. A suppliant Othello extends his clenched fists to heaven, not in prayer, but swearing vengeance, and hence his own eventual destruction. Iago glances sideways at his human prey, feigning sorrow and regret while inwardly rejoicing at his successful ruse. A few pages later, by the beginning of Act IV, Iago stands triumphant over a completely prostrate Othello. The traditional visual image of Santiago Matamoros is thus transformed or inverted into the very symbol of evil intentions, embodied by the ensign Iago with the defeated Othello as his not-so-innocent but still sympathetically tragic victim.

Gilbert's demonstrative illustrations of the Shakespearean and innately English hostility towards the Santiago cult, though dating from the late 1800s, had their stylistic roots in the German Protestant engravings for the printed word long before Shakespeare's time. Even before the Reformation and Age of Discovery had begun, for that matter, the illustrative work of Martin Schongauer had cast Santiago Matamoros into a noticeably harsher light that seemed to presage worse things yet to come, both for the military cult of Saint James the Greater and for the world at large (see Chapter 11). Then during the early 1500s came the brilliant, distinctive engravings of Lucas Cranach the Elder (1472?–1453), a German engraver well-known to both the Protestant Martin Luther and the Roman Catholic Charles V. Cranach's *Saint James the Greater* from his *Martyrdom of the Apostles* series (like the Schongauer image, today the property of the Art Institute of Chicago), on its surface appears relatively faithful to the biblical account from *Acts of the Apostles*, but the comparison ends there. Herod Agrippa, his Jewish advisors, attendants, and executioner all come off as sinister and murderous Spanish inquisitors, while James and a sympathetic peasant woman bystander become oppressed Protestants of Germany or the Low Countries. By the 1520s, both regions were already under severe pressure from the Holy Roman Empire. Even more troubling is an anonymous portrayal of Saint James the Greater from approximately the same time and place, usually attributed to a follower of Lucas Cranach the Elder, and today in possession of the de Young Fine Arts Museum of San Francisco. Here, Santiago is presented in his standard pilgrim's garb, but also as a decrepit, blind and barefoot old man clutching a Dominican rosary. The depiction is far from flattering. One is instantly reminded of Martin Luther's advice to his would-be German pilgrim readers to stay home and take care of their families and the poor (see Note 10). By the end of the same century, this Protestant ambivalence would explode into outright hostility as effectively expressed through the dramatic genius of Shakespeare.

By the end of the 16th century, it had become abundantly clear to any ordinary observer that western civilization had changed profoundly from what it had always seemed to have been only a hundred years previously. The English defeat of the Spanish Armada in 1588 had alone signaled to everyone that neither the Old nor New Worlds would be exclusively dominated by Spanish Catholicism, and that Protestant northern Europe, particularly England, would wield powerful influence in all future world affairs. Aside from religion and politics, by the year 1600, everyday life, both in Europe and America, had changed as well. Ordinary people worked, played, studied, ate and drank much differently than their forebears had.[21] In sum, human thinking had itself changed within the short time span of a few generations. Most philosophers would have said, and still would say, that this overall change was for the better; nevertheless, some things had been lost as well, and many of these losses might well be considered regrettable. For one, the religious cult of Saint James the Greater long centered around Santiago de Compostela would never again command the same legions of faithful that it had back in the days when Christian Iberia had to fight for its very independence. The brave Galician men and women who successfully drove back marauding English invaders led by Francis Drake in 1589 could still not alter the bigger course of history. Faith in, and dedication to their local shrine could not roll back the Protestant Church of England or, for that matter, prevent Native Americans from incorporating their traditional religious practices into an updated version of Roman Catholicism. Our Lady of Guadalupe would soon enough rival Santiago de Compostela as a Christian pilgrimage destination. Moreover, for those incapable of clinging to such a simple, unquestioning faith, much more would be required from now on to satisfy pure intellectual curiosity. This same relatively novel sentiment carried over into most other fields of human endeavor, including patriotism, military service, and even romantic love. Moving forward, the long-established cult and image of Santiago would, after the turbulent 16th century, frequently assume an aspect that was far more ambiguous, nuanced, and at times, even somewhat ironic.

13

The End of Chivalry
(early 1600s)

"You're too simple-minded, Sancho," answered Don Quijote. "Remember that this great Knight of the Red Cross was given to Spain by God Himself, to be its patron saint and protector, especially in its fierce struggles with the Moors, so he's invoked and called on in all our battles, and he's frequently been seen, visibly present on the battlefield, humbling and trampling, destroying and murdering, those Squadrons of Hagar [Moors]*, a truth of which I could give you many citations from the works of our truthful Spanish chroniclers."*—Miguel de Cervantes[1]

As discussed earlier within the pages of this study (see Introduction), among many regional Spanish derivations for the name "James," one of the more popular is "Diego." In the present day United States, the best-known usage as a place name is of course the country's eighth largest metropolitan area located in southern California. The European history of that locale in turn dates from the year 1602, in which Spanish explorer Sebastián Vizcaíno led his fleet and flagship *San Diego* into the same bay previously designated as San Miguel (Saint Michael) by Juan Rodríguez Cabrillo in 1542. Vizcaíno promptly renamed the bay, river, and territory after his flagship, and the newer designations stuck; however, in this instance the name Diego was not a reference to Saint James the Greater, but rather to Saint Didacus (or Diego) of Alcalá (1400?–1463), a Franciscan holy man who died decades before the Reconquista was completed or the New World even discovered. As far as the record shows, Didacus ("Didacus" being a variation on his saintly apostolic namesake) lived a blameless and admirable life, selflessly devoting himself to his fellow beings, especially those less fortunate than himself.[2] He was officially canonized in 1588, the same year the Armada was defeated (see Chapter 12), and his original designated Feast Day was November 12, the same date

that Vizcaíno's expedition celebrated the first known Christian mass in modern day California.[3] The event is significant in other respects as well. By 1602, Spanish adventurers in the New World were no longer exclusively claiming Saint James the Greater as their personal patron or protector, not merely to be contrarian or individualistic, but more so because the old Santiago cult had ceased to be of central importance in their exploratory endeavors.[4] As the 17th century progressed, the military conquest of Latin America was winding down, and for all practical purposes had already become an established fact on the ground. Moreover, the concept of Spanish Catholic world dominion, one so widely perceived and so feared outside of Spain less than a century previous, had by then given way to the idea of a uniquely Latin American culture, as opposed to that of a strictly Iberian colonial outpost.

A mere three years after Vizcaíno made landfall at San Diego Bay, a landmark literary event occur, one in many respects boldly demarking the new attitude of Spanish-speaking peoples throughout Spain and Latin America. In 1605, the first part of *El ingenioso hidalgo don Quijote de la Mancha* by Miguel de Cervantes Saavadre (1547–1616) was published. It quickly became the most popular Spanish language novel in history on both sides of the Atlantic. Part II of *Don Quijote* was published 10 years later in 1615 and enjoyed similar success. One year later (1616), its 69-year-old author had passed away in Madrid, by then a celebrity and likely quite aware (and proud) of the major cultural phenomenon which he had single-handedly created.[5] This is not the proper place to expound at length upon one of the greatest literary works in history, but suffice it to say that Cervantes took the entire western tradition of romantic chivalry and reduced it to the comic tale of a madman and a simpleton (Don Quijote and Sancho Panza, respectively). References to Saint James the Greater make it into the novel both directly and indirectly. While on one his many road excursions, the Don peruses several bas relief sculptures of SS. George, Martin, Paul, and James, the latter of whom he identifies most enthusiastically: "Now this is a true knight in Christ's holy army! His name is Don San Diego Matamoros, one of the bravest saints and most courageous knights the world has ever seen or Heaven ever held, to this very day."[6] Cervantes is careful to distinguish San Diego "Matamoros" from the other San Diego who by that time had possibly surpassed his original namesake in popularity as a Catholic saint. One page later, the Don must elaborate further on why Matamoros happens to be so famous, but Sancho quickly loses interest (see header quote). Even in English translation, Cervantes' trademark sense of titanic irony is difficult to escape.

Prior to 1605, life had not dealt a kind hand to Miguel de Cervantes. Born into a proud but impoverished Castilian family in the town of Alcalá, the same city associated with Saint Didacus, no one knows with any certitude how he obtained his prodigious book learning, although it is clear there was

a wide gulf between what Cervantes read in those books and what he saw in real life. As a young man, Cervantes did what many impoverished young men from his time and place did, namely, to seek military glory.[7] In 1571 at age 24, he found exactly that, not in the New World, which by then had already been conquered, but rather in the eastern Mediterranean at the epic sea battle of Lepanto, in which the Holy League defeated (with great effort) the ever-aggressive Ottoman Turks. Cervantes, fighting in the ranks as a volunteer marine, was severely wounded and permanently lost the use of his left arm, though fortunately for book lovers, not the use of his writing hand. After a lengthy convalescence, he then found himself captured by Barbary pirates and spent five years in North African slavery until his poor relatives eventually raised enough money to ransom his freedom, beggaring themselves in the process. After a stint as a middleman supplier for the failed Spanish Armada invasion of England in 1588, Cervantes declared bankruptcy but still landed in debtor's prison at Seville (circa 1592) after his bank had failed and all his funds lost during the economic upheavals of that chaotic period. According to reliable tradition, it was in prison that the idea for *Don Quijote* first took shape. Cervantes spent the next decade or more eking out a living as a tax collector, trying with difficulty to keep his government auditors happy, and creating Part I of the book for which he will always be remembered, meanwhile dreaming of immigration to the Americas and a new life, even as his petitions and job applications for doing so were being repeatedly denied.

As things transpired, it was Don Quijote and Sancho Panza, instead of Cervantes, who reached America, and rather promptly at that. In 1607, a mere two years after the publication of the novel's Part I, first prize for a jousting tournament in the mountains of Peru went to contestants masquerading as the Man from La Mancha and his loyal sidekick.[8] This was less than eight decades after Peru had been brutally conquered by Francisco Pizarro, and Spaniards had begun designating various place names as "Santiago" in and around Lima.[9] This was also (still) an astounding seven years before the *Mayflower* would make landfall at Plymouth Rock in 1620.[10] Shortly after the death of Cervantes in 1616, Spain along with most of western Europe was engulfed in the perception-altering conflict later dubbed the Thirty Years War (1618–1648), which began as Catholics and Protestants fighting each other over religious grounds, but ended with uneasy Catholic-Protestant combines negotiating realigned territorial borders in north central Europe. Meanwhile, Stuart England stood mostly aloof, only to erupt into its own civil war between 1642–1646, later ending with a short-lived Puritan ascendency and the Parliament-approved execution of King Charles I in 1649. As England and Spain were distracted by ongoing wars in Europe, the Dutch used the opportunity to invade (and occasionally secure) former Spanish and

Portuguese holdings in the New World, most notably in Brazil and the Caribbean.[11] Long before the English, French, and Dutch began to seriously challenge Spain's supremacy in the western hemisphere, however, *Don Quijote* had already found a firm foothold in the hearts and imaginations of Latin American readers. As observed by the Argentine scholar Valentin de Pedro, "America was the scene where chivalry rode for the last time"—beginning with Christopher Columbus himself, one might well argue.[12]

In reality, chivalry of the type that had so long nurtured and sustained the Santiago cult probably ended before Don Quijote and Sancho Panza leapt off the pages of Cervantes' revolutionary novel in 1605. One might even view Don Quijote mounted on his broken-down warhorse Rocinante as representing a subtle parody of Santiago Matamoros—along with a healthy dose of plausible deniability—or worse, Sancho Panza astride his beloved donkey Dapple, representing that same parody taken to a greater extreme. Don Quijote is certainly not an Iberian Reconquista warrior *à la jinete* in the literal sense, nor a White Rider of the Apocalypse, nor Santiago Matamoros, and yet there are unsettling echoes from all these traditions in the vivid portrayal presented to readers by Cervantes. Quijote imagines himself to be a mounted chivalric champion in the purest sense, following strict precepts taken from the same body of medieval literature in which these traditions had been originally preserved. Cervantes himself would no doubt have taken umbrage at the suggestion, just as he expressly denied (tongue in cheek) being the original author of the novel itself. Even so, no less a perceptive literary critic than W.H. Auden asserted that Don Quijote himself appears to be the caricature of a Christian saint, although he stopped short of saying whether a specific saint was being represented.[13] In any event, it is no mere coincidence that in the immediate aftermath of *Don Quijote*, Spain entertained a fiery public debate as to who in fact the true patron saint or saints of its country should be.

Another cause of declining devotion to the Santiago cult was that, by the early 1600s, there had been a number of very real, very well-documented Spanish saints recently born, living, and dying within the confines Spain itself. In addition to the widely-revered Saint Didacus, surely the most famous and beloved of these home-grown Spanish religious paragons was Saint Teresa of Ávila (1515–1582), Carmelite reformer, popular author, and possessing that rarest of titles, a female Doctor of the Roman Catholic Church. Along with Spanish co-reformer Saint John of the Cross (1542–1591), Teresa devoted her life to helping others develop their inner spirituality during a time in which Spanish society was being overtly corrupted by massive amounts of inflowing wealth and power. Hailing from the same region of Spain that a century earlier had produced Queen Isabella I, Teresa was revered by both commoner and nobility alike, somehow managing often to challenge institutional customs

without running afoul of the Inquisition.[14] Like her secular counterpart Cervantes, she took a critical view of literature devoted to romantic chivalry, for which she was enthusiastic as a child but later blamed (along with some bad company) for a slightly wayward adolescence. Then after it became clear to everyone about three decades after her death that she was destined for official sainthood, something unexpected happened. Many Spaniards, including Spanish royalty, began clamoring that Teresa be made co-patron saint of Spain, along with Saint James the Greater.[15] After her canonization in 1622, a public debate on the topic began rather spontaneously, seemingly giving the initial advantage to Teresa's partisans, but by the mid–1620s the backlash in favor of Santiago had turned the tide in favor of the traditional status quo. In the forefront of the opposition to Teresa was the Spanish courtier poet, Francisco de Quevedo (1580–1645), a friend and younger contemporary of Cervantes, even though his serious and reactionary outlook might well be described as anti–Quixotic, depending on one's perception level of irony within the novel.[16] Then in 1630, Pope Urban VIII settled the matter by declaring in favor of Santiago as the Spanish patron saint, along with the Virgin Mary as the national protectress.[17]

The entire episode seems to have given everyone in Spain a start. Although Spanish ambitions had been decisively checked and contained by the English in 1588, the pretense of world domination continued for long afterwards. For the first time in modern memory, by the beginning of the 17th century there appeared to be a wide chasm between the official policies of the Spanish state and the mood of the Spanish people, or, to put it more forcefully, between rhetoric and reality. Now, misconceptions were beginning to collide with reality, and the 1600s would accordingly witness a painful and gradual decline in Spanish prestige and power, accelerated by aggressive entry into the Americas by the English, French, and Dutch. One cultural expression of this ambiguity was *Don Quijote*; another was the unanticipated argument over which Christian saints should symbolically represent the Spanish Empire. Santiago, in his incarnation as a Moor-slayer or Indian-slayer, represented the past. Teresa, as a very recent, real-life inspiration for human virtue, wisdom and intelligence, represented for many Spaniards the future. The compromise, ultimately, was that Santiago remained as patron, but with more emphasis on pilgrimage and less on conquest, while the failsafe traditional cult of the Virgin Mary was reaffirmed as national protectress for those needing a more maternal figure of worship. Despite this setback for Teresa's partisans, however, reminders of her continuing veneration can still be found almost everywhere, including the Americas where the popular shrine at the Immaculate Conception of El Viejo in Nicaragua has received official papal recognition since 1989.[18]

During the prelude to this historic debate came the works of Cervantes

and all the visual arts which it subsequently inspired. The theme of religious pilgrimage held a special place in the imagination of Cervantes, notwithstanding many ironic implications found within *Don Quijote*. Widely forgotten today is that Cervantes considered his masterpiece to be, not *Don Quijote*, but rather his final, posthumously published *Los trabajos de Persiles y Sigismunda* (1617), completed only a few days before his death in 1616. "The Trials of Persiles and Sigismunda" is a pilgrimage romance in which the hero and heroine's final destination is Rome, as opposed to Santiago de Compostela.[19] One is immediately reminded of Montaigne's humorous remark that Spanish pilgrims preferred travel to Italy, a remark published years before Cervantes produced his most famous works (see Chapter 8). As for Cervantes himself, his memory is (not too surprisingly) honored in countless ways throughout Spain, especially in Madrid. Anyone fortunate enough (as this writer was) to visit Madrid in 2016, the 400th anniversary of Cervantes' death, would encounter numerous reminders of this popular celebration. Unlike concurrent Anglo-American festivities for the same supposed anniversary of William Shakespeare—or, for that matter, the ongoing Spanish traditions of Saint James the Greater—those of Miguel de Cervantes are firmly rooted in documented, undisputed facts. Moreover, readership perceptions concerning Cervantes' biography fit tidily within the textual themes of his landmark output. In short, there are no gaps, not even small ones, between the literary biography and the literary text.

Though not a massively implied construct on the scale of Stratford-upon-Avon or Santiago de Compostela, the Cervantes Monument in Madrid, located within the attractive Plaza de España, has in modern times become, in its own right, a pilgrimage destination of sorts, and certainly one that great city's most visited destinations both for tourists and locals. Built originally during the late 1920s, with some additions during the late 1950s, the centerpiece of the plaza is a large monument depicting four-dimensional sculpted scenes inspired by *Don Quijote*. The location of the plaza, a short walk north from the Sabatini Gardens and monumental Palacio Real, has itself a significant history on several different levels. In addition to being near the old Camino route from Madrid to Santiago, the site of the Plaza de España, according to tradition, was also the scene of Spanish patriots being executed by French soldiers on May 3, 1808, during the Napoleonic-era Peninsular War (see Chapter 16). This vividly re-imagined event was forever stamped into the popular consciousness by Francisco de Goya's tremendous canvass, *The Third of May 1808*, still conveniently on display for the viewing public at the Museo de Prado on the other side of central Madrid. Thus the plaza itself becomes for all visitors highly symbolic of Spanish patriotism, martyrdom, and sacrifice, in this particular instance, all rolled into one and topped off by a magnificent, imposing reminder of Spanish Renaissance literary

achievement. By extension, this same literary symbol has been transformed into universal cultural heritage, including for those of us in the English-speaking world.

As previously noted, to the immediate south of the Plaza de España is the Palacio Real ("Royal Palace"), one of Madrid's most imposing tourist attractions and built upon the foundations of the original Islamic fortress established in response to early successes of the Reconquista back in the ninth century. There in 2016, as one small part of the Cervantes 400th anniversary celebration, displayed throughout the Main Gallery were several sets of embroidered tapestries decorated with scenes from *Don Quijote*. Among these were those commissioned by King Philip V of Spain (1683–1746) between 1721–1746, titled *The Story or Fable of Don Quixote of La Mancha*, designed by the artists Andrea Procaccini (1671–1734) and Domingo María Sani (1690–1773), and manufactured by the Dutch master weavers Jacobo and Francisco Vandergoten. Among these beautiful, brightly colored tapestries is "Don Quixote in the cage," based Chapters 56–57 from Book I, in which the Don is tricked into confinement by devious local officials wishing to transport him back to his home town. Here we see a perplexed Quixote seated in a portable cage being drawn by two enormous oxen in procession, surrounded by local peasantry and nobility, many of whom are in disguise. The scene is alarmingly reminiscent of the popular legend of the martyred Saint James the Greater being drawn by a pair of oxen to the Galician castle of Queen Lupa, as depicted by many Renaissance artists (see Chapter 5). In the Cervantes tapestry, a loyal Sancho Panza, along with his donkey Dapple and the broken down Rocinante, substitute for the saint's disciples—representing another alarming similarity. Most striking, however, at the bottom center of the scene, are two seated (not standing) Camino pilgrims, clearly demarked with staff and scallop shell emblems, observing the proceedings in wonder or amazement. This detail is not found in Cervantes' novel and obviously represents considerable artistic license, although it appears merely to take one step further the description contained within the novel. All in all, this cheeky attitude is both in keeping with the ironic tone of *Don Quijote* and a deep, nearly hostile skepticism of the Enlightenment directed towards most conventional religious beliefs.

A more subversive (though less obvious) moment occurs within the pages of the novel itself in Book II, Chapter 54, when Sancho, recently disillusioned with governing an island, astride Dapple and traveling alone along one of the Caminos encounters a group of Germans wearing hooded pilgrim's gear. To his astonishment, one of the pilgrims reveals himself to be Sancho's former neighbor, Ricote the Moor, a Morisco (Christianized Muslim) recently expelled from Spain but returning now in disguise to retrieve buried treasure near their village.[20] Sancho agrees not to reveal Ricote's secret but also refuses

to offer help, which would be treason in Sancho's view, as well as far more courage and energy that he is able to offer for much of anything. Later in Chapter 63, all problems are neatly resolved when Ricote's virtuous daughter Ana Felix, a devout Christian (unlike her father), marries a Spanish gentleman. This strange, funny, and relatively unknown interlude near the end of *Don Quixote* foreshadows Cervantes' next and last work, *Persiles y Sigismunda*, with its blended themes of romance, personal disguise, and religious pilgrimage. Stepping further back from the *Quijote* narrative, one is reminded that Cervantes humorously distances himself from the entire tale by attributing the entire work to the (fictional) Arab historian Sidi Hamid Benengeli ("Mr. Eggplant"), via an anonymous Morisco translator, after Cervantes allegedly discovered the original Arabic manuscript in Toledo.[21] Thus attributed authorship for one of the greatest works in all of world literature is emphatically denied within the text by the narrator who is obviously in fact the true author.[22]

The memorable episode of Sancho Panza, Ricote, and the Pilgrims was perhaps nowhere better illustrated than in 1863 by the inimitable Gustave Doré (1832–1883), the prolific French commercial artist whose pictorial work did for Cervantes' novel what that of his English contemporary John Gilbert also did for Shakespeare (see Chapter 12). Frequently partnered with the engraver Héliodore Pisan (1822–1890), Doré produced vivid literary images that are often difficult to disassociate from their much older textual inspirations.[23] In the case of *Don Quijote* alone, these illustrations staggeringly number over 500, but none better showcase his talent than that of the disturbing encounter between Quijote's loyal sidekick in misadventure and Ricote the Moor with the Camino pilgrims. Here we see a very corpulent Sancho Panza riding Dapple slowly in the opposite direction of the departing pilgrims (including Ricote), his mouth covered in comic disbelief, horror, fear, or perhaps all the above—it is difficult to tell. Sancho silently conveys the proverbial "I know nothing" better than any words possibly could, not unlike the Sergeant Schultz character from the popular late–1960s television series *Hogan's Heroes*. When confronted with an inconvenient truth, Sancho (like Schultz), prefers feigned ignorance or, better yet, plausible deniability. Matters are not helped in Cervantes' account by the genuine German pilgrims seemingly being on the Camino mostly to vacation, frolic, and escape duties closer to home so vigorously preached by the likes of Martin Luther, similar to the pleasure-loving pilgrims found in Boccaccio or Chaucer. Ricote, though a fraud, at least has a somewhat logical reason for making his feigned pilgrimage. By the early 1600s, as Spain began its long decline as a world power, the Road to Santiago had obviously lost much of its earlier mystique, probably even for those patriotic Spaniards who still depended upon the Caminos for a livelihood.

By the mid–17th century, in midst of tremendous shifts involving military and economic realignments across the globe, if there was one thing that most observers could agree upon it would be that the Protestant Reformation had been victorious, but at a very high cost. England was finally beginning to assert its presence in North America, especially now the English Civil War had ended, while north central Europe had made it abundantly clear that its future political fate would be mostly independent of Rome, Madrid, and all other outside forces. The conclusion of the Thirty Years War had restored diplomatic order of sorts to Europe, but the conflict had also changed the way people thought and behaved, especially with regards to religious matters. France, despite its Roman Catholic faith, had demonstrated to its neighbors that worldly affairs always took precedence over spiritual matters, at least within the realm of international politics. Meanwhile, Spain continued to behave as if it were leading global affairs, when in fact several of its rivals, including England and France, had already passed it by. No sooner had Spain symbolically decided for good that Santiago was indeed its national patron saint than the always artificial Iberian Union between Spain and Portugal came to an abrupt halt in 1640 with the latter reasserting its own distinctive national identity. One immediate result was that Brazil, the largest country in Latin America, began to appear more separate and politically unique within the western hemisphere. Another was that Protestant churches across the western hemisphere began to establish their own notions of what constituted legitimate pilgrimage and saintly veneration. As for traditional ideals of chivalry, these may have ended, but did not necessarily die. Instead, for many devout believers, these old notions had been more internalized, rather than simply cast aside. Therefore, it would be remiss for this survey not to briefly review some of the outstanding artistic productions flowing from this new attitude.

14

Penitents of the Reformation (late 1600s)

I have heard of many of your Husband's Relations that have stood all trials for the sake of the Truth. Stephen *that was one of the first of the Family from whence your Husband sprang, was knocked o' the head with Stones.* James, *another of this Generation, was slain with the edge of the Sword. To say nothing of* Paul *and* Peter, *men antiently* [anciently] *of the Family from whence your Husband came… 'Twould be impossible utterly to count up all the Family that have suffered Injuries and Death for the love of a Pilgrim's life.*—John Bunyan, *The Pilgrim's Progress*[1]

In the year 1656, the Seville-born artist Diego Velázquez (1599–1660) painted *Las Meninas* ("The Maids of Honor") in Madrid, one of the most famous and sophisticated paintings in all western art, incorporating into the work a self-portrait of the artist at age 57 and at the height of his abilities. Four years later (in 1660), Velázquez passed away, leaving a professional and personal reputation of the highest rank among his Spanish, if not all European peers, although the latter was somewhat slower in coming. In 1659, one year before his death, Velázquez had been awarded the Cross of Saint James and honorary membership within the elite Order of Santiago by his admiring monarch, King Philip IV (1605–1665). According to tradition, King Philip then personally painted or stenciled an image of the famous red badge signifying the Order on the chest of Velázquez's self-portrait in *Las Meninas*, perhaps to emphasize his royal favor towards the painter, especially in the eyes of a resentful Spanish nobility not used to seeing common-born artisans receive such ostentatious honors. Whether Velázquez lived long enough to witness this gesture is unknown. What is certain is that today the memory of the painter continues to be honored throughout Spain and particularly in Madrid, where the name (and likeness) of Velázquez can still prominently

be seen on street signs near the touristy Plaza de Ramales, close to the (now lost) final resting place of the artist within the original Iglesias de San Juan Bautista y Santiago before its careless demolition in 1810 (see Chapter 16). By 1660, Spanish chivalry may have been, strictly speaking, a thing of the past, but its symbolic memory continued to live on in the hearts and minds of the Spanish people through landmark works such as *Las Meninas*.

The late 17th century also seemed to witness a growing, pervasive sense of regret in both the political and religious arenas. Perhaps this provides a useful lesson for our own modern times. In contrast to the hardened certitudes frequently pronounced during the Reformation and Counter-Reformation, written commentary from the Baroque era now often reflected a more widespread admission that some mistakes had in fact been made, although when it came to which courses of action should have instead been followed, consensus still tended to break down. Nevertheless, it seemed undeniable that the old conventional wisdoms no longer held true. Spanish Catholicism was not in fact destined to rule the world, not even the New World. Wholesale destruction of Native American cultures was not justified by mere financial profit. In hindsight, total expulsion of Jews and Muslims from the Iberian Peninsula may have been too hasty a decision, etc. The list continued. On the other hand, when not busy fighting Spanish ambitions, European Protestants could agree upon little amongst themselves; moreover, English and Dutch entry into North America far exceeded the Spanish in terms of ruthlessly handling indigenous cultures. For the English and the Dutch, there was no pretense of religious motivation; Native Americans were generally given two options: leave or die. For that matter, the Thirty Years War had clearly demonstrated that religious convictions tended to be shallow and pliable whenever real estate acquisition was concerned.[2] By the 1650s, those with any conscience or the ability to look beyond their own personal gain were beginning to have second thoughts. Furthermore, it was through this intellectual reassessment of the late 1600s that came the first philosophical foundations of the United States, although the event itself would have to wait another century.

Nowhere was new intellectual foment and climate more evident than in Protestant England. A short-lived era of Puritan republican rule under Lord Protector Oliver Cromwell had come to a merciful conclusion by 1660, while the Restoration monarchy of King Charles II enthusiastically began. The popular acclaimed welcoming back to the English throne the son and heir of a Parliament-executed monarch (Charles I) effectively repudiated that country's short-lived experiment with kingless government, as well as its temporary infatuation with Reformist religious movements. The 1660s also produced some of the most famous works in all English literature, often coming from the pens of aging Puritan writers now out of favor with and sometimes impris-

oned by the new regime. As English Puritans suffering under the unfavorable scrutiny of official authorities, these authors typically had little or no use for the Spanish associations of Saint James the Greater. In their natural, innate hostility towards the Santiago traditions they were not unlike their famous English forerunner Francis Drake (see Chapter 12), but instead of physically attacking the Santiago shrine, they mostly chose to ignore or boycott it. Foremost among these fiery iconoclasts was John Milton (1608–1674), whose epic poetry, to paraphrase an unfairly disdainful George Bernard Shaw, is often confused with Holy Scripture by the piously unlearned.[3] Far less sophisticated but still more widely read than Milton was his younger contemporary John Bunyan (1628–1688), whose allegorical novel *The Pilgrim's Progress* (1678), published four years after the death of Milton, is said to be the second most widely read book in the English language after the Bible itself. Any brief perusal of Bunyan's homely testament to inner spiritual development will provide many useful insights into that era's unique mood of Calvinist defiance intermixed with deep regrets for the past and wishful hopes for the future.

In Bunyan's sincerely and deeply-felt masterpiece, religious pilgrimage instead becomes a symbolic inner journey marked by growing self-knowledge and awareness, along with repentance and reform, rather than any grand tour of a physical destination marked by a commercialized shrine or designated by the Roman Vatican. This was well in keeping with early Protestant preaching against religious tourism, without sacrificing any of the spirituality or reverence that presumably attached to such long journeys. There was also a patriotic aspect involved. English Puritans might be accused of many things before, during, and after the English Civil War, but one thing they could never be accused of was being over-enamored of Spanish Catholicism. If nonconformist preachers like John Bunyan were wary of the Church of England, they were absolutely disdainful of the Vatican in general, and of Spain in particular. As of 1678 (the year of publication for *Pilgrim's Progress*), it had only been nine decades since the Spanish Armada had attempted a forced entry into the British Isles, and only three decades since the Peace of Westphalia which brought the Thirty Years War to an uneasy conclusion. Formally, on the surface at least, England and Spain were now at peace; however, plenty of hostility between the two nations remained, especially among their more conservative religious elements, the Puritans and the Inquisition, respectively. Moving forward, this old animosity would be far from eliminated; instead, it would now be channeled into new energies competing for high-stakes supremacy in the New World.

Somewhat surprisingly, however, Saint James the Greater receives an honorable mention in *The Pilgrim's Progress*, not in any connection with Spain or Santiago de Compostela, but rather as a distant spiritual forebear to the

symbolic pilgrim "Christian," husband to "Christiana," both of whom travel voluntarily but separately from their home in the "City of Destruction" to the "Celestial City" of Mount Zion (see header quote). In this sense, appropriate tribute is paid to the unique biblical status of Saint James as being the very first in apostolic martyrdom (see Chapter 1), along with the proto-martyr Saint Stephen, and later martyrs for the faith, SS. Peter and Paul.[4] Bunyan does not stop there. The fourth and youngest son of Christian and Christiana is named James as well.[5] Along with his siblings, James stays behind in the mortal world to continue the Lord's work after his parents pass on to the Celestial City.[6] It is also the younger James who marries Phoebe, daughter of the Innkeeper Gaius, who hosts the pilgrims during the second and final part of their journey.[7] This episode, taken as whole, comes across as a subtle homage to the Way of Saint James without specifically mentioning any of the Caminos of Spain, France, or Portugal, nor suggesting that anyone should even bother traveling to these places. It was as if Bunyan wanted to go as far as he possibly could in honoring the various longstanding traditions associated with Saint James the Greater, but without giving any express undue credit to the pilgrimage claims of any foreign entity beyond England, or for that matter, within England itself.[8]

While Bunyan was being incarcerated for his nonconformist views on matters of faith against the Church of England and beginning his composition of *Pilgrim's Progress*, other far more insidious forms of religious censorship were taking place within the realms of Spanish-speaking Roman Catholicism. Unlike English Puritans, who often enjoyed wide latitude and de facto freedom of worship by immigrating to North America and New England, progressive thinking Mexican Catholics living within the jurisdiction of New Spain frequently came under severe pressure from a Spanish Inquisition based in faraway Toledo on the opposite side of the Atlantic Ocean. Loss of a few northern European countries to Protestantism had done little to blunt the aggressive, hands-on approach of the Inquisition or the Vatican to enforced religious doctrine, especially given that millions of new converts from Latin America, some more willing than others, had been successfully added to its rolls over the last two centuries. Thanks mainly to the patiently sustained efforts of the religious orders, especially the Franciscans and the Dominicans, growing numbers of Native Latin Americans had been gradually brought into the fold of mainstream Christianity, and most would stay there. Part of the thinking was surely that the best way for Catholicism to beat or outshine Protestantism was to do it in the New World, versus fighting endlessly futile wars in Europe. With the best-laid plans, however, always come unexpected results. One such unintended consequence in this instance was that New World evangelization was so resoundingly successful that it also created entirely new societies possessing their own unique identities combined with

a lukewarm (at best) loyalty to Spain only slightly better than the open hostility professed by English Puritans now settled in North America.

On one hand, this forceful evangelization owed part of its growing number of converts to a grudging willingness in accommodating Native American cultures and customs. Hernán Cortés had learned these hard lessons in the immediate aftermath of the Aztec conquest with the foundation of a new shrine at Our Lady of Guadalupe, and the drawn-out Chichimeca rebellion of the late 1500s (see Chapter 12). In short, for the Spanish, effectively governing the New World proved far more difficult than conquering it in the military sense. The iconic image of Santiago Mataindios for obvious reasons did not achieve the same amount of popular resonance in New Spain as had Santiago Matamoros in the Old World. Once again, for the first time since the eighth century Islamic conquest of Iberia, it seemed (in the New World at least) that Saint James the Greater had little to do with Spain. Now, by the mid–1600s, Santiago had once again become merely an inner-circle apostle who was the first to be martyred for his faith. In this sense, things had come full circle. Moreover, any resident of New Spain who dared to challenge or even question the intellectual judgment or wisdom of Inquisitors from Toledo soon found themselves the objects of intense scrutiny, or worse, witch hunts as frenzied as anything being concurrently conducted by the English Puritan immigrants in faraway Salem, Massachusetts.[9]

Surely the most renowned of these wrongly persecuted Mexican intellectuals from that era was the Hieronymite nun and poet-dramatist Sor ("Sister") Juana Inés de la Cruz (1651–1695) of Mexico City, today rightly celebrated as one of the greatest cultural representatives of the Spanish Golden Age from Latin America. The illegitimate daughter of a Spanish officer and wealthy Creole woman, Juana came of age during a period in which Mexico (New Spain) was beginning to assert its own dynamic cultural identity on somewhat equal terms with that of its distant mother country. In 1659, the Mexico City Cathedral, under construction for nearly a century and one of the world's most famous examples of Spanish Colonial architecture, was finally consecrated, appropriately symbolizing New Spain's growing status and prestige. Five years later, at age 13, Juana arrived in Mexico City as a child prodigy from the provinces, where she quickly became a favorite of the viceroy and his wife, both of whom proceeded to subsidize her literary activities for many years to follow. Possessing good looks, good breeding, and a keen intelligence that startled and alarmed her male contemporaries, Juana repeatedly declined offers of marriage while remaining single-mindedly determined to further her education. At this point in history, there were basically two ways for a woman to do this—either to become a courtesan or a nun. Juana chose the latter course, entering the Convent of Santa Paula in 1669. There she spent the next 26 years cementing her permanent legacy as one the most versatile

minds of the Baroque era, as well as providing a stark cautionary tale for any-
one, woman or man, then daring to exceed the establish bounds of social
convention.

The apex of Sor Juana's extraordinary career and contemporary reputa-
tion came between 1689 and 1692, when her complete literary works were
published in Madrid and Seville, then distributed worldwide. Astonished,
hostile reaction from the mostly male establishment of Spanish-speaking
intelligentsia was immediate and unrelenting. Juana had not only proposed
tentative feminist ideas long before such things were generally even heard
of, but clearly demonstrated her ability to forcefully articulate these ideals as
well. Juana attempted to soften the blow by dedicating these works to Spanish
knights of the Order of Santiago affiliated with her Mexican patrons, but
these compliments only seemed to add fuel to the flames.[10] Shortly thereafter,
she was targeted by the Inquisition, forced to sell her entire library, and finally
to give up all literary activities. In 1695, she died of an epidemic in Mexico
City at age 43, while tending to other sick nuns, which likely spared her fur-
ther persecution and possibly an even more violent end. Famously, she signed
one of her last letters as "I, the worst of all women," which became her highly
ironic epitaph. One is immediately reminded of John Bunyan's guilt-ridden
pilgrim "Christian" setting out for the Celestial City (in the literary sense) a
few years earlier in 1678. Unlike Bunyan, however, Sor Juana ended her life
under a cloud of censorship and repression, and at a much earlier age than
did Bunyan. She was arguably the greatest intellectual victim of the Roman
Catholic censorship since Galileo about half a century earlier.[11] Though never
an official candidate for sainthood, Sor Juana's status as a martyr for the arts
and sciences, as well as advocate for feminist equality, continues to grow
healthily into the present day. In a strange twist of fate, circa 1697, two years
after Juana's death, construction was completed in central Madrid for a new
Church and Convent located adjacent to the Plaza de las Comendadoras (of
Santiago). The very same military Order of Santiago, members to whom Sor
Juana had recently dedicated her complete works, probably in hopes of restor-
ing some degree of respectability, now had become the formal protectors of
the newest royally-sponsored monastery and house of worship located within
the confines of Spain's capital city.[12]

For a good part of the 17th century, one of the favorite genres utilized
by professional painters, especially those receiving Roman Catholic patron-
age, was the depiction of Saint James the Greater in the guise of a lone Camino
pilgrim. Many classics were produced in this typecast, ranging from the pitiful
portrayal of Santiago by El Greco as a homeless beggar asking for a handout
(see Chapter 9), to that of a near Christ-like spiritual intercessor as imagined
by the Italian master Guido Reni (1575–1642), today on magnificent display
in the Prado Museum. As for the old Santiago Matamoros stereotype, after

a patriotic outburst of artistic activity during the early 1600s, this aspect of the cult seems to have gone into a temporary period of dormancy, especially as the overtly areligious horrors of the Thirty Years War became widely apparent to everyone involved. Santiago the Pilgrim, however, kept on going strong, and began appearing in art more introspective, if not outright regretful, than ever before. By far the most prolific in this regard was the Spanish-born, Italian-based Jusepe de Ribera (1591–1652), a painter influenced by Reni, and one executing numerous canvasses in this specific mode, all quite interesting and no two exactly alike. For Ribera, artistic representation of Saint James the Greater as a lone Camino pilgrim appeared to be an ongoing process rather than a fixed notion—a fluid, ever-developing concept, as opposed to any static or rigid state of being.[13] There is something uniquely appealing in this idea—the idea of always becoming, in contrast to that of simply being. By the 1660s, this transient, ephemeral feeling within the context of the Santiago cult of pilgrimage would be magnificently captured in a single work of art created by a revered Dutch master possessing both the superhuman talent and mature depth of experience to effectively convey it.

A strong argument can be made that no greater artist ever lived or painted than Rembrandt Harmenszoon van Rijn (1606–1669), born in the Netherlands to a wealthy family divided by religion on the very eve of the Thirty Years War. Rembrandt's father was a member of the Dutch Reformed Church, and his mother was a Roman Catholic, but Rembrandt himself never officially affiliated with either side, although religious subjects and themes formed an integral part of his extensive artistic output.[14] All of these religious portrayals are pointedly set within Rembrandt's own contemporary time and place—the Low Countries of the mid-17th century—rather than any distant or imagined past. He painted what he knew, thus giving his work a heightened sense of realism and immediacy not often found in Judeo-Christian-themed art.[15] Unusually for an artist of this caliber, Rembrandt appears to have never left his own native country; the idea of a lone Camino pilgrim traveling across strange foreign lands to a Roman Catholic shrine would appear at first glance to be completely alien to him. As to what exactly prompted Rembrandt at age 55 to take up the (by then) overexposed genre of Santiago portraiture, one can only speculate. After a meteorically successful career in several visual media, extensive government patronage and widespread public acclaim, the great Dutch master hit on hard times for his final decade. Multiple personal tragedies in his own immediate family, combined with accumulated reckless spending and a penchant for living well beyond his means, Rembrandt was by 1660 effectively bankrupt, and forced to considerably reduce his circumstances. In 1661, a major commission for the city of Amsterdam was reluctantly awarded to Rembrandt, but the completed work, *The Conspiracy of Claudius Civilis*, was ultimately rejected by the city fathers, returned to the

painter, and likely never paid for. It was perhaps the first time that the artist had suffered such a rebuff or, for that matter, such an insult to his limitless abilities. It was also around this same period of extreme disappointment and disillusionment circa 1661, that Rembrandt created, not for any particular commission, one of his most memorable religious portraits, and one with a rather surprising twist.

Rembrandt's *Saint James the Greater* must rank as one of the most personal statements in the painter's oeuvre, as well as a work standing in stark opposition to the massive grandiosity of his concurrently rejected canvass for the city of Amsterdam. Rembrandt presents viewers with an apostle James seen in devout profile, presumably kneeling, with oversized hands clasped in deep prayer. The prayerful hands are in fact the focal point of the work. The subject himself is bareheaded, with the obligatory pilgrim's hat laid aside in obscure shadow. The only signs of the pilgrim's identity is what appears to be a small scallop shell fastening the cloak to the right shoulder, along with a propped wooden staff barely visible in the background. The overall mood is penitential, sorrowful, full of regret. The physical look of the penitent is haggard, and worn out with the cares of the world. Taking this further, Rembrandt's *Saint James the Greater* may possibly be a self-portrait. Compared to the somewhat corpulent though magnificent self-portrait by Rembrandt three years earlier in 1658, *Saint James* might represent a completely different side of the artist's complex personality—a snapshot of humility and vulnerability. Either that, or the painter was lucky to find an unusually good model who could effectively project the artist's own personal feelings. Eight years later, Rembrandt would himself die destitute and be buried in a pauper's grave, itself destroyed and irretrievably lost not long afterwards. His prolific works lived on, however, and seem to only continue growing in stature with the passage of time, notwithstanding their widely acknowledged high quality even during the artist's own lifetime.[16] Rembrandt never personally made it to the Camino or Santiago de Compostela, nor perhaps ever cared to, but he made certain that others would at least not forget what it meant for the heartbroken to search for personal redemption. His memorable foray into an overcrowded field surely marks the apotheosis of that specialized genre.

Coming a mere five years after Velázquez's landmark portrayal of *Las Meninas*, Rembrandt's *Saint James the Greater* appears in hindsight to denote the end of a certain era, at least in terms of artistic attitudes towards the old Santiago cult.[17] This was only natural since European and American cultures were both on the cusp of major upheavals sparked by scientific intellectual trends gaining momentum for several centuries. New breakthroughs were now coming so fast and furious that anything containing the slightest whiff of superstition could be automatically dismissed, and this included many of the traditional religious dogmas. Individuals or societies constrained by

religious institutions—and this included Rome and the Spanish Inquisition—found themselves at a great disadvantage in terms of technological advances, since anything resembling dissent was swiftly suppressed.[18] Whether by logical extension of this handicap or an unfortunate coincidence, Spain was about to have whatever was left of its pretensions of empire completely shattered by internal conflicts. Meanwhile in the New World, especially in modern day California, the old Spanish-speaking missionary impulse of bringing Christianity to Native Americans was about to make its final impressive push northwards. Little help from the mother country, however, would be forthcoming. This time, the Franciscans would be mostly on their own, left to their own devices, were acutely aware of the fact, and possibly even preferred it that way, at least for the most part. Just as New England Puritans were being given a bit of latitude by the Church of England to establish their own unique American identity, Roman Catholic missionaries of Latin America now had somewhat less to fear from the same Spanish Inquisitors that had not too long previously so harassed and persecuted talented daughters of church like Sor Juana Inés. From the 1700s moving forward, Americans living in both hemispheres would begin their steady, irresistible progression towards independence from the Old World, both in politics and in culture.

15

From Iberia to Sonoma
(1700s)

Upon the Supposition that this is the place of the Sepulture of Saint James, there are great numbers of Pilgrims, who visit it, every Year, from France, Spain, Italy and other parts of Europe, many of them on foot."—John Adams[1]

For many prominent Protestant thinkers of the late 1600s, certain introspective regrets appear to have rapidly transformed into the trademark intellectual restlessness of the early Enlightenment period. These new ideas would in turn be quickly transmuted to the New World, especially via the British Empire, but also from Roman Catholic nations such as Spain, Portugal, and France as well. It would not be much longer before American nationalism began to forcefully assert itself across two hemispheres, fueled in significant part by major shifts in international power alignments from which Spain would prove to be by far the greatest loser. Surprisingly, however, this loss of Spanish authority over the New World would not automatically translate into loss of Spanish cultural or Roman Catholic influence. On the contrary, Catholic missionary efforts among Native Americans, however forcefully inappropriate, continued to prove incredibly effective, especially in North America, pushing northward and extending from coast to coast. Even more surprisingly, in New France, extending from the modern day Canadian province of Quebec to the future U.S. state of Louisiana, French Catholic missionaries seemed to accomplish their religious objectives with minimal use of violence and intimidation, oftentimes by playing upon Native Americans' well-founded mistrust (and dislike) of both English and Spanish neighboring settlers.[2] The age of Anglo-French ascendency in North America was poised to begin.

The biggest blow to Spanish imperial pretensions since the defeat of the Armada in 1588 came during the first 14 years of the new century (1700–1714)

as the War of the Spanish Succession drew half of Europe into opposing camps, either favoring or opposing Bourbon Spanish rule descended from Louis XIV of France. The details of this lengthy, complex struggle are far beyond the scope of this study; the end results, however, were plain and clear even at the time. The international sway of Spain and its traditional ally, the Holy Roman Empire, were severely weakened, while the influence and prestige of France were substantially boosted both in the Old and New Worlds. England, still waiting in the wings, came out ahead as well. By 1715, Philip V, grandson of Louis XIV, ruled Spain and all its American possessions. Concurrently, Louis XV, son of Louis XIV, ruled France and all its American possessions. Both cultures also shared long traditions venerating Saint James the Greater along their adjacent Caminos, and took this veneration with them to the Americas. For a moment, it looked as though the old Anglo nightmare of a grand Spanish-Franco worldwide alliance might become a reality, but then several unanticipated factors intervened to prevent it. The most significant of these deterrents had in fact existed before the war began at the turn of the century. European settlements in the New World, whether these be Spanish, French, or English, had by then, after over two centuries of existence, formed their own stubborn identities quite separate and apart from those of their European mother countries. These immigrant communities had originally left Europe for compelling reasons, whether these be economic or religious, and were becoming measurably slower and more reluctant to act in unison even when ordered to do so by their self-proclaimed royal benefactors on the other side of the Atlantic Ocean.[3]

No sooner had peace been re-established throughout Europe and the Iberian Peninsula, than all hell seemed to break loose in the Atlantic Ocean between the west African coast and the Caribbean Sea. Although piracy and privateering had flourished along western trade routes ever since these were first established during the Age of Discovery, the period between 1716 and 1726 has since been dubbed the Golden Age of Piracy, producing some of the most notorious and colorful names in the naval history of outlaw behavior. With a considerably weakened Spain no longer able to properly protect its merchant fleets, vulnerable Spanish shipping became easy pickings for enterprising buccaneers of all nationalities, especially experienced Anglo-French raiders suddenly deprived of their semi-legitimate livelihood as privateers with the official establishment of peace in 1715. One of the most renowned of these privateers-turned-pirates was the Welsh-born Howell Davis (1690–1719), whose intimidating flagship *Saint James* had been commandeered during a raid in the Cape Verde Islands (including Santiago Island).[4] In plundering this Portuguese-owned corner of the world, Davis may have been emulating Francis Drake's successful foray from the year 1585 (see Chapter 12). It was as if the old Santiago Matamoros persona had now been turned

with a vengeance against its own original Iberian inventors. Nevertheless, even as Atlantic commercial shipping was being stolen and disrupted, Spanish culture continued to flourish and develop both in the Old and New Worlds. The 18th century saw the open emergence or general acceptance of art forms and blood sports now closely associated with Spain, especially in southern Spain, such as flamenco music and bullfighting.[5] Just as Anglo pirates such as Howell Davis seemed to delight in appropriating the image of Santiago for their own illegitimate purposes, the Spanish-speaking peoples of southern Iberia, never overly enamored of a medieval religious cult centered around northwestern Galicia, now began to assert their own cultural mores on Spain and throughout Latin America as well.

One somewhat odd indication of Spain's diminished status in the world after the War of Succession could be found in the Philippine Islands. Although Ferdinand Magellan had been killed by natives in the Philippines circa 1542 (see Chapter 11), the archipelago had fallen under Spanish dominion soon afterwards, when in 1565 the Basque conquistador Miguel López de Legazpi launched a successful military expedition from Mexican New Spain. By 1571, the same year that the Ottoman Turks were defeated by the Holy League at Lepanto, Manila had become the capital city of Spain's latest acquisition under King Philip II. Absurdly, at least in logistical terms, the Philippines were now under the legal jurisdiction of far distant Mexico City, which in turn was ruled from Madrid on the other side of the world. Two centuries later, however, the balance of power had shifted considerably, and Spain was struggling to hold onto its global possessions, oftentimes even within Spain itself. Nevertheless, in 1743, the city or Pueblo of Santiago Apostol de Carig (today known simply as Santiago) was officially founded in the northern Philippines, possibly the last place of any significance named in honor of Saint James the Greater, not counting other individuals themselves possessing the saint's name or various nicknames (see Chapter 16).[6] The Philippine Islands (named after King Philip II), notwithstanding their ancient savagery and distant removal from the continent of Asia (not to mention Europe), had by modern times wholeheartedly adopted Spanish language, religion, and customs, yet retaining their own distinctive cultural heritage, not unlike its colonial counterparts in faraway Latin America. The usage of Santiago as a civic symbol in a remote region subdued long before by a colonial power then in the process of losing control of its colonial possessions strikes a note of desperation. On the other hand, no one complained at the time, or has complained since. As Spanish imperial sway enjoyed its last period of glamor on the world stage, it could boast, however briefly, that the banner of its patron saint had spread across all civilized continents of the globe, east and west.[7]

At this point in world history, it would be remiss not to observe substantial French inroads made in the New World during the late 17th and early

18th centuries, especially in North America. Whereas the Spanish and Portuguese plundered precious metal wealth from the southern hemisphere, the French discovered a different kind of valuable commodity from the northern climes, namely, wild animal pelts. By the early 1700s, the lucrative North American fur trade, particularly from modern-day Canada, had helped to enrich French merchants and monarchs to an impressive extent never anticipated. French missionaries quickly followed in the immediate wake of explorers and traders to convert Native Americans to Roman Catholicism, often with similarly surprising success (as mentioned previously) merely by effectively playing upon extant indigenous hostility towards other Europeans. Saint James the Greater had become the patron saint of furriers long before Europe was even aware of the New World, as pilgrims traveling the French and Spanish Caminos purchased bodily relief from exposure to the elements. Now, there was serious money to be made. As French settlements and cities sprung up from Quebec to Louisiana, most notably in the fortress-trading post of Ville-Marie, later becoming the city of Montreal (see Chapter 17), French place names bearing the moniker of Saint James or Saint-Jacques became commonplace, and survive to this very day as a reminder of that heritage. Not until the French and Indian War, culminating in British victory at the Battle of Quebec in 1759 and conquest of French-speaking Canada, were the ambitions of the latter in North America permanently checked. This epic conflict had itself been sparked by earlier escalating skirmishes between French and British traders, the latter often encroaching upon established commercial relationships with Native Americans who naturally tended to side with their longstanding French partners.

The same year (1759) that the French were being defeated by the English on the Plains of Abraham outside of Quebec City, Portugal initiated suppression of the Jesuit religious order throughout its empire. Spain, France, and southern Italy followed their example over the next eight years. Ever since its foundation at the beginning of the Counter-Reformation by the Basque nobleman Saint Ignatius of Loyola (1491–1556), the Society of Jesus had both done tremendous good across the globe and acquired enormous grassroots political power, inevitably incurring the envy and wrath of government authorities whose old prerogatives had been effectively usurped. This suppression was eventually lifted by the Vatican, but it held long enough to allow the older Franciscan order to step in and fill its place on the ground, particularly in the New World. Probably the most outstanding exponent of newly energized Franciscan missionary efforts was Majorcan-born Saint Junípero Serra (1713–1784), canonized by Pope Francis I in 2015.[8] Around age 36, Serra arrived in the New Spain and immediately proceeded to zealously convert Native Americans in the remote areas north of Santiago de Querétaro with considerable success.[9] This was the same region that two centuries earlier

had been the focal point of the long and drawn out Chichimeca War, which the Franciscans had also played a key role in subduing with their famously soft touch (see Chapter 12). Bolstered by his evangelical success, Serra was given near-consular powers by the Spanish Inquisition along the Baja California Peninsula and northernmost frontiers of New Spain. With the Jesuit fall from power and favor complete by 1767, Serra was in the right place at the right time to lead a reinvigorated Franciscan missionary push along the Pacific coastline northwards. The first of what would eventually become a chain of 21 Franciscan outposts in the future state of California came in 1769 with the establishment of the Mission San Diego de Alcalá, named in honor not of San Diego the Greater but rather the 15th century Franciscan holy man who never knew of the Americas but whose namesake Spanish flagship had sailed into San Diego Bay circa 1602 (see Chapter 13). If one is to judge by the usage or non-usage of place names, Saint James the Greater, either as a pilgrim or as a Moor-Indian slayer, had by this point in time little or no currency with either the Franciscans or Native Americans along the northern reaches of New Spain, even to a single-minded Roman Catholic evangelist such as Father Junípero Serra. In terms of place names, Serra may have begun his permanent legacy at Santiago de Querétaro in Mexico (named after the greater apostle), but he then later began its final phase at the Mission San Diego de Alcalá in California.[10]

As Father Serra worked tirelessly to establish Franciscan missions along the California coast, it is unlikely that he ever imagined within less than a century these same institutions would become the official property of a newly founded Anglo-descended nation-state.[11] In 1776, the same year that Buenos Aires became the designated capital city for the Spanish Viceroyalty of the Río de la Plata, the Declaration of Independence was signed by representatives of the 13 formerly British, now American, colonies. This was also the same year that Serra founded Mission San Francisco de Asís, today the oldest surviving structure in that prominent U.S. municipality.[12] Meanwhile, on the opposite side of the North American continent, a war was being fought and, more importantly, international diplomacy waged by the colonists on a sweeping scale that their British antagonists had hardly thought them capable of achieving. After swift victory eluded the British during the first two years of the struggle, the colonists accomplished the stunning feat of bringing the French back into the American theater as colonial allies, followed in short order by the Spanish and Dutch (as French allies), although it was only the French who were capable of fielding significant manpower and munitions. All were united in their fear of growing British global power and particularly its threat against their New World holdings. Although some of the American Founding Fathers (such as Alexander Hamilton) were already thinking in terms of hemispheric expansion, during the 1770s this seemed like a far-fetched

idea to the conventional wisdom of the times. Santiago Matamoros, after all, belonged to the Spanish and perhaps, to a lesser degree, to the French—not to the British American colonial upstarts. Nor did the American colonials (unlike say, the Franciscans or Jesuits) exhibit any special interest in converting other peoples to a specific religious creed, having very little common ground amongst themselves in that regard.

Among the prominent American Founding Fathers, the Puritan-descended John Adams of Massachusetts was one of few who resembled a conventional Christian. Interestingly, as things would play out, it was Adams who in late 1779 volunteered to undergo a hazardous trans-Atlantic passage, then overland trip through northern Spain, to make a diplomatic rendezvous with fellow-revolutionary Benjamin Franklin in France. Traveling with his two young sons Charles and John Quincy, Adams made port in A Coruña along the northern Galician coast in December of that year. Then, bypassing Santiago de Compostela for the sake of making haste, he landed on the old pilgrim Caminos near Lugo and began traveling eastward, away from Santiago and towards France along the traditional return routes. Writing on December 28, 1779, Adams—good former Englishman that he was—implies a healthy dose of skepticism towards the authenticity of the Santiago cult without expressly denying it (see header quote). More impressed by the rugged terrain of Caminos and dismayed by the squalor of 18th century rural Spain, Adams later admitted to his wife Abagail that he had made a logistical mistake in traveling overland.[13] From Adams' account, it is apparent that traveling the Caminos during the Age of Enlightenment, even in reverse direction, was as difficult as ever. Once in France, Adams was mostly regarded either as a frontier bumpkin or crazy person, depending on with whom he was dealing, but for all Americans, the desired end-result was achieved.[14] With French help, the Revolution was won, and in 1783, Great Britain formally recognized American independence in the Treaty of Paris. Six years later (in 1780), the Paris Bastille was stormed and the French Revolution began. Like its American counterpart, the upheaval in France would have major repercussions for Spain and Latin America, but this impact would prove to be far more immediate and, in hindsight, more sustainable for those directly involved (see Chapter 16).

As the United States achieved independence and France lurched towards revolutionary chaos, Spain enjoyed one last hurrah of sorts in terms of imperial pretense. King Charles or Carlos III (1716–1788) ascended the throne in 1759, and for the next 29 years proved himself to be one of the more capable European monarchs of the Enlightenment era.[15] Although a religious man in the conventional sense, Charles was hostile towards the growing political power of the Jesuits and initiated their censor and suppression throughout what remained of the Spanish realm, thus clearing the way for Franciscan

missionary activities in places such as California and the future American southwest. It was also Charles who was king when the American revolutionary John Adams was allowed safe passage through northern Spain in route to meet up with Benjamin Franklin in France. Most notably, Charles undertook to beautify Madrid into one of the great (and newest) European capital cities, even though its political and military heyday as a center of power was by then long past. Palaces became bigger, more opulent, and more ostentatious; later when the Spanish empire disintegrated, many of these palaces and open spaces were gradually donated to the public as museums and parks. Originally conceived with pretentions of global empire, these now public properties in Madrid today distinguish that city as an attractive destination for both international tourists and Spaniards from every corner of the Iberian Peninsula, as well as the Spanish-speaking world in general. In truth, these monuments had been built during the 1700s as an attempt to restore a prominence lost earlier during the War of the Spanish Succession, a prominence never to be regained but providing a convenient reminder for all observers of what once had been the greatest political power center on earth. Within these magnificent public displays, physical traces of the old Santiago cult may still be found for anyone caring to take notice.[16]

Among the numerous artists and artisans employed by Charles III to beautify Madrid, one of the more famous was the Venetian-born painter Giovanni Battista Tiepolo (1696–1770). Tiepolo was a very prolific exponent of the Rococo style which dominated European artistic tastes during the mid– and late–18th century, although the merits of that style are often overlooked or undervalued in comparison to the Baroque and Neoclassic or Romantic eras which surround it chronologically. Tiepolo was a highly successful journeyman throughout his long career, which culminated in spectacular fashion at the Madrid court of Charles III between 1761 and 1770. There the largest of his allegorical frescoes are still viewed daily by over-awed tourists at the spacious Palacio Real, including *The Apotheosis of the Spanish Monarchy* and *Glory of Spain*, both executed by Tiepolo between 1762 and 1766, with the latter created for Charles' magnificent throne room. For one of his final works (1767–1769), Tiepolo painted a stunning version of *The Immaculate Conception* for a Franciscan altarpiece, around the same time that King Charles was officially suppressing the Jesuit order in favor of the Franciscans, and today on view at the Museo del Prado.[17] This majestic and austere depiction of the Virgin by Tiepolo represents in some respects a throwback to the older Baroque style, accurately portraying her as a global phenomenon by the late 1700s.[18] 1769 was also the same year in which Father Junípero Serra established the first of his Franciscan missions near San Diego, California (see above). Tiepolo, from the beginning stages of his career, had demonstrated considerable flair for religious and allegorical themes in his work, but one canvas

completed during his younger days in Venice, now on display in the Museum of Fine Arts in Budapest, had especially exhibited this talent.

Tiepolo's startling *St. James the Greater Conquering the Moors* (1749–1750) was reportedly commissioned by the Spanish ambassador to England, perhaps designed as a reminder to the English that it was the Spanish who originally paved the way for them in the New World.[19] England would have then been in the process of preparing to wage war against the French in the theaters of North America and Europe.[20] To describe Tiepolo's version of *St. James* as over-the-top would not be inappropriate. Here we see a haloed, decidedly light-skinned, unarmored, white-cloaked saint, fighting in the traditional *à la jinete* style, mounted on a magnificent white steed, as if descended from the overhanging storm cloud. He carries a white banner displaying the red cross of Santiago, gazing towards heaven as if receiving directions, while cherubim look on approval as the saint mutilates a dying Moor with his sword. All the Moors are portrayed as dark-skinned sub-Saharan Africans—historically inaccurate since the Islamic conquerors of Spain largely consisted of Berber Caucasians. The fictional Battle of Clavijo rages in a picturesque background. It appears as if Santiago is killing Shakespeare's Othello (see Chapter 12). The scene could also be easily interpreted as a disturbing allusion to the ongoing slave trade with America, one in which by then the English had taken the decisive lead. During the mid–18th century, importation of African slaves to the British colonies of the American South was burgeoning, thanks to the huge profitability of cash crops such as cotton and tobacco. Taken in context, the painting comes across a subtle warning and reminder to the English diplomats who would be soon viewing it in London.

All in all, it would be accurate to say that the 18th century Age of Reason was not kind to the Santiago cult. Though still active, the Spanish and French Caminos appear to have been in decline, both in terms of pilgrim traffic and supporting infrastructure. In general, anything that hinted of religious superstition was out, especially if it was being used as a pretext to conquer and exploit the vulnerable. For those still clinging to religious faith, the Marian cult appears to have completely superseded that of Santiago, whether he be warrior or pilgrim, in both the Old and New Worlds, but especially the latter. In Spanish-speaking regions, place names were now being named San Diego more typically after the Spanish Franciscan saint, rather than the elder son of Zebedee. In France, the accumulated wealth of churches was looted by revolutionaries, regardless of which saint the church was named after. In Paris, the great Tour Saint-Jacques, located not far from Notre-Dame Cathedral itself, was mostly demolished, while the great Abby of Cluny, one that had done so much during the Middle Ages to promote the pilgrimage cult of Santiago, was razed to the ground in a fury. Above all, Islam no longer presented a threat to Europe or its colonial holdings, with a few isolated

exceptions. No symbol of popular resistance was any longer needed. On the contrary, it might well be said that by the 18th century, Christian Europe—particularly England, France, and Spain—had become the main threat to the rest of the world in terms of subjugation. In the strict military sense, Santiago Matamoros had done his work all too well from a global perspective.

With the death of King Charles III of Spain in 1788 came the end of a long era: the absolute monarchy that had dominated Europe since the fall of the Roman Empire, and had also given rise to the Iberian Santiago cult during the Dark Ages. In the United States, it had been cast aside (with French assistance) by the American Revolution, then in France itself shortly thereafter, by the guillotine. The last decade of the century would mark the low point in Spanish prestige as a sinister prelude to Napoleonic invasion (see Chapter 16). As the highly visible examples of the American and French Revolutions spread their influence across several continents, remaining colonies that owed their original foundation to Spain and Portugal felt little gratitude or duty towards their mother countries. Spain could no longer protect its colonies from other countries or even pirates, though it still insisted on exploiting these satellites for its own benefit. As for Portugal, its once domineering global power had been thoroughly broken. Soon Portuguese monarchs would be seeking refuge and sanctuary within its own American colonies from the Napoleonic storm that was about to engulf all of Europe. To the intrepid citizen-armies of Bonaparte, the ancient cult of Saint James the Greater would have little or no resonance, although oddly enough, they would unwittingly help to revive a certain degree of sympathy for Spain (and Santiago Mayor) on an international level, including from very unlikely quarters within the still quite formidable British Empire.

16

Latin American Independence (early 1800s)

Behold, this is wisdom in me; wherefore, marvel not, for the hour cometh that I will drink of the fruit of the vine with you on the earth, and with Moroni, whom I have sent unto you to reveal the Book of Mormon, containing the fulness of my everlasting gospel.... And also with Peter, and James, and John, whom I have sent unto you, by whom I have ordained you and confirmed you to be apostles, and especial witnesses of my name, and bear the keys of your ministry and of the same things which I revealed unto them... —Joseph Smith, *Doctrines and Covenants*[1]

The northward-extending chain of 21 Franciscan missions in the future state of California came to an impressive conclusion in 1823 with the establishment of the Mission San Francisco Solano in Sonoma, named in honor of Saint Francis Solano (1549–1610). Solano was a Spanish-born Franciscan making his reputation in South America as a friend of the poor, the disenfranchised, and Native Americans at a time in which the Spanish Empire was mainly concerned with imposing its will across the New World and exploiting its vast resources (see Chapter 12). By 1823, however, the world had changed. California was no longer under the long-distance jurisdiction of Madrid, but rather that of a newly independent Mexico City. In Sonoma County, Mexican settlers were colliding head on with Russian, English, and American traders coming from the north and east, while Mexican rule would itself be swept away in the name of Manifest Destiny within the space of a quarter century. For the time being, however, northern California and the Pacific Northwest appeared to be under the primary sway of Roman Catholicism. In Bay-area cities from San Francisco to Napa, streets were (and remain) named after Santiago Mayor, while further to the north in British Columbia, the historic Fort St. James had been established by English fur traders as an official outpost

by 1806 and named after the patron saint of furriers, notwithstanding the fact that Great Britain had long since been a staunchly Protestant nation.

Just as the War of the Spanish Succession had been a catalyst of global change at the outset of the 18th century (see Chapter 15), so were the Napoleonic Wars of the early 19th century. Regarding vulnerable Iberia, Bonaparte initiated hostilities in 1807 by invading Spain and Portugal, thus inaugurating a Peninsular War lasting through 1814, and ending only with Bonaparte's defeat in Russia. This was accompanied by the rise of Arthur Wellesley, future Duke of Wellington, with a string of tenacious victories won against the French within former Spanish and Portuguese dominions. While the British army and local Iberian militias clawed back homeland territory from the French, the once proud Portuguese royal court fled to its Brazilian colony in Rio de Janeiro, where it remained in exile for the next 14 years. As for the Spanish monarchy, whereas in a previous time Louis XIV of France had effectively used legalities and local politics to make his grandson king of Spain, Bonaparte unilaterally placed his brother Joseph on the Spanish throne in 1808, much to the consternation of the Spanish people.[2] On May 2, 1808, a spontaneous riot broke out in Madrid when French Mameluke mercenaries were attacked by Spanish patriots using mostly their bare hands and fists. For the Spanish, it was one thing to be invaded and occupied by their old rivals and partners, the French; it was quite another, however—and quite intolerable—to stand by and watch Islamic troops parade through their capital city after all that had transpired over the last thousand years or more. The next day, Spanish rioters were rounded up by French occupiers and summarily executed by firing squad. The tumultuous events of May 2–3, 1808, were soon afterwards immortalized in two magnificent paintings by Francisco Goya (see below), today both on prominent display within the Museo del Prado.[3]

Another highly unpopular move in Madrid by the French, though far less commented upon, was the ordered demolition and redevelopment in 1810 by Joseph Bonaparte of the Iglesias de San Juan Bautista y Santiago. The original historic church structure dated from the Crusader era of the 12th century and was located at the terminus of Calle de Santiago (leading to the Plaza Mayor) in the Asturias district of Madrid. Later the original church had become a royal chapel for the Palacio Real located to the immediate west and served as a convenient starting point for Camino pilgrims traveling from Madrid to Santiago de Compostela. More universally, the older church was the final resting place of Spain's greatest artist, Diego ("James") Velázquez, who had been interred there by his own request in 1660 (see Chapter 14). During demolition, the tomb of Velázquez was irretrievably lost. Today, the former site is marked by the adjacent Plaza de Santiago and Plaza de Ramales (popular with both tourists and locals alike), the latter marked by an image

of Velázquez on its street sign.[4] As for the 1810 church (which replaced the old one), it is not without aesthetic merit. The distinguished Spanish architect Juan Antonio Cuervo (1757–1834) was commissioned to designed the new edifice, decorated with a bas relief of Santiago Matamoros at the entrance, and adorned within by an impressive painting of the same image by the Spanish-Italian artist Francisco Rizi (1614–1685). Nevertheless, the imposed and artificial reign of Joseph Bonaparte over Spain did not long outlast the displeasure of Madrid citizenry over these various indignities.[5] After the fall of his more formidable younger brother, Joseph fled, first to France, then to the United States, and finally to Italy, where he supported himself partly by selling off Spanish antiquities looted during his brief but memorable reign over the Iberian Peninsula (see Chapter 3, note 21).

Arguably the absolute low ebb during the long history of the Santiago cult occurred in 1834 when the notorious Voto de Santiago, a tax imposed on the rest of Spain since the Middle Ages for the maintenance of the religious shrine at Santiago de Compostela, was formally abolished by a now liberated Spanish Cortes or parliament.[6] Even the special interests lobbying in favor of its continuance primarily based their arguments on a 1492 decree by Queen Isabella and King Ferdinand affirming its validity, as opposed to any alleged historicity of the document, which by then was widely acknowledged as a forgery.[7] By the time that the keenly observant British traveler and author Richard Ford toured Spain in 1830–1833, the proverbial writing was on the wall. When Ford's acerbic recollections were later published circa 1845, he made it abundantly clear that he was far more impressed by the simple religious faith and resilience of the Spaniard people, as opposed to any professed authenticity or legitimacy of the Santiago cult.[8] Ford's sharp dismissiveness was in fact part of a long Anglo tradition dating back to the English Reformation (see Chapter 12); on the other hand, by 1834 it was obviously apparent that a majority of the Spanish people outside of Galicia were no longer in favor of paying taxes for the mere upkeep of the Santiago shrine, even while continuing to cherish its traditions and symbolism.

Not surprisingly, one major, immediate effect of these Iberian upheavals of the early 19th century was to spark Spanish-speaking independence movements across the New World. In May of 1810, the same year that Joseph Bonaparte carelessly ordered demolition of the Santiago church in Madrid, Argentina became the first Latin American country to formally and successfully declare independence from its capital in Buenos Aires. Later that same year (1810), on September 16—today celebrated as Mexican Independence Day—the Catholic priest and Mexican patriot Miguel Hidalgo y Costilla issued his *Grito de Dolores* ("Cry of Dolores") proclamation, initiating an acrimonious seven-year struggle to transform New Spain into its own sovereign state. Between 1814 and 1822, most nations comprising modern Latin

America achieved independence with help from talented Libertador generals such as Simón Bolívar, José de San Martín, and Bernardo O'Higgins, the latter winning a decisive victory over royalist forces near Santiago, Chile, in 1818 at the Battle of Maipú.[9] In 1822, Brazil became the last major South American country to declare independence, less than a year after its would-be Portuguese monarchs in exile had returned to an Iberian Peninsula by then made safe by sustained British military efforts. After a decisive victory by the Peruvians over Spanish royalists at the Battle of Ayacucho in 1824, overt hostilities ceased, at least between Latin American patriots and royalist sympathizers, and a new map of the world, one with far more independent nation-states, became commonplace. Thus, what began in Philadelphia circa 1776 as a Pan-American movement in favor of colonial independence from European mother countries came to successful conclusion some 48 years later in the remote regions of the Andes Mountains.

As chronicled within these pages, by the mid–19th century the cult of Santiago, either as Moor-slayer or Camino Pilgrim, carried little if any resonance for Latin American patriots or, for that matter, anyone else beyond a shrinking number of devotees within certain parts of Spain itself. Libertador generals were not in the habit of invoking Santiago Matamoros while rallying troops, although the ever-popular Virgin Mary was occasionally used for that purpose. One exception was the curious inversion of the Matamoros symbol into Santiago Mataespañoles ("Spaniard-killer"), a convenient slogan for Native Americans or mixed-blood Latin Americans, but obviously less appealing to those patriots of pure Spanish ancestry.[10] Remnants of another exception may still be found in the northeastern Mexican city of Matamoros, located in the Province of Tamaulipas, directly across the Rio Grande River from Brownsville, Texas. Originally this town had been called Villa del Refugio, but in 1826, five years after the success of the first Mexican War for Independence, it was renamed in honor of the fallen patriot Mariano Matamoros (1770–1814), whose family name was in turn clearly derived from the old Santiago cult.[11] Among the many Mexican warrior-priests who had put aside their vestments and taken up arms (and subsequently gave their lives) in the cause of independence, none were more venerated than Matamoros, who achieved the high rank of Lieutenant General within the revolutionary forces before being captured and executed by royalist sympathizers during the height of the bloody conflict. As for his namesake city, it has proven to be one of the more prosperous and growing municipalities in northeastern Mexico, in large part thanks to economic stimulus provided by the controversial North American Free Trade Agreement of 1994 (see Chapter 20).[12] The 19th century history of Matamoros was no less colorful, being among other things, a heavily-used port of entry for Confederate privateers during the War between the States, before the port itself fell into oblivion.[13]

Around the same time that Villa del Refugio was being rechristened to commemorate the patriotic memory of Mariano Matamoros, a tremendous religious revival in west-central New York State was producing an entirely new group of Christian Protestant offshoot denominations with distinctively American idiosyncrasies, including Jehovah's Witnesses, Adventists, Shakers, and perhaps most prominently of all, the Church of Jesus Christ of Latter-day Saints (LDS), originally led by its energetic founder, the New England–born evangelist Joseph Smith (1805–1844). This is not the proper place to delve into the endless complexities and subtle policy shifts characterizing the American Mormon sect over the last two centuries. For purposes of this study, however, suffice it to note that the turbulent and somewhat obscure beginnings of the LDS Church in upstate New York included the 1835 publication of Smith's *Doctrine and Covenants*, recounting his religious visions experienced as a young man during the 1820s near his then-home of Palmyra, New York. Significantly, for purposes of doctrinal legitimacy (at the very least), heavenly personages appearing to Smith in these visions included SS. Peter, James, and John (see header quote).

The two sons of Zebedee had of course figured prominently as part of the Christian inner circle for Christ's teachings ever since the time of the New Testament (see Chapter 1). Given that they, along with Saint Peter, had ordained Smith and his followers to a higher priesthood, helped to provide clear justification for establishment of a new church. In a broader context, Smith's recording of this personal experience circa 1829–30 was only the latest strange occurrence in over a thousand years of strange occurrences regarding the cult of Saint James the Greater, underscoring James' preeminence among most Christians as being first in apostolic martyrdom, but having also having absolutely nothing to do with Spain or Latin America. After Smith and his devotees fled New York State for the Midwest in 1830, and later following Smith's murder in 1844 by a mob in Carthage, Illinois, the greater part of the Mormon flock under the leadership of Brigham Young migrated to the Utah territory, even as that remote region was still being contested during the ongoing war between Mexico and the United States (1846–1848). In this sense, one could say that the Church of LDS proved to be one of the main beneficiaries of that infamous conflict.

The prelude to the annexation of west-central North America by the United States came in March of 1836 when the Republic of Texas declared its own independence from Mexico, which itself had achieved independence from Spain only some 15 years previous. After an army led by Mexican President and General Antonio López de Santa Anna overran the Alamo mission in San Antonio a mere four days after Texan independence had been proclaimed, the Mexicans were then promptly defeated and Santa Anna taken prisoner by Texan revolutionaries under the command of Virginia-born Sam Houston

at the decisive Battle of San Jacinto on April 21. It was, for all practical purposes, the first time that a major Spanish-speaking military force had been cleanly beaten in the field by an Anglo-led competitor in the New World. The old mystique of Santiago Matamoros obviously no longer held any sway, particularly in the face of American Manifest Destiny; moreover, this indifference seemed rather appropriate since no one on either side was known to have invoked the saint's help during these struggles. Then in 1845, a mere nine years after the Battle of San Jacinto, Texas achieved official statehood. Mexico and the U.S. were now adjacent neighbors, but peace between the two did not last very long. The final irony in this long saga is that by 1861, after Texas had been quickly transformed into a slave state by its new masters, it voted to secede from the Union—over the strong objections of an aging Sam Houston—and fought tenaciously for the Confederate Army during the War between the States. To this day, the state of Texas retains a strong secessionist element among its populace—not unlike the contemporary Basque region of Spain, which throughout history has witnessed innumerable foreign powers cross its borders while contending for supremacy.

Within a year after Texas became an American state, the Mexican War broke out in 1846. Two years later (by 1848), American expeditionary forces in Mexico had achieved total victory, and dictated its terms of peace, later commonly known as the Mexican Cession. Consequently, the U.S. acquired all of what had previously been northern Mexico (and before that, northern New Spain), including the modern-day states of California, Arizona, New Mexico, Nevada, Utah, Colorado, and parts of Wyoming. In an unprecedented move, cash compensation of approximately $15 million was willingly paid by the victors to the vanquished.[14] It was as if the collective American conscience was somewhat troubled by what it had just accomplished. Among the countless prominent Americans who were combat veterans of the Mexican War, many such as Ulysses S. Grant agreed that the conflict was little more than a pretext for a naked land grab (for the sake of expanding slavery) by a strong nation against a weaker one. In his memoirs, Grant ruminated at length on the decisive U.S. victory despite severe numerical inferiority while fighting on foreign ground for a rather dubious cause at best. Ultimately, he attributed American military success (and territorial conquest) to superior leadership, training and resources—in the process strongly suggesting these were the very same reasons for Northern federal victory over the South in the War between the States.[15] In short, righteous valor was no match for disciplined might.[16] Though Grant did not speculate any further than this, additional reflection shows that these were the identical factors giving earlier victories to the Spanish Conquistadors in America, as well as to Spanish Christians over Moorish Spain during the Reconquista.[17] After the Mexican War, the Rio Grande River valley became a designated buffer zone between the two

countries, which have remained at peace with one another ever since, excepting ongoing immigration and labor disputes (see Chapter 20).

As discussed elsewhere in this study (see Chapter 2), the artistic legacy of Francisco de Goya holds a special place of its own both during the late 18th and early 19th centuries. Few painters, Spanish or otherwise, can claim similar greatness for technical brilliance, emotional impact, or diversity of ever-evolving style; moreover, Goya addressed the Santiago theme and symbolism in a number of his works, both directly and indirectly. For example, Goya's 1804 portrait of Ignacio Garcini y Queralt (1752–1825), Spanish Brigadier of Engineers, presents its military subject proudly displaying the red sword-cross medal of the Order of Saint James. This was only about three years before the entire Iberian Peninsula would subjugated by the Napoleonic invasion. Imposing companion works such as *May 2, 1808*, and *May 3, 1808*, while neither makes any overt reference to the Santiago cult, both still provide plenty of symbolic overtones recalling the old Spanish tradition. In *May 2*, Spanish patriots are unapologetically portrayed as Moor-slayers, killing North African Islamic mercenaries who occupy Madrid, while in *May 3*, these same patriots are presented as martyrs more in the political sense, dying before a French firing squad, yet at the same time receiving final benediction from a priest who himself is also among the condemned victims. Goya's interpretation of a recent historical event evokes a new kind of Spanish nationalism, presaging the trend towards European nation-states of the 1800s, while incorporating, consciously or unconsciously, traditional elements of the distant past into that same vision.

Returning to Latin America (Mexico specifically), a far simpler work of art perhaps speaks greater volumes as to the subtly continuing influence of the Santiago cult over Spanish-speaking military affairs and Latin American nationalism of the early to mid–19th century. Mexican artist José María Obregón (1832–1902) was born after Mexican independence had been achieved from Spain in 1821 but well before the Mexican Cession to the United States of 1848. A native of Mexico City, the formally trained Obregón had made a name for himself as a painter of historical subject matter by the time that Austrian-born Maximilian I (1832–1867) began his short-lived reign as Emperor of Mexico in 1864. Attempting to take advantage of diverted U.S. attention while the American Civil War raged, a foolish Napoleon III of France, when not covertly sympathizing with the Confederate cause, attempted to impose his influence on the New World by placing his own man on the Mexican throne, even though Mexico had by that time been a stubbornly independent republic for many years (see Chapter 17).[18] Obregón associated himself with the court of Maximilian to his own personal advantage while it lasted, but with the arrest and execution of the would-be Emperor in 1867, the artist was forced to make amends in the eyes of republicans, both

for the sake of his life and his career. At this crucial juncture in 1868, Obregón chose the slain revolutionary Mariano Matamoros as his subject matter, since no known images of the popular fallen hero were known to exist. It proved to be a shrewd choice, allowing Obregón once again to fully demonstrate his not inconsiderable talents as a portrayer of sentimental and romanticized Mexican history, both distant and recent.

Obregón's 54-year posthumous heroic portrayal of Mariano Matamoros (from 1868), today on display in the Palacio Nacional in Mexico City, is interesting on several levels. The subject is depicted with what appears to be priestly vestments covered by the simple coat jacket and cape of citizen-soldier, bare-headed, and holding a lowered curved sabre in his right hand. Mounted Spanish patriots parade behind him in the background, but the gaze and focus of Matamoros himself is forward-looking, solely towards the future. In many respects Obregón's depiction of the Mexican Lieutenant-General is similar to that of another American Lieutenant-General, Ulysses S. Grant, painted by John Antrobus a few years earlier in 1863–1864.[19] Both men strike a similar aloof, bareheaded pose with a concentrated expression.[20] Both are strictly men of the people, holding high rank despite their humble origins. The difference is that by 1868, Grant was on the verge on being elected President of the United States, whereas Matamoros was an idealized war hero and fallen patriot of a fairly distant Mexican past. Like his namesake Saint James (Matamoros) the Greater, Mariano Matamoros was widely viewed as a martyr for his nationalist cause—a cause, though political, one also heavily overlaid with religious or semi-religious connotations.

It appears evident that by the mid–1800s, and probably long before that time as well, popular associations with the Matamoros nickname or sur-name—especially in Latin America—had become more anti–Spanish or anti-royalist than the more traditional, opposite meanings. In truth, there was a racial component to this inversion of usage. Latin Americans by then could, far more oftentimes than not, claim Native American heritage over the Arabic heritage of any Spanish ancestry, while in Spain traces of the old Islamic Iberian world, both ethnically and culturally, one subdued long previously by the Reconquista, were still far more in evidence. In the New World, whether one spoke of Santiago Matamoros or Santiago Mataindios, the old image of force-ful conquest was considered merely offensive or oppressive by anyone behold-ing it. North of the Rio Grande Valley, with some isolated exceptions in New Mexico, one rarely encountered the image at all. In Mexico itself, it had become more of a battle cry against imperialism, rather than against Islam. Even in Spain, outside of Galicia, there was waning enthusiasm, especially if it involved paying more taxes. Wherever a Christian religious shrine or cult was needed, the Virgin Mary suited that purpose far better. In short, by 1850 the cult of Saint James the Greater was badly in need of a makeover, both in

and outside of Spain. This it would shortly receive, however, not before Spain was completely stripped of the last vestiges of what once had been an aspiring global empire by its international rivals. Curiously enough, before the remnants of the old Spanish Empire received their final death blow, the rapidly populating plains of North America would witness the spectacle of light cavalry fighting each other in the style of *à la jinete*, a stratagem developed in North Africa during ancient times and transported to a new continent by Spanish practitioners. Now Santiago Matamoros had nothing to do with the conflict. It was as if things had finally come full circle.

17

Beyond Manifest Destiny
(late 1800s)

The Moors cried, "Mohammad!" The Christians, "Saint James!"
In a moment, thirteen hundred Moors lay dead on the field.
—*The Song of the Cid*[1]

The dissonant collision between Spanish-American, Anglo-American, and Native American cultures in the New World is today perhaps nowhere better witnessed than in the northern New Mexico town of Taos, an ancient enclave once the habitat of civilized peoples long before the Iberian Reconquista extended little further than the province of Asturias. In Taos, along the aptly designated Camino de Santiago (named after the co-patron saint of the town), one can find the St. James Episcopal Church, first established as a Protestant mission as recently as 1945.[2] Also along the Taos Camino de Santiago is the Church of Jesus Christ Latter-day Saints, another Anglo-American derived sect venerating Saint James the Greater, whose roots in the American West date back to the mid–1800s (see Chapter 16). Throughout its lengthy colonial history, extending back to the early 16th century, New Mexico (and Taos in particular) has been the focal point of continual conquests, revolts, raids, and reconquests, including in 1847 when the first U.S.–appointed governor was killed during a violent Native American uprising.[3] Unusually, at least for an American city patron saint, Santiago Mayor seems rather appropriate for a geographic place having known so much political turmoil and organized aggression over the last millennium. During an age that celebrated Latin American independence from Europe, as well as U.S. westward expansion in the name of Manifest Destiny, the volatile heritage of Taos, New Mexico, stood (and still stands) as a stern reminder that, ultimately, all politics are local, and that all military conquests are far easier than any peaceful governance.

After decisive American victory in the Mexican War by 1848, the image

of Saint James the Greater, both in his Protestant and Roman Catholic guises, seemed to spread across the western territories of the continent as far as the Pacific northwest. Along the then-remote Columbia River Valley, within Fort Vancouver, Washington, St. James Catholic Church was established in 1851, soon after which a young and still-unknown Captain Ulysses S. Grant arrived to serve a short, unhappy stint of duty in 1852–1853. By 1885, a St. James Cathedral had been built near the same location, but by the turn of century it was apparent that the city of Seattle would be the new commercial hub of the region. Accordingly, in 1905, a more magnificent and still-standing St. James Cathedral was constructed in Seattle, making Saint James the patron saint of that growing Roman Catholic archdiocese. From these trends, it appeared as if the cult of Saint James the Greater was ever pushing north-westwards, just as it had a thousand years earlier in Galician Spain, including the first century CE (see Chapter 1), where according to tradition, the apostle-evangelist ventured into the most remote corner of the Roman Empire and then known world. In short, the Way of Saint James seemed to lead contin-ually westward, especially northwesterly, even after discovery of the New World, and regardless of whether one was Spanish, French or Anglo.

Such a sweeping premise as this might be viewed as overstatement until one visits the thriving Quebec metropolis of Montreal, Canada, where phys-ical remnants of the same mentality are still in plain view for everyone to see. Here the prominent Rue Saint-Jacques extends directly westward from the center of the old city, beginning directly in front of Notre-Dame Basil-ica—not unlike Paris itself wherein another, more ancient Rue Saint-Jacques once led Camino pilgrims of a former epoch from Notre-Dame Cathedral into the generally westward direction of far distant Santiago de Compostela.[4] In North America, however, the newer French Camino was less about pil-grimage and more about appropriation of natural resources, spreading both the Christian gospel and commercial fur-trading in roughly similar, if unequal measures. By the late 19th century, France's colonial ambitions had been greatly diminished by its European competitors; nevertheless, similar objectives were adopted by the ascendant Anglo-American powers that had not long previously supplanted their French rival.

As if to personify the new mood and emphases in French Canadian reli-gious fervor, the mid–1800s saw coming of age in Quebec Province a young priest, born Alfred Bessette (1845–1937), and better known in contemporary times as Saint André of Montreal after his formal canonization by the Vatican in 2010. Unlike many of his devout Quebecois brethren, Brother André pre-ferred veneration of Saint Joseph, husband of the Virgin Mary, over that of Saint James the Greater. Saint Joseph was even more mysterious and obscure in his historical personage, but unlike Santiago Mayor, was much closer asso-ciated with faith healing and charity towards the poor. These seemed to be

more pressing priorities to Brother André as he surveyed the world surround-
ing him. His single-minded devotion to the cult of Saint Joseph and subse-
quent championing of a great new shrine in Montreal, the monumental Saint
Joseph's Oratory, would later prove to be one of the more remarkable stories
in the chronicles of North American religious life. It also continues to provide
dispassionate observers with a useful foil (for comparison's sake) to the now
more obscure cult of Saint James the Greater, at least within the limited con-
fines of the North America continent (see Chapter 18).

The last meaningful attempt at French political influence in North
America came and went with the Franco-Mexican War of 1861–1867, most
of which time the United States was too distracted by its own internal divi-
sions to act more in character as an enthusiastic interventionist. An overly
ambitious Napoleon III of France had instigated the conflict when Mexico
defaulted on its international debt payments, but the French were denied a
quick military victory on May 5, 1862 ("Cinco de Mayo"), when a heavily
outnumbered but deeply determined and well-led Mexican army defeated its
foreign invaders at the Battle of Puebla. The upshot of this unexpected turn
of events was that Mexican President Benito Juárez maintained his elected
office while the French pretender, Emperor Maximilian I, was eventually
deposed and later executed in 1867. Following the triumph of Mexican repub-
licans, along with the establishment of a Canadian Confederation that same
year (1867) and recently enforced federal union within the United States, it
had become abundantly clear that the days of overt European interference
in North American affairs was a thing of the past. Moving forward, political
and religious decision-making across the New World would be more locally
based, often influenced, but never dictated by European leaders. One of the
few things that English-speaking, Spanish-speaking, Portuguese-speaking,
French-speaking, and Native Americans could all agree upon was that they
preferred to settle their own problems without any colonial-driven pressures
coming from without. By the time that Brazil became the last significant
nation-state to formally abolish slavery in 1888, it did so voluntarily and of
its own accord, driven mainly by economic motives rather than any ideology.
Ironically, some of these same emancipated Brazilian slaves were African-
born or descended Muslims whose distant ancestors had likely fought against
Christian banners and the cult of Santiago during the old Iberian wars of
Reconquista.

July 4, 1876, marked the first centennial of American Independence, but
celebrations were somewhat dampened late in June of that same year when
an experienced U.S. cavalry strike force under the seasoned command of
General George Armstrong Custer was annihilated near the Little Bighorn
River in southeastern Montana. Destruction of Custer's over-confident expe-
dition was administered by an improvised coalition of Native American

tribes, rallied in the camp by the visions of Sitting Bull (c.1831–1890) and inspired in the field by the exploits of Crazy Horse (c.1842–1877). Although U.S. Cavalry had previously lost minor engagements to Native Americans, Little Bighorn was the first time a large, highly organized expedition had been cleanly beaten in the field by indigenous combatants since the French and Indian wars of the pre–Revolutionary era. Despite media attempts to spin the defeat into patriotic sacrifice for purposes of the centennial ("Custer's Last Stand"), the truth was that the fiasco mainly whipped up white hysteria, in turn leading to the immediate and ruthless suppression of all tribes. After the murders of Crazy Horse and Sitting Bull (both after surrendering themselves into U.S. custody), the tragic Plains War culminated with the ignoble Wounded Knee Massacre of 1890 in South Dakota, in which political protest and civil disobedience were, for all practical purposes, punished as capital crimes with no due process of law, put down with the force of automatic weaponry. The brutal response at Wounded Knee was reminiscent of distant events in totalitarian Spain from the Middle Ages; however, whereas the Iberian Reconquista lasted nearly eight centuries, the U.S. Plains War spanned only a few decades with the outcome never really in doubt.

About three years after Native Americans of the Great Plains temporarily disrupted the relentless triumphalism of Manifest Destiny at the Little Bighorn, something remarkable began taking shape in faraway Santiago de Compostela. There, Cardinal Miguel Payá y Rico, correctly sensing that, after over a thousand years, the old religious shrine was badly in need of reaffirmation, as well as a P.R.-makeover, directed that the contentious issue of relic location be thoroughly investigated.[5] Fortunately for defenders of the traditional cult, the person chosen to lead this initiative was the versatile cathedral historian, Canon Antonio López Ferreiro (1837–1910), who embodied that rarest of combinations—author, scholar, archeologist, administrator, and above all, man of faith. Beginning in 1879, Ferreiro spearheaded efforts to precisely identify the tomb of Saint James the Greater, a question that had vexed the Compostela for centuries, especially with local tradition holding that the relics had been hidden in response to hostile English raids, beginning with Francis Drake in 1588 (see Chapter 12). As recently as 1719, during one of the periodic flair-ups between Spain and Great Britain following the War of the Spanish Succession (see Chapter 15), British invaders at nearby Pontevedra caused another panic, further fueling similar rumors.[6] Ferreiro's team of 19th century excavators, however, quickly produced results, locating three skeletons together which conveniently corresponded in theory to Saint James and his two Spanish disciples of tradition, Athanasius and Theodore (see Chapter 4), all expertly certified to be of appropriate antiquity.[7] The specific skeleton of James was then ingeniously and impressively identified by matching a documented skull fragment donated during the early 12th century by

none other than Archbishop Diego Gelmírez to the Tuscan cathedral in Pistoia, Italy (see Chapter 6).[8] By this point, even disbelievers and naysayers were forced to admit, at the very least, that the Compostela site had genuinely ancient and compelling associations with Christian religious worship.[9]

When Pope Leo XIII officially declared from the Vatican in 1884 that the new findings at Santiago de Compostela were valid, it seemed like the longstanding place of worship had finally received its much-needed vindication.[10] After centuries of withering, erudite attacks on its legitimacy, there was now a semblance of modern science and scholarship verifying accuracy of the pilgrimage site location. Canon Ferreiro, however, was shrewd enough to know that papal proclamations alone were not enough to deflect criticism. Indeed, perpetual skeptics, even within Spain itself, complained that the discovered relics, given their age and obscurity, could be those of anyone, including condemned Galician Bishop Priscillian, executed for heresy during the 4th century (see Chapter 1). Accordingly, Ferreiro spent the rest of his life producing a near-definitive 11-volume treatise, *Historia de la Santa A. M. Iglesia de Santiago de Compostela* (1898–1910), laying out for future generations exactly what had been done, why, and how.[11] Though now over a hundred years old, and not yet translated into English, Ferreiro's *Historia* remains, if not the final word on its subject matter, most certainly an inescapable benchmark. Intellectually, its premise was ingenious, and is often recognized as such even by doubters—namely, that at this very late date in history, no one can prove or disprove much of anything regarding the Santiago cult. Known or agreed-upon facts are rationally and patiently presented as such, with minimal extravagance or embellishment. As for conclusions, these become, ultimately, a matter of religious faith and personal belief, rather than any irrefutable logic or universal acceptance. Spain's long, troubled history in matters of religious doctrine seemed to be in the back of Ferreiro's mind as he wrote, even while that country was being stripped of its last overseas colonial possessions during the Spanish-American War (see below).

Back in the United States, the aftermath of Wounded Knee and end of the Plains War witnessed the highly influential World's Fair Exposition of 1893 held in Chicago, where European-descended Americans celebrated the recent 400th anniversary (1892) of Christopher Columbus' first voyage and sustained encounter with the New World (see Chapter 11). Native Americans and African-Americans were less celebratory. Original Spanish patronage of Columbus' venture was downplayed as well, although Spain was one of 46 countries sponsoring national pavilions at the exposition. Among the sculptures exhibited at the Spanish Pavilion was an imposing effigy of Saint Isidore by José Alcoverro, today on prominent public display at the entrance to the Spanish national library in Madrid (see Chapter 2, note 3). Ironically, at the Columbian Exposition, Americans lauded Spanish "discovery" of the New

World, even as the U.S. prepared to forcefully take away from Spain what little was left of their once sprawling global empire.[12] Nevertheless, the Chicago event was notable for its grandeur and diversity, at least by more modest 19th century standards. The fair also served as a convenient symbolic reminder or assertion that the United States would from then on be the dominant power on the world stage, rather than Spain, Great Britain, or any other European-based nation state of the distant past.

Almost right on cue, military demonstration of this enhanced global status for the U.S. arrived with the short but decisive Spanish-American War of 1898. Fueled in part by a persistent Cuban independence movement—Cuba being one of the few Latin American states still under the direct rule of Spain—the U.S. entered the conflict initially as a self-appointed referee, but then nearly overnight transformed into the surprising role of anti-imperialist champion for Cuban freedom. This occurred when one of its warships, the *USS Maine*, blew up under hazy circumstances while docked in Havana harbor. Within a matter of months, the U.S. Army, Navy, and Marines were on the doorsteps of Spanish territories. In the Philippines, islands named after a former Spanish monarch and including a city called Santiago (see Chapter 15), quickly fell to American control after U.S. steel battleships made short work of all opposition, simultaneously intimidating any other European competitors in the vicinity, including Great Britain and Germany. In the Caribbean region, U.S. ground forces won a smashing victory at the so-called Battle of San Juan Hill on the outskirts of Santiago de Cuba, a city that once upon a time had been a launching pad for Spanish conquistadors subduing the New World all the way from California to Patagonia.[13] One significant political outgrowth of the Spanish-American War was to bequeath celebrity status to a 39-year-old Colonel Theodore Roosevelt, commander of the famed Rough Riders regiment, who would go on in the next century to lead his country in the truest international sense.[14] Meanwhile, Cuba, Puerto Rico, Guam, and the Philippines were all ceded by Spain to permanent or temporary U.S. territorial status. Another result of the conflict was to signal to the world that American territorial ambitions now far exceeded the previous hemispheric limits of Manifest Destiny, supplanting the international dominance not only of Spain, but Great Britain and other European powers as well.

Accompanying Theodore Roosevelt and the Rough Riders into Cuba was the celebrated American artist Frederic Remington (1861–1909), whose sculptures and paintings have defined popular images of the 19th-century West much the same way that Norman Rockwell's later 20th-century work defined American middle-class perceptions of itself. Among Remington's extensive output, his equestrian subjects, particularly those involving Native Americans, are memorable and perhaps definitive, despite an occasional condescending attitude typical of that era. One of Remington's first forays

into this subject matter, as well as one his most frequently reproduced pro-totypes, is "The Scalp" (originally titled "The Triumph"), a bronze sculpture from 1898, depicting a mounted Plains warrior holding aloft a grisly battle trophy of unspecified origin.[15] Echoes of the violent Santiago Matamoros tra-dition clearly reverberate, although it is unlikely that either artist or his sub-ject had the Santiago cult specifically in mind. Remington's numerous other paintings of mounted Native Americans, cowboys, U.S. troopers, and Rough Riders are only slightly less visceral, but all call to mind vivid memories of Santiago Mayor on horseback for anyone even slightly aware of that pre–Columbian symbol. One of Remington's most noteworthy creations in this same vein (but with far more pathos) is the oil painting "How the Horses Died for Their Country at Santiago" (1899), depicting the scene prior to the Rough Riders' infantry-style assault against the San Juan Heights, of which Remington was himself an eyewitness.[16] By the turn of the 20th century, mil-itary horses had become nearly as synonymous with American patriotism (and sacrifice) as were the riders themselves.

While Remington created realistic scenes of heroism for mass consump-tion, another significant development in American art was transpiring, although one not coming to widespread public attention until many decades later. Lakota Ledger Art was the product of untrained but talented Native American artists who, against all odds, had first survived the Plains Wars, then either by accident or necessity recorded their memories of historical events and lifestyles mostly vanished by the time that Theodore Roosevelt became President in 1901. The medium itself came into existence simply by Native Americans gaining first time access to paper and coloring devices. Ledger artists like Amos Bad Heart Bull (1868–1913) and Kicking Bear (1846–1904) may not be household names within the contemporary art world, but both were survivor-witnesses of the Little Bighorn—Amos as a seven-year-old child and Kicking Bear as a 30-year-old warrior—and both drew depic-tions of the battle that are hard to forget for anyone beholding them. Nothing is sentimentalized or glorified, even from the viewpoint of the victors. Amos shows a rifle-wielding Crazy Horse in the middle of the action furiously riding a white steed while charging or chasing routed and dying U.S. caval-rymen, not unlike Santiago Matamoros of old, but with a detached objectivity betraying its stark realism—an understandable memory from a mature adult whose life as a child had probably been saved by the feats of Crazy Horse and Kicking Bear. Amos knew all too well that within a year the heroic Crazy Horse would be dead, murdered as a prisoner of war with a degree of com-plicity from his own people.[17] This had not been a war of triumphant Recon-quista, but one of desperate defense and determined survival. A few had indeed managed to survive, but in hindsight they could perhaps only wonder and question the terrible sacrifices made along the way.

As observed by historians, the horses ridden by the Plains Indians both in war and peace were, in all likelihood, descended from those brought to the New World by Spanish conquistadores after 1492, which in turn were likely descended from horses participating on both sides of the Iberian Reconquista struggle dating back to the Middle Ages. Therefore, by extension, the white steed of Crazy Horse at the Little Bighorn so vividly depicted by Amos Bad Heart Bull was possibly a distant descendant of the same animals inspiring visions of Santiago Matamoros from another earlier epoch.[18] To repeat the somewhat obvious, however, it is even more unlikely that Native Americans of the Great Plains had ever heard of the Santiago Matamoros, let alone been influenced by the Spanish religious cult or military order. Rather it would appear that this equestrian imagery from the Great Plains represented a good example of iconography parallel to those arising in Spain at least as early as the ninth century.

The Ledger Art of the Lakota tribes certainly is comparable in its primitive style, vivid coloring, and dynamic symbolism to say, the 10th century illuminated manuscripts illustrating the Apocalyptic commentaries of Beatus (see Chapter 3). While these illuminations predated wider circulation of the Santiago Matamoros legend itself, both the illustrators of Beatus and their kindred spirit Lakota visionaries of the distant North American future shared several artistic traits. One similarity was that both viewed their invader enemies as more than simply an economic or political threat, but even more seriously, as a threat to their societal values and traditional ways of life. As such, individual life was worth giving to preserve those values, or at the very least it was psychologically necessary to believe that.[19] The difference was that the Lakota do not appear to have frequently implored the aid of the Great Spirit in their defensive struggle against European or American interlopers. The gradual Latin American transformation of Santiago Matamoros, first to Mataindios (see Chapter 16), and then later to Mataespañole, was not adopted by the Sioux warriors of the North American Great Plains. Fair to say, their resistance proved heroic enough without it.

The breathtaking range of Lakota Ledger Art cannot be done any sort of justice in this limited space; however, within the narrow context of this subject matter one image stands out especially. Circa 1880–1881, as part of a now famous series, a gifted Lakota artist by the name of Black Hawk (c.1832–c.1890) drew a representation which came to be known as "Thunder Being," subtitled "Dream or vision of himself changed to a destroyer and riding a buffalo eagle."[20] Created after the Little Bighorn, but with an inherent sense of aggrieved fatalism, "Thunder Being" depicts a supernatural mounted warrior—part human, part buffalo, part eagle—similar to the rider's horse also possessing the claws of an eagle and horns of a buffalo. The horse's extended tail becomes a sweeping rainbow, while the mounted destroyer is armed with

a scythe-like weapon tipped on one end in vivid blood red. Rider and mount both carry an ample supply of hailstones, like something out of a biblical apocalypse.[21] Nearly 140 years after its creation, the image still retains its power and ability to frighten viewers. Nothing is known of Black Hawk's whereabouts after 1890, and it is widely presumed that he was one of the victims murdered at the Wounded Knee Massacre that same year. In the visual legacy of the artist, however, one may continue to view a striking parallel development in the Native American imagination with that of the Iberian Santiago Matamoros—a fearful image of the mounted heavenly warrior presented as irresistible, divine avenger.

With the violent suppression or segregation of Native American culture, and subsequent U.S. international expansion at the close of the 19th century, it appeared that the conquering westward push originating out of Renaissance Europe had finally come full circle. While some Americans dreamed or fantasized of continuing this push westwards towards Asia, as Columbus and the Spanish had first envisioned, harsh reality was about to intervene. Nations such as India, China, and Japan had already been advanced civilizations for several millennia. In terms of warfare, cavalry was nothing new to them; in fact, one could easily argue that the Mongols of the Khans had taken horsemanship to its ultimate skill level, even more so than the formidable *à la jinete* fighters of Iberia. Moreover, Japan was rapidly modernizing, and within a few short decades would manage to sink the U.S. fleet stationed at Pearl Harbor. The real sticking point, however, for advocates of continuing westward conquest was that European totalitarianism was on the rise as well, and would soon threaten the New World itself. Beating back this new, unexpected threat from the east would require a massive coordinated effort from younger American nations (led by the U.S.) who had enjoyed independence from Europe for only two centuries or less. One of the leading European hot spots for this threatening totalitarianism, not too surprisingly, would be within Spain itself, where tough autocratic rule had a long tradition extending back to the Visigoth era of the Dark Ages. As things would transpire, Santiago Matamoros still had one last disturbing ride to make, one undertaken within his own adopted Spanish homeland.

18

Negotiated Global Conflict
(1900–1939)

Then the rider threw back the cloak and a flash of steel smote light into John's eye's and on the giant's face. John saw that it was a woman in the flower of her age: she was so tall that she seemed to him a Titaness, a sun-bright virgin clad in complete steel, with a sword naked in her hand... "My name is Reason," said the Virgin.—C.S. Lewis, *The Pilgrim's Regress*[1]

The 20th century began calmly enough, notwithstanding the assassination of U.S. President William McKinley in 1901 and swearing in of Vice President Theodore Roosevelt as new chief executive, but within a decade it was widely apparent that global politics were not going to transpire according to the conventional wisdom of the last century. The United States would indeed be foremost among international powers, but not in the precise manner that its apologists had envisioned. To begin with, technological advances were changing everyday life much faster than anyone previously imagined. Then the tumultuous Mexican Revolution of 1910–1920 signaled to all outsiders (including the United States) that Latin American democracy was its own force to be reckoned with, one having little tolerance for foreign interference, even from within its own hemisphere.[2] The grand opening of the Panama Canal in 1914 was overshadowed by the outbreak of the World War I, dubbed the Great War to End All Wars, into which the U.S. was somewhat reluctantly drawn by 1917. That same year (1917), after a period of uneasy neutrality, Brazil also declared war on Germany, becoming the only Latin American country to actively participate in that conflict. By the time a shattered and depopulated Europe brought the Great War to an armistice in 1918—mainly because of forceful American intervention—peoples of all nationalities suddenly found themselves living in a strange modern world that few (if any) anticipated only five years earlier.

Despite all the upheaval and mayhem, however, there still appeared to be a secure place for Christian religious shrines. As the U.S. and Brazil entered World War I in 1917, Brazil's former mother country Portugal was the scene of Catholicism's latest series of Marian visions at the remote mountainous village of Fátima, whose name, curiously enough, was originally derived from the daughter of the Islamic Prophet.[3] There, a group of three shepherd children reported seeing repeated apparitions of the Virgin Mary. Soon afterwards, a "Miracle of the Sun" was reported in which thousands of witnesses, many not particularly religious, saw unusual solar phenomena on a date previously forecasted by the same three children. This quickly led to the establishment of a chapel, later and better known to the world as Our Lady of Fátima. Therefore, nearly overnight, not so distant Spanish Zaragoza had a serious Portuguese rival for Marian pilgrimage or tourism traffic (see Chapter 2). The difference was that the Fátima apparitions had nothing to do with Saint James the Greater, nor the long-cherished Iberian apostolic tradition. More significantly, Galician Santiago de Compostela to the north was no longer the exclusive Christian pilgrimage site for western Iberia. In truth, the Fátima cult seemed to arise as a response to the mass suffering produced by the Great War which, tragically enough, would prove not to be a passing phase, especially within Iberia. In 2017, on the centennial of the event, Pope Francis I canonized two of the Fátima child witnesses as saints over few, if any objections.[4]

As World War I unleashed its fury on western civilization, another holocaust—perhaps the first true holocaust in the modern sense of the term, though one not widely reported at the time—was triggered against the ancient Armenian community living within the confines of the old Ottoman Empire.[5] The origins of the genocide were complex, but in short, the Armenians made convenient scapegoats for the Turks, some victims being agitators for ethnic independence, others supporting Turkish political progressive causes, and most resisting military conscription into a world war they wanted nothing to do with.[6] As a result, by 1916, it is believed that well over a million Armenians, many of them Christian, had been murdered by their Turkish persecutors throughout Asia Minor. Somewhat miraculously, many refugees found sanctuary within the Armenian Quarter of Jerusalem—a city also under Turkish rule, but traditionally with its own separate Armenian patriarch, and more importantly, located in distant Palestine, over which the Ottomans exerted less total control, thanks in no small part to a growing Arab revolt movement throughout the Middle East. In December of 1917, British forces under the command of General Edward Allenby, spearheaded by the creative efforts of British operative Major T.E. Lawrence "of Arabia," permanently wrestled control of Jerusalem away from Ottoman rule. Thus, the Armenian Quarter of Jerusalem, centered around its own traditional shrine and relics

of Saint James the Greater (see Chapter 6), became symbolic of miraculous Armenian sanctuary and divine protection during an era in which it seemed the entire community might be exterminated. It was in fact during the period of the British Mandate, culminating in the 1920s, that the Armenian population of Palestine reportedly reached its peak. In effect, the British Empire had once again, either intentionally or unintentionally, helped to steal a little bit of prestige away from the faraway Spanish shrine of Santiago de Compostela.

By 1917, the Armenian Quarter of Jerusalem had been under continuous Islamic rule since the 1187 conquest of Saladin, or 730 years total, during which time its Cathedral of Saint James had not only survived, but at times even seemed to thrive. During that long interval, Islamic rule, even coming from Istanbul, tended to be tolerant or at times favorable towards the Jerusalem Armenians, since the Jerusalem Patriarchate frequently helped to offset the substantial influence of other Christian or Jewish rivals within the holy city, as well as that of the separate Armenian Patriarchate of Constantinople, the latter tending to bear the brunt of escalating Turkish persecutions. The establishment of the British Mandate towards the end of the Great War, on its surface at least, seemed to usher in a golden age for the Armenian Jerusalem shrine. Here was a powerful new governing body that espoused religious freedom, and was committed to modern democratic institutions, but at the same time no great booster of rival Roman Catholic religious cults, especially those in Spain. Nevertheless, the same stubborn iconoclastic separatism that had served Jerusalem Armenians so well for so long during times of adversity, now appeared as liabilities, often putting them at odds with outside local insurgents given similar freedoms by the British. A bigger factor in decline was that the Armenian Quarter was surrounded by rival or hostile groups, in contrast to faraway Galician Spain in which that society was pretty much homogenous, both religiously and, for the most part, politically as well. By the eve of World War II, population within the old Armenian Quarter of Jerusalem had been reduced to few thousand residents as in pre-war levels. Moreover, all religious pilgrimage to the Holy Land was once again about to be disrupted by ongoing global conflict.

Meanwhile in the distant United States, the aftermath of the Great War saw the Santiago tradition undergo another unlikely literary transformation, one whose popularity seemingly continues to grow. In 1919, American pulp fiction writer Johnston McCulley produced *The Curse of Capistrano*, better known by its 1920 silent film title, *The Mark of Zorro*. Matinee idol Douglas Fairbanks by random chance read McCulley's artless tale of romantic heroism, and immediately had it transformed into a star vehicle for himself. In the book and movie, Zorro's real name is Diego (James) de la Vega (of the Meadow), while his nom de plume translates as "fox," denoting both cunning

and the furrier trade with which Santiago was so closely associated.[7] Zorro swears oaths "by the saints" and adopts multiple personas worthy of any superhero or religious icon. He is a mounted warrior par excellence in the *à la jinete* tradition, a natural leader of men (especially of men in revolt against established authority), and a friend of the oppressed in general. He thinks nothing of covering long geographic distances, having been educated in overseas Spain, then in California moving easily between Capistrano (near San Diego) to Santa Barbara along the central coast. Thus, without invoking the name of James or Santiago a single instance, McCulley, and later the movies inspired by his novel, repeatedly echo the cult of Spain's famous patron saint, distilled into paperback or Hollywood format for popular consumption by American general audiences.[8] Over, a hundred years later, the Zorro franchise still appears to be going strong.[9]

In England, a more distinguished writer appears to have been mildly influenced by the Santiago tradition during this same period as well. In 1933, the same year as the Nazi takeover of Germany, Irish-born Oxford don C.S. Lewis released his first work since his conversion to Christianity (two years earlier), *The Pilgrim's Regress*, an opaque and somewhat difficult allegory that still offers substantial rewards for those readers patient enough to peruse its compact pages. Lewis' chosen title was obviously a play on John Bunyan's *The Pilgrim's Progress* (see Chapter 14), upon which Lewis would eloquently comment not long afterwards in his classic 1936 study, *The Allegory of Love*. In *Pilgrim's Regress*, Lewis takes highly critical note of ascendant fascism worldwide, including Germany, where Hitler and the Nazis are bitterly satirized as Mr. Savage and the Dwarves. The hero-pilgrim John eventually becomes an aspiring knight-errant and dragon-slayer, inspired by the allegorical figure of Reason, a supernaturally-armed virgin female on horseback capable of killing giants or removing any other obstacles that stand in her way (see header quote). This presentment of Reason as a Santiago Matamoros–like figure is interesting on several levels, not the least of which is Lewis' inversion of conventional gender roles. Although images of the Virgin Mary had been used by Christians both in war and peace since at least the Middle Ages, Reason of *Pilgrim's Regress* is clearly more in the tradition of the biblical Apocalyptic riders that most likely influenced the first conceptualization of Santiago Matamoros via medieval Spanish writers such as Beatus of Liébana (see Chapter 3). The fact that one of these Apocalyptic riders becomes a woman in early 20th century literature should not surprise us, plus it adds considerable resonance to an ancient, if not all-too-familiar symbol.[10]

During the 1930s, as the political and military situation in Europe rapidly deteriorated, Latin America and the United States enjoyed a level of harmony and cooperation not enjoyed before or possibly since. Horrified by the Great European War in which they had reluctantly opted to participate, Brazil

reacted, among other ways, by erecting the monumental *Cristo Redentor* ("Christ the Redeemer") statue in Rio de Janeiro, completed in 1931.[11] Convinced that an unabated rise in secularism had contributed to the human catastrophes of the early century, the local Roman Catholic Archdiocese decided it needed to make a bold statement. No one has argued with it since. Then in 1933, newly-elected U.S. President Franklin Delano Roosevelt initiated his "Good Neighbor" policy towards Latin America by withdrawing American troops and promoting smooth trade relations—both stark contrasts to previous American involvement in the southern hemisphere. The move was designed as a bold and surprisingly effective counterweight to rising fascist influence within those countries. 1936 saw the landslide re-election of FDR, as well as Carlos Saavedra Lamas (1878–1959) of Argentina becoming the first Latin American awarded the Nobel Peace Prize. Lamas, after a distinguished political career of his own, worked tirelessly as an international diplomat for his country and advocate of nonaggression between South American nations of the type that had so recently destabilized Europe. A continuing legacy of Lamas' efforts is that political violence in South American countries has pretty much ever since been limited to internal divisions, with a minor exception of brief and intermittent territorial disputes between Peru and Ecuador. Santiago Matamoros (or his various permutations) was nowhere to be seen. Instead, religious shrines such as Christ the Redeemer or Our Lady of Guadalupe, or even the newer Saint Joseph's Oratory of Montreal (see below), now seemed to predominate instead.

One would think that by this late stage in history, slightly more than 80 years before the present day, the very notion of Santiago Matamoros would be dismissed as psychologically passé, archaic or obsolete, and yet this proved not to be the case. In America, whether it be Latin, Anglo or French, the old icon appears to have been, at the very least, dormant; in the adopted Spanish homeland of the saint, however, the ancient supernatural horseman had at least one more ride to make. The highly complex origins and aftershocks of the ghastly Spanish Civil War (1936–1939) are emphatically not the focus of this study; however, a few agreed-upon facts may be restated herein for purposes of backdrop and perspective.[12] In brief, within a space of three years, the leftist Second Spanish Republic, one proving overly hostile towards the Spanish nobility and Roman Catholic Church, was violently overthrown by a populist counterrevolution that in many respects, defying Marxist stereotypes, pitted rural Spanish commoners against urban elites and intellectuals from Republican strongholds such as Madrid and Barcelona.[13] Victorious Nationalist forces were led by the controversial and charismatic Galician-born General Francisco Franco, supplied with crucial covert munitions and air support from Mussolini's Fascist Italy and Hitler's Nazi Germany. The end-result was that by the outbreak of World War II in 1939, exhausted and

depopulated Spain, along with its latest unlikely ally, the authoritarian *Estado Novo* ("New State") of Portugal, both declared themselves officially neutral during the impending conflict, but in fact were quite willing to cooperate with Hitler's Third Reich should it continue ascendant.

Hostilities in earnest for the Spanish Civil War were initiated at the Battle of Mérida north of Seville and east of Lisbon on August 10, 1936, in which an invading Nationalist army under the command of General Franco decisively defeated Republican defenders.[14] The Nationalist victory at Mérida was crucial in that it gave Franco's seasoned forces a firm foothold on the Iberia Peninsula, also allowing them to geographically link their scattered allies from both north and south. From this point moving forward, the Republicans never really recovered, although it took another three years for opposition to be ruthlessly crushed. Startlingly, at Mérida, Santiago Matamoros was reportedly seen fighting on behalf of the Nationalists—perhaps not surprisingly, since the Republicans were generally hostile towards the Roman Catholic church and many Republican elites questioned the very authenticity of the Santiago cult.[15] More persuasively, Franco's Nationalists benefited from their German-supplied weaponry, and crucially, the presence within their ranks of the formidable Spanish Legion, an elite corps of veteran shock troops, still today representing the ultimate pride of Spain in terms of military discipline.[16] The successful Nationalist counterrevolution of the Spanish Civil War might be viewed in hindsight as a modern Reconquista of sorts, therefore favored by boosters of the Santiago cult, especially given that Galicia and northwestern Spain supported almost unanimously their cause throughout course of the conflict. The fateful 1936 Battle of Mérida also represents the last or latest point in recorded history that Santiago Matamoros was said to have intervened for the winning side.[17] Ironically, many of the political principles that Spanish Republicans fought in vain to achieve during the war—parliamentary government over monarchy, clear separation between church and state, a more secularized society, etc.—eventually became firm realities in Spain, but only after the death of Franco in 1975 (see Chapter 19).

In contrast to the rank inhumanity of the Spanish Civil War and global conflagration following in its wake, the legacy of Saint André of Montreal from roughly the same time period, physically symbolized by the popular shrine of Saint Joseph's Oratory, offers a pleasing beacon of hope for the future of humankind. By way of background, the city of Montreal and the French-speaking Canadian province of Quebec had their own long and unique legacy in relation to Saint James the Greater, or Saint Jacques-le-Majeur (see Chapter 17). This French Canadian legacy might in fact boast a more multi-cultural and less violent interpretation, or at least one less domineering, than that put forth by its Spanish-speaking counterpart. One of the oldest surviving local remnants of this devotion is the Saint-Jacques Cathe-

dral, now part of the University of Quebec at Montreal (UQAM), whose original parish roots extend back to the early 1800s and the first Bishop of Montreal, Jean-Jacques Lartigue (1777–1840), whose personal namesake patron saint was James the Greater.[18] The façade of the current structure dates from the late 1800s, after a series of fires had destroyed or disfigured previous cathedral buildings, but a transept rooftop statue of Saint Jacques in pilgrim's guise still towers over the Rue Saint Catherine, becoming an officially designated landmark structure for the 1967 Montreal Exposition.

Seemingly in response to the bad luck that dogged this original cathedral site, the diocese then constructed a newer, more magnificent Saint-Jacques Cathedral, located in the western downtown district of the city in 1894. It remains the seat of diocese, although the basilica was itself re-consecrated as Mary Queen of the World Cathedral in 1955.[19] Vestiges of the old Saint Jacques cult remain, however, both within and without, including statutes of the saint and prominent gold letter texts (in Latin) from the nave touching upon the life of James the Greater, one of which acknowledges that he preached in Spain—but nothing regarding the other legends, most notably the apostle's alleged interment there. The church also contains a prominent statute of Brother André, who did much of his life's work within the environment of the Montreal diocese. Thus in 1939, as Spain became a dictatorship, and France fell outright to Hitler while England alone stood on the brink, Canada continued to be free, thereby allowing the dream of Brother André (who died in 1937) to be completed as a monument to charity and healing, one for which he will always be remembered.

After years of planning, promotion, and preliminaries, construction on the final Saint Joseph's Oratory of Montreal began in 1924, and its dome was completed in 1939 while yet another world war commenced. Today it is the largest church in Canada and that country's most renowned pilgrimage site, situated atop Mount Royal (facing west) for everyone in the area to clearly behold. In a major metropolis which derives both its civic flag and coat of arms from the original red cross of Saint James, the Oratory stands as an interesting example of how older religious traditions are sometimes transformed into new ones having different meanings. Montreal began life as a North American trading post in which French explorers dreamed of spreading Christianity westward as they made themselves wealthy from commercial activity and appropriation of natural resources, not unlike the Spanish conquistadors. By the 20th century, however, France was no longer in the local picture (although French language and culture are both alive and well), and under the humane vision and influence of Brother André, devout residents of Montreal retooled their religious focus towards the cult of Saint Joseph, co-patron saint of Canada.[20] The change marks a notable contrast to the reinvigorated cult of Saint James the Greater at Santiago de Compostela in

Spain, where General Franco's lifelong veneration was carried to grotesque extremes. Even so, within the magnificent edifice of Saint Joseph's Oratory, one may still view a striking, oversized wooden sculpture of Saint Jacques-le-Majeur (as one of the 12 apostles) by Henri Charlier (1883–1975).[21]

Choosing artwork that captures the spirit of this restless, impulsive era is ultimately a subjective task in the extreme. The worldwide rise of totalitarianism amidst widespread economic hardship during the early 20th century was far from the first time in history that this correlation had occurred. One must bear in mind that it produced both bad and good results. On one hand, it led to political dictatorships; on the other, it also generated a selfless religious fervor of the type so well represented by Saint André of Montreal or Saint Frances Cabrini (see Summary). With respect to Saint James the Greater, surely the incident in his life that captures this impulse the best, one recorded so unambiguously in all three of the New Testament synoptic gospels (and of which there is no reason to doubt), is his calling, along with his brother John, to become a disciple of Jesus, accompanied by SS. Peter and Andrew.[22] In keeping with their reputed fiery temperament, both brothers immediately drop the drudgery of their thankless labor, and leave their no doubt stunned father to join Jesus in what the older Zebedee surely viewed to be a carefree, vagabond life of adventure on the road. The subject has been popular with painters since the Renaissance, and has inspired several notable works. These range from the massive pre–Columbian mural depiction in the Sistine Chapel by Michelangelo's teacher Ghirlandaio Domenico (1449–1494), or a striking French treatment by Claude-Guy Hallé (1652–1736) originally displayed in the since destroyed Saint Jacques de la Boucherie Church of Paris (see Chapter 15), to the English pre–Raphaelite austerity of Victorian master Edward Armitage (1817–1896). Among all these, however, it would be remiss not to mention one other highly unusual painting by a little-known artist working in Venice during the same historical era that saw the initial rise of Spanish power in the New World.

Marco Basaiti (c.1470–c.1530) was active in the Veneto and contemporary with many of the most famous artists and political figures of the High Renaissance, though he remains relatively obscure even within circles of dedicated art lovers. Very little is known of Basaiti's life, and his output was comparatively small; he painted strictly religious themes and portraiture. It is generally believed that he was not native to Venice, and that his family came there as refugees from a Greek or Albanian homeland oppressed by the rise of the Ottoman Turks after the fall of Constantinople in 1453. In this respect, Basaiti is an artistic forerunner of El Greco, who came to Spain from Greece about a century later (see Chapter 9), bringing with him a more eastern, and hence somewhat more bleak and severe aesthetic. The age in which he developed as an artist was also similar in some respects to the early 20th century;

just as civilization was being threatened by fascism during the prelude to World War II, Europe was also being threatened by the expansion of the Ottoman Empire during the late 15th century. By 1492, however, the tables had suddenly turned. Western Europe had by then gone on the offensive, and was expanding westward in the truest global sense. Around the year 1510, Basaiti painted his *Call of the Sons of Zebedee* for an altarpiece at the Venetian defensive outpost at Certosa Island, today on display at the Gallerie del' Accademia in Venice.

The canvass is stunning; it rarely fails to elicit comment from even the most sophisticated of critics. The depiction is completely faithful to scripture and has nothing to do with Spain, as if the artist has the Venetians appealing to James for continuing protection against Turkish aggression. Jesus on the shoreline is flanked by the brothers Peter and Andrew, as the bearded, presumably older brother James leads his younger brother John out of the fishing boat, while a helpless, alarmed Zebedee follows, as if scolding them. Tools of the trade lay scattered about. Idle bystanders are either uninterested or appear somewhat entertained. Shepherds off to the left are equally unengaged. In the background, on the lake, crewman of another fishing boat slave away with no apparent success. In the further distance are fortified towns, castles, and ancient ruins, subtly suggesting that these things come and go, but the Word of God is eternal. A few years later, Basaiti also painted a depiction of the *Agony in the Garden*, in which James, John, and Peter are portrayed sound asleep like children, but in the earlier work we see the sons of Zebedee wide awake and in decisive motion. The feeling effectively captured is that of the impoverished dispossessed being summoned to something greater and more meaningful in their otherwise tedious and unglamorous lives.[23]

Returning to the mid–20th century, it had become apparent by then to most sensible people that global conflict was something to be negotiated if possible, rather than simply fought out as it had been in times of old. Technology had finally reached the point where all-out war was simply too destructive, and the dawn of nuclear age was upon humankind. The old model of forcible conquest, as symbolized by Santiago Matamoros, was still being clung to by various dictators and autocrats, but for those hoping that civilization might outlast their own lifetimes, there needed to be a new approach to resolving international disputes. Unfortunately, although Hitler, Mussolini, and Japan would all soon be beaten, the Franco regime in Spain had become a type of inspirational model for Latin American dictatorships to follow. At the other end of the spectrum, and providing far more hope for the future, was the allegorical Reason of C.S. Lewis, also an irresistible warrior on horseback, but one with a completely different sensibility, no overt loyalty to any specific religious creed, and whose wrath was directed solely against world oppressors, rather than against the oppressed.

19

Model Dictatorships
(1939–1980s)

The creed is, of course, very ancient, and it is also indestructible. It cannot be extinguished by historians or archeologists, or even to any appreciable extent weakened by them. It has been attacked again and again, fairly and unfairly; but it has survived little changed, and is still dearly cherished, still a comfort to many souls, still a means or warming and emboldening many hearts. It is quite safe.—T.D. Kendrick[1]

The unprecedented destruction and loss of life caused by World War II is today in danger of being forgotten now that the generation who fought the conflict rapidly and almost daily disappears. For those who still do remember, or at least can comprehend something read of the historical events in print, there is surely a takeaway lesson that brute force is no longer a logical, permanent solution to much of anything, especially in the wake of Hiroshima and Nagasaki. In short, the cult of Santiago Matamoros would seem to have become obsolete, notwithstanding his alleged intervention at the Battle of Mérida in 1936. As for the temporary partnership of convenience between Francisco Franco and Adolf Hitler, this alliance proved to be as awkward, unnatural, and short-lived as that between Spain and Germany during the distant era of Alfonso the Wise (see Chapter 8). By the time that world peace of sorts had finally been achieved in 1945, the only things in Spain that had been reaffirmed were that it was indeed a society with deep authoritarian traditions plus a very long history of dubious autocratic leadership. These regrettable characteristics were nowhere better represented than in its stridently militaristic establishment, the epitome of which was the impressive Spanish Legion, many of whose hearty recruits hail from northern Spain and the birthplace of the Reconquista, as symbolized by their ubiquitous mountain goat mascot. Nevertheless, it was this very same militarism that had once

helped to make the Spanish-speaking world into something to be respected, if not outright feared or admired.

Latin American participation in World War II was limited but noteworthy. Mexico and Brazil openly sided with the Allies and fought with them accordingly. Other parts of the New World south of the U.S. border were less enthusiastic, at least initially; in fact, many of these countries might have well defected to the Axis had it not been for two important developments. One was the tremendous prescience shown by the FDR Administration's Good Neighbor policy of the 1930s, one that greatly strengthened U.S. commercial ties with Latin America, as well as considerably easing tensions and resentments over previous U.S. interference in those regions. The second was Hitler's insane 1941 declaration of war against and invasion of the Soviet Union, which had one effect of immediately bringing Central and South America in bloc over to the side of the Allies. By 1942, all North and South America had become a coordinated military industrial complex aimed against the Axis Powers. Recoiling from Nazi rashness, Franco's Spain stayed mostly out of it, then switched sides in a timely manner, but not before it had set an extremely bad example. The aftermath of the war saw some outmigration of former Nazis to several South American countries with similar military dictatorships, particularly to Argentina and Chile. Some Spanish-speaking countries, though, reacted in an opposite manner. For example, after enduring its own brief but bloody civil war, Costa Rica permanently abolished its entire military in 1949, and has ever since been a forceful voice in favor of peaceful resolutions within the international community. Along these same lines, it might well be said that by 1950, Latin American as a whole had achieved a more neutral and cautious outlook than its powerful neighbors to the north, especially with respect to foreign policy, consistently showing themselves more reluctant to reflexively take sides in ongoing international disputes, especially during the subsequent Cold War era.[2]

Like many other things by the mid–20th century, religious cults had become far more secularized, a trend on display nowhere better than in the relatively unique Latin American society of Argentina. There, in 1952, the attractive and popular Argentine First Lady, Eva Duarte Perón, died of cancer at the young age of 33. She was widely mourned and given a massive state funeral, the likes of which were usually reserved for major world leaders, and has pretty much grown in public stature ever since, although the popular image seems to become further removed from reality as time passes. This remarkable transformation occurred almost overnight, some would say during her own lifetime.[3] Even before Eva's short, meteoric life had been romanticized and semi-fictionalized by the hit musical (and later film) *Evita*, Isabel Perón, the third wife and widow of former Argentine President, General Juan Perón (Eva's widower), had become the world's first elected female head of

state in 1974, mainly through the power of Eva's married name.[4] Eva, despite having little education and no pedigree, had herself risen from the humblest of roots to become a forceful populist leader in the truest sense, and her multitude of devoted followers clearly recognized her as one of their own. Her husband also recognized this quality, and took full advantage of it.

After her death, Eva's posthumous image and physical relics were treated in the same manner as a semi-religious shrine by the Argentine nation. Embalmed relics were stolen, reappeared, and re-enshrined in a manner that recalled the most controversial cults of the ancient saints, including that of Saint James the Greater. Dispassionate observers of the phenomenon have correctly noted that Eva, notwithstanding her lack of conventional sophistication, was shrewd enough to craft a durable public image of herself which borrowed elements from the ever-popular Marian cults of Latin American Roman Catholicism.[5] During her crucial teenage years in late–1930s Buenos Aires, while General Franco in Spain was claiming victory with military assistance from Santiago Matamoros, a teenaged Eva Duarte was no doubt far more impressed by the widespread veneration of the Virgin Mary throughout her native country, and the youthful impression seems to have stuck.[6] After her meteoric rise to power in Argentina during the postwar era, a deeply impressed General Franco invited the Peróns to Spain in 1947 for an official state visit, which they gladly accepted.

With the death of FDR in 1945, and along with him, the gradual demise of his official "Good Neighbor" policy towards Latin America, resentment against increasingly exploitive U.S. behavior steadily grew. Things finally came to a head in 1959 at the height of the Cold War, when Fidel Castro proclaimed victory for the Cuban Revolution, deliberately choosing to make the announcement from the old city of Santiago de Cuba, which only 60 years previous had witnessed Colonel Theodore Roosevelt's Rough Riders charging to victory during the Spanish-American War (see Chapter 17). Mercifully, Castro claimed no express help from Saint James the Greater in his party's triumph, but the intended symbolism of the locale was still hard to miss for anyone paying attention. The establishment of a Marxist government in nearby Cuba helped to partly spoil the addition of Hawaii and Alaska as U.S. states that same year (1959), both of which included long-established place names and churches in honor of Saint James, son of Zebedee.[7] Two years later in 1961, the U.S.–backed Bay of Pigs invasion into Cuba was defeated, creating further widespread consternation, especially among Cuban-American exiles. That same year (1961), the Anthony Mann film *El Cid* was nominated for three Oscars, providing American movie audiences with their first and possibly only cinematic glimpse of *El Campeador*, preeminent medieval hero of the Spanish Reconquista (see Chapter 6). Although *El Cid* is certainly one of the best epic films ever made, it makes no reference to

Saint James the Greater, perhaps a wise thing given the public mood of that era, as well as public ignorance.

In 1962, the frightening Cuban Missile Crisis ended only after Soviet ships elected to withdraw from the region, with neither superpower claiming or admitting that God had taken sides in the conflict.[8] In a curious postscript to the tumultuous Cuban uprising and its subsequent international fallout, in 1967 the restless revolutionary Ernesto "Che" Guevara was killed while trying to incite a similar government overthrow in Bolivia, the same country that, according to tradition, had seen the deaths of exiled American outlaws Butch Cassidy and Sundance Kid during the early 20th century.[9] Since Guevara's death, his stylized visual image has become nearly synonymous with the revolutionary spirit itself, one which can be seen nearly everywhere, including the United States. Like Eva Perón before him, Che Guevara has in effect become a secularized icon whose cult rivals those of the Christian saints, a kind of Santiago Matamoros for the irreligious among the proletariat class.

With the death of Francisco Franco in 1975 passed the last surviving fascist dictator of the World War II era, and some (by then) elderly exiles of the Spanish Civil War began returning to their homeland, many from Latin America. Unfortunately, however, after over three decades, Franco's long tenure in power had established a successful prototype, based on traditional Spanish totalitarianism, that was widely imitated throughout the New World and beyond. Moreover, the United States during the Cold War era, especially after the Cuban fiasco, displayed a disturbing penchant for supporting Franco-style dictatorships in Latin America whenever Marxist politics threatened to upset the established order, or worse, wherever existing dictatorships failed to properly serve U.S.–owned business interests. For example, in 1973, the elected leftist Chilean President Salvador Allende was overthrown in a U.S.–backed military coup and replaced by the totalitarian regime of General Augusto Pinochet. As FDR might have predicted, this heavy-handed approach to enforcement of the Monroe Doctrine often backfired as local resentments over foreign interference kicked in. The weakness and shortsightedness of the Carter Administration with respect to U.S.–Latin American policy was nowhere better illustrated than in the near-spontaneous and violent Sandinista Revolution of 1979–1980 in Nicaragua, one which successfully overthrew (and assassinated) the U.S.–backed dictator Anastasio Somoza Debayle, and eventually resulted in Daniel Ortega emerging as a new Nicaraguan leader.[10] In the two decades since Cuba had rejected U.S. intervention into its political affairs, it seemed as if little had changed in terms of local public opinion and sentiment. Interestingly, near the center of Nicaragua's capital city of Managua is the landmark Catedral de Santiago, a 1920s–built retro-style structure that has since managed to survive multiple earthquakes and fires, as well as the violent Contra Civil War of the 1980s.

A turning point of international opinion appears to have coalesced during the unsettling aftermath of the brazen 1980 assassination of Archbishop (and Saint) Óscar Romero (1917–1980) of El Salvador, later canonized a saint by Pope Francis I in 2015. There was nothing mythological or legendary about Romero's martyrdom; he was murdered publicly in cold blood for boldly speaking out against human rights abuses in his country. Although his murderers were never officially identified or charged, it is likely that they were members of right-wing paramilitary organizations opposing El Salvador's recently installed revolutionary government. In a broader sense, the true cause of Romero's tragic demise was that he refused to align the local Roman Catholic Church with either side in the Salvadoran conflict, quite unlike the earlier Spanish Civil War in which Catholicism was overtly Nationalist in its sympathies (see Chapter 18). The shift in stance was noteworthy. By the time of Romero's martyrdom, the church establishment seems to have lost all enthusiasm for endorsing any kind of organized aggression, probably knowing all too well that most of its long-suffering flock by then shared a similar point of view. Since Franco's death five years earlier, popular moods had noticeably changed, although it would still take a while for outward political stances to catch up with it. Nevertheless, the rest of the 1980s decade witnessed increasing political opposition to Latin American totalitarianism, both at home and abroad.

The 1982 British victory over the Argentine Navy in the brief Falklands War may have been instigated by dubious motives, but ultimately resulted two years later (1984) in Argentina's returning to civilian rule after decades of intermittent military dictatorship. As usual, however, the U.S. was slow learning the same lesson. The sudden and successful 1983 invasion of the south Caribbean island-nation of Granada—an island named after the last Islamic stronghold of Andalusia (see Chapter 10)—mainly drew heavy international criticism against the United States while revealing that the Marxist threat against the island was likely far less than perceived before the invasion. In practice, U.S. policy makers were trying to avoid another Cuba fiasco, but the Cuban Revolution was by then becoming a thing of the distant past, while the Contra Civil War in El Salvador raged on indecisively. Irrespective of results, by the mid–1980s interventionist policies had generally fallen out of favor.[11] With the unexpected dismantlement of the Berlin Wall in 1989 and rapid collapse of the Soviet Union—including collapse of all Soviet aid to Latin America—the U.S. moving forward needed updated justifications for its habitual interference into that region. New reasons, however, were not long in being provided. The 1989–1990 U.S. lightening invasion of Panama made it clear to all impartial observers that the true goal of the operation was to remove an unpopular, uncooperative dictator (Manuel Noriega) while, more importantly, protecting extensive U.S. commercial ties to the Panama Canal.

The widespread devastation caused by the second World War included the artistic productions of human hands, as well as human lives. The wholesale incineration of Japanese and German cities, whatever their justification, inevitably led to the permanent loss of both the innocent and the useful. With respect to the legacy of Saint James the Greater, no doubt the most regrettable example of this loss occurred on March 11, 1944, when an Allied bombing raid against the ancient Italian city of Padua resulted in the obliteration of an extensive mural cycle known as the *Stories of St. James*, painted by Andrea Mantegna (1431–1506) at the Ovetari Chapel in the Church of the Eremitani.[12] The cycle consisted of six panels, individually titled *Vocation of the Saints James and John, St. James Preaching, St. James Baptizes Hermogenes, Judgment of St. James, Miracle of St. James,* and *Martyrdom of St. James.* Fortunately, at least for present day discussion purposes, black and white photographic records of the murals had been made earlier, from which more recent, somewhat imprecise reconstructions were completed, occasionally colorized with the use of modern technology. Also surviving today is an original study sketch by Mantegna for one of the panels which (interestingly enough) is quite different from the one eventually executed for the destroyed mural, at least according to the photographic record. The various scenes for the six panels chosen by the artist ranged from the more typical to the highly unusual. *Vocation, Hermogenes,* and *Martyrdom* had all been covered by previous Renaissance painters and are discussed elsewhere within the pages of this study. Others, however, such *Preaching, Judgment,* and *Miracle,* have been far less frequently treated, and based on what has survived, their irretrievable loss is particularly regrettable.

Mantegna, yet another a great master of the High Renaissance hailing originally from Venice, needs little introduction among modern art lovers. Working throughout the Veneto region during his long career, Mantegna eventually settled in Mantua where he produced some of his best-known masterworks, influencing most of his contemporaries in the process, including Leonardo da Vinci. As a relatively young man in his late 20s, however, and well before he became a widely-known artist, Mantegna was among those painters receiving contracts to decorate the Ovetari Chapel in Padua, one of his first highly prestigious commissions. The year was 1448, five years before the fall of Constantinople to the Ottoman Turks, and over four decades before European discovery of the New World by Christopher Columbus (see Chapter 11). Neither Princess Isabella of Castile nor Prince Ferdinand of Aragón had yet been born. The Ovetari commission would drag out nearly 10 years before its completion due to various legal and financial disputes (some of which involved Mantegna personally), during which time western European politics and attitudes changed noticeably.[13]

By 1455, Italy had become the military front line of operations against

the Turks, while the Venetian Republic in particular bore the brunt of these assaults along the eastern Adriatic seaboard. Around this same period, Mantegna painted another masterwork, *The Agony in the Garden*, depicting a young Saint James the Greater sound asleep while the arrestors of Jesus approach, and which probably later influenced Marco Basaiti's treatment of the same subject matter (see Chapter 18).[14] Amateur psychological analysis suggests that much of western Christendom at the time felt their great saintly protector Santiago Matamoros to be asleep as the Ottoman Turks triumphantly approached a terrified Europe from the east. It was also around this same period (1455) that Mantegna produced the surviving preparatory drawing which he would then use as a starting point for the most unusual panel within the Paduan *Stories of St. James* series. By this time the cycle would have been nearing completion with Mantegna apparently in sole control of the commission, giving him de facto latitude for making bold experimentations on the last mural panels.

The *Miracle of St. James*, often referred to as *St. James Led to His Execution*, before its wartime destruction was situated on the bottom left of the six panels in Mantegna's series. It portrays the moment when, according to Jacobus de Voragine (see Chapter 9), James, while being led to execution by soldiers and his accuser Josias, is forcefully approached by a paralytic begging for a healing cure. After this wish is instantly granted, the suppliant falls to his knees as James blesses him, while a profoundly impressed Josias, still connected to James with a rope, and astonished executioner both look on in amazement. Vorgaine relates that Josias on the spot pronounced himself a Christian and was consequently executed along with James.[15] The persecutor thus became a convert; the oppressor, a co-martyr for the faith. The story of Josias has frequently captured the imaginations of other artists (see Chapter 7), and occasionally the healing miracles of James, but the precise moment of Josias' transformation and conversion was rarely if ever depicted with such poignancy and impact.[16] In the multifaceted drama of Mantegna's mural panels, it is easy to overlook that nowhere is there any reference to Santiago Matamoros, or for that matter, Saint James the Greater in connection to the various Iberian traditions. In some respects, this is not surprising from a Venetian artist working for Italian patrons; on the other hand, Mantegna's considerable achievement was a reminder that the legends and traditions of Saint James the Greater had a universally appealing character, as noted more recently by T.D. Kendrick (see header quote), but also with an appeal quite separate and apart from any of its aspects relating to Spain.

In pure technical terms, the *Miracle* panel is of special interest as well. In keeping with the Renaissance fascination over perspective, original audiences for this panel (and unlike the other panels) were given a so-called worm's-eye view in which the various standing and kneeling figures are

portrayed as if seen from the ground up. In effect, we the audience are provided with the same viewpoint as the kneeling suppliant. Notably, Mantegna's study sketch for the panel, today in the possession of the British Museum (at which Kendrick was once the director), does not have this innovation. The sketch, however, is still remarkable in its own way. The amazed soldier-executioner (identified by his large sword) is still in the center of the image, while James is off to the left and the observing crowd off to the right. The serenity of the saint stands in marked contrast to the somewhat unruly mob on the opposite side of the frame. In the sketch, Josias appears to be standing to the right of James, but in the final painting was wisely moved to the left for purposes of emphasis and clarity; nor does the sketch contain any of Mantegna's trademark background architecture, always seeming to highlight or signify the temporal nature of worldly power. Because the sketch employs normal perspective, the viewer is on the same level as the soldiers and mob, rather than the paralytic, giving the preparatory work a slightly different tone and feel. To repeat, with only one of six panels utilizing this innovation, it stood out all the more from the other five as a result.

Like the inspirations for his signature backdrops of ancient architecture, much of Mantegna's work has survived, yet one is reminded that all art, including great art, is ultimately ephemeral, and that most has perished before coming to widespread attention, or worse, been frequently forgotten forever. In the meantime, however, we may contemplate and enjoy that which we still have before us, even in the secondhand form of old photographic images. Mantegna lived and worked during a time of tremendous excitement and discovery, but also one that began with great anxiety and fear, later becoming triumphant and confident, at least until Martin Luther publicly posted his 95 theses in Wittenberg on October 17, 1517. The careers of outstanding artists were frequently characterized by mobility and relocation, depending on where opportunities could be found. A similar mood could be found towards the latter half of the 20th century. Half a century after the conclusion of World War II, a globalized economy seemed to place main emphasis on the amassing of wealth, at least for those willing and able to exploit new technologies and possessing easy access to cross-border, low-wage workers. Everyone else—meaning most everyone else—was left to fend for themselves as best they could, both artist and non-artist alike. The Pax Americana of the postwar era had enabled commerce and capital to move much more freely from country to country than it had in the past. What the historical James, the simple but fiery fisherman son of Zebedee, would have thought of all this is hard to say. What is clear, however, is that his saintly image and cult have survived the millennia intact, including images quite separate and apart from his heavenly warrior persona captivating imaginations in medieval Iberia during distant bygone days of the Reconquista.

20

Labor Without Borders
(1990–2014)

*Beyond the fountain is the forecourt, divinely inspired, with
a pavement of stone where they sell the shells to pilgrims that
are the sign of St. James, and the wineskins, deerskin satchels,
purses, laces, belts, and all kinds of medicinal herbs and other
spices, and much more. The French street has money changers,
hotel keepers, and other merchants. The forecourt is a stone's
throw long and wide.—Codex Calixtinus[1]*

Frequently the main purpose of a dictatorship, or an oligarchy, or a
junta, is to facilitate commerce for the benefit of the few, generally at the
expense of the many, but oftentimes with full cooperation from the exploited
nonetheless. An important corollary to this general principle is the coordi-
nation or control of labor forces, either with or without the support of trade
unions. From the standpoint of capital, labor must be made readily available,
disposable whenever necessary, and above all, as inexpensive as possible. The
unprecedented globalized economy of the late 20th and early 21st centuries,
a vision pioneered by Spain and its European competitors during earlier times
but later taken to new heights of sophistication (or oppression, some would
say) by the United States and Great Britain, put a strong emphasis upon the
freedom of commercial activity to cross international boundaries with little
or no restraint. Selective military force of course played an important role in
this system as well, but by the 1990s naked aggression for its own sake had
fallen out of political favor; moreover, it had become apparent by then that
there were far more efficient and less expensive ways to enforce a New World
Order in the economic sense. One of the most popular, at least among cor-
porate decision-makers, would be to offer jobs and higher living standards
to those needing these the most, typically people living in countries other
than ones in which paying consumers of products and services resided. The

184

new system has proven an effective way to make fast money for those able to best take advantage. It is also a system showing itself adaptable to almost any kind of enterprise, including the ancient business of servicing and maintaining religious shrine pilgrimage or tourism.

The 500th anniversary in 1992 of Christopher Columbus' maiden voyage to the New World received far more mixed reactions and public commentary than foreseen by its boosters. Even those socioeconomic groups benefiting most from The Encounter seemed embarrassed to be reminded about it. Proposed world fairs and expositions of the type so successful in Chicago a century previous were disdainfully declined or expired in the planning stages. Would-be blockbuster films on the same subject matter tanked or were met with a mixture of indifference and hostility.[2] In fairness to the memory of Columbus, the half-millennial anniversary of his achievement deserved far better than what the public relations industry was able to achieve for it.[3] The religious fanatic from Genoa who originally sailed under the Spanish banner of Saint James the Greater did in fact accomplish his long-term goal, which was to convert the majority of the New World's indigenous population to Christianity, or at least the majority of those who were able to survive. Refugee overflow from the other then-known continents also found temporary safehaven. Competing claims from other parts of Europe or Asia that had in fact reached the New World before 1492 should be reminded that these prior events, real though they were, did little good to anyone else at the time. In truth, it took the Iberian spirit of conquest in the name of religion (i.e. Santiago Mayor) to make it a thing of true significance. As for the subsequent, dazzling rise of the United States as the last great superpower, only time will tell whether this was ultimately a good or bad thing for humankind. So far so good, at least. In the meantime, let us praise Christopher Columbus for all his extraordinary, one-of-a-kind accomplishments, as opposed to merely criticizing him for his obvious shortcomings.

That same year (1992), seemingly in response to unanticipated controversy over The Encounter, Rigoberta Menchú of Guatemala became the first Native American (Mayan) to be awarded the Nobel Peace Prize. Six years later (in 1998), more impressively in some respects, Menchú was the recipient of the Princess of Asturias Award, a prize bestowed from the very cradle of the Spanish Reconquista, in acknowledgment of her efforts on behalf of indigenous American human rights. Some of the worst atrocities during Guatemala's intermittent civil conflicts that Menchú helped bring to international attention were the 1990 massacres occurring in Santiago Atitlán, a city whose Spanish history extended back to the early 16th century (see Chapter 12). Atitlán's notoriety had in fact been achieved nine years earlier in 1981 when the U.S.–born Roman Catholic priest stationed there, Father Stanley Francis Rother (1935–1981), was gunned down by paramilitary operatives.

This was only a year after Archbishop Óscar Romero had been murdered under similar circumstances in nearby El Salvador (see Chapter 19).[4] The widespread suffering, civil strife, and killing of innocent life throughout Central and Latin America in fact seemed to only escalate as more developed countries of the Northern Hemisphere prospered during the late 20th century. By the early 1990s, it became harder to resist the notion that profitable growth for some automatically translated into misery and desperation for others. One theory, or promotion rather, was that absolute freedom of international trade would allow the supposed miracle of capitalism to spread to these less fortunate societies and thereby reduce the number of outrages then playing out in a seemingly continuous pattern. One direct result of this thinking was the 1994 North American Free Trade Agreement (NAFTA) signed by the United States, Mexico, and Canada, thereby loosening trade (and labor) restrictions between these contiguous nations. An immediate by-product of NAFTA was the dramatic rise of Mexican *maquiladora* districts south of the Rio Grande River, such as the city of Matamoros (see Chapter 16). By the late 20th century, it seemed as if the old conquering ghost of Santiago Mayor had somehow resurrected, this time into a dominating commercial entity, spreading across the international landscape and largely fueled by unrestricted mobility of capital, combined with a limitless supply of cheap labor oblivious to the inconvenience of strong trade unions.

A happier, though somewhat isolated consequence of this same era resulting from labor without borders and cross-border commercial activity pertained to the performing arts. Interestingly, this prominent example had little or nothing to do with NAFTA, but rather with a slight thawing of cultural interchange between the United States and Cuba. In 1996, the American recording artist and impresario Ry Cooder found himself sent to Havana for a musical project that never materialized, but then decided to manufacture one on his own while staying there. The spectacular result was *Buena Vista Social Club*, named after the legendary but long-defunct local venue, a throwback Cuban all-star recording that, with little marketing effort, became a global best-selling album in 1997, then later in 1998, an acclaimed documentary film directed by Wim Wenders.[5] Twenty years later, the venerable consortium continues to perform, although many of its original members, advanced in age at the time, have since passed away. While pre-revolutionary pop music in Cuba is a study unto itself, one of its key building blocks (as acknowledged by Cooder and others), was the *son de Cuba* (Cuban songs) originating on the east side of the island during the early 20th century, representing a classic fusion style of African and Spanish musical forms. One of its first and greatest recording exponents between 1925 and 1961 had been the Trío Matamoros, led by Miguel Matamoros (1894–1971) of Santiago de Cuba. After the 1959 revolution, however, tourist-based clubs like the Buena

Vista and others mostly closed while their working musicians, for the most part, had to find other livelihoods, that is until Cooder's offbeat project reunited many of the best surviving exponents during the late 1990s for a final flurry of creative activity.

The unpleasant dawning of the 21st century unleashed multiple disruptive phenomena against North and South American societies, but in truth these tensions and dissatisfactions had been building for a long time—for centuries, one might easily argue. The immediate impact of the cell-based terrorist attacks against the United States on September 11, 2001, was to shift the considerable energies of U.S. foreign policy away from Latin America (upon which it had been focused for more than half a century), with far more emphasis now given towards the Middle East. As Americans tried to wrap their heads around why Islamic extremism had lashed out against the U.S. without warning so violently and suddenly, one of the more bizarre yet revealing pronouncements came from the mouth of none other than Osama bin Laden. In an opening statement made to the media only a few days after the attacks, Bin Laden vehemently maintained that the "tragedy of Andalusia" would not be repeated in Palestine.[6] In the New World (which had just been attacked), the proclamation was met mostly with incomprehension. Essentially, Bin Laden was saying that Islam would never be forced out of Palestine the way it had out of Spain back in 1492 (see Chapter 10). Thus, old resentments over the Iberian Reconquista seemed once again to force their way into the forefront of public attention, 509 years after the fact. Notwithstanding the insanity of the rationale, its earnestness seemed to be affirmed when other terrorist attacks later played out against European countries such as Spain, France, and England—nations that had actively participated in the Reconquista and Crusades more than half a millennium before. Another, perhaps even more destructive consequence of 9-11, was that the lion's share of U.S. military and diplomatic resources were quickly transferred from nearby Latin America to far distant locales such as Iraq, Afghanistan, and the Persian Gulf, where the logistical expense (born as usual by the American taxpayer) increased exponentially and continues to do so as this is being written.

The United States, for its part, reacted to the homicidal extremism of 9-11 mostly with hysteria and more false assumptions about the world around it. Instead of focusing on breeding grounds for terrorist cells, it lashed out against old adversaries to settle scores, such as its former ally, the military dictatorship of Iraq, which had gone rogue in 1990 by attacking its defenseless neighbor Kuwait. Most of Latin America condemned the second U.S. invasion of Iraq in 2003 or remained neutral, with the notable exceptions of Colombia, Honduras, Nicaragua, El Salvador, and the Dominican Republic, all of which lent some support while receiving little or no credit in the process.[7] Within its own hemisphere, the U.S. exhibited more bizarre behavior by establishing

a terrorist detention camp on the doorstep of southeastern Cuba at Guantanamo Bay in 2002.[8] This in turn led to widespread irrational associations of terrorist activity with the Marxist Castro regime, only slightly less removed from reality than the widely peddled notion that Iraq had been stockpiling WMDs prior to the latest round of hostilities. In truth, Guantanamo had been set up mainly to annoy Castro and reassure the American voting public that the terrorist problem was far removed from the homeland—yet another false assumption. No one talked much about the deeper psychology motivating the suicide attackers or their perceived grievances, most of these going back for centuries, and specifically aimed at almost everything represented by western civilization.

Meanwhile, finally left to its own devices after decades of foreign interference, Latin America displayed a surprising willingness to engage in commercial activity with the Far East—just as Christopher Columbus had striven to accomplish five centuries previously. For example, during the first decade of the 21st century, international trade between the Spanish-speaking New World and the Peoples Republic of China (PRC) burgeoned, with the latter quickly becoming Latin America's second largest trading partner after the U.S. In 2005, Chile became the first Latin American country to sign a free trade agreement with the PRC, being ideally positioned for that role in terms of geography, capacity, and temperament. Thus, the capital cities of Beijing and Santiago became closely linked both through treaty and commerce. This was not exactly what Imperial Spain had anticipated back in 1492, but nonetheless represented a fulfillment of that old ambition. Three years later (in 2008), as the U.S. economy plunged into the Great Recession, the Union of South American Nations (UNASUR) was founded with headquarters in Ecuador and its own parliament in Bolivia, motivated in no small part by the limitless possibilities of foreign trade beyond that with the United States.[9] Perversely, by that point in time illegal narcotics trafficking between the U.S. and south-of-the-border countries had skyrocketed, further fueling mutual suspicion and hostility.[10] Simultaneously, a seemingly insatiable appetite had developed in the U.S. for all agricultural labor and produce originating from Latin America, whether these be legal or illegal in official status.

The plain fact of the matter was that by the dawn of the new century the U.S. economy, especially its agricultural economy, had become more dependent upon south-of-the-border labor supplies than ever before. Illegal labor was particularly desirable in that it was the cheapest, union-free, and completely devoid of government regulation. Nor was it stealing jobs from anyone else who wanted to do similar work (there being but few), although domestic political resentment was intensely felt nonetheless towards migrant workers, generating various myths about their use of taxpayer-funded public services, educational facilities, and even voter fraud. As the traditional patron

saint of menial laborers, Santiago Mayor appeared to be invading the United States not as a warrior, but rather as a migrant worker. In the meantime, relationships between Spanish-speaking Americans and their Anglo counterparts continued to subtly change by increments. In 2008, Raúl Castro succeeded his demonized but still living brother Fidel as President of Cuba, after the latter had held power for nearly half a century. The ultimate result of this peaceful, orderly change was that long-strained U.S.–Cuban relations continued to improve gradually. On the mainland domestic front, Bronx-born and Puerto Rican–descended Sonia Sotomayor was appointed by President Obama in 2009 as the first Hispanic and Latina Justice of the U.S. Supreme Court. By the end of the first decade of the 21st century, it had become abundantly clear to any objective observer that Spanish-speaking and bilingual culture had become an integral, essential part of American society whether one liked it or not. For American citizens to deny the all-pervasive Hispanic influence on their contemporary society had become as ridiculous as Spaniards trying to deny pervasive Moorish influence on their own—something the Spaniards themselves had long ago given up on trying to do.

One thing the Spanish had not given up on was the Camino de Santiago; indeed, the Way of Saint James appeared to be more popular than ever as a pilgrimage or tourism route, both for Christians and non–Christians alike. The burgeoning postwar revival phase of the religious tourism industry in Spain had in many respects begun in 1957 with the publication of Walter Starkie's excellent travelogue, *The Road to Santiago: Pilgrims of St. James.* Over the next half century, infrastructure was improved, information made readily accessible, and promotional materials continued to pour forth from various multimedia sources. Arguably the highest profile of these came in 2009, when on-site shooting began for *The Way*, an independent film designed as a star vehicle for celebrity actor Martin Sheen by his son, the director-producer-writer Emilio Estevez. The movie was released in 2010 and was a modest critical and commercial success, although many of Sheen's biggest fans have still never heard of it, mainly because of its offbeat, faith-based emphasis. In the immediate wake of this increased visibility, news broke in 2011 that the oldest surviving illuminated manuscript of the *Codex Calixtinus* (see Chapter 6) had been stolen from its keepers at the Cathedral of Santiago de Compostela.[11] By 2012, the valuable artifact had been recovered (and its convicted hijackers later imprisoned), but this disconcerting episode, taken in tandem with the recent motion picture by Sheen and Estevez, seemed to announce to otherwise disinterested observers that the Caminos were big business more than ever before. The same commercial forces that had thrived along these routes during the Middle Ages, including all the attached employments and labor support (see header quote), continued to stretch across the

entire Iberian Peninsula into adjacent countries such as France and Portugal, and well beyond, even to other continents and hemispheres.

The (conjectured) 1200th anniversary year for discovery of the shrine at Santiago de Compostela in 2013 (see Chapter 4) was also marked by the election of Cardinal Jorge Mario Bergoglio of Buenos Aires as Pope Francis I, the first Latin American to become head of the Roman Catholic Church. Although Pope Francis to date has shown little sign of being a devotee to the Santiago shrine, he did opt to name himself after the ever-popular Saint Francis who in fact visited Santiago de Compostela as a pilgrim during the early 13th century. In 2010, Pope Francis' predecessor, Pope Benedict XVI, had made an official visit to the Santiago shrine, which was met largely with a combination of apathy or resentment by a Spanish society now increasingly suspicious of the church establishment, especially after the horrors of civil war during the late 1930s (see Chapter 18).[12] As for Pope Francis, by contrast he within two years would visit Santiago de Cuba, the old launching pad for aggression in the New World, if one is to judge by the likes of Hernán Cortés, Theodore Roosevelt, or Fidel Castro.[13] Like many of other Pope Francis' shrewd public relations activities, his Cuban visit and homily was both surprising to hard-liners yet well-received by the majority of both Christians and non–Christians alike.[14] The contrast in approaches towards the place name and memory of Saint James the Greater between the two successive pontiffs was notable. Whereas Benedict had preached and warned against the dangers of secularism from the ancient rallying point of the Reconquista, Francis urged mercy and mutual forgiveness from the revolutionary flashpoint of Latin America. Then again, as a native Latin American himself, albeit one of Italian-Argentine descent, Francis understood all too well where he was and to whom he was addressing his remarks.

During past and present times, the papacy has been headquartered at Vatican City in Rome, situated within the ancient capital but politically independent from the Italian state, strictly speaking. Aside from being itself one of the world's leading tourist attractions and pilgrimage destinations, the Vatican has, since the 16th century, become symbolic of the Counter-Reformation itself, both in religious ideology and architectural style. Prominent among these physical symbols at the Vatican is the Archbasilica of St. John Lateran, the official seat of the Roman pontiff, and a church whose historical origins go back to the late imperial era. Within this iconic Baroque-Neoclassical structure are 12 striking statues of the apostles, including *Saint James the Greater*, the latter presented as a staff-holding pilgrim, but otherwise easily mistaken as a pagan deity of the type once worshipped long ago on this very same site. The artist was the noted Italian sculptor Camillo Rusconi (1658–1728), who executed four of the 12 apostolic figures at St. John's, including the church's namesake son of Zebedee (brother of Saint James), the

evangelist Saint Matthew, and Saint Andrew (brother of Saint Peter).[15] The statue of Saint James was reportedly the last of four completed by Rusconi himself, circa 1715–1718, based on an earlier sketch by the distinguished Italian artist Carlo Maratta (1625–1713). In this portrayal, the visage of the saint is directed upwards towards the heavens, but also looking sideways, as if for guidance or direction on a perilous journey—a fitting inspiration for any past or present-day Bishop of Rome.

Years later, the Rusconi *St. James* may well have been viewed by a young Austrian artist visiting Rome, Martin Johann Schmidt (1718–1801). Schmidt would go on to produce his own distinctive interpretation on a similar theme, the elaborate etching titled *St. James the Greater Preaching*, circa 1764, produced when the painter was in his mid–40s and today in possession of the Metropolitan Museum of Art in New York City, along with other valuable works by the same artist. Schmidt may have also come into contact with the famous (but later destroyed during World War II) cycle on the life of Saint James the Greater painted in Padua by Andrea Mantegna (see Chapter 19), which included another memorable depiction of the apostle as an evangelist.[16] The episode is significant in that it presumably led directly to James' martyrdom in Jerusalem (as recounted in *Acts of the Apostles*) and there is no reason to doubt its historicity. In any event, nearly all of Schmidt's surviving work displays familiarity with and affinity for that of Rembrandt's, another outstanding artist attracted to religious themes in general, as well as to those relating to Saint James the Greater (see Chapter 14). As such, Schmidt's *St. James* is unique in that it combines technical elements both from Catholic Rome and Protestant Amsterdam, cohesively integrated into his own individual style.

Schmidt's *St. James the Greater Preaching* places a statuesque apostle with outstretched arms haranguing a large surrounding crowd from atop an outdoor rock, likely symbolizing the gospel message. James' former pilgrim status is denoted only by what appears to be a water gourd hanging from his belt. The crowd reaction in Schmidt's portrayal is more diverse and varied than in Mantegna, where the response is exclusively that of fear and alarm. At the apostle's feet in Schmidt are the half-naked destitute of society, including an impoverished mother and child. James' admonitions appear to be primarily aimed at a wealthy listener on horseback, richly attired with a sun umbrella. A pet dog with the privileged bystander seems to be better cared for than the nearby human destitute, although at least the dog (unlike its master) glances in pity towards the poor. In the heavens above the scene, angels and cherubim give alms to another poor person seated upon a ledge. Others in the audience are curious, admiring, or suspicious. The entire episode likely alludes to the New Testament *Letter of James*, in which the author gives a passionate sermon in favor of good works over mere faith or

belief. The artistic interpretation is based on the common misunderstanding that the *Letter of James* was written by the elder son of Zebedee, a notion today typically rejected by Christian scholars.[17] Nevertheless, Schmidt's dynamic portrayal is well in keeping with the Greater James' reputation for intensity and lack of compromise, hence the nicknames given to him and his brother by Jesus as "Sons of Thunder" (see Chapter 1).

As the year 2014 closed, the winds of endless political change seemed to be yet again gathering strength across the Old and New Worlds. With borderless forces of labor and unrestricted mobility of capital came massive collateral damage, especially to the struggling or former middle classes of Great Britain and the United States.[18] Unprecedented, vast fortunes had been accumulated by those able to fully exploit the new global order—not unlike the Spaniards of the 16th century—while everyone else was left to struggle through as best they could. The old cult of Saint James the Greater, whether presenting itself as irresistible conqueror, Camino pilgrim, preacher of the gospel, or otherwise, more than anything appeared, on the surface at least, to be mostly forgotten, even among those enthusiastically professing the Christian faith. Whether this was mainly the result of irreligious commercial trends, decline in conventional religious faith, failing public education, or all the above, we are not prepared to say. Notwithstanding all this, however, the cult remained entrenched within the collective memory, and in some more subtle respects, stronger than ever before. Iberian Camino traffic flourished, including well beyond Iberia itself. Prominent place names still bore the Santiago-Saint James moniker, and claimed the patronage of the apostle, from Jerusalem to Montreal, from Chile to the Philippines, and from Paris to Salt Lake City. In short, Saint James the Greater was far from disappearing anytime soon, even after everything that had transpired over the last 2,000 years.

21

2016 Presidential Election and Aftermath (2014–Present)

> *Those who cannot remember the past are condemned to repeat it.*—George Santayana[1]

In early 2015, few would have guessed that the political and socioeconomic paradigms of the very recent past were on the verge of widespread popular rejection. In the New World, trade relations between the U.S. and Cuba continued to gradually normalize, even as ideological hardliners on both sides openly complained of this trend towards liberalization. Goods and services, whether these be legally sanctioned or not, exchanged between the U.S., Mexico, and Canada with seemingly unrestricted ease, just as the 1994 NAFTA treaty had intended. All in all, everything seemed to be going according to an established economic plan from a limited point of view, a view endorsed mainly by those few most benefiting from maintenance of the status quo.[2] A similar type of outward stability was being enjoyed by a German-led European Union.[3] This was all a far cry from a thousand years earlier in Christian Europe, when a fledgling Spanish state was still reeling from devastating Islamic counteroffensives led by Almanzor during the late 10th century (see Chapter 5). Medieval commercial trade could only function along short established links not disrupted by war—for example, along the Camino routes between France and Galicia. Both the European Union and North American combines of the early 21st century, however, could have taken lessons from the Iberian Reconquista, in which peace and progress were things generally achieved (at best) only in slow, gradual increments, with routine setbacks and disasters punctuated in between.

Meanwhile, in Jerusalem and the Holy Land, the Armenian Orthodox Church and Cathedral of Saint James struggled to maintain their identities

and continued existence. Since the Six-Day Arab-Israeli War of 1967, the ancient Armenian Quarter of the city had been under the legal jurisdiction of the Israeli state. As such, Jerusalem Armenians were, on paper at least, fully protected by the law; the reality, however, was that they were far more often (than not) equated with their traditional neighbors and allies, the Palestinians, the latter of whom began a long ongoing struggle to either recover their lost homeland or to build a new one from scratch.[4] The sustained impact of far-from-resolved Israeli-Palestinian disputes on the Armenian Quarter of Jerusalem has been to isolate and depopulate it. Major outmigration of Jerusalem Armenians to the Soviet Union during the post–World War II era had made the Quarter highly vulnerable to external pressures, and the Palestinian conflict with their Israeli overlords has only escalated its decline. Today the tiny enclave is sustained by a devoted handful of clerics and residents, perhaps a thousand or more, and is in danger of vanishing altogether sometime within the current generation.[5] This melancholy prospect would be especially tragic given that the Christian Armenian community in Jerusalem has existed continuously for at least 1,700 years. As for the great Jerusalem shrine of Saint James the Greater and venerated relics housed within it, whatever one might think of their authenticity or competing claims with those of Santiago de Compostela, no one will dispute that Jerusalem was in fact the place in which the saint was martyred, or that he was first of the original 12 apostles in that city to give his life for the faith (see Chapter 1).

In contrast to the visible chaos and desperation widespread throughout the Middle East in wake of the second Iraq War, Latin America appeared to be reaching new heights of world prominence by 2016. Notwithstanding escalation of civil conflict in countries such as Venezuela, South American nations particularly seemed to be moving front and center to the international stage, especially now that one of its native sons, Pope Francis I of Argentina, was head of the Roman Catholic Church. In August, the XXXI Summer Olympic Games were successfully held in Rio de Janeiro, despite many pundits incorrectly predicting that Brazil's fragile infrastructure and political instability could not support such a major event. Then in October, President Juan Manual Santos of Colombia was awarded the Nobel Peace Prize for his impressively determined efforts to calm civil strife in a country that had known little else over the last half century. If Colombia could restore a degree of domestic order, it seemed, then almost anyone could do the same with good leadership and proper international support. One of the civic symbols of Colombia's newfound, comparative stability was the prospering municipality of Santiago de Cali on the Pacific Coast, a city that traced its Spanish conquistador origins back to the year 1536. By the year 2016, however, it was better known simply as Cali, without any reference to Santiago Mayor, as if to intentionally shed any violent legacy attaching to the saint's memory, espe-

cially with respect to the New World (see Chapter 11). Perhaps it would be more accurate to say that the traditional conquering spirit of Saint James the Greater still very much existed, but by now had become submerged into a brand-new identity, one mainly concerned with domination through international trade and commerce, particularly with Asia and China (see Chapter 20).[6]

The celebratory parade held in Madrid on Columbus Day (the national holiday of Spain), on October 12, 2016, was instructive to witness (as did this writer), in that it illustrated a complex overlay of ideas that are still being publicly debated with regards to the various Santiago traditions. Saint James the Greater, patron saint of Spain, was hardly anywhere to be seen, although echoes of his legacy were plentiful, at least for those having any awareness of Spanish history—which in fact most Spaniards possess in abundance. The vaunted Spanish Legion on parade was clearly the crowd favorite, and with good reason given its legendary prowess in the field. No mention was made that this same outfit had been General Franco's personal regiment during the horrific civil war of the late 1930s, or that Franco claimed Santiago as a supernatural agent coming to the assistance of Nationalists at the Battle of Merída in 1936 (see Chapter 18). Nor was there any mention of Santiago *Mataindios*, which Cortés and others had credited with aiding conquistador victories in the New World, even though the crowd was filled with visitors from the New World, both Spanish-speaking and otherwise. Many in the crowds were also recent Camino pilgrims to Santiago de Compostela; however, few if any displayed badges or other designations of their pilgrim status. The Madrid festivities of October 12 seemed to in fact transcend religious beliefs, although traditional religious beliefs were certainly an integral, even necessary part of those celebrations.

As for the legacy of Christopher Columbus, the fanatical navigator who sailed under the banner of the Spanish Santiago in 1492, this single aspect provided more than enough controversy for the public and press to handle. Officially, the holiday has been renamed *Fiesta Nacional* in Spain and rebranded in many other countries and states in which it is observed, oftentimes to recall the innocent multitudes of indigenous peoples perishing from the great Encounter between Europeans and Native Americans. Going a step further, the city of Barcelona, traditionally a more liberal city at political odds with Madrid, took trouble to cancel the holiday altogether for the genocide it supposedly glorified.[7] Mainly, however, the people of Spain, along with its many tourist visitors, took time to simply enjoy the festivities and pay tribute to Spain's generally underrated place in world history, as well as its continuing relevance as the birthplace of all Spanish-speaking culture. In a very real sense, Spain has become a moral beacon of sorts for our own modern times, given its broad cultural experience and long collective memory.[8] Simultaneously

on October 12, Spain and Latin America enthusiastically celebrated, with little or no reservations, the Feast of Our Lady of the Pillar, marking the first Marian vision of Saint James the Greater at Zaragoza (see Chapter 2), an event which, quite unlike Columbus' first voyage, is highly open to factual debate.

Back in the States, the 2016 U.S. Presidential election on November 8 will likely be written about by historians so long as history is recorded. There is little need to reiterate the well-known details herein except insofar as these may pertain to our immediate subject matter. The conventional wisdom before the event held that one major candidate would court and win the Spanish-speaking vote while the other would disparage and lose it.[9] This proved to be mostly the case, although hindsight revealed a shocking number of exceptions; moreover, the end-result underscored a widespread anxiety— whether it be justified or not—among a growing percentage of non–Hispanic voters over the recent rise in Spanish-speaking prominence within a society once the exclusive province of the former.[10] Above all, however, the results reflected that these seemingly irresistible trends were largely indifferent or oblivious to American electoral politics. Political candidates may come and go, but facts on the ground such as international trade, technological advances, and multicultural interchange are not so easily disposed of.[11] Furthermore, physical symbols of Saint James the Greater persist, and occasionally, the memory of their meaning persists as well. Cities and shrines and churches are still named after the saint, and continue to thrive. Artwork celebrating the proto-apostolic martyr is prominently displayed, both publicly and privately, and new art continues to be created as this is being written. Perhaps the truly relevant question is whether these symbols will continue to have the same popular associations as in the past or instead subtly change and shift as time passes. Taking a longer view of history suggests that the latter scenario is more likely, although only time itself will tell which of these specific changes and shifts might take hold.

As for the 2016 U.S. election, whatever the long-term impact may prove to be, certain short-term trends are already widely apparent. One of these, perhaps the most prominent across the entire spectrum of political belief, is a popular reinvention of the past, or worse, total loss of collective memory. To give one small example (as previously mentioned), hardly anyone seems to know who exactly Saint James the Greater was, even among those fervently professing Christian religious beliefs. Not surprisingly, a close corollary to this collective loss of memory is a frequent popular or populist disagreement over basic scientific or present-day facts.[12] If average citizens cannot agree upon present realities, then it naturally follows that they will disagree on past realities as well, or more likely, not even be cognizant of those past realities in the first place. More applicable than ever is the famous aphorism (see

header quote) by George Santayana (1863–1952), whose long life spanned the American Civil War, the Spanish-American War, two World Wars, and the Cold War. Born in Spain, educated in the U.S., and buried in Rome, Santayana's best-known work, *The Life of Reason*, was written while the Spanish-American philosopher was teaching at Harvard University circa 1905–1906, as western civilization was on the brink of a catastrophic Great War, supposedly to end all wars. Personally, Santayana appears to have had little use for religious symbolism or iconography, but was also a rare example of someone possessing a profound appreciation for the effects that these things can have on the human condition and world events, both for better and for worse.[13] It would today seem that academic study of his relatively neglected work might be poised for a revival.

Though far from being neglectful, the many numerous, contemporary fans of Salvador Dalí (1904–1989) also typically have no idea that Saint James the Greater was one of the favorite subject matters for the Catalan-born artist, particularly during his late period. This interest should come as no surprise given the flamboyant Dalí's pronounced Spanish heritage, yet serves as perhaps another (albeit small) example of public memory loss both collective and selective, even among the cultural elite. The only outward indication of this interest at the highly-visible Dalí Museum in St. Petersburg, Florida, is the sprawling 1959 canvas, *The Discovery of America by Christopher Columbus*, in which the sails of Spanish ships making landfall at San Salvador (see Chapter 11) are prominently decorated with red crosses symbolizing the Order of Saint James. The painter's wife and muse Gala is depicted as the Virgin Mary, and given appropriate precedence in the canvas as namesake of Columbus' first flagship *Santa María*. Sacred crucifixes and warlike banners fill the surrounding skies, as if the two notions were inseparably linked, as indeed they often were during the Age of Discovery. Dalí's masterpiece of surrealism had in fact come right on the heels of another one of his important works, similar in some respects, and in many ways a companion piece, though apparently far less well known to the public, not being currently on display in a U.S. museum. Taken together, however, the two paintings shed a good deal of light on Dalí's view of Spanish-speaking culture's prominent role in development of the New World, as well as his view of the overall legacy in art of Santiago Mayor.

Santiago El Grande ("Saint James the Great") from 1957 is today on display in the Beaverbrook Art Gallery, located in the somewhat remote location of Fredericton, New Brunswick, Canada. The 13-foot canvas, in addition to being a major work from Dalí's later period, is also probably the most striking artistic representation of the saint created during the entire 20th century.[14] After being displayed at the 1958 World's Fair in Brussels, Dalí sold the painting to a buyer of his personal choice, rather than the highest bidder, surely

a sign of esteem for his own creation. There is no good critical reason to debate that assessment. After World War II, Dalí opted to move back to his native Catalonia, in the process accepting (embracing, some would say) the ongoing dictatorship of Francisco Franco, and thus incurring heavy political criticism from fellow artists and countrymen who continued to live in exile until after Franco's death in 1975. In keeping with the conservative or reactionary temperament of Spanish government during the 1950s, Dalí drew upon tried and true subject matter—Saint James the Greater—but with a twist, or rather with multiple twists. Stylistically, the artist built upon his reputation as a founding father of Surrealism, but with multiple layers of religious and scientific imagery added, seemingly conflicting ideas in which Dalí had become increasingly interested later in life, but which he viewed as not necessarily being in true conflict. This attitude was not unlike that of his well-known Spanish-born contemporary, the previously mentioned George Santayana. To all of this, the painter added themes touching upon the ongoing Cold War and emerging environmental anxieties which continue to resonate during our own contemporary times.

The Santiago Mayor or El Grande of Salvador Dalí resembles traditional portrayals of the saint in that he is astride an imposing white steed rearing on its hind legs and boldly displaying the emblematic scallop shell of the saint on its harness.[15] After that, however, all conventional similarities vanish, as one would expect with the typically unconventional style of this artist. Though on horseback in a decidedly warlike posture, Dalí's Santiago the Great otherwise displays no sign of his Matamoros or Moor-slayer aspect. Instead, at the feet of the supernatural steed is an atomic mushroom cloud rising from a presumably Catalan seacoast, topped by an eccentric personal touch—a jasmine flower symbolizing purity.[16] Santiago himself is seen holding not a lance or a sword, but rather an oversized crucifix, which he seems to propel towards the heavens even as he and his mount are being propelled upwards by the mushroom cloud below.[17] The saint's oversized, dirty bare left foot projects outwards toward the viewer, hinting at the beloved pilgrim status of the icon as well. Dalí depicts himself as a sleeping boy along the seashore, perhaps representing his own dreamlike vision of the image, one of the painter's trademarks. Dalí's wife Gala stands on the beach off to side dressed as a monk, symbolizing who knows what. Enveloping the entire sky is a greenhouse-like canopy, possibly suggesting earthly versus heavenly existence, but more likely the irreparable damage caused to the environment by such an ongoing cataclysm. The overall effect, almost needless to say, is one of Doomsday or, at the very least, a culmination of history. While departing from many of the longstanding stereotypes associated with Santiago Mayor, Dalí's apocalyptic slant on the same theme is in fact very much in keeping with the original visions of judgment and catastrophe recorded by Beatus of

Liébana long before during the eighth century, visions which played a crucial role in the original formation of the Santiago legend (see Chapter 3). Dalí takes us back to the roots of the tradition, but set in a more contemporary mode. The work was created during a postwar era witnessing an unrestrained arms race and testing for weapons of mass destruction, as well as a time in which environmental concerns for the planet were first being raised by those fully cognizant of its possible disastrous consequences.

Even after this tremendous masterpiece, however, the artist was not quite through with the Santiago legend. Beginning in the early 1950s, Dalí had gradually produced an impressive series of 100 engraved color woodblock prints to illustrate a new edition of the never-out-of-print epic poem *Commedia* or *Divine Comedy* by the medieval Florentine poet Dante Alighieri (1265–1321). As the series of prints concluded around 1960, one of the last and most famous images committed to watercolor by the painter was *The Apparition of St. James*, also known as *St. James of Hope*. The illustration depicts the dramatic episode from Canto XXV (the final *Paradiso* section) in which the poet, guided by his heavenly muse Beatrice, encounters the three disciples closest to Jesus according to biblical tradition, SS. Peter, John, and James.[18] Dalí's interpretation is inscrutable, much like the lines in Dante's poem from which the scene is taken. The poet and his muse are clearly discernable, but Saint James the Greater seems to float across scene with barely distinguishable features, like an apparition, barely separable from the other beautiful flora and fauna surrounding him. No facial features are recognizable, only signs of motion and gesture. In the poem, Dante literally hopes to return to his native Florence (from where he had been long-exiled) before he dies to receive the poet's laurel wreath in the same place of his baptism.[19] He correctly answers the questions posed by the saint on the nature of hope itself, but is left hanging without any definitive response on whether his wish will be fulfilled. Indeed, it proved not to be; Dante died still living in exile shortly after completing the *Commedia*. Dalí's watercolor effectively conveys the eternal longing and never-to-be-satisfied desires expressed by the Italian poet in exile. While containing certain echoes of the first century Marian vision by Santiago Mayor at Zaragoza, the episode portrayed by Dalí from *Paradiso* comes entirely from the early 14th century imaginative invention (and genius) of Dante himself.

Salvador Dalí's visual meditations on the symbols and meanings attached to Saint James the Greater date from 57–60 years before the present day, yet seem more up-to-date than ever before. On one hand, the ferocious and aggressive Moor-slayer persona continues to be with us, despite all its political incorrectness and logical implications of world destruction. What began with Christopher Columbus discovering and initiating conquest of the New World might well end in nuclear holocaust and environmental degradation. Yet even

Dalí's overpowering presentation of the apostle-martyr patron saint of Spain also suggests more peaceful and constructive associations—those of religious pilgrimage, earthly beauty, and heavenly majesty. This more positive read finds fuller expression in the same artist's illustration for Dante's *Commedia*. Here, Santiago Mayor becomes the patron saint of all those seeking spiritual hope, albeit with no definitive answers or firm predictions for the future. Dante was himself a traveling pilgrim of sorts, one living permanently in exile who desired nothing more than to return home and receive some recognition for the tremendous literary work he bequeathed to all future generations—a rather modest ambition perhaps, but one that still sought out words of comfort from the patron saint of all traveling pilgrims (via his heavenly mediator, Beatrice). The sentiment seems appropriate given that, according to longstanding Christian tradition, the proto-apostle-martyr was the greatest pilgrim of all in terms of his distant round-trip journeys between first century Iberia and Jerusalem. This conceit, whether it be real or fabricated, succeeded in capturing the imaginations of these two particular artistic giants (among many others throughout history), one during the early 1300s, the other during the late 1950s. Today, the same dichotomy of anxiety and hope would appear to apply. For those of us who have not completely forgotten history, perhaps there is chance that we will not repeat it exactly, at least on an individual basis. Thus, in the year 2017, we all continue to face a highly uncertain future, all the while searching for various degrees of personal meaning in our own lives.

Summary

Jesus answered, "You do not know what you are asking. Can you drink the cup that I am going to drink?" They [James and John] replied, "We can." He said to them, "Very well; you shall drink my cup..."—Matthew 20:20[1]

Religious faith always has, and always will, transcend human reason. To merely function in this irrational, ever-changing world, individuals need to have some basic familiarity with the religious customs of their surroundings, or otherwise risk complete irrelevance to whatever path in life is chosen. Personal belief has little to do with it. For example, whatever one may think regarding the factuality or historical basis for various legends and traditions surrounding the cult of Saint James the Greater, it can be stated with confidence that these phenomena have generated considerable interest over the last two millennia, both among the Christian faithful and among talented artists, two groups that do not necessarily overlap. While these legends and traditions appear to be currently on the wane in terms of widespread awareness, there is also some evidence that new ones (based on the old) may currently be in the formative stages. Moreover, the old ones have far from disappeared. The Iberian Caminos leading to Santiago de Compostela seem busier than ever, both with Christian and non–Christian pilgrimage traffic. Throughout both the Old and New Worlds, the names of Saint James the Greater, or Santiago Mayor, or Saint-Jacques Majeur, or San Giacomo il Maggiore, or any other designator for the same proto-apostle-martyr, continue to find common usage (as place names if nothing else) even among those who have little knowledge or interest in religion. In what has more recently been described as a post-truth society, the omnipresence of this religious icon (among many others like it), serves to illustrate—and for artists, literally illustrate—how the earthly affairs of humankind are typically driven, not by established facts in the strict scientific sense, but rather by beliefs based on emotion or instinct, oftentimes for worse, but sometimes for better as well.[2]

For purposes of comparison and contrast, it is useful to examine the still widespread (though somewhat diminishing) veneration for the first naturalized citizen of the United States to be canonized by the Roman Catholic Church, Saint Frances Xavier (aka "Mother") Cabrini (1850–1917), achieving

this distinction in 1946, only 28 years after her death.[3] Born in the fabled Lombardy region of northern Italy before the Risorgimento era of Italian history, Cabrini seemed destined at an early age to leave her mark on the religious life of western society, despite chronic bad health, humble origins, and all the handicaps of her sex at a time and place in which being a woman usually precluded worldly achievement within the Roman Catholic hierarchy. By the time of her death (in Chicago at age 67), however, she had established a global reputation for charitable activities, particularly her indefatigable ministry towards Sicilian immigrants in North America.[4] In 1955, nine years after Cabrini's widely-celebrated canonization, a National Shrine dedicated to her memory was established on Chicago's north side, then in 2012, incorporated into a much larger and impressive development, today hosting a steady stream of visitors from the deeply devout to the merely curious.[5] The shrine itself is located off Lincoln Park, not far from the center of her missionary activities on Chicago's Near North Side.[6] Ironically, the impoverished neighborhood to which Cabrini had devoted her life's work has since largely become one of the most gentrified and affluent urban areas in the Midwest.[7]

Though separated by nearly 2,000 years and several continents, the respective cults of Mother Cabrini and James the Greater share several interesting similarities, as well as presenting instructive differences. Both traditions have established major shrines in multiple locations today hosting significant pilgrimage traffic. Both saints hailed from relatively obscure, impoverished, and disadvantaged roots. Both shared deep Christian convictions that downplayed personal, physical well-being, yet attracted their own numerous followers and disciples. Mother Cabrini, like James the Greater (at least, according to the Spanish tradition), repeatedly travelled long distances across land and sea while preaching and ministering the gospel, was buried far from her place of origin, had her relics eventually distributed among several shrines, and many miracles associated with her name, both during and after her lifetime.[8] Both saints found their greatest posthumous veneration in countries other than the ones in which they were born. Both now have countless places and institutions named after them. As for differences, the most striking is obviously with respect to Mother Cabrini, miracles notwithstanding, in that there is little or no dispute as to the facts of her life and work; moreover, much of her biography is well documented, being exclusively from our own modern times. Another primary difference between the traditions of Cabrini and James is that the former has not had a fraction of the artwork dedicated to her legacy, compared to the proto-apostle-martyr of Jerusalem. Once again, this may be the result of her more contemporary status, or perhaps because of less alleged mythology and legend being attached to her memory. In any event, as the year 2017 marks the centennial of her death (on December 22), this seems like an appropriate moment in which to

honor Cabrini for the things making her so unique, as well as different from other prominent Christian personages.

Within the same relatively contained geographic area covering the north side of the Chicago metropolitan area, one can also find many remnants of the Santiago or Saint James tradition—some Catholic, some Protestant, and never to be excluded, Armenian Orthodox as well. In August of 2017, the St. James Armenian Church of Evanston celebrated its popular annual street festival, a vibrant reminder of Chicago's important 20th century Armenian heritage.[9] Strictly speaking, the Evanston church is named not after Saint James the Greater, but rather Saint James of Nisibis, a fourth century father of the Armenian Orthodox Church, himself possibly named after the original Greater apostle of Jerusalem.[10] The Evanston Armenian community is itself part of a much larger North American diaspora of refugees from the late 1800s and early 1900s fleeing lethal Ottoman persecution in their native homeland (see Chapter 18).[11] Thus one may easily assert that, regardless of whether the true relics of Saint James the Greater are to be found in Spain, Jerusalem, both or neither, the all-important traditions of the saint eventually found their way into the everyday fabric of American life from all of its various strands, whether these be Spanish, French, Anglo, Armenian, or otherwise.

Despite this persistent internationalism, however, nowhere are images and symbols of Saint James the Greater more visible than in modern day Spain, a country still claiming his relics and protection as patron saint. To understand Spain, one must understand the Santiago tradition. This continuum has remained one of the few constants in a volatile society witnessing unprecedented highs and lows of global political power over the last 1,200 years or more. After several millennia of continually reinventing itself, the country once again appears on the brink of change, although only time itself will tell specifically what these changes may prove to be. A charter member of the tenuous European Union, as well as a member state of NATO, Spain will perhaps prove itself a useful future friend to the United States, putting aside all past differences and conflicts. At the geographic and cultural center of the Spanish landscape lies Madrid, where the many diverse strands of the country continue to meet. Strangely enough, all this regional diversity is subtly united by Arabic influences of the past, from language to architecture to social customs. Gracious manners and hospitality to strangers are frequently observed as a point of personal honor, regardless of how Spanish hosts may truly feel about their guests. There is possibly an element of guilt as well, since this was the country that once forcibly expelled Muslims and Jews from its realm, not to mention religious heretics and, in the not so distant past, advocates of Republican Parliamentary government. Today in Madrid, public signage proclaims that all refugees are now welcome; nevertheless, ghosts of the past

remain, frequently intertwined with religious symbolism, and before that, pagan mythology. And then there are the outer barrios of Madrid—the real Madrid—in which ordinary, everyday life carries on just as it has since the city's foundation by Islamic occupiers during the Middle Ages.

For Spain, however, as with the entire cult of Saint James the Greater, all spiritual roads still lead to Galicia and Santiago de Compostela. Growing numbers of pilgrims and tourists, both Christian and otherwise, continue to cross oceans and mountains and national boundaries to reach their storied destination at the extreme northwestern corner of continental Europe. If one is taking the most traditional route from France along the Camino Frances, one might easily bypass the hardships of the Pyrenees Mountains by simply flying over this barrier to begin their overland trek at a closer point, often-times at Sarria, roughly 108 kilometers from Santiago and the minimum walk-ing distance required to receive an official certificate of completion from the Vatican.[12] Within Spain itself, one constantly encounters the ubiquitous pil-grim shell-motif in architectural and commercial art, a subtle reminder to visitors and locals alike that the national economy is ever-dependent upon this important industry. No small part of this pilgrimage traffic comes from the distant United States, where countless institutions and place names des-ignated with the moniker of Saint James the Greater may easily be found from Florida to Washington state, from California to Maine, and everywhere in between. Nevertheless, many of these enthusiastic American pilgrims of the Camino de Santiago do not consider themselves to be Christians, let alone Roman Catholic. Some are fervently anti-religious, at least in the institutional sense, while others firmly hold to non–Christian religious beliefs. Some are merely curious. Others get close, then walk away, either by choice or necessity, like that great contrarian among the American Founding Fathers, John Adams (see Chapter 15). All who do finally reach their destination, either on foot or by other means, cannot fail to be impressed by what they see. At any rate, few come away disappointed, or admit to being disappointed. Even in the unlikely event that Santiago de Compostela proves to be a personal letdown, one still has the magnificent legacy of European art attaching to this ancient icon.

And what of Latin America? Larger countries such as Mexico and Brazil have emerged in recent decades as nation-states to be economically reckoned with, while smaller ones such as Costa Rica and Ecuador have taken on the more symbolic roles of hemispheric conscience and consensus. Cuba, for better or worse, remains the lynchpin of the Caribbean region, just as it was back in the days of the conquistadors. In a global economy, are these countries not the greatest potential allies for the United States, both in war and peace?[13] Lest we forget more recent history, was not an essential part of the winning Allied strategy during World War II to integrate Latin America into the

Arsenal of Democracy, when these same nations had previously exhibited a propensity towards fascism, combined with marked hostility towards the U.S. (see Chapter 19)? One might well ask how any of this relates to artistic representations of Saint James the Greater. The short answer is that if history has proven anything, it has shown that most people, both high and low, are typically motivated by traditional religious beliefs. Whether one views James as the patron saint of all laborers, or more specifically as patron of veterinarians, pharmacists, or other professions, or in his most destructive guise as Santiago Matamoros, there is a clear historical record demonstrating how this veneration has influenced human behavior, and the symbols (including art) still exist to prove the vast extent of this customary, established reverence.

Despite some reports that conventional religious institutions are in decline, the cult of saints in general today appears to be bigger than ever, or at least it would seem so. One highly visible example may be viewed at Almudena Cathedral in Madrid, where the recently canonized (Saint) Pope John Paul II, who personally consecrated this edifice in 1993, is visibly revered more than any other saintly personage, with possible exception of the Virgin Mary, and certainly more so than Saint James the Greater.[14] Most of the urbane Spanish locals, who have a long memory for history, are well aware that the cathedral probably stands on the site of a former mosque destroyed during an 11th century Reconquista effort often appealing to Santiago Matamoros for aid. They simply prefer to use the site for honoring the memory of someone else, a far more contemporary saint, and for many, a more relevant religious figure to their daily lives. This conscious diversity in saintly veneration also helps to underscore that cults of saints are typically multifaceted, even for the same individual being honored. Just as Pope John Paul II represented many things to many different people, the much older traditions of Saint James the Greater are quite varied as well, Santiago Matamoros representing only one facet. This medieval aspect of the Santiago veneration appears today less in fashion, representing an ugly "God is on our side" mentality, yet can still be occasionally evoked at the most surprising moments. Given escalating tensions between religious and political extremists during our own times, it is safe to say that the Matamoros version of the Santiago devotion is one to be greatly dreaded, as recognized by contemporary artists such as Salvador Dalí (see Chapter 21). The perceptive British scholar T.D. Kendrick reiterated an old observation (by the 19th century English tourist Richard Ford) that the Santiago phenomenon in Spain may have originally begun as a hostile reaction to Islam, along with the latter's obligatory Mecca pilgrimage, just as the Mecca pilgrimage may itself have been an early reaction to Saint Helen's claims for the True Cross relic of Jerusalem.[15] If Ford's idle theorizing of an endless cycle for religious extremist reaction was correct, then the future

prospects for humankind are indeed grim. In any event, it appears that relics and saints and pilgrimages often drive historical events for everyone regardless of personal faith, whether we like to admit it or not.

During the 16th century and Age of Discovery, this dynamic was widely understood, though difficult today for some modern observers to grasp or comprehend. A textbook example can be found in the prolific and influential work of the Renaissance master Veronese, born Paolo Caliari (1528–1588) in Verona at a time in which the once seemingly invincible power of the Venetian Republic was being rapidly undermined by Spain's unprecedented conquests in the New World.[16] Along with his contemporaries Titian and Tintoretto, Veronese formed one third of the triumvirate dominating Venetian fine art of that era. Veronese was also likely influenced by the famous Giulio Romano of Mantua, where the artist had spent apprentice time and had to have been impressed (as is everyone else) by the grand scope and scale of Romano's larger works. One of the first culminations of Veronese's highly visible genius came in 1562–1563 with his sprawling masterpiece *The Wedding at Cana*, created in tandem with the architect Andrea Palladio for the monastery at San Giorgio Maggiore, and today on view at the Louvre Museum in Paris. The painting displayed all the hallmarks that often distinguished the artist's compositions—brilliant use of color, massive backdrops, multiple themes, harmonious relationships, and above all, idiosyncratic personal interpretation of scripture designed to apply its lessons to contemporary life. Soon after this highly successful commission, Veronese would bring the same talents to bear on one of the most enduring stories of Saint James the Greater, taken directly from the New Testament.

In the immediate aftermath of *The Wedding at Cana*, Veronese produced *Christ Meeting the Wife and Sons of Zebedee*, circa 1565, now on display at the Musée de Grenoble in France. The artist was in his late 30s at the time, and probably at the height of his powers, as well as enjoying his first flush of fame in a time and place that keenly appreciated his talent. The unusual subject matter is drawn from the Gospel of Matthew, in which Salome, the wife of Zebedee and mother of the apostles James and John, approaches Jesus to ask that her sons be allowed to sit on his right and left hand when he comes into his kingdom. The response of Jesus is both plaintive and frank: the favor is not his to grant, but rather God's alone. He challenges the two apostles with his own question—can they drink the same cup that he will drink, meaning his suffering and sacrifice? They, not grasping his meaning, reply that yes, they can, and Jesus then foretells that they in fact will, meaning their future martyrdom (see header quote). Later in Acts of the Apostles, James becomes the first apostle to die for his faith. No one, to the knowledge of this writer, has ever challenged the historicity of this account. Veronese, as an artist, takes the scene one step further, presenting James and John as mere

teenagers or at best, young adults, immature in their outlook and under-standing, while other older apostles stand around Jesus openly displaying annoyed indignation at Salome's biased maternal request.[17] The overall effect is one of considerable poignancy and depth, and rather unique within its context.

Stripping away later embellishments or revivals of folklore attaching to Santiago Mayor, while focusing strictly on standard scripture relating to the saint, would appear to convey a simple but austere message: ultimately, living the gospel means self-sacrifice, endurance of persecution, and possibly mar-tyrdom as well. Nothing is sugarcoated, at least not with respect to Saint James the Greater. One is tempted to think that everything which followed in the Santiago tradition—and there is a lot of it—represented various attempts to sugarcoat or deflect the sober warning of Jesus from Matthew's account. Human reason can be a very frail, fragile, and fallible thing. One thing I have learned over the course of life is that our own personal opinions are often mostly the product of our environments and upbringings; moreover, our own true opinions are sometimes intentionally hidden from the common view out of fear for approbation. For example, one may dislike water sports because of a bad childhood experience, but most normal people enjoy water sports, so one is hesitant to openly express any dislike. In a similar vein, a habitual reliance on conventional scientific methodology may cause us to distrust whether a holy relic can cause miraculous cures, but we decline to say it publicly because so many obviously believe otherwise. As for changes in personal beliefs (which have been known to occur), these often derive from changes in surrounding personal circumstances, as well as that rarest of rare occurrences, shifts in personal attitude and outlook, resulting, one might say, from our own personal pilgrimage through life. And perhaps there is still a chance that the relics at Santiago de Compostela (or the Armenian Cathedral of St. James in Jerusalem) are in fact genuine, notwithstanding all human arguments to the contrary. Our alleged powers of reason may urge us not to believe this, but we are still loath to leap to such an unnecessarily bold conclusion, knowing all too well our own personal imperfections.

Timeline

Part I—27 CE to 1492 (The Old World)

Circa 27—Beginning of the ministry of Jesus; the calling of James, son of Zebedee.

Circa 30—Death of Jesus; Pentecost and outpouring of the Holy Spirit onto the church.

Circa 40-43—According to later Spanish tradition, James briefly visits Spain; while there he experiences the first recorded Marian vision at Zaragoza.

Circa 44—According to the *Acts of the Apostles* by the Evangelist Luke (possibly written circa 70-80), James is executed in Palestine by Herod Agrippa I; according to later tradition, his relics are transported and interred on July 25 at Iria Flavia (Padrón) in the Roman Province of Gallaecia (Galicia).

Circa 57-58—In his *Letter to the Romans*, Saint Paul states his intention to visit Spain because (as he seems to imply) Christianity had not yet been preached there.

Late 3rd or Early 4th Century—Roman-Hispanic poet Prudentius writes in praise of Spanish Christian martyrs, saints, and shrines in his *Peristephanon*, buts makes no mention of Saint James the Greater.

301—King Tiridates III proclaims Christianity the national religion of Armenia; Christian monks begin migrating to the Armenian Quarter of Jerusalem (earliest evidence letters by Jerusalem Bishop Macarius to Armenian Bishop Vertaness, c. 325–335).

303-310—"Great Persecution" of Christians by Roman Emperor Diocletian.

311-313—Civil war throughout the empire; Constantine the Great emerges as sole Emperor (312); he issues Edict of Milan restoring freedom of religion (313); Christians shown imperial favor thenceforth.

Early 4rd Century—Eusebius, in his *Church History*, citing a lost work by Clement of Alexandria (early 3rd century) and possibly other sources, recounts the martyrdom of Saint James the Greater, adding new details but makes no mention of Spain.

324-330—Constantine redevelops Greek Byzantium, rechristened Constantinople and new capital of the Eastern Roman Empire.

385—Priscillian, Bishop of Ávila, is declared a heretic and executed by the Emperor Maximus; according to tradition, he is buried in Galicia.

Early 5th Century—Saint Jerome suggests that Christianity had been preached in Spain by an apostle but makes no mention of Saint James the Greater in this context.

406–410—Germanic tribes erupt across the Rhine into the Western Roman Empire (406); they invade the Iberian Peninsula (409); several years of famine, pestilence, and political chaos as tribes assimilate; Galicia becomes part of the Suebian kingdom; Gothic army under Alaric sacks Rome (410).

444—Church or Martyrium, possibly dedicated to Saint Menas, located on the future site of Armenian Cathedral of SS. James in Jerusalem.

476—Western Roman Empire is officially terminated; traditional beginning of the "Dark Ages" (as later characterized by Petrarch).

Circa 500—Anonymous *Passio Jacobi Majoris* recounts life and death of Saint James the Greater in Palestine, embellished with new details, but makes no mention of Spain.

585—Galician kingdom of Suebia absorbed into the expanding Visigoth kingdom of greater Iberia, centered in Toledo (Spain) and Toulouse (France).

614—Jerusalem captured and looted by the Persian Sassanids; original church or martyrium of Saint Menas reportedly destroyed.

Circa 630—Isidore of Seville, in his *De Ortu et Obitu Patrum*, asserts that James preached in Spain, the first preserved reference to this tradition; Byzantines under Heraclius recapture Jerusalem (event recorded in the Islamic Q'uran); Jerusalem shrine of Saint Menas rebuilt shortly thereafter.

632—Death of the Prophet Mohammad.

638—Islamic conquest of Jerusalem.

Late 7th Century—Julian of Toledo, writing of James the Greater, ignores the tradition that James preached in Spain.

Before 709—Aldhelm, English Bishop of Malmesbury, refers to Saint James the Greater having preached in Spain.

701–710—Visigoth kingdom rules most of the Iberian Peninsula uncontested since the fifth century; by 710, however, realm is badly divided by ongoing civil strife between King Roderic and rival contenders for the throne; North African Umayyads launch probing military excursions into Iberia.

711—Visigoths and King Roderic defeated at the Battle of Guadalete near Cádiz by Umayyads under Berber general Tāriq ibn Ziyad; Visigoth kingdom collapses; most of Iberian Peninsula quickly overrun by invaders; Sephardic Jews, persecuted by Christians for centuries, favor Islamic rule because of greater tolerance shown towards them.

718—Visigoth nobleman Pelagius (Pelayo) leads Christian revolt in remote northern Iberia; defeats Umayyad force at Covadonga (northeast of León); Pelagius proclaimed first King of Asturias.

732—Umayyad invasion of France is decisively repulsed by Frankish forces led by Charles Martel at the Battle of Tours; Islamic forces retreat to Iberia.

Mid–8th Century—Bishop Odoario of Lugo in Galicia dedicates church to Saint James the Greater (Santiago) in Meilán.

776—Asturian monk Saint Beatus of Liébana advocates Spanish nationalism in his *Commentary on the Apocalypse* and endorses the tradition of Saint James

the Greater having preached in Spain; later hymn *O Dei Verbum* (attributed possibly to Beatus) also refers to James preaching in Spain.

778—Basque forces ambush and annihilate Frankish rearguard at Battle of Roncevaux Pass in the Pyrenees (later romanticized in the French *Le Chanson de Roland*), only military defeat ever suffered by Charlemagne.

796–798—Alfonso II *El Casto* ("the Chaste") officially recognized as King of Asturias by Charlemagne and Pope Leo III.

Circa 800—Charlemagne establishes the March Hispania in Catalonia as a buffer zone between the French Carolingian and Islamic Umayyad kingdoms.

813–814—Sometime during reign of Alfonso the Chaste (according to 12th century sources), shrine of Saint James the Greater (Santiago) established near traditional burial site in northwestern Galicia near Compostela (possibly derived from Latin *Campus Stellae* or "Field of Stars"); relics discovered by the monk Pelayo and legitimacy ratified by Galician Bishop Theodomor.

Mid–9th Century—Florus of Lyon and Usuard of Saint-Germain-des-Près both refer to the relics of Saint James the Greater near Iria Flavia.

859—Asturians under King Ordoño I victorious over Islamic forces at the Battle of Monte Laturce in Aragón; elements of the battle later incorporated into the fictional Battle of Clavijo, in which *Santiago Matamoros* ("Saint James the Moor-slayer") supernaturally appeared to fight for Christians.

868—Portus Cale (Grande Porto) conquered by Asturian nobleman Vimara Peres; County of Portucale (northern Portugal) established as Christian jurisdiction.

871—County of Coimbra (south of Portucale) conquered by Galician nobleman Hermenegildo Gutiérrez.

910—Alfonso III of Asturias, in response to rebellion of three sons, divides his realm into three separate kingdoms: Asturias, Galicia, and León.

912–955—Reign of Abd-ar-Rahman III, Caliph of Córdoba; inaugurates "Golden Age of Spanish Jews" as their political influence grows.

920—Allied Christian armies of León and Navarre defeated by Islamic Caliphate of Córdoba at the Battle of Valdejunquera.

939—Islamic Caliphate of Córdoba defeated by allied Christian forces of León, Castile and Navarre at the Battle of Simancas near Valladolid; Santiago Matamoros is again said to make an appearance during the battle.

981—Portuguese rebellion in Coimbra suppressed by Ramiro III of León.

985–1000—Islamic Berber armies led by Almanzor (Al-Mansur) temporarily retake or sack large portions of Iberia, including Santiago de Compostela in 997 (August 10); previously feuding Christian kingdoms react by renewing alliances with each other.

1000—Almanzor is victorious over allied Christian forces at the Battle of Cervera near Burgos; costliness of the victory, however, brings Almanzor's campaigns to a halt.

1020—Alfonso V recognizes legal rights of Spanish Jews at the Council of León.

1029—Sancho III of Navarre seizes control Castile and designates his youngest son Ferdinand (the future Ferdinand I) as Count of Castile; Sancho then incorporates León into his kingdom (1034); during his reign, increased pilgrimage traffic along the Camino de Santiago across northern Iberia.

1031—Collapse of Iberian Umayyad Caliphate formerly based in Córdoba.

1056—Ferdinand I (*El Magno* or "The Great") declares himself Emperor of Spain.

1064—Portuguese Coimbra retaken by Ferdinand I; Siege of Barbastro in Aragón; city sacked by Christian forces including Norman mercenaries led by William of Montreuil.

1066—Granada Massacre of Jews by Islamic fundamentalists; Jewish political influence at Iberian courts begins to wane.

1072-1078—Georgian Orthodox church built as a shrine for Saint Menas in Jerusalem.

1075—Construction begins on the Cathedral of Santiago de Compostela.

1085—Toledo conquered by Castilians in the name of Alfonso VI *El Bravo* ("the Brave"); Alfonso appoints first Christian governor of Toledo, the Mozarab (Arabized Christian) Sisnando Davides; Muslims appeal to Almoravids of North Africa for aid.

1086—North African Almoravids under Yusuf ibn Tashfin defeat Castilians at the Battle of Sagrajas; Alfonso VI wounded and Christian southern advance halted.

1094—Castilian warlord Rodrigo Díaz de Vivar nicknamed *El Cid* ("the Master") seizes control of Valencia.

1095—Bishopric of Galicia is transferred from Iria Flavia to Santiago de Compostela.

1096-1099—First Crusade results in capture and sack of Jerusalem; Godfrey of Bouillon elected first King of Jerusalem; inspires Christian offensives across Iberia; Armenian Orthodox Church is granted control over Georgian Church of Saint Menas.

1099-1102—Death of El Cid (1099) is followed three years later by the fall of Valencia to the Almoravids (1102).

1108—Almoravids defeat Castilians at Uclés near Toledo.

1118—Zaragoza conquered by Alfonso I of Aragón.

1120—Diego Gelmírez appointed by Pope Callixtus II as first Archbishop of Santiago de Compostela; Gelmírez relentlessly promotes the cult of Santiago Mayor.

1122—Uncompleted Cathedral of Santiago de Compostela opens for worship.

Circa 1135-1139—Five books of the illuminated manuscript *Codex Calixtinus* (i.e. *Liber Sancti Jacobi*) are compiled in Santiago by the French Cluniac monk Aymeric Picaud and fictitiously attributed to Pope Callixtus II (d. 1124); contains the first preserved reference to Santiago de Compostela as the burial site of Saint James the Greater.

1137—Seeking protection from Almoravids, County of Barcelona voluntarily merges with the Kingdom of Aragón.

1139—Almoravids defeated by Portuguese at the Battle of Ourique in southern Portugal on the Feast Day of Saint James (July 25).

Circa 1140—Anonymous *Historia Compostelana* is written, recounting the tenure of Archbishop Gelmírez; Armenian Cathedral of Saint James in Jerusalem begins construction.

1143—Portuguese autonomy under King Afonso Henrique recognized by Alfonso VII of Castile in Treaty of Zamora.

1147—North African Almohads displace Almoravids as dominant Muslim power in Iberia; they capture Seville; Lisbon captured by Portuguese with help from English.

Circa 1150—Earliest surviving account for the legendary Battle of Clavijo, allegedly fought in 834 or 844, from a manuscript by Pedro Marcio of Santiago de Compostela.

1165—John of Würtzburg reports that the completed Armenian Cathedral of Saint James in Jerusalem claims possession of relics, including the skull of Saint James the Greater.

1171—Military Order of Santiago formally established with Pedro Fernández de Castro as first Grand Master.

1172—Almohads capture Murcia in southeastern Spain.

1184—Combined Portuguese and Leónese force defeat Almohads at Santarém.

1187—Islamic coalition under Egyptian Sultan Saladin decisively defeats Crusaders at the Battle of Hattin in modern day Israel; Christian Kingdom of Jerusalem surrenders to Saladin shortly thereafter; all subsequent Crusades fail to decisively regain Holy Land.

1195—North African Almohads under Caliph Moulay Yacoub defeat Castilians at the Battle of Alarcos near Toledo.

1207—Anonymous epic poem *El Cantar de mio Cid* written in Castilian.

1211—Completed Cathedral of Santiago de Compostela is dedicated.

1212—Coalition of Spanish and Portuguese forces led by Sancho VII (*El Fuerte* or "The Strong") of Navarre defeat Almohads at the Battle of Las Navas de Tolosa in Andalusia.

1214—Saint Francis of Assisi visits the shrine of Santiago de Compostela.

1217-1252—Ongoing crisis in Almohad succession; reign of (Saint) Ferdinand III; he reunites the crowns of Castile, León, and Galicia; massive territorial gains for Christians in Andalusia, including conquests of Córdoba (1236) and Seville (1248); Granada remains only independent Islamic kingdom but pays tribute to Castile.

1226—Jaume (James) I *El Conquistador* of Aragón conquers the Balearic Islands.

1232-1273—Reign of Muhammad I ibn Nasr, founder of the Nasrid dynasty; he builds Alhambra Palace in Granada; Nasrids continue to rule Granada until 1492.

1249—Alfonso III of Portugal conquers Faro in the southern Algarve region, completing the Portuguese phase of the Iberian Reconquista.

1259-1286—Reign of North African Marinid ruler Abu Yusuf Yaqub ibn Abd al-Haqq; he repeatedly intervenes militarily in Iberian affairs, creating confusion with shifting Islamic-Christian alliances between Granada, Castile, and Aragón.

Circa 1260—*The Golden Legend* is compiled by Jacobus de Voragine, including the Santiago de Compostela tradition of Saint James the Greater.

1265—*Siete Partidas* legislation codified during reign of Alfonso X *El Sabio* ("the Wise") of Castile; he promotes cultural collaboration between Christians, Muslims, and Jews; Castilian dominant Iberian dialect outside of Portugal.

1270—Eighth and final Crusade led by (Saint) Louis IX of France abandons siege of Tunis after death of king and much of his army from disease; European interest in Crusader military interventions begins to wane.



1469—Ferdinand II of Aragón, grandson of Ferdinand the Just, marries Isabella I of Castile; they become joint monarchs of those newly-united kingdoms.

1474–1479—War of the Castilian Succession results in the confirmation of Isabella I as legitimate heir to the throne.

1478—Spanish Inquisition established by Ferdinand & Isabella.

1481—Zahara sacked by Granada in retaliation against Christian raiding parties.

1482—Ferdinand & Isabella initiate final Granada War by sacking Alhama; Castilians introduce modern artillery into the conflict; Granada divided by internal conflicts.

1487—After a lengthy siege, Castilian conquest of Andalusian port city Vélez-Málagra reduces Kingdom of Granada to the size of a city-state.

1491—Siege of Granada by Castilians begins; November 25: Granada surrenders city to Castilians, effective January 2, 1492.

1492—January 2: Granada under Mohammad XII (aka King Boabdil) surrenders to Ferdinand & Isabella of Spain; March 31: Alhambra Decree issued by Ferdinand & Isabella, expelling un–Christianized Jews from Spain, effective July 31.

Part II—1492 to Present Day (The New World)

1492–1493—August 3: Columbus sails west from Palos de la Frontera in search of the Asian continent; October 12: he reaches San Salvador in the West Indies; explores neighboring islands, including Cuba and Hispaniola; commands the *Nina* after shipwreck of flagship *Santa María*; returns to Palos (via Portugal) on the Ides of March 1493.

1493—Papal bull issued by Alexander VI dividing all newly discovered and conquered lands between Catholic Spain and Catholic Portugal; details worked out in subsequent Treaty of Tordesillas (1494).

1493–1504—Second, third, and fourth voyages by Columbus to New World; most of Caribbean region claimed for Spain.

1495–1498—Leonardo da Vinci paints *The Last Supper* in Milan.

1495—Santiago de los Caballeros founded in modern day Dominican Republic.

1497—Vasco de Gama of Portugal rounds the African Cape of Good Hope; his achievement spurs Spanish exploration efforts westward.

1497–1526—Islamic religious freedom gradually abolished throughout the Iberian Peninsula; unconverted Muslims leave for North Africa.

16th Century—Global agricultural production begins major shift; New World crops such as corn, tomatoes, potatoes, and chocolate find new markets; Old World crops such as sugar, coffee, cotton, and tobacco thrive in the Americas.

1500—Pedro Álvarez Cabral claims Brazil in the name of Portugal.

1504–1505—Letters of Italian-Spanish explorer and cartographer Amerigo Vespucci published as *Mundus Novus*; his belief that new continents were being discovered (rather than Asia) gain widespread currency; popular use of Vespucci's Latinized first name (America) becomes standard reference to the New World, following German publication of *Cosmographiae Introductio* (1507).

1513—Spaniard Vasco Núñez de Balboa crosses Panama and becomes first European to sight the Pacific Ocean; former Spanish governor of Puerto Rico, Ponce de León, discovers Florida while, according to posthumous tradition, searching for the legendary Fountain of Youth; the name of his flagship is *Santiago*.

1515—July 25 (Feast of Saint James): Santiago de Cuba founded by Diego Velázquez de Cuéllar; subsequently used as launching point for conquest of Mexico.

1516–1520—Raphael paints *The Transfiguration* in Rome.

1517—Martin Luther initiates the Protestant Reformation.

1519—Charles V elected Holy Roman Emperor.

1519–1520—Hernán Cortés conquers Mexico and the Aztec Empire; unprecedented quantities of precious metal wealth begin flowing into Spain.

1519–1522—Sailing in the name of Spain, Portuguese-born Ferdinand Magellan leads first circumnavigation of the globe; after Magellan is killed during skirmish in the Philippines (1521), expedition continues sailing westward; *Victoria*, last surviving of five original ships, returns to Spain after three-year voyage.

1530–1533—Francisco Pizarro conquers Peru and the Inca Empire for Spain.

1531—Apparition later known as Our Lady of Guadalupe first appears to (Saint) Juan Diego in Mexico City near former Aztec sacred site at Tenochtitlán.

1535—Viceroyalty of New Spain established; includes Mexico and Central America, along with large portions of Caribbean region, and present day southern U.S.

1536—Santiago de Cali is founded in modern day Colombia.

1538—Santiago de Guayaquil is founded in modern day Ecuador.

1539–1542—Hernando de Soto explores Florida and most of southeastern U.S.; becomes first known European to encounter the Mississippi River.

1540–1542—Vázquez de Coronado explores much of southwestern U.S. in search of the legendary Seven Cities of Gold (*El Dorado*); his lieutenant García López de Cárdenas becomes first European to view the Grand Canyon (1540).

1541—Pedro de Valdivia founds the city of Santiago, Chile.

1542—Juan Rodríguez Cabrillo of Spain explores the California coast as far north as the Russian River; Viceroyalty of Peru established with capital at Lima; jurisdiction includes most of modern day Peru, Chile, and Argentina; Spanish New Laws passed by Charles V, outlawing slavery of Native Americans, first emancipation legislation in history.

1547—Santiago Atitlán is founded in modern day Guatemala.

1550—Public debate over human rights of Native Americans in Valladolid, Spain, between Bartolomé de las Casas and Juan Ginés de Sepúlveda.

1550–1590—Protracted Chichimeca War in north central Mexico becomes first widespread uprising of Native Americans against Europeans in the New World; decades-long conflict only resolved after Spanish troops removed, government subsidies granted ("Peace by Purchase") and continuous intervention of Franciscan missionaries.

1551—National University of San Marcos in Lima and the University of Mexico in Mexico City are both founded.

1553—Francisco de Aguirre crosses from Chile into Argentina and establishes the city of Santiago del Estero (del Nuevo Maestruzgo).

1556—Charles V abdicates as Holy Roman Emperor and retires to a monastery; he is succeeded by his son, Philip II of Spain.

1565—City of Saint Augustine, Florida, is founded.

1579—Francis Drake reaches Point Reyes, CA, while circumnavigating the globe.

1580-1640—Iberian Union of Spanish & Portuguese crowns.

1588—"Invincible" Spanish Armada of Philip II defeated in the English Channel, then ravaged by storms; Protestant England remains free.

1589—Attempted English raid of Galicia by Francis Drake is repulsed but in response, Santiago relics are hidden and subsequently lost for three centuries; Drake later dies after failed attack on San Juan, Puerto Rico (1596).

1605-1615—Two parts of *El ingenioso hidalgo don Quijote de la Mancha* by Miguel de Cervantes Saavadre are published; it quickly becomes the most popular novel in the Spanish language on both sides of the Atlantic Ocean.

1610—City of Santa Fe, New Mexico, is founded.

1618-1648—Thirty Years War in Europe; Dutch use opportunity to invade Spanish and Portuguese holdings in the New World, most notably in Brazil and the Caribbean.

1620—The *Mayflower* lands at Plymouth Rock.

1630-1654—Dutch Brazil (New Holland) effectively controls large coastal portions of Portuguese South America.

1648—City of Santiago, Nuevo León, Mexico, is founded.

1656—Diego Velázquez paints *Las Meninas* in Madrid, incorporating self-portrait with badge displaying the Order of Saint James.

1659—Mexico City Cathedral, under construction since 1573 and one of the world's most famous examples of Spanish Colonial architecture, is consecrated.

1661—Rembrandt paints *Saint James the Greater* in Amsterdam.

1689-1692—Works of Mexican nun and poetess Sor Juana Inés de la Cruz are published in Madrid; shortly thereafter, she is targeted by the Inquisition and forced to give up all literary activities.

1701-1714—War of Spanish Succession fought in Europe; international power of Spain and Holy Roman Empire severely weakened.

1716-1726—So-called Golden Age of Piracy, centered in the Caribbean region, with vulnerable Spanish shipping continuously raided by privateers and buccaneers.

1759-1767—Jesuits suppressed throughout Portuguese and Spanish Empires.

1769-1823—Initiated by (Saint) Father Junípero Serra, 21 Franciscan missions constructed in California alone; the last one, Mission San Francisco Solano in Sonoma, CA, is dedicated in 1823.

1776—Viceroyalty of the Río de la Plata founded with Buenos Aires as capital; Declaration of Independence signed by 13 American colonies.

1783—Treaty of Paris; Great Britain recognizes American independence.

1789—Storming of Bastille and beginning of French Revolution.

1807-1814—Peninsular War begins with Napoleonic invasion of Portugal and Spain but ends with French withdrawal concurrent with defeat of Napoleon

in Russia; Spanish upheavals spark Latin American independence movements.

1807–1821—Exiled Portuguese royal court relocates to Río de Janeiro, Brazil.

1810—Argentine independence declared in Buenos Aires, first of successful revolutions in Latin America ("May Revolution"); September 16: Catholic priest Miguel Hidalgo y Costilla issues *Grito de Dolores* ("Cry of Dolores") proclamation, now celebrated as Mexican Independence Day.

1814—During War of 1812, the frigate USS *Essex* under the command of Captain David Porter is captured by the British at the Battle of Valparáiso (Chile).

1814–1822—Argentina, Chile, and Peru successively achieve independence, with military aid from Libertador General José de San Martín.

1818—Chileans victorious over Spanish at the Battle of Maipú near Santiago; Bernardo O'Higgins appointed as first Chilean Supreme Director.

1821—June 24: Libertador General Simón Bolívar leads Venezuelans to victory over Spanish royalist forces at the Battle of Carabobo, thereby consolidating independence for former states of New Granada (Venezuela, Bolivia, Colombia, Ecuador, Panama); August 24: Treaty of Cordoba; Spain formally recognizes Mexican independence.

1822—Brazil declares independence from Portugal.

1824—Latin American independence movement concludes with Peruvian victory over the Spanish at the Battle of Ayacucho.

1836—Republic of Texas declared (March 2); Mexican army led by General Santa Anna overruns Alamo mission in San Antonio (March 6); Mexicans defeated and Santa Anna taken prisoner by Texans under Sam Houston at the Battle of San Jacinto (April 21).

1846–1848—Mexican War; U.S. acquires southwestern states, including California.

1855—American freebooter William Walker declares himself President of Nicaragua; two years later (1857) he is executed in Honduras.

1862–1865—Mexican War of French Intervention; May 5, 1862: heavily outnumbered Mexican army defeats invading French force at Battle of Puebla; beginning of Cinco de Mayo tradition; Mexican President Benito Juárez maintains office; French pretender Maximilian is executed (1867).

1879–1884—Rediscovery efforts of traditional Saint James burial site at Santiago de Compostela led by Canon López Ferreiro.

1888—Brazil becomes the last modern nation-state to legally abolish slavery.

1892—Highly influential World's Fair Exposition in Chicago celebrates 400th anniversary of Columbus' first voyage.

1898—Spanish-American War; U.S. acquisitions include Cuba, Puerto Rico, and the Philippines; Battle of San Juan Hill fought near Santiago de Cuba, resulting in U.S. victory and celebrity status for Colonel Theodore Roosevelt.

1910–1920—Mexican Revolution leads to implementation of new national constitution (1917) and election of Álvaro Obregón as President (1920).

1914—Panama Canal opens.

1917—After a period of neutrality, Brazil declares war on Germany and becomes only Latin American country to actively participate in World War I; Jerusalem,

after centuries of Ottoman rule, becomes part of the British Mandate, including the Armenian Quarter.

1929—Ecuador becomes first Latin American country to grant women's suffrage.

1931—Christ the Redeemer statue dedicated in Rio de Janeiro.

1933—FDR initiates U.S. "Good Neighbor" policy towards Latin America by withdrawing American troops and promoting trade relations.

1936—Carlos Saavedra Lamas of Argentina becomes the first Latin American to be awarded the Nobel Peace Prize.

1936–1939—Spanish Civil War; victorious Nationalist forces led by Galician-born General Francisco Franco, with covert support from Nazi Germany; Santiago Matamoros claimed to be seen helping Nationalists to victory at Battle of Mérida (1936).

1941—FDR signs Lend-Lease Act into law, extending massive aid to Latin American Allies, including, Brazil, Mexico, and Cuba.

1945—Gabriela Mistral of Chile becomes the first Latin American awarded a Nobel Prize in Literature.

1946–1950—Aftermath of World War II sees outmigration of former Nazis to several South American countries, particularly Argentina and Chile.

1949—After civil war, Costa Rica permanently abolishes its military.

1952—Argentine First Lady Eva Perón dies of cancer at age 33.

1956—U.S.-backed Nicaraguan dictator Anastasio Somoza assassinated.

1959—Fidel Castro proclaims victory for the Cuban Revolution from Santiago de Cuba

1961—U.S.-backed Bay of Pigs invasion in Cuba is defeated; Anthony Mann film *El Cid* is nominated for three Oscars.

1962—Cuban Missile Crisis ends after Soviet ships withdraw from region.

1967—Cuban revolutionary Ernesto "Che" Guevara killed in Bolivia; Six-Day Arab-Israeli War results in Jerusalem Armenian Quarter becoming part of Israeli state.

1973—Chilean elected President Salvador Allende is overthrown in a U.S.-backed military coup and replaced by General Augusto Pinochet.

1974—Isabel Perón, third wife and widow of former Argentine President Juan Perón, becomes the world's first elected female head of state.

1975—Death of dictator Francisco Franco; some Spanish Civil War exiles begin returning to Spain from Latin America.

1976–1978—*Evita* by Andrew Lloyd Webber and Tim Rice, a semi-fictionalized account of Eva Perón's life and times, becomes a hit Broadway show.

1979—Sandinista Revolution in Nicaragua overthrows U.S.-backed dictator Anastasio Somoza Debayle; Daniel Ortega emerges as new Nicaraguan leader.

1980—Saint and Martyr Archbishop Óscar Romero of El Salvador assassinated.

1982—British Navy defeats Argentine Navy in Falklands War; two years later (1984), Argentina returns to civilian rule.

1983—U.S. invades island-nation of Granada.

1986—Roland Jaffé film *The Mission* wins Oscar for best cinematography.

1989—Berlin Wall falls; former Soviet Union aid to Latin America ceases.

1989–1990—U.S. invades Panama.

1992—500th anniversary of Columbus' voyage receives mixed reactions; Rigoberta Manchú of Guatemala becomes first Native American to win Nobel Peace Prize.

1994—North American Free Trade Agreement (NAFTA) is signed by the U.S., Mexico, and Canada, loosening trade restrictions between these countries.

1997—*Buena Vista Social* Club, recorded in Havana, Cuba, under the direction of American impresario Ry Cooder, becomes best-selling album in the U.S.; later a successful documentary film by Wim Wenders (1998).

1998—Self-described Marxist Hugo Chávez elected President of Venezuela; election inaugurates so-called *marea rosa* ("pink tide") in Latin American politics.

2000–2010—Trade relations between Latin America and China burgeon, with the latter becoming Latin America's second largest trading partner after the U.S.; Chile becomes first Latin American country to sign a free trade agreement with China (2005).

2001—September 11: Terrorist attacks against the U.S.; American foreign policy focus shifts away from Latin America with more emphasis towards the Middle East.

2002—U.S. detention camp established at Guantanamo Bay in Cuba.

2003—Most of Latin America condemns the U.S. invasion of Iraq or remains neutral, with the exceptions of Colombia, Honduras, Nicaragua, El Salvador, and the Dominican Republic; Colombia declines to contribute troops.

2008—Union of South American Nations (UNASUR) founded with headquarters in Ecuador and parliament in Bolivia.

2009—Sonya Sotomayor appointed by President Obama as the first Hispanic and Latina justice of the U.S. Supreme Court.

2011–2012—*Codex Calixtinus* illuminated manuscript at Santiago de Compostela stolen and later recovered.

2013—Cardinal Jorge Mario Bergoglio of Buenos Aires elected as Pope Francis I.

2016—June 23: United Kingdom votes to leave the European Union ("Brexit"); August: XXXI Summer Olympics held in Rio de Janeiro; Nobel Peace Prize awarded to President Juan Manuel Santos of Colombia; November 8: U.S. Presidential election.

Chapter Notes

Introduction

1. Gibbon, Vol. I, 394–395.
2. Flying into Madrid for the first time, however, confirmed this preconceived image. The surrounding arid countryside appeared like a backdrop from an El Greco painting.
3. See my earlier study *Chrétien de Troyes and the Dawn of Arthurian Romance* (McFarland, 2010).
4. Few at the time could have guessed at the worldwide impact this cult would one day exert, the world as we know it today still being centuries removed from the Age of Discovery.
5. Gibbon, Vol. I, 395, *n*91.
6. For example, see *The Islamic Design Module in Latin America* by John F. Moffitt (McFarland, 2004).
7. In this respect, the cult of Saint James resembles Arthurian traditions, which gradually progressed over time from a Dark Ages warrior myth to a far more spiritual (and personalized) quest for the Holy Grail.
8. From the Prologue of *Canterbury Tales* (see Chapter 9).
9. The Haitian customs relating to the Santiago cult are thought to have possibly been imported from the sub-Saharan African Kongo where the saint had a tradition of veneration. See Chapter 11, *n*11.
10. The Epistle of James from the New Testament is today more associated with James the Just, "brother" or cousin of Jesus, or a written tradition associated with him, rather than with the apostle James the Greater.
11. By way of contrast, several books were published around the turn of the 21st century on James the Just, in many respects an even more obscure figure than James the Greater. This sudden interest came (and went) as the result of what may have been a mistaken recent piece of archeological evidence in Jerusalem.
12. Convincing arguments have been made that the original 12 apostles were intended to be Christian counterparts to the 12 tribes of Israel. This may have even been the intent of Jesus himself.
13. In some parts of the New Testament (Galicians 1:19), James the Lesser is identified as "the Lord's brother," although some authorities interpret this as meaning first cousin to Jesus. For a good summary of this problem, see Butler, Vol. II, 203–207.
14. Most of this ancient knowledge reentered and was reintroduced to Spain from North Africa and the Middle East much later thanks to Islamic rule and preservation of these sources.
15. Complicating matters further, southern Spain venerates Saint Torquatus and his Seven Companions as the first to evangelize that region (Guadix, near Granada) during the Apostolic Age of the first century. This stands almost in contradiction to the Santiago tradition that Saint James the Greater passed through the same area while experiencing the first Marian vision near Zaragoza (see Chapter 2). It will be noted throughout this timeline that southern Iberia has historically shown less enthusiasm for the Santiago cult in comparison to Santiago de Compostela and northern Spain, the latter whose economic interests have always been closely tied to pilgrimage and the Caminos.
16. See my earlier study, *De Vere as Shakespeare: An Oxfordian Reading of the Canon* (McFarland, 2006).
17. This study will betray the author's own personal enthusiasm for Venetian art pertaining to Saint James the Greater, of which several examples will be examined throughout.
18. Among other useful services, Kendrick supplies the names and works of outstanding scholars throughout the centuries, including Spanish, that have made a critical analysis of this difficult topic. His extensive bibliography alone is well worth the paper it is printed on.
19. For example, Kendrick keenly observed that the outrageous "Lead Book" frauds of the late 16th century surrounding the Santiago cult appear to have been sparked by widespread hys-

teria surrounding military defeat of the Spanish Armada by the English in 1588. See Kendrick, 69.

20. Kendrick, 14.

21. The *Codex Calixtinus* of Salamanca is so designated because it is currently housed by the Spanish University of the same name. Also known as Ms. S, the Salamanca illuminated manuscript is one of four surviving long versions of the Codex that is illustrated, the other three being housed at Santiago de Compostela, Rome (in the Vatican City), and London (at the British Library).

22. The scallop shell has also been known to symbolize the Christian baptismal font, as well as pilgrimage.

23. It is possible that the medieval warrior image of Santiago drew the from biblical description (by Jesus) of SS. James and John as "sons of thunder" (see Chapter 1).

24. We have restricted our choices to the mediums of painting and drawing, with occasional references to sculpture, stained glass and architecture.

Chapter 1

1. Mark's Gospel, traditionally attributed to the traveling companion of Saint Peter, is frequently viewed by scholars as the oldest of the four gospels, at least in its original primitive form, possibly written as early as c. 63 CE. See *New Jerusalem Bible*, 2072.

2. Convincing parallels have been drawn between the sons of Zebedee and the Greco-Roman deities of Castor and Pollux. One of the earliest studies to appear was *Boanerges* (Cambridge University Press, 1913) by the noted British biblical scholar James Rendel Harris (1852–1941). A similar idea was later advocated by the Spanish scholar Américo Castro. See Kendrick, 183–184.

3. The three synoptic gospels are called as such because all adopt a similar point of view and sequence of events, as opposed to the non-synoptic Gospel of John.

4. Herod Agrippa I was the grandson of the same Herod the Great who attempted to kill the infant Jesus by ordering a Massacre of the Innocents, as recounted in Matthew (2:16).

5. Much later sources such as Voragine assign the traditional date of James' martyrdom to March 25, the Feast of the Annunciation, with his own feast day being July 25, the date of his relics arriving in Spain.

6. The martyrdom of Saint Stephen set off a chain of events leading to the conversion of Saul (i.e. Paul) and the spread of Christianity beyond Judea largely through Paul's missionary activities.

7. As an example of apostolic outreach, Luke mentions, not James, but rather Philip, who after the Pentecost travels to Samaria and then later baptizes an Ethiopian eunuch, albeit in Gaza (Acts 8:4, 26).

8. *Romans* is sometimes dated circa 57–58 CE. See *New Jerusalem Bible*, 2071.

9. Eusebius has much more to say about James the Just, kinsman of Jesus and first Bishop of Jerusalem, to whom the canonical *Letter of James* is nowadays generally attributed, or at least to his circle.

10. In addition to Clement of Alexandria, Eusebius is thought to have drawn upon an early version of a lost document known as the *Passio Jacobi*, possibly dating from the third or fourth century, later expanded into the *Liber Sancti Jacobi* of the Codex Calixtinus (see Chapter 6), dating from the 12th century. See Herwaarden, 314–315.

11. Eusebius details apostolic missions in Asia (III.1), but only refers to SS. Peter and Paul in regards to Rome and the Western Empire. Gaul, Britain, and Iberia do not appear to have been on his radar.

12. According to tradition. Christianity had originally been brought to Armenia by SS. Bartholomew (the Apostle) and Thaddeus during the first century.

13. Although Armenian merchants had been in the Holy Land for many centuries previous, the first documented evidence of the Armenian Orthodox Church in Jerusalem dates from the years 325–335, in which Bishop Macarius of Jerusalem wrote letters to Bishop Vertaness of Armenia. By the fifth century, Armenian religious establishments in Jerusalem are documented. See Hintlian, 1–2.

14. Kendrick, 33.

15. *Culture and Society*, 478. T.D. Kendrick notes that at least two other writers from Jerome's era also believed that an apostle had been to Spain. It is therefore a fair assumption that some kind of Spanish apostolic tradition existed before the fall of the Western Roman Empire. See Kendrick, 28.

16. The alleged heresies of Priscillian appear to have been benign by modern standards. For example, he advocated the study non-canonical writings and apocrypha. His condemnation and execution by Maximus was said to have been primarily motivated by politics, avarice, and old scores to settle amongst the Spanish. Ávila, the seat of his bishopric, is today venerated mainly as the birthplace of Saint Teresa, who for a brief period competed with James the Greater as the patron saint of Spain (see Chapter 13).

17. This event was also an insidious, distant forerunner of the Spanish Inquisition (see Chapter 10).

18. The main contemporary source for events surrounding the Priscillian affair (and a fairly reliable one at that) is the Gallic-Roman historian Sulpicius Severus, writing during the early fifth century. See Herwaarden, 352–353.

19. Arianism, without getting into too much theology, viewed Jesus, as the Son of God, as being inferior to God, hence diminishing the divinity of Jesus.

20. Zurbarán is often favorably compared to Caravaggio (1571–1610) because of his advanced mastery of *chiaroscuro* oil technique.

21. The dimensions are 252 cm. × 186 cm. (approximately over 8 ft. by 6 ft.).

22. Nicolle, 45.

23. The popular saluki canine breed, originally from the Middle East, is a highly appropriate symbol in this instance. Salukis later became very popular in Europe as well, having been brought there by Crusaders returning home, or perhaps by North African invaders into Iberia.

24. The highly destructive Thirty Years War (1618–1648) involved most of Europe, including Spain, the latter gaining little if anything from the extended conflict.

25. One such contemporary work, *Saint James the Greater*, is usually attributed to the followers of Zurbarán, ambiguously depicting the apostle as a pilgrim in armor, with dazed and vanquished opponents (or partisans?) at his feet. The painting is beautiful but the message conveyed somewhat confused and the overall effect a bit cluttered.

Chapter 2

1. Butler, Vol. II, 26.

2. The original Saint Isidore is not to be confused with his much later namesake, Saint Isidore "the Farmer" or "the Laborer" (1070–1130), patron saint of Madrid. The other five statues surrounding the complex depict Miguel Cervantes, Lope de Vega, Diego Velázquez, King Alfonso the Wise, and the sculptor Alonso Berruguete, along with humanist educators Antonio de Nebrija, and Luis Vives.

3. The statue itself was the creation of noted Spanish sculptor José Alcoverro (1835–1908), unveiled in 1892 in celebration of the 400th anniversary of the first transatlantic voyage of Christopher Columbus. Other works by Alcoverro were exhibited at the 1893 Columbian Exposition held in Chicago.

4. The best known artistic representation of Isidore is probably the painting (c. 1655) by Zurbarán's younger contemporary, Bartolomé Esteban Murillo, depicting the saint as a scholarly and kindly Spanish bishop of the Counter-Reformation era.

5. Butler, Vol. II, 26. Saint Braulio was Isidore's younger contemporary, Bishop of Zaragoza, and Isidore's first biographer. Father Alban Butler (1710–1773) was a Roman Catholic hagiographer of the British Enlightenment. His more recent editors include Father Herbert J. Thurston and Donald Attwater.

6. It was during this era in Iberian history that churches affiliated with Saint James the Greater are first identified, such as the Iglesia de Santiago de Meilán, dedicated by Bishop Odoario of Lugo. Landmarks such as these, however, viewed in isolation, do not prove or disprove that James preached in Spain or was buried there; rather it reflects the growing popularity of the saint, particularly in the region of Galicia.

7. Two of Isidore's brothers, Leander and Fulgentius, and one sister, Florentina, were also later canonized by the church.

8. English translations are rare. One of these (Thomas Deswarte) reads: "James, son of Zebedee, brother of John, and fourth in rank ... preached the Gospel to Spain and the western places, and spread the light of preaching in the sunset of the world.... He was buried in Acha Marmarica ... this James ... was the first to convert the peoples of the Spains." See *Culture and Society*, 479. This plural reference to Spain designates the traditional Roman and Visigoth division of Iberia into two separate regions.

9. The ambiguous Latin phrase is most frequently translated as "a place by the sea"; however, the phrase itself may be the result of a scribal error (or series of errors), and scholarly opinion is divided. See *Culture and Society*, 479. Alternative locations suggested by the phrase for James' final resting place include the Holy Land or North Africa.

10. Hannibal came of age serving in Spain under his father during the First Punic War. Carthage had long laid claim to Iberia, given the Peninsula's long Phoenician heritage. Military historians often credit later adoption of the famous legionary short sword or *gladius* by the Romans from its original Spanish prototype used by their adversaries.

11. Kendrick, 29–30.

12. Isidore himself had help set a precedent in which the Visigoth church would be comparatively independent and self-contained; this trend appears to have accelerated under Julian's later influence.

13. These questionable outside influences would have even occasionally included the previous likes of Isidore, whose dominance of the church despite his Sevillian background likely raised more than a few eyebrows in Toledo.

14. Julian, despite his canonization, stands accused of being complicit in harsh Visigoth edicts made against Spanish Jews. A minority opinion defends his reputation in this regard, suggesting that he had little choice in the matter and that his alleged complicity was more of a reluctant acquiescence.

15. See *New Advent Catholic Encyclopedia* under "Compostela."

16. King Arthur's heroic tradition does not appear to have received widespread dissemination until Geoffrey of Monmouth's highly mythologized *History of the Kings of Britain* was written during the 12th century.

17. Strictly speaking, the Spanish had always been conquerors, since the Visigoths originally came to Roman Iberia from Germany. Their conquest of the New World, however, would be

on an entirely larger and more permanent scale, as the second half of this study shall examine.

18. Isidore probably wrote approximately three centuries after the time of Constantine.

19. See *New Jerusalem Bible*, 1787 (John 19:25); other ancient sources do not remark on the alleged familial relationship, which seems to speak against its likelihood.

20. Goya had also painted a separate image of the Virgin on a pillar around the same time he executed his first Santiago work in 1768–1769. A very similar image of the Virgin was later incorporated into his Madrid Santiago painting.

21. The extensive private collections of Barberini and Cassiano eventually evolved into the one currently housed by the Palazzo Barberini, still today one of the finest art museums in Rome.

22. Compare, for example, similarities with Poussin's *Inspiration of the Poet*, dating from around the same period (circa 1630).

23. Raphael's masterpiece is today on display at the Prado Museum.

Chapter 3

1. New Jerusalem Bible, 2048.

2. See Gibbon's *Decline and Fall of the Roman Empire*, Vol. III, Chapter LI.

3. According to tradition, Tāriq's invasion of Iberia was greatly aided by the Visigoth nobleman Julian, charged by the Visigoth king with guarding the Gibraltar crossing, notwithstanding many political and personal resentments that Julian held against Roderic.

4. Before the eighth century, the vicinity of Gibraltar was more commonly known by its pagan appellation, the Pillars of Hercules.

5. The Visigoth Roman Catholic Church, based in Toledo, which not long previous had proudly resisted all outside influences, even those such as Isidore of Seville (see Chapter 2), now found itself happy to be allowed continued existence under its Umayyad conquerors.

6. Various legends have Pelayo originally residing in the Asturian mountains not by choice, but because he had been exiled there by Visigoth authorities, either before they were overthrown or after their collaboration with the Umayyad invaders.

7. Pelayo is normally portrayed as the first Spanish (as opposed to Visigoth) king. For example, his modern day statuary portrayal can still be seen in the spectacular Plaza de Oriente situated between the Royal Palace and Opera House in Madrid.

8. The 1843 English translation of al-Maqarri by Pascual de Gayangos opts for the less-offensive phrase "thirty barbarians" as opposed to "30 wild donkeys" used by his original source, Ibn Ahmed al-Rází, governor of Andalus. Pelayo's followers were perceived by the Umayyads as not worth pursuing or conquering, according to the chronicle.

9. Charles held the nominal title of Mayor or Duke, but consistently declined higher honors for political reasons. Because of his military prowess, Charles had been the de facto ruler of Gaul since around 718, possibly the same year that Pelayo of Asturias won his (seemingly at the time) small victory at Covadonga.

10. The Battle of Tours was fought a little over 100 years after the death of the Prophet Mohammad in 632.

11. Adding to the escalating problems of the Umayyads, their Caliphate in the Middle East was overthrown by the Abbasids around 750. Iberian Umayyads, however, remained independently entrenched at Córdoba until 1031 (see Chapter 5).

12. After the Battle of Tours, Charles Martel fought repeated successful engagements against the Umayyads as they continuously attempted to reinvade France from Spain. His grandson Charlemagne later succeeded in establishing the "March Hispania" along the Pyrenees, extending all the way to Catalonia and Barcelona, as an essential buffer zone between his kingdom and that of Andalusia.

13. The 2010 film *The Way* humorously dramatizes such an argument (see Chapter 20).

14. The *Revelation* of John, according to tradition, was written or dictated by Saint John the Evangelist, son of Zebedee, and brother of Saint James the Greater. It is therefore natural that Beatus should have made such a strong connection between the two apostles.

15. The anonymous eighth century hymn *O Dei Verbum* also praises Saint James the Greater as having preached in Spain and is often attributed to Beatus as well.

16. Kendrick, 188–189.

17. Alfonso's father King Fruela was the brother of Queen Adosinda. Alfonso's grandfather, Alfonso I, was an effective military leader who expanded the Asturian kingdom into Galicia and León.

18. Charlemagne was himself then proclaimed Holy Roman Emperor by Pope Leo III circa 800.

19. Interestingly, the 1961 epic film *El Cid* features many interior set designs that seem to have been inspired by the illuminated art of the Beatus Apocalypses. This film was thankfully made long before the days of computer generated imagery (or CGI).

20. Excellent details regarding the history and provenance of the Silos Apocalypse can be found on the website for the British Library. See http://www.bl.uk/onlinegallery/sacredtexts/silos.html.

21. Joseph Bonaparte was an unwitting participant in Iberian artistic history, as well as political. His ordered demolition of the Madrid Church of Saint James appears to have been one of several highly unpopular moves triggering the bloody revolt of 1810 (see Chapter 16).

22. In addition to the White Rider multitudes of *Revelation*, the same chapter earlier introduces

the Four Horseman of the Apocalypse, later famous in both biblical and secular art.

23. The Salamanca Codex Calixtinus is so-named after is current curator, the University of Salamanca, even though the manuscript was itself created at Santiago de Compostela.

24. A more recent and thorough discussion of this topic can be found in "The Islamic Rider in the Beatus of Girona" by O.K. Werckmeister, *Gesta* (Vol. 36, No. 2, University of Chicago Press), "Visual Culture of Medieval Iberia" (1997), 101–106.

Chapter 4

1. See Voragine, *Saint James the Greater.*

2. Some more recent scholars assert this year as being closer to 818, almost 100 years exactly after Pelayo's successful rebellion circa 719. See *Culture and Society*, 481.

3. Pelayo is said to have been attracted to the burial site by bright stars in the sky overhead.

4. The mountainous 323 kilometer Camino Primitivo from Oviedo is widely considered one of the more challenging paths for hikers to Santiago. Thanks likely to Alfonso II, sites along this Camino route became well-known landmarks, such as the Benedictine Monasterio de San Xulián de Samos near Lugo, where according to some sources, Alfonso was born and later, as a young deposed monarch, found sanctuary and refuge, along with his aunt, the Dowager Queen Adosinda. San Xulián also became a forerunner of the great Benedictine Spanish-Franco monasteries that would come to dominate Camino routes during later centuries (see Chapter 6).

5. Thanks to Beatus, Saint James the Greater had by then become, in the words of James D'Emilio, "...inseparably the patron of the Asturian Kingdom and of Hispania." See *Culture and Society*, 480.

6. Although not yet officially separated, Constantinople, even at this early stage, ambitiously vied with Rome for supreme authority over Christendom, the latter boasting possession of its own venerated relics, those of SS. Peter and Paul.

7. Hartley, 27.

8. Jan van Herwaarden wrote that "From the ninth century on there were plenty of believers, but the element of doubt never really disappeared." See Herwaarden p. 352.

9. Earlier proponents of the tradition, such as Isidore and Beatus, were at best ambiguous with respect to James' exact place of burial.

10. There are other good reasons as well for doubting the historicity of Clavijo, or at least accounts of the battle given much later; however, these are beyond the scope of this study. Among modern scholars, the British skeptic T.D. Kendrick gives a fairly thorough summary in his classic 1960 book.

11. Musa had defeated the Franks in this same

vicinity at the First Battle of Albelda in 851. At the Battle of Monte Laturce in 859, spoils taken from Musa by Christian forces included items thought to have been paid as ransom for Frankish leaders earlier taken prisoner.

12. Islamic Toledo, then governed by Musa's son, was reportedly so impressed by the Christian victory at Monte Laturce that it temporarily paid tribute to Asturias.

13. Claudio Sánchez-Albornoz (1893–1984) was one of the leading Spanish intellectuals of his day, as well as the living symbol of Spanish resistance in American exile against the dictatorship of Francisco Franco. His work on Clavijo was published in 1948, during an era in which Spanish Republican hopes had been temporarily dashed. His debunking of the Clavijo myth may well have been inspired by his personal disdain for the Galician Franco, who embraced and promoted the legend (see Chapter 18).

14. Portus Cale (Grande Porto) was conquered by the Asturian nobleman Vimara Peres in 868, establishing the County of Portucale (northern Portugal) as a Christian jurisdiction; the County of Coimbra (south of Portucale) was conquered by the Galician nobleman Hermenegildo Gutiérrez in 871.

15. It was at this point that Iberian Christians of the north seemed to first think in terms of territorial expansion rather than purely defending what they held.

16. Gradually this power would shift to first Toledo, and then later, Granada.

17. Hartley, 29.

18. The sack of Pamplona by the Franks in 778 formed the prelude to the Battle of Roncevaux Pass and subsequent literary tradition of Roland, which blamed his death on Islamic forces rather than the Christian Basques who in fact killed him (see Chapter 3).

19. Starkie, 57.

20. The story of "Luporia" in connection to Santiago had in fact another written precedent from the first half of the 11th century. See *Culture and Society*, 522.

21. According to tradition, Athanasius and Theodore were later buried next to Saint James the Greater, and their relics discovered alongside of his by the monk Pelayo during the early ninth century.

22. Galicia was comparatively matriarchal in the sense that the men were often simply gone to war, leaving women to make legal decisions otherwise made by men, similar in that regard to ancient Sparta.

23. Among other serious problems, Christian Spain during the later 14th century was embroiled in one of its many civil wars.

24. The Florentine native Giotto (c.1267–1337) is perhaps best famous for his spectacular frescoes in Padua at the Scrovegni Chapel (c. 1305).

Chapter 5

1. Specifically, Herwaarden compares Santiago de Compostela (as a Christian religious shrine) to the Muslim Kaaba shrine of Mecca. See Herwaarden, 451.

2. Starkie, 25.

3. Starkie, 27.

4. Herwaarden p. 453. Walter Starkie added that the most trustworthy sources concurring with this account are from Muslim historians. See Starkie, 28.

5. Two centuries later when Córdoba fell to the Christian Reconquista, the Great Mosque lanterns made from the metal bells and gates of Santiago were brought back to Toledo for safekeeping (see Chapter 7).

6. Once again, a comparison of Almanzor's campaigns with the Punic Wars between Rome and Carthage seems apt. Rome, like Christian Iberia, emerged from the conflict stronger than ever, notwithstanding Hannibal's invasion of Italy and multiple victories there over an extended time period.

7. The precise date of origin for the Taos Pueblo in New Mexico is still debated among archeologists. Its website asserts, with some plausibility, that the current structure was a long evolving project, roughly during the years 1000–1450.

8. All these sites are today found within the Chaco Culture National Historical Park. Original dates of construction are surmised to have taken place roughly between the ninth and 12th centuries. Chaco Canyon is also, like Santiago de Compostela, part of a designated UNESCO World Heritage Site.

9. Sancho's queen (and Ferdinand's mother) was Muniadona of Castile (d. 1066).

10. While Ferdinand was forcing a realignment of political and military power in Iberia, the Berber Almoravids were consolidating control of the North African Maghreb, founding the city of Marrakesh as their capital city in 1062, the same year that Ferdinand invaded the taifa of Toledo.

11. The Cid came of age as a young warrior under Ferdinand the Great's southern Iberian adventures and conquests. His father and grandfather also served under Ferdinand.

12. More specifically, the title "El Cid" was derived from the Arabic al sayyid, meaning master or chieftain. See Nicolle, 3.

13. According to another disputed tradition, the Cid, along with his Muslim allies, may have been involved in a military victory over Ferdinand's half-brother, King Ramiro I of Aragón (who was killed in battle), the latter having attempted to encroach upon Ferdinand's newly-acquired domains by invading the surrounding territories of Zaragoza.

14. Jan van Herwaarden remarked that the Virgin Mary began to overshadow Saint James

the Greater as a patron-protector of Spanish Christian armies from the 12th century onwards. See Herwaarden, 483. We would add that this process may have begun in earnest during the 11th century with the southern conquests of Ferdinand.

15. Herwaarden added that veneration of the Virgin Mary also naturally tended to attract a more multicultural following of worshippers than that of Saint James the Greater. See Herwaarden, 487.

16. The bank of the Ebro River was also the purported site of Saint James the Greater's Marian vision circa 40 CE near the Roman city of Caesaraugusta or Zaragoza (see Chapter 2).

17. Starkie, 69.

18. By way of contrast, King Alfonso V had earlier recognized legal rights of Jews living within the expanding Christian kingdoms at the Council of León in 1020. The immediate result appears to have been at least a blunting of active Jewish resistance against Christian authorities, as well as less overt and arbitrary persecution of Jews within those Christian realms.

Chapter 6

1. As an aside, Walter Starkie added that he made no fewer than four personal pilgrimages to Santiago de Compostela between 1924 and 1954. See Starkie, 40.

2. Pringle, 169. For more details on Saint Menas (or Mennas), see Butler, Vol. 4, 313–314.

3. Hintlian, 52.

4. To this day, the Armenian Cathedral of Saint James on this same site includes a side chapel dedicated to the ancient associations of the shrine with Saint Menas. See Pringle, 173.

5. Pringle, 169.

6. Geographically, Georgia (not referred to as such in surviving sources until the 11th century) is located to the northwest of Armenia in a more mountainous and then far less developed region. The Georgians were likely viewed by their Armenian Christian neighbors as more barbaric, and possibly heretical as well. The Georgians are thought to have derived their namesake identity from George of Cappadocia (d. 361), the condemned Arian Bishop of Alexandria, Egypt. See Gibbon, Vol. III, 2009, n18.

7. Pringle, 169.

8. Armstrong, 64.

9. Pringle, 181.

10. Pringle, 169. Karen Armstrong, in her fine book on the Crusades, makes the not uncommon error of conflating the traditions of Saint James the Greater with that of Saint James the Just (p. 58).

11. Armstrong, 158, 174.

12. Later substantial additions to the Cathedral of Santiago de Compostela between the 12th and 18th centuries were made in the Gothic and Baroque styles.

13. The distinguished French art historian Émile Mâle (1862–1954) was among those to comment upon the extensive connections between Muslim and Christian Iberian architecture. See Starkie, 3.
14. The Toulouse site was recorded to be a Christian shrine location by the early fourth century and was probably one before that time as well. The Basilica of Saint-Sernin is the largest purely Romanesque church still surviving in Europe.
15. T.D. Kendrick provided an excellent summary of this infamous fraud, perpetuated for obvious political reasons and successfully asserted by the Spanish monarchy for a surprisingly long period of time. See Kendrick, 193–200.
16. Nicolle, 14.
17. Twenty-two years later in 1108, the Castilians were again defeated by the Almoravids at the Battle of Uclés near Toledo; an infirm Alfonso was not present at this engagement but his son and heir to throne, Sancho Alfónsez, was killed in action. Alfonso died the following year in 1109.
18. Later in their conflicts with the Spanish, and with continued help from the English, the Portuguese would adopt Saint George as their patron saint in battle, as opposed to Saint James the Greater (see Chapter 9).
19. Within three years after the death of the Cid in 1099, the Almoravids would temporarily take Valencia.
20. Later, during an era dominated by Crusaders and Jihadists, the comparatively tolerant, multicultural legacy of the Cid stood out even more so.
21. David Nicolle remarked that "Yet there was no real crusading attitude before the 12th century, and even then religious motives were often secondary to political or economic calculations." The Iberian military career of El Cid must be viewed in hindsight as a prime example of this contrast. See Nicolle, 4.
22. Nicolle, 46. "Jinete" literally translated "horseman." Later it became more synonymous with the hit and run tactics of light cavalry. Central Iberia, especially around Toledo, became the new epicenter for these asymmetrical tactics. Nicolle also observed that Iberia, because of its topography and isolation, had been a "cavalry arena" since ancient times. See Nicolle, 11, 20. Possibly the first notable instance of this distinctively North African style of cavalry warfare had appeared during the Second Punic War when Hannibal's Numidian light horseman repeatedly wreaked havoc against the Roman legions in Italy. It was only after the Roman General Scipio Africanus persuaded the Numidians to switch sides that the tide of the conflict seemed to turn.
23. Nicolle, 9.
24. With respect to cattle raising (and rustling), it should be noted that Spain's reputation for high-quality leather goods extends back to this period in medieval history and beyond as well.
25. Herwaarden, 314–315.
26. Nicolle, 17.

Chapter 7

1. Armstrong, 436–437.
2. Pringle, 169.
3. The 11th century Georgian Orthodox Church of Jerusalem had been built under Islamic rule.
4. Herwaarden, 348–352.
5. Surviving the Second Crusade as a young man, Castro was inspired in his example by the Christian military orders originating in the Middle East, such as the Knights Templar.
6. The stated goal of the Fourth Crusade was to recapture Jerusalem, but the Latin army never got any further than Constantinople where the riches of the city and dubious loyalty of Byzantines to the Crusader cause simultaneously provoked greed and fury. The Latin Empire of Constantinople proved to be ephemeral like its Jerusalem counterpart, as well as politically incompetent, falling back into Byzantine hands 57 years later in 1261.
7. Like the Cid before him, Castro had an uncanny knack for fighting on the winning (though not always politically correct) side throughout his long and checkered career. For his pains on behalf of the Almohads, however, he was excommunicated by the Papacy and later died an exile in Morocco, though his remains were later brought back to Spain for burial in a Castilian monastery. Curiously, he was known to be a devotee of Saint Isidore (see Chapter 2).
8. The compositional process of *El Cantar de mio Cid* appears to have been a long one, beginning perhaps as early as the mid–12th century.
9. Francis of Assisi had begun his famous career as a lay preacher only five years previous to this around the year 1209.
10. Doubleday, 22.
11. David Nicolle observed that "James [*El Conquistador*] came to the throne virtually penniless. His subsequent seizure of Muslim Majorca in an interesting example of combined land-sea operations was a gamble that opened up trade across the western Mediterranean, thus solving many of the king's money problems." See Nicolle, 18.
12. Gibbon, Vol. III, 2099.
13. Among the unenthusiastic who refused to participate in the Eighth Crusade was the companion and later biographer of Saint Louis, Jean de Joinville.
14. See https://www.theguardian.com/world/2015/may/20/sainte-chapelle-paris-stained-glass-window-restoration-completed.
15. An excellent and detailed photographic documentation by Stuart Whatling of the Jamesian

windows at Chartres can be found at http://www. medievalart.org.uk/Chartres/05_pages/Char tres_Bay05_key.htm.

16. By extension, Western Europe, from Germany to Iberia and from Italy to England, became significantly richer during the High Middle Ages, and the first signs were appearing in society of what today would be called an economic middle class.

17. It was during this same era (circa 1260) that *The Golden Legend* by Voragine first appeared, a very popular work concisely summarizing the Santiago legend for non-Spanish European readers not having access to the *Codex Calixtinus* (see Chapter 6). Voragine (d. 1298) was the Italian Archbishop of Genoa.

18. Tiepolo's own painting for San Stae was *The Martyrdom of St, Bartholomew.*

19. Appropriately, the Musée National du Moyen Âge is located immediately off the Camino Frances (Rue Saint-Jacques) in central Paris just south of Notre Dame Cathedral. Originally, the museum had been built during the 14th and 15th centuries as the Hôtel de Cluny for the abbots of that order which had done so much to develop the Camino over previous centuries.

20. Besides within the museum itself, the image of Saint James the Greater can be viewed within the context of all four panels at http://www.therosewindow.com/pilot/Paris-Musee-Cluny/w37.htm.

Chapter 8

1. Michel de Montaigne, *The Complete Essays*, Translated by M.A. Screech (Penguin, 1991), 696.

2. The bas relief of Alfonso the Wise may be found, along with 22 other figures, within the Chamber of the U.S. House of Representatives.

3. Karen Armstrong has outlined the 12th century Iberian origins of this intellectual revolution in her classic study, *A History of God* (Ballantine, 1993), 204–205.

4. The *Estoria* has generated considerable scholarly debate in modern times, but mostly among Spanish academics and outside of the English-speaking world. For example, the chronicle recounts the so-called Battle of Jerez in 1231, in which Castilian *à la jinete* ("hit and run") cavalry conducted a successful raid into southern Iberia. Alfonso X was supposedly among the Castilian raiders, but he would have been only nine years old at the time. Others plausibly maintain that the chronicle in fact refers to a different Alfonso, brother to King Ferdinand III.

5. The repeated tragedies and disappointments of Alfonso's later reign appear to have affected his mental stability, or least made him more unpredictable and frightening in the eyes of his opponents.

6. Alfonso preferred his grandsons, the children of the slain Ferdinand, as his heirs. Alfonso's

son Sancho, however, had the support of the Castilian nobility, which proved crucial.

7. Doubleday, 211.

8. Prince Ferdinand visited Santiago de Compostela on the Feast Day of Saint James (July 25), 1270. See Doubleday, 152–153.

9. Herwaarden, 484.

10. Herwaarden, 483.

11. Doubleday, 191. The *Cantigas* helped to further popularize the *guitara latina*, a forerunner of the modern Spanish guitar, as a musical instrument.

12. Doubleday, 219.

13. Herwaarden, 487.

14. The Hohenstaufen dynasty had for many years ruled the Kingdom of Sicily which, like Iberia, was one of the great religious, racial, and cultural melting pots of Europe. Alfonso would have been well acquainted with its legacy through his mother.

15. Doubleday, 484.

16. Butler, Vol. I, 674.

17. Saint Catherine of Alexandria was, according to legend, a virgin Christian martyr from the great persecutions of the early fourth century. Her tradition, however, does not first appear until the 10th century, thus making hers an even more recent phenomenon than that of Saint James the Greater. She is frequently depicted as a scholar holding a book or bible, along with the device of her martyrdom, popularly known as the Catherine Wheel. See Butler, Vol. IV, 420–421.

Chapter 9

1. Chaucer, Geoffrey, *The Canterbury Tales*, translated by Ronald L. Ecker and Eugene Joseph Crooks (Hodge & Braddock, 1993), Prologue.

2. Ferdinand had condemned two knights to death for allegedly killing one of his favorites. According to some accounts, before their execution, the condemned knights maintained their innocence and prophesized that the king would himself be soon called to divine justice, which in fact came to pass.

3. See Canto XXV from Dante's *The Divine Comedy* (Vol. III Paradise). The poet Dante Alighieri (1265–1321) was writing late in life, circa 1310–1320, hoping to return to his native Florence from where he had been politically banished.

4. Alfonso's father, Ferdinand IV, had briefly conquered Gibraltar in 1309.

5. The outbreak and progress of the plague in Europe is surprisingly well documented. It reached Sicily in 1347 through Genoese galleys, Pisa in 1348, and Marseilles by early 1349. It then spread like wildfire across the European continent.

6. Ibn Battuta, 934.

7. Boccaccio's series of novellas titled *Decameron* is set within the context of young men

and women escaping from Florence and the plague to the country. It was written shortly after the height of the pandemic. In contrast to this outward gaiety, Petrarch mourned the loss of his muse Laura, another victim of the plague.

8. The epic conflict began when King Edward III of England disputed ownership of Gascony with King Philip VI of France. Joint sovereignty over large parts of both countries had been perceived as the norm since the days of William the Conqueror.

9. At one point, Chaucer was a POW during the Hundred Years War, but ransom for his release was paid by King Edward III himself, surely a sign of Chaucer's high royal favor.

10. Church officials are portrayed unfavorably in *The Canterbury Tales*, and most of the other characters are far from being devout, despite their religious pilgrimage activities. It seems reasonable to suppose a similar mood of cynicism prevailed in Spain and France along the Caminos.

11. Ibn Battuta, 941. Battuta was fortunate to have encountered Granada at the height of its affluence during the reign of Sultan Yusuf I, which was likely a prime motivator in the Castilian initiative under Alfonso XI to attempt conquering the city.

12. Marco Polo dictated his memoirs to Rustichello da Pisa while both were POWs in Genoa during the late 13th century.

13. Ibn Battuta, 934.

14. Ibn Battuta, 940.

15. Ibn Battuta, 934–935.

16. As this is being written, a British Prime Minister is issuing warnings that Great Britain will use military force if necessary to defend the sovereignty of Gibraltar from perceived outside threats of Spanish or European Union naval maneuvers in the aftermath of the 2016 Brexit vote. Residents of Gibraltar voted overwhelmingly to remain in the European Union. Great Britain has effectively controlled Gibraltar since 1704 and the War of Spanish Succession. It has proved a continuing sore spot in Anglo-Spanish relations.

17. The break became official when, after electing the Neapolitan Pope Urban VI in 1378 and then being treated disrespectfully by him, the college of Cardinals, led by the French, elected Pope Clement VII as Pope that same year.

18. The city-shrine of Tours was part of the Camino Frances. Back in the fourth century, Bishop Priscillian had been executed over the objections of Saint Martin and other prominent churchmen (see Chapter 1).

19. The entrance to this famous Parisian landmark is still frequently by the homeless seeking alms given in the spirit of Saint Martin, whose image decorates the church entrance.

20. *Butler's Lives of the Saints* favors the latter theory. See Butler, Vol. I, 305 ("St. Severinus").

21. The martyr Saint Sernin was the first Bishop of Toulouse during the early fourth century (see Chapter 6).

22. The Avilla, Indiana, St. James Restaurant is located within the local St. James Hotel and has successfully been in business since 1948.

23. The results of two early royal commissions by El Greco were coolly received by King Philip II, and so no more were given afterwards.

24. Another variation of this same prototype can be viewed in Novgorod, Russia.

25. Other artists, however, had suggested it. For example, see *Pilgrim's Mass* by the Catalan circle of Jaime Hugnet (1414–1492), today on display in the Thyssen-Bornemisza Museum in Madrid, in which a miserable looking pilgrim (among several) is offered alms by an unidentified saint.

26. These slightly inferior versions do not have Saint James holding a pilgrim's staff, or at least that part of the portrait is not shown, nor is the bright luxuriousness of the green cloak so obviously akin to that of Saint Martin's beggar.

Chapter 10

1. Ibn Battuta, 941.

2. In 1431, the same year that Joan of Arc was burned at the stake, Castile and Granada fought to an effective draw at the Battle of La Higuerula. Although Castile exacted tribute from Granada afterwards, the result seemed to also confirm the latter's continuing ability to defend itself from outside invasion.

3. The two other papal claimants in 1409 were Benedict XIII and Gregory XII. Interestingly, the voluntary resignation of Gregory XII in 1415 was the last time such an event occurred before the resignation of Pope Benedict XVI in 2013.

4. Immediately after Ferdinand's conquest of Antequera, the city was fortified and grew rapidly in its Christian population. It would prove to be a thorn in the side of Granada for the remainder of the 15th century.

5. After Ferdinand's death, political relations between and within Christian Iberian kingdoms continued to be unstable. For example, in 1445, a major rebellion against the Castilian crown led by its own nobility was forcibly suppressed.

6. Gibbon, Vol. III, 2360–2361.

7. According to Edward Gibbon, the Turks held Otranto and dared all comers with a mere garrison of about 800 troops, displaying their confidence and contempt for European military capacity of that era. See Gibbon, Vol. III, 2361.

8. Interestingly, the Armenian Church was allowed to return to Constantinople by the Ottomans after it had been previously banished by the Greeks. This was obviously done in part to forcefully remind the Greeks that the Ottomans were now in charge of the city, as well as to keep the local Christian minority weak through division.

9. Edward Gibbon wrote: "We may reflect with pleasure ... that the mechanics of a German town had invented an art which derides the havoc of time and barbarism." See Gibbon, Vol. III, 2354.

10. Both Isabella and Ferdinand were the great grandchildren of King John I of Castile, making them second cousins.

11. Notwithstanding his promise to Isabella, Henry repeatedly attempted to marry Isabella off to foreign royalty, including that of England and Portugal.

12. The end for Granada probably would have come much sooner than 1492 had the Castilians not been engaged in a civil war until 1479, a full 17 years after the fall of Gibraltar to the Reconquista.

13. Ferdinand and Isabella were first betrothed to each other at ages five and six, respectively. At the time, neither was heir to a throne. See Downey, 41.

14. Ferdinand became King of Aragón the following year in 1475, upon the death of his father, King John II.

15. Herwaarden, 489.

16. Isabella herself later became known as an enthusiastic and regular pilgrim to Santiago de Compostela. See Downey, 225.

17. By way of contrast, modern English-language biographies of the English Queen Elizabeth I are plentiful.

18. Isabella was about four years old when she was moved to Arévalo, immediately after the death of her father King John II of Castile in 1454. This would have been a highly impressionable age for her, as noted by biographer Kirstin Downey. See Downey, 37.

19. Segovia and Arévalo are both towns with strong Islamic heritage, today reflected by their surviving architecture. During the formative years of Isabella, this sense of otherness may have reinforced a feeling of insecurity. Curiously, she was known to have developed an appreciation for Islamic culture as she grew older, even as she persecuted its adherents.

20. Isabella's mother died in 1596. Afterwards, Isabella had a striking alabaster statuette of Saint James the Greater (portrayed as a pilgrim), designed by Gil de Siloe and placed at the head of her tomb in Miraflores. This small but notable work has been most recently displayed at the Metropolitan Museum of Art in New York City.

21. Downey, 322.

22. Downey, 28–29, 40–41, 408.

23. A good example of this same theme contemporary with the Catholic Monarchs themselves may be found in the Tempietto ("Small Temple") situated within the San Pietro in Montorio Church in Rome, commissioned by Ferdinand and Isabella circa 1502, and decorated with the scallop shell motif of Saint James the Greater. See Downey, 274. The church marks the traditional spot of Saint Peter's crucifixion.

24. Downey, 410.

25. The painting was commissioned for display in the Spanish Senate chamber.

26. The Crusades and Mogul invasions of the Middle Ages also created refugees, but not along the sweeping scale of what the Spanish and Portuguese were about to initiate after the fall of Granada.

Chapter 11

1. Armstrong, 459.

2. Kendrick, 198.

3. The church was itself demolished during the French Revolution, but the imposing Tour Saint-Jacques (Saint-Jacques Tower) still stands as a reminder of its historical significance.

4. Armstrong, 458.

5. Europeans, and Asians as well, had reached the New World on previous occasions; it was the voyage of Columbus, however, that changed the course of history.

6. Columbus Day has been a federal holiday in the U.S. since 1937, although it has been celebrated in the U.S. since the 18th century. Today, American Columbus Day always falls on the Monday of the week of October 12, and therefore usually does not correspond to that exact date. Other Latin American countries celebrate Columbus Day, although a severe worldwide backlash gained momentum during the 20th century. This movement was in support of indigenous American peoples who were killed, enslaved, or dislocated, resulting from the European conquests that began with Columbus.

7. The Feast Day of the Virgin of the Pillar is celebrated throughout Latin America as well, including Brazil.

8. Even in Spain, however, there are notable exceptions. For example, in 2016 the mayor of Barcelona, along with others, decided to boycott festivities in a show of solidarity with oppressed indigenous peoples of the New World.

9. The treaty allowed Portugal to claim Brazil, that area being geographically closest to Europe. Spain was given the rest, which dissatisfied Portugal. Pope Alexander VI was Spanish-born. No other European powers accepted the treaty, and a good argument can be main that it helped fuel the Protest Reformation, especially in England.

10. Isabella's only son and favorite, John, Prince of Asturias, died in 1597 at age 19. She was said to have never recovered from this blow.

11. In one of the more bizarre episodes from this era, sometime during the early 1500s, King Nzinga Mbemba (1460–1542) of the African Kongo, known as Alfonso I by his Portuguese sponsors, was victorious over his rival brother for the throne at the Battle of Mbanza Kongo, claiming supernatural help from Santiago Matamoros. Alfonso proved to be a key figure in the establishment of Christianity within the

sub–Saharan continent. Ironically, by this late point in history, Portugal had largely replaced Saint James the Greater with Saint George as warrior protector patron of their state.

12. Vespucci had been a crew member of Portuguese expeditions to the New World between 1499 and 1502.

13. Charles was the only male descendant of Ferdinand and Isabella surviving to adulthood. The only other surviving issue was their daughter Catherine of Aragón, destined to become Queen of England as the first wife of Henry VIII, and as such, a key figure in the English Reformation.

14. Starkie, 5–6. See also Weckman, 111–112.

15. Herwaarden, 488.

16. Starkie, 44; Weckman, 112.

17. Traditional Islam offered the vanquished a choice of conversion, tribute or the sword. For Catholic conquistadors, tribute was not typically an option offered.

18. Curiously, by coincidence (or not), the baptized name of Juan Diego combines the two names of the sons of Zebedee, John and James, or the Sons of Thunder, as Jesus called them (see Chapter 1). Diego is another Spanish variation of James (see Introduction).

19. The same Franciscans who had converted and rechristened Juan Diego were among the doubters. The Dominicans, however, saw merit in the alleged visions, and supported his claims. Juan Diego was later canonized by the Roman Catholic church in 2002 as the first Native American saint on record.

20. Raphael's masterpiece may today be viewed at the Museo del Prado in Madrid.

21. Luther had little use for pilgrimages (see Chapter 14).

22. The provenance of the engraving states that it was the gift of the Potter Palmer family to the Art Institute of Chicago in 1956. The Palmers were well-traveled Chicago hotel and real estate magnates, as well as patrons of the arts.

23. By contrast, the Christian knights being led by Santiago are heavily armored, more reflective of European warfare during the 15th century.

24. On the other hand, given that Europe was then being threatened by the Ottoman Turks, Schongauer's engraving might have been designed as a strident inspirational harangue against the Islamic enemies of Christendom, especially given that German soldiery often faced the eastern European front.

25. The English, French, and Dutch were all slow to catch up in this regard, but would eventually do so with decisive effectiveness (see Chapter 12).

Chapter 12

1 Sung by Ophelia during the mad scene from *Hamlet*, Act IV, scene v, 23–26. See also Starkie, 60.

2. This law made Henry VIII and succeeding English monarchs supreme heads of the Church of England.

3. The term *La Leyenda Negra* ("Black Legend") was first coined during the late 19th century by the influential Galician-born novelist and critic Emilia Pardo Bazán.

4. Named after the north central Mexican province that was the flashpoint of the conflict.

5. Another sign of progressive advances during this era were the founding of national universities in both Mexico City and Lima, Peru, the first of their kind in the New World.

6. For example, one symbol of this Protestant resistance was in the Jacobikerk ("St. James' Church") in Ultrecht, still today the beginning point for Dutch pilgrims traveling to Santiago de Compostela. By the 1580s, during the reign of Charles' son Philip II (as conflict in the Low Countries escalated), the Jacobikerk was declared Protestant by the locals, stripped of its Roman Catholic iconography, and used as an artillery platform against occupying Spanish forces.

7. During his abdication speech, Charles asked forgiveness from anyone he may have wronged, widely interpreted as an allusion to his Protestant opposition.

8. There is some evidence that Elizabeth consciously modelled her style of governance after her highly-revered and similarly-named Spanish predecessor, Isabella. One of the most widely read books of the age in all languages (including English) was *The Courtier* by Baldesar Castiglione, an Italian diplomat who spent his final years in Madrid and in the book lavishes tremendous praise on the legacy of Isabella.

9. More precisely, St. James's Palace was built by Henry VIII on former site of a leper hospital by the same name. Queen Elizabeth I is said to chosen this palace as a waiting place for news during the Spanish Armada crisis of 1588.

10. Martin Luther had himself preached against religious pilgrimages. Better to stay home and take care of one's family and the poor, he argued. See Harpur, 128–129. Given unflattering portrayals of pilgrims by the likes of Chaucer and Boccaccio, this criticism appears not to have been entirely unfounded.

11. There is no preserved definite reference to Shakespeare's *Othello* before 1604; however, Shakespeare's source material from the Venetian writer Cinthio had been published in 1565. See *De Vere as Shakespeare* (Chapter 36) by William Farina (McFarland, 2006).

12. *Cymbeline* was not published until the First Folio of 1623. The play was partially based on a much earlier story by Boccaccio. A primitive stage adaptation of Shakespeare's work may have been performed at the English court as early as 1578, a period during which political relations between England and Spain were seriously deteriorating.

13. Starkie, 60.

14. Shakespeare's *Hamlet* did not appear in print until 1603. An early allusion to the play made by Thomas Nashe, however, dates from 1589, the year after the Spanish Armada. This "Ur-*Hamlet*" may or may not have been an early version by Shakespeare the writer, depending on which authorship theory is accepted.

15. "Rossillion" is often taken to mean the French province adjacent to the Pyrenees Mountains and Spain, but in the play this is more likely a reference to the town of Roussillon in the Rhone River Valley, north of Marseilles. The latter port would in fact be a logical destination for Helena whether she was shipping west to a Spanish Camino or her true destination, Italy in pursuit of Bertram.

16. An English version of the Italian-sourced tale (by Arthur Brooke) first appeared in 1562. The first printed quarto version by Shakespeare dates from 1597.

17. Even by this early date, Drake had already been awarded his knighthood.

18. Most famous among these traditions was that of one María Pita, who after her husband had been killed, personally dispatched an approaching English standard bearer.

19. Starkie, 58–59.

20. Also like Drake, Gilbert was eventually rewarded for his efforts with a knighthood.

21. To give a single example, by the beginning of the 17th century, global agricultural production had begun a major shift. New World crops such as corn, tomatoes, potatoes, and chocolate found new European markets, while Old World crops such as sugar, coffee, cotton, and tobacco thrived in the Americas.

Chapter 13

1. Cervantes, Miguel de, *Don Quijote*, Translated by Burton Raffel, Edited by Diana de Armas Wilson (W.W. Norton & Company, 1999), Volume 2, Chapter 58, 664–665. In the biblical *Book of Genesis*, Hagar was the Egyptian concubine or second wife of Abraham and mother of Ishmael. Both mother and son were expelled from Abraham's household after his wife Sarah gave birth to Isaac, but both are revered in Islam through their family connection with Abraham.

2. Evidence of the growing popularity for Saint Didacus during the 15th and 16th centuries in Spain is surprisingly abundant. For example, the Monasterio de las Descalzas Reales in central Madrid, originally a palace for Charles V and later converted into a Claretian convent for the wealthy by his daughter Joanna, includes a portrait of Saint Didacus among its many treasures, but little or no artistic trace of Saint James the Greater is to be found.

3. Saint Didacus died on November 12, 1463; however, his official Feast Day was later changed to November 13.

4. For example, the founding in 1648 of Santiago, Nuevo León, Mexico, was anticlimactic in that the town proved to be a comparative backwater, a small suburb of the greater town of Monterrey, Mexico.

5. In 2015, the 400th anniversary for the publication of *Don Quijote* (Part II), the tomb of Cervantes was reportedly rediscovered in central Madrid. See http://news.nationalgeographic.com/2015/03/150318-don-quixote-cervantes-tomb-madrid/.

6. Cervantes, 663.

7. According to some sources, Cervantes' father was of Galician ancestry.

8. Cervantes, viii–ix.

9. For example, the Iglesia Santiago Apóstol de Surco in Lima, Peru, was built in 1571, the same year that a young Cervantes fought and was crippled at the Battle of Lepanto.

10. By comparison, in 1607 the Spanish founded Santa Fe, New Mexico, one of their more recent settlements in the New World. In contrast, Jamestown, Virginia, was founded by the English that same year, but was abandoned between 1610 and 1616 before being later reestablished.

11. Between 1630–1654, Dutch Brazil or New Holland effectively controlled large portions of Atlantic coastal South America.

12. Cervantes, vii (Note 9).

13. See Auden's provocative 1948 essay, "The Ironic Hero: Some Reflections on *Don Quixote*."

14. Teresa died six years before the Armada was defeated in 1588; therefore, many Spaniards looked backed at her pious life with nostalgia, as time before Spanish political ascendency had been permanently curbed.

15. Kendrick, 60–68.

16. Quevedo publicly advocated in favor of Saint James the Greater over Saint Teresa of Ávila in his pamphlet addressed to King Philip IV, *Su Espada por Santiago* (1628). Quevedo was also among those partisans asserting that James and Jesus were first cousins, lending an almost clannish outlook to his advocacy. See Starkie, 55–57.

17. Starkie, 55.

18. The Virgin Mary icon of El Viejo, according to tradition formerly possessed by Saint Teresa herself, was reportedly brought to the New World in 1562 by her brother Rodrigo Ahumada.

19. Like his contemporary Shakespeare, Cervantes was attracted to the romance form in his final work.

20. King Philip III had expelled the Moriscos from Spain in 1609, after the publication of *Don Quijote* Part I in 1605 but before the publication of Part II in 1615. Sancho describes Ricote's disguised appearance as that of a "carnival clown" and "a god damned Frenchy," momentarily forgetting that the other pilgrims are German (Raffel translation).

21. This surprising, delightful device is unexpectedly introduced by Cervantes in Book I,

Chapter 9, long after the narrative is well under-way.

22. On the other hand, in a repressive police state such as Spain during this period, devices like this help to partially explain how great artists were sometimes able to get away with making bold social statements.

23. Pisan sometimes phonetically signed his work "H. Pizan."

Chapter 14

1. Bunyan, John, *Pilgrim's Progress* (Dover Thrift, 1678 / 2003), Book II, 268.

2. The shocking behavior of partisans during the Thirty Years War had in fact been anticipated two generations earlier by Montaigne, writing in midst of the French Wars of Religion, who noted that true repentance is a rare thing and that "I can find no quality so easy to counterfeit as devotion unless our morals and our lives are made to conform to it; its essence is hidden and secret: its external appearances are easy and ostentatious." See Montaigne's essay "Of repenting" (Frame translation).

3. Milton's passionate prose defense of free speech, for which he sometimes paid dearly, was also influential on the future founders of the American republic.

4. In addition to Stephen, James, Peter, and Paul, specifically named in the text among the early martyr-saints are SS. Ignatius, Romanus, and Polycarp.

5. Bunyan, 226–227.

6. Hedging any direct Camino associations, Bunyan's character Mr. Honest observes that Christiana's son James should model himself after James the Just. No mention of James, son of Zebedee, is made until a few pages later. See Bunyan, 256.

7. Phoebe was the name of the "deaconess" praised and trusted by Saint Paul in the final chapter (16) of his New Testament letter to the *Romans*. Gaius was the name of Paul's host from the same epistle. Interestingly, *Romans* includes Paul's stated intention of visiting Spain because no Christian missionary had supposedly preceded him there (see Chapter 1).

8. For English Puritans, even a domestic pilgrimage to, say, Canterbury, was considered frivolous and unnecessary in terms religious salvation.

9. The infamous Salem witch trials took place in 1692–1693, almost during the same time period in which the writings of Sor Juana Inés were coming under heavy criticism by the Spanish Inquisition.

10. The two knights of Santiago in question were Don Juan Camacho Gayna and Don Juan de Orue y Arbieto. See *Sor Juana, or, the Traps of Faith*, by Octavio Paz, translated by Margaret Sayers Peden (Harvard University Press, 1988), 431–432. Juana's own personal badge was a ubiq-uitous medallion, seen in all her visual representations as a nun, portraying the Annunciation to the Virgin.

11. In 1633, Galileo had been forced by the Vatican and Inquisition to formally recant his scientific belief in the heliocentric theory of the earth's orbit around the sun.

12. This site had been a convent since the late 16th century. Its expansion and beautification was completed during the late 17th century.

13. Many of Ribera's Saint James portraits appear to use different models, thus adding a multifaceted visual sense to the legend.

14. As a parent, Rembrandt carefully ensured that several of his children were christened within the Dutch Reformed Church, the politically correct choice for that time and place. One can easily speculate that he did not want his children exposed to the same type of prejudice that he presumably had been as a noncommitted churchgoer.

15. The same approach applied to Rembrandt's pagan mythological subjects.

16. Rembrandt's painting of *Saint James the Greater* was reportedly auctioned for $25.8 million to a private collection by Sotheby's in 2007. See "Rare Rembrandt Sells for $25.8 Million," Associated Press for the *Washington Post*, January 25, 2007.

17. Another fine example of the genre from this period is the 1655 portrait by Bartolomé Esteban Murillo (1617–1682), a contemporary of Velázquez and Rembrandt.

18. To give a single small example, in Mexico, Sor Juana had enthusiastically corresponded on scientific matters with Isaac Newton (1643–1727), who considered her an intellectual peer. Soon afterwards, all of her writings were suppressed, whereas in England, Newton was not only tolerated but celebrated, despite holding unconventional religious beliefs that made many others uncomfortable.

Chapter 15

1. John Adams autobiography, part 3, "Peace," 1779–1780, sheet 11 of 18 [electronic edition]. *Adams Family Papers: An Electronic Archive*. Massachusetts Historical Society. http://www.masshist.org/digitaladams/.

2. To this day, within the confines of the U.S. Great Lakes region, one can sometimes hear remnants of the French language being spoken on Native American reservations.

3. This was indeed the immediate cause of the American Revolution, as many American colonists proved unwilling to be taxed arbitrarily for being allegedly protected from the French by the British Empire during the Seven Years' War.

4. Davis, though evidently a man of keen intelligence and reputed personal charm (for a pirate, at least), later became mentor for the more brutal Bartholomew Roberts (1682–1722), a

fellow Welshman who succeeded his command after Davis was killed in an ambush set by Portuguese authorities.

5. By 1726, matador Francisco Romero is credited with establishing many of the stylistic forms still closely associated with bullfighting. Flamenco music and dance are first mentioned as a distinctive Spanish art form by José Cadalso in his *Cantas Marruecas* from 1774.

6. Santiago city later became part of the Philippine Province of Isabela, named after Queen Isabella II of Spain.

7. The Portuguese, French and English could make similar boasts, but on a less extensive scale.

8. Serra's canonization by Pope Francis was not without controversy. Some argued that Serra was comparatively insensitive towards Native American cultures, while others disapprovingly noted his close collaboration with the Spanish Inquisition.

9. Santiago de Querétaro (today known as Qerétaro City), the largest municipality in this region of Mexico, was originally founded in 1531, the same year as the shrine at Our Lady of Guadalupe (see Chapter 11).

10. Father Serra founded nine California Franciscan missions during his lifetime, earning the nickname "Apostle of California." He died at the Mission San Carlos Borromeo in Carmel.

11. Serra was known to have favored the American Revolution as being anti–British and offering more freedom of religion for Roman Catholics.

12. Also known as the Mission Dolores, founded on June 30, 1776, five days before July 4, 1776. The landmark is part of the appropriately designated Mission District of San Francisco.

13. Despite his skepticism, Adams regretted never being able to see the shrine at Santiago de Compostela. See *John Adams* by David McCullough (Simon & Schuster, 2001), 229–231.

14. Franklin was particularly disdainful or mystified by Adams' demeanor towards the French.

15. Charles III was the son of the Spanish Bourbon King Philip V, and the great-grandson of the French King Louis XIV. He had previous been the King of Naples and Sicily, but inherited the Spanish throne upon the death of his siblings.

16. For example, the magnificent Sabatini Gardens, located adjacent to the Royal Palace, still display the scallop shell symbols of Santiago pilgrims along portions of its gated perimeter.

17. Tiepolo's *The Immaculate Conception* was originally painted for the newly-constructed Church of Saint Pascual in Aranjuez near Madrid.

18. In this late work, Tiepolo literally portrays the Virgin standing astride a globe, crushing a serpent (representing Satan) beneath her feet.

19. See *Giambattista Tiepolo, 1696–1770*, edited by Keith Christiansen (The Metropolitan Museum of Art, New York) p. 231.

20. The Seven Years' War broke out four years later in 1754.

Chapter 16

1. The prologue to Section 27 begins: "Revelation given to Joseph Smith the Prophet, at Harmony, Pennsylvania, August 1830." See *Doctrine and Covenants*, Church of Jesus Christ of Latter-day Saints (Section 27: verses 5 & 12).

2. Almost immediately, Joseph Bonaparte was derisively nicknamed *Pepe Botella* ("Joe Bottle") by his Spanish subjects for his alleged alcoholism, generally considered among Mediterranean peoples to be a moral weakness rather than a disease. The shortened moniker of "Pepe" for a royal personage named "Joseph" was particularly disrespectful.

3. Goya's *May 2, 1808* painting inverts the Santiago Matamoros image by having Spanish patriots on foot pulling Islamic Mamelukes off their white steeds, while on *May 3, 1808* these same patriots become political martyrs (with blessings from a martyr-priest) at the hands of a French firing squad.

4. Other small Spanish churches from an earlier era, however, have managed to survive. Some of these include the Iglesia de Santiago Apóstol in Valladolid, and the Iglesia de Villa del Prado Santiago Apóstol in suburban Madrid, both dating from the late Reconquista era of the 15th century.

5. In hindsight, it is safe to say that neither of the Bonaparte brothers harbored sufficient sympathy or respect for the Spanish Santiago cult, since both were products of the Age of Enlightenment, in which worldly success and progress mainly depended on individual Reason (and talent) rather than religious Faith.

6. Also known as the so-called Diploma of King Ramiro I (see Chapter 6).

7. Kendrick, 170–171. Joseph Bonaparte had in fact been the first authority to officially abolish the tax, one of the few initiatives that were later kept by an independent Spanish government (see Kendrick, 168).

8. Kendrick, 171–178.

9. During the same period, Great Britain and the fledgling United States busied themselves with fighting the pointless War of 1812 to a stalemate. One notable action of that conflict occurred in 1814 near the harbor of Valparaíso, Chile, in which American the frigate USS *Essex* under the command of Captain David Porter was captured by the British.

10. Good artistic examples for both Santiago Mataespañoles and Santiago Mataindios may today be viewed in the Museo das Peregrinacions at Santiago de Compostela. Many of these are Peruvian in origin. For example, see http://museoperegrinacions.xunta.gal/es/santiago-mataespanoles.

11. At least two other Mexican towns have been named after Matamoros as well.

12. Matamoros has become nearly synonymous, both in good and bad ways, with the

maquiladora business model promoted by the NAFTA treaty.

13. This was the curiously-named Port of Bagdad, no longer in existence. The place name may have derived from the arid climate and desolate landscape of the region, as well as the use of camels by Confederate supply trains.

14. This equates to approximately $500 million in 2017 dollars.

15. Grant emphasized that the Mexican army was not lacking in courage or patriotism. See *Personal Memoirs of U.S. Grant* (University of Nebraska Press, 1885/1996), 101–102 (Chapter V).

16. In perhaps the most bizarre episode of the Mexican War, mostly Irish-born Mexicans (some of them American army deserters) made a ferocious but futile stand against the U.S. army at Churubusco near Mexico City. One of the prominent leaders of that resistance was named Santiago O'Leary. Grant, an eyewitness, later noted that "…Churubusco proved to be about the severest battle fought in the valley of Mexico." See Grant's *Memoirs*, 88 (Chapter IV).

17. Like most historians of worth, Grant expressly and consistently maintained that the War between the States was a direct outgrowth of the Mexican War.

18. Thus, within the space of half a century, two French monarchs (Joseph Bonaparte and Napoleon III) alienated large Spanish-speaking countries. In the case of Bonaparte, it was Spain itself; for Napoleon III, Mexico, formerly New Spain.

19. It seems unlikely that Obregón ever viewed the Antrobus portrait of Grant, though this is unknown. The poses used in both paintings were common for military portraiture of that era.

20. The Antrobus portrait of Grant was sketched out in late 1863 after Federal victory at Chattanooga. Grant holds field glasses in his left hand while placing his right hand upon an artillery field piece.

Chapter 17

1. *The Song of the Cid* (Raffel translation), 51.

2. The present-day adobe-style structure for St. James Episcopal Church was built in 1959. The other co-patron of Taos is Santa Anna (Saint Anne).

3. Also known as the Taos Revolt, comprised mainly of Pueblo Native Americans and long-time Hispanic residents.

4. The Parisian Camino initially travels in a southwesterly direction, then westward over the Pyrenees Mountains into northern Iberia.

5. Kendrick, 179.

6. During the Peninsular War of the early 19th century (see Chapter 16), neither the British nor the French showed much interest in the comparatively remote Santiago de Compostela, probably a fortunate development for the physical welfare of the shrine itself.

7. Starkie, 58–59.

8. Kendrick, 179–180. At this juncture, the Galician Santiago tradition came into direct contradiction with the Armenian Jerusalem tradition which had long claimed possession of similar relics.

9. Another factor likely working in favor of Santiago shrine defenders at this stage in history was that the highly unpopular Voto de Santiago, or Spanish national tax in support of the shrine, had been officially abolished by 1834 (see Chapter 16).

10. Kendrick, 180.

11. Kendrick, 216.

12. For an excellent overview, see "Marginalizing Spain at the Chicago Columbian Exposition of 1893," by M. Elizabeth Boone, in "Centering the Margins of Nineteenth-Century Art," *Nineteenth Century Studies* (2011): 199–220.

13. The Battle of San Juan Hill was in fact mostly fought on the less glamorously named Kettle Hill, part of the San Juan Heights located in the eastern suburbs of Santiago de Cuba.

14. Roosevelt had resigned from a cabinet post as Assistant Secretary of the Navy to risk his life in the Spanish-American conflict. After the American media glorified his exploits with the Rough Riders, within three years he progressed from Governor of New York and Vice President of the U.S., to finally President, after William McKinley was assassinated in 1901.

15. One of the more striking prototypes of this sculpture is today on display within the Amon Carter Museum in Fort Worth, Texas.

16. The painting is today owned by the Art Institute of Chicago.

17. Lakota chief Little Big Man has been accused of being one of Crazy Horse's last assailants. He is not to be confused with the fictional character of the same name from the 1964 novel by Thomas Berger and 1970 film by Arthur Penn (based on the novel).

18. Surely the most unusual representation in this regard is the ongoing (and controversial) Crazy Horse Memorial on Thunderhead Mountain in Custer County, South Dakota. While the actual memorial has made limited progress since its beginning in 1948, and may never be completed, the original model by Polish-American sculptor Korczak Ziolkowski (1908–1982) is quite impressive. Crazy Horse is depicted on his white stallion pointing towards the burial grounds of the Lakota people. The monument was commissioned unilaterally by Henry Standing Bear (1874–1953) partly in response to the nearby Mount Rushmore project, which includes an image of Theodore Roosevelt.

19. The famous war cry of Crazy Horse was "It is a good day to die."

20. The Lakota artist Black Hawk is not to be confused with the earlier Sauk military leader by the same name (1767–1832) who led Native American resistance against U.S. settlers in the

Upper Midwest during the first half of the 19th century.

21. See *American Indians: Celebrating the Voices, Traditions & Wisdom of Native Americans*, published by the National Society for American Indian Elderly (Goldstreet Press, 2008), 202.

Chapter 18

1. Lewis, C.S., *The Pilgrim's Regress* (William B. Eerdmans Publishing Co., 1933/1981), 52.

2. The revolution finally ended in 1920 with the free election of Álvaro Obregón as Mexican President, after implementation of a new national constitution in 1917.

3. Fátima or Fatimah was the youngest daughter of the Prophet Mohammad and the wife of Ali. She is venerated throughout the Islamic world. The Portuguese village was more precisely named after an Iberian Muslim princess (who in turn was named after the daughter of the Prophet) who converted to Christianity either voluntarily or by force, depending on the source.

4. The two canonized children died shortly thereafter from a Spanish flu epidemic. The third child, Sister Lucia dos Santos, eventually took holy orders and lived until 2005, writing her memoirs during the interim.

5. The most recent film to portray the Armenian Genocide was *The Promise* (2016), which failed at the box office and received mixed reviews as drama, but high critical praise for its historical accuracy.

6. In many respects, the Armenian Genocide of World War I was a precursor to the even larger holocaust that would play out in Germany a generation later.

7. Zorro's true surname "de la Vega" ("of the Valley" or "of the Meadow") is suggestive of mountainous Galicia or Green Spain.

8. In addition to the 1920 silent film, Zorro has been the subject of numerous reinterpretations and sequels, including the 1940 remake starring Tyrone Power, and the 1998 version with Antonio Banderas.

9. Chilean-American writer Isabel Allende has recently updated the same theme with her novel *Zorro* (2005). In this version, the hero's Spanish mentor is Santiago de León, captain of the Madre de Dios ("Mother of God"), but more of a secularized free-thinker and member of a secret society otherwise reminiscent of the historical Order of Saint James.

10. The post–World War I era was politically dominated by, among other things, the women's rights movement, both in Europe and America. For example, in 1929, Ecuador became the first Latin American country to legally adopt woman's suffrage.

11. The designer was the Polish-French sculptor Paul Landowski.

12. The Spanish Civil War was the first major conflict in which the horrors of modern aerial bombardment were introduced by Nazi-armed Nationalist forces, powerfully immortalized by the artist Pablo Picasso in his sprawling work *Guernica* (1937), today on view at the Museo Reina Sophia in Madrid.

13. Some historians have plausibly argued that the Spanish Nationalist counterrevolution of 1936 was largely a reaction against prominent Communist and anti–Catholic elements among Spanish Republicans. It is certainly true that Spanish Republicans underestimated the power of its own native religious cults, as well as being too anti–Catholic in general to achieve widespread populist support.

14. Coincidentally (or perhaps not), the Battle of Mérida was fought in a region of Spain (Extremadura) which had produced many conquistadors during the Age of Discovery (see Chapter 11).

15. Starkie, 57.

16. The historical origins of the Spanish Legion go back centuries to the time of the Holy Roman Empire, but the modern unit was formally organized in 1920. By the time of the civil war outbreak, it had routinely seen action in North Africa, and was the most battle-seasoned corps in all of Iberia. Many of its recruits were from northern Spain. During Franco's lifetime, it was his personal regiment, for all practice purposes. To view them on parade, for example, annually on Spanish Columbus Day (October 12) in Madrid, is indeed an impressive spectacle.

17. Astonishingly, after the war Franco commissioned a mural painting by Arturo Reque Meruvia, still on display at the Military Historical Archives in Madrid, titled *Alegoría de Franco y la Cruzada* (1948–1949). It literally depicts Franco as a Reconquista knight in shining armor, with an all-white Santiago Matamoros riding through the skies above him.

18. Bishop Lartigue was a member of the Sulpician order (the Society of the Priests of Saint Sulpice), who supplanted the Canadian Jesuits in prominence after the latter's general suppression during the 18th century. In this respect, French Sulpicians were akin to the Spanish Franciscans of Latin America.

19. The new cathedral became, in some respects, a symbol of French-speaking Canadian nationalism. It has been designated a national historic site. Also located in central Montreal are two historic Protestant churches named after Saint James the Greater, the Anglican Church of Saint James the Apostle (today known as St. Jax Montréal), and St. James United Church (originally Methodist), both built during the late 1800s and both situated along the Rue Sainte-Catherine.

20. On a personal note, the author's grandmother, Sicilian-born Frances Coletti Farina (1888–1958) was also a lifelong devotee of Saint Joseph.

21. The Charlier sculpture of Saint Jacques at

Saint Joseph's Oratory is highly unusual in that it combines the imagery of Santiago Matamoros (a sword) with that of a pilgrim (a scallop shell).

22. See Matthew 4:21–22; Mark 1:19–20; and Luke 5:10.

23. Basaiti may have been influenced as well by Andreas Mantegna's depiction of the same event from his *Life of St. James* cycle at the Overtari Chapel in Pauda, painted during the mid–15th century but since destroyed during World War II (see Chapter 19).

Chapter 19

1. Kendrick, 14.

2. This new international image was reflected in 1945 when poetess Gabriela Mistral, aka Lucila Godoy y Alcayaga (1889–1957), became the first Latin American awarded a Nobel Prize in Literature. Though a Chilean by birth, with many Chilean landmarks now named after her (including within the capital city of Santiago), Mistral was in fact a well-travelled exile for most of her adult life, finally living and dying in the United States, and always a strong proponent of non-violent conflict resolution.

3. Before her death, Perón was awarded the honorary title "Spiritual Leader of the Nation." The controversies and adoration surrounding her subsequent entombment are worthy to the traditions of most Christian saints, including Saint James the Greater.

4. *Evita* by Andrew Lloyd Webber and Tim Rice was produced in 1976; the major motion picture based on the musical and starring (an appropriately named) Madonna, was released in 1996.

5. For one example, see the section on "Latin America" from the *Oxford Illustrated History of Christianity* by John McManners (Oxford University Press, 2001).

6. Coming of age in Buenos Aires during the Perón years of the 1940s and 1950s was a young Jorge Mario Bergoglio (b. 1936), later becoming Pope Francis I. See https://www.washingtonpost.com/world/you-cant-understand-pope-francis-without-juan-peron—and-evita/2015/08/01/d71e6fa4–2fd0–11e5-a879–213078d03dd3_story.html?utm_term=.006a88b59281.

7. Some of these include St. James Episcopal Church in Waimea, and Saint James the Fisherman Episcopal Church in Kodiak.

8. Speculative motivations for the subsequent 1963 assassination of President John F. Kennedy have sometimes, with a degree of plausibility, been tied to prior events in Cuba, either originating with Castro, his opponents, or both. The question falls outside the scope of this study; however, the chaotic political violence of the era did evoke medieval Spain. For example, two years before the Kennedy assassination, the film *El Cid* dramatizes the assassination of Spanish King Sancho II (of Castile and León) in 1072.

9. Butch Cassidy and the Sundance Kid were, according to most sources, killed by government authorities in Bolivia circa 1908, an event romanticized in the 1969 film by George Roy Hill.

10. Troubles in Nicaragua reacting to foreign interference dated back to 1956 when the unpopular U.S.–supported dictator Anastasio Somoza had been assassinated.

11. One indicator of the new public mood was the 1986 Roland Jaffé anti–imperialist film *The Mission*, which won an Oscar for best cinematography.

12. The cycle was situated along the northern wall of the Ovetari Chapel, and was likely painted in its entirety by Mantegna.

13. Problems also included artistic differences between Mantegna and other painters, with Mantegna completing more of the work than originally planned. Between 1451 and 1453 (the year of Ottoman conquest), no work was completed due to funding shortages.

14. Mantegna's work may today be viewed at the National Gallery in London.

15. The exact sequence of events as related by Voragine is somewhat confusing. The healing miracle was said to have occurred as James was being led to execution, but the conversion and condemnation of Josias is presented as a rather drawn-out affair on its own, before he is martyred along with James.

16. Compare, for example, Giovanni Battista Piazzetta's *Martyrdom of St. James* from 1722, in which Josias before his conversion is portrayed as a brutish lout (see Chapter 7).

Chapter 20

1. *Codex Calixtinus*, Book V (Pilgrim's Guide), Chapter IX, Translated by Denis Murphy (2011). See https://sites.google.com/site/caminodesantiagoproject/.

2. Witness, for example, Ridley Scott's *1492: Conquest of Paradise* (1992) and John Glen's *Christopher Columbus: The Discovery* (1992).

3. As of this writing in mid–2017, the 500th anniversary of the Reformation, another highly important event in human history, seems to be receiving far more favorable reception.

4. Father Rother is scheduled to be beatified (quite appropriately) by Pope Francis I before the end of 2017.

5. This writer and his wife had the privilege of seeing the original ensemble perform at the Chicago Theater during its first international tour.

6. As reported by (among others) the *Washington Post* on October 7, 2001.

7. In a curious diplomatic tightwire act, Colombia officially supported the U.S. but declined to send troops.

8. The Guantanamo Bay Detention Camp is located to the immediate southeast of the highly symbolic city of Santiago de Cuba.

9. The Latin American trend of increased friendliness towards the PRC had in some respects begun in 1998, when self-described Marxist Hugo Chávez was elected President of Venezuela. This election inaugurated the so-called *marea rosa* ("pink tide") in Latin American politics.

10. By 2010, Ciudad Juárez on the Mexican-U.S. border had become the world's leading city for violent crime per capita, although that rate began to decline immediately thereafter.

11. For one account of the heist, see http://www.telegraph.co.uk/culture/art/art-news/9376658/Stolen-Codex-Calixtinus-recovered-in-Spain.html.

12. See https://www.csmonitor.com/World/Europe/2010/1107/In-Spain-Pope-Benedict-XVI-lambasts-aggressive-secularism.

13. See https://www.theguardian.com/world/live/2015/sep/21/pope-francis-in-cuba-pontiff-to-hold-mass-in-holguins-revolution-square-live.

14. Pope Francis is often credited with helping to continue the thaw of formal relations between Cuba and the United States.

15. All of the statues at St. John Lateran were personally commissioned by Pope Clement XI, and designed to fill the 12 interior porticos of the recently built structure, designed by Francesco Borromini.

16. Mantegna's mural showed Saint James the Greater as evangelist directly engaging demons in debate from the pulpit while other bystanders in the audience flee or hide in terror.

17. Today it is generally accepted that the *Letter of James* was written as a pseudonym for James the Just, Bishop of Jerusalem, sometimes equated with the apostle Saint James the Lesser.

18. Not by coincidence had these two nations been the same ones in which *laissez-faire* capitalism had been most aggressively promoted since the Industrial Revolution.

Chapter 21

1. Taken from Santayana's *The Life of Reason*, written in 1905–1906. The proverb is still displayed at Auschwitz in Poland.

2. Conversely, those most damaged by the recent Great Recession—representing the overwhelming majority—had never fully recovered from its adverse effects.

3. De facto German leadership of the E.U. was widely apparent long before Great Britain's "Brexit" vote to leave the Union on June 23, 2016.

4. The Jerusalem Armenians are neither ethnic Arabs nor Muslims, yet the conflation of the two groups persists because of their longstanding ties in government, business, and general coexistence.

5. Prior to his 2010 visit to Santiago de Compostela, Pope Benedict XVI visited the Armenian Quarter in Jerusalem (on May 15, 2009), attempting to promote Christian unity and draw attention to the plight of the Armenian community there.

6. The recently established Union of South American Nations (UNASUR) held annual summits in 2014 at Santiago de Guayaquil in Ecuador, and in 2008 (its first) at Santiago, Chile (see Chapter 20).

7. See http://www.independent.co.uk/news/world/europe/spanish-city-badalona-hispanic-day-holiday-genocide-christopher-columbus-a7355481.html.

8. As this is being written, the city of Barcelona has suffered a lethal terrorist attack from Islamic extremists, despite its historically mild political views on Spanish nationalism. Thus, Spain continues to be the object of violence for perceived misdeeds committed during an earlier millennium.

9. The blatant anti–Mexican rhetoric of real estate developer and reality talk show host Donald Trump seemed to initially propel the then-candidate past his numerous Republican Primary rivals.

10. The devastating electoral loss of the Clinton campaign most certainly failed to address this anxiety, rooted largely in voter economic insecurity, thus taking political incompetence to new and greater heights.

11. For example, commercial relations between the U.S. and Cuba continue to move slowly towards normalization, notwithstanding recent election results. As if to punctuate the beginning of a new era, the death of Fidel Castro at Santiago de Cuba on November 25 signaled the end of the old contentious regime, at least in terms of the Cuban Revolution's most prominent figure.

12. The complex causes of these phenomena are completely beyond the scope of this study; however, plausible (and widely cited factors) include general decline of the public education system, allowed disregard of the news media for fairness and accuracy in reporting, and growing hysteria over economic downsizing of the American middle class and concentration of wealth.

13. Part III of Santayana's *The Life of Reason* is titled *Reason in Religion*. The philosopher dwells at length at the perceived conflicts between religion and science, but finds the two surprisingly compatible.

14. See http://dali.exhibits.wag.ca/shows/display,artwork/106/santiago-el-grande.

15. Similar in this respect to the depiction of Santiago Matamoros in the Salamanca *Codex Calixtinus* (see Introduction).

16. The work was in fact seen on display at the St. Petersburg Dalí Museum in late 2014. See http://thedali.org/exhibit/santiago-el-grande-2/.

17. To the right of the saint (and his supernatural steed) are what appear to be multiple images of the Madonna and Child ascending to heaven, recalling the Pillar tradition of nearby Zaragoza (see Chapter 2), a tradition near and dear to Dalí's native Catalonia as well.

18. Dante never specifically names Saint James the Greater, but clearly identifies him as the church father who attracts pilgrims to Galicia in Spain. For one English translation of the *Paradiso*, see Mark Musa (Penguin Classics, 1984/1986).

19. Dante had been banished from Florence as a political supporter of the papacy, versus its then opposition, the Holy Roman Empire, with which the ascendant Florentine party was aligned.

Summary

1. *New Jerusalem Bible*, 1642. See also Mark 10:35.

2. The phrase "post–truth society" has gained increasing usage during the new century since the Second Iraq War and widely circulated claims regarding weapons of mass destruction. The origins of the idea, at least in modern times, are traceable to the mid–20th century literary works of British novelist George Orwell.

3. The first American saint in the strict historical sense, or rather, Native American saint, was Juan Diego, original witness to the Marian vision at Guadalupe during the early 16th century (see Chapter 11).

4. Mother Cabrini has since been recognized as the patron saint of all immigrants, a fitting and highly relevant status for our own times. Her Feast Day is November 13.

5. The Chicago National Shrine for Mother Cabrini is located on the site of the former Columbus Hospital, originally founded by Cabrini and where she herself died in 1917. The author's cousin Philip Farina (see Acknowledgements) was born at Columbus Hospital.

6. Cabrini's life and work closely paralleled the author's own immigrant family history, my father's ancestors coming to Chicago from Sicily around the same period.

7. Another site closely affiliated with Cabrini's legacy is Assumption Catholic Church at 323 West Illinois Street in Chicago, built in 1886 and whose school was staffed by Cabrini's religious order, the Missionary Sisters of the Sacred Heart. See http://assumption-chgo.org/WA.asp?dseq=10. The author's father was baptized at this church in 1916 (the year before Cabrini's death), and the public funeral service of his father's first cousin, noted actor Dennis Farina, was held here in 2013. Though having no overt connections to Saint James the Greater, the proto-apostle-martyr of Jerusalem is artisticly portrayed several times within the church interior, as is Mother Cabrini (in stained glass).

8. Despite her fragile health, Cabrini is said to have made over 20 trans-Atlantic voyages during a lifetime that predated long-distance commercial aviation.

9. Evanston, Illinois, especially showcases numerous merchants of Armenian textiles, an ancient but still-thriving commercial art form locally dominated by immigrants and descendants of immigrants from that distant part of the world. Disclosure: Evanston is also the longtime abode of the author.

10. Saint James of Nisibis (d. 338) became Armenian Bishop of his namesake city during the early fourth century, having survived the great persecutions of Christians by Roman authorities of the preceding decades. James was reputedly a cousin of Saint Gregory the Illuminator (see Chapter 1), and his presence is documented at the historic First Council of Nicaea held in 325 CE, where he was noted as an eloquent proponent of Christian orthodoxy in the face of the Arian heresy.

11. The city of Nisibis (after which the later Armenian Saint James took his name) is today located in modern-day southeastern Turkey.

12. If choosing to fly Air France to Madrid or some other closer walking distance to Santiago de Compostela, one might easily encounter promotional videos of models wearing the classic "St. James" striped shirt, popularized long ago by the artist Pablo Picasso, and manufactured in the French Normandy town known by the same name, so designated long ago, according to tradition, by William the Conqueror.

13. Recent debate over U.S. immigration policy represents only one facet of this complex problem. For instance, there can be little denying that the American economy depends heavily upon cheap, unregulated, and typically illegal immigrant labor, especially in the agricultural sector.

14. A statue of the Polish-born Pope John Paul II stands in front of the cathedral, as well as his own shrine in the lower-level crypt. He was canonized in 2014 by his protégé Pope Francis I.

15. Kendrick, 172–173.

16. The Venetian attitude towards Spain was highly ambivalent at best. Though formally aligned in religion, Spain's economic and political rise had come at the expense of Venice. Spain's agent Christopher Columbus hailed from Genoa, the traditional enemy of the Venetian Republic and much more conservative in temperament. Generally hostile towards the Inquisition, Venice had built its empire by looking east, while Spain now looked west for expansion. Consequently, Venetian artists tended to be far less impressed with the legend of Saint James the Greater as a military protector.

17. The follow-up to this memorable incident in Matthew is a beautiful sermon by Jesus on the importance of humility through sacrifice and service to fellow human beings. "…anyone who wants to become great among you must be your servant, and anyone who wants to be first among you must be your slave." (Matthew 20:26–28)

Bibliography

Armstrong, Karen, *Holy War: The Crusades and Their Impact on Today's World* (Doubleday, 1988/1991).

Butler's Lives of the Saints, Edited, Revised and Supplemented by Herbert J. Thurston, S.J., and Donald Attwater, Volumes I–IV (Thomas More Publishing, 1956/1996).

The Codex Calixtinus and the Shrine of St. James, John Williams and Alison Stones, Editors (Tübingen, 1992).

Culture and Society in Medieval Galicia: A Cultural Crossroads at the Edge of Europe, Edited and Translated by James D'Emilio (Brill, 2015).

Doubleday, Simon R., *The Wise King: A Christian Prince, Muslim Spain, and the Birth of the Renaissance* (Basic Books, 2015).

Downey, Kirstin, *Isabella: The Warrior Queen* (Anchor, 2015).

Harpur, James, *The Pilgrim Journey: A History of Pilgrimage in the Western World* (BlueBridge, 2016).

Hartley, Catherine Gasquoine, *The Story of Santiago de Compostela* (E.P. Dutton & Co., 1912).

Herwaarden, Jan van, *Between Saint James and Erasmus: Studies in Late-Medieval Religious Life, Devotion and Pilgrimage in the Netherlands* (Brill, 2003).

Hintlian, George, *History of the Armenians in the Holy Land* (St. James Press, 1976).

Hodum, Robert, *Pilgrim's Steps: A Search for Spain's Santiago and an Examination of His Way* (iUniverse, 2012).

Ibn Battuta, *Travels, A.D. 1325–1354, Vol. IV*, translated by H.A.R. Gibb (Hakluyt Society at the Cambridge University Press, Vol. 178, 1994).

Kendrick, Thomas D., *St. James in Spain* (Methuen & Co Ltd, 1960).

King, Georgiana Goddard, *The Way of St. James*, Volumes I–III (G.P. Putnam's Sons, 1920).

Lowney, Chris, *A Vanished World: Medieval Spain's Golden Age of Enlightenment* (Free Press, 2005).

Mullins, Edwin, *The Pilgrimage to Santiago* (Interlink Books, 1974/2001).

Nicolle, David, *El Cid and the Reconquista 1050–1492*, Illustrated by Angus McBride (Osprey, 1988).

The New Jerusalem Bible (Doubleday, 1985).

The Pilgrim's Guide to Santiago de Compostela, William Melczer, Translator (Italica Press, 1993).

Pringle, Denys, *The Churches of the Crusader Kingdom of Jerusalem*, Vol. III (Cambridge University Press, 2007).

The Song of the Cid, Translated by Burton Raffel, Introduction and Notes by María Rosa Menocal (Penguin Books, 2009).

Starkie, Walter, *The Road to Santiago: Pilgrims of St. James* (University of California Press, 1957/1965).

Stone, James S., *The Cult of Santiago: Traditions, Myths, and Pilgrimages; A Sympathetic Study* (Longmans, Green and Co., 1927).

Voragine, Jacobus de, *The Golden Legend: Readings on the Saints*, Volume II, Translated by William Granger Ryan (Princeton University Press, 1993).

Weckman, Luis, *The Medieval Heritage of Mexico*, Vol. I (Fordham University Press, 1992).

Index